Life and Death in Ancient Egypt

Life and Death in Ancient Egypt

SCENES FROM PRIVATE TOMBS IN NEW KINGDOM THEBES

SIGRID HODEL-HOENES

Translated from the German by David Warburton

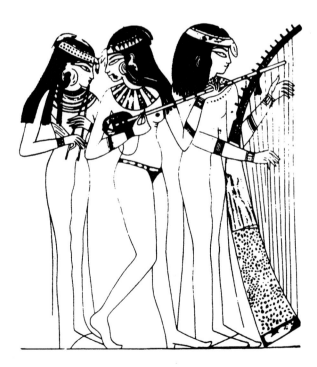

CORNELL UNIVERSITY PRESS
Ithaca and London

Original German edition, *Leben und Tod im Alten Ägypten:*
Thebanische Privatgräber des Neuen Reiches, copyright © 1991
by Wissenschaftliche Buchgesellschaft, Darmstadt

English translation copyright © 2000 by Cornell University

English translation first published 2000 by Cornell University Press

Printed in Hong Kong

Cornell University Press strives to use environmentally responsible
suppliers and materials to the fullest extent possible in the publishing of
its books. Such materials include vegetable-based, low-VOC inks, and
acid-free papers that are recycled, totally chlorine-free, or partly
composed of nonwood fibers. Books that bear the logo of the FSC
(Forest Stewardship Council) use paper taken from forests that have been
inspected and certified as meeting the highest standards for
environmental and social responsibility. For further information, visit our
website at www.cornellpress.cornell.edu.

Librarians: A CIP catalog record for this book
is available from the Library of Congress.

Cloth printing 10 9 8 7 6 5 4 3 2 1

Contents

Preface to the English-Language Edition

THIS BOOK IS INTENDED for those who wish to learn more about the Theban private tombs. Although detailed and heavily illustrated, it is not a guidebook; it is also not a scientific publication. The German edition was intended as an aide-mémoire for those who had been to Egypt and as an introduction for those who were planning to go there; it was also meant for the pleasure of Egyptophiles. The English-language edition includes many more illustrations than the original German edition and takes account of material published since the appearance of that edition in 1991.

My introductory chapter on the general situation of the tombs has been largely rewritten, based on recent work. It endeavors to answer the most frequently posed questions, as well as to explain some of the technical language used by Egyptologists. Inevitably a brief treatment of such a complicated topic produces imprecision. Yet these pages on the tombs and the significance of the paintings should allow a glimpse into the minds of the ancient Egyptians, and reflect their thoughts on life and death. For those readers who are inspired to undertake further study, the text is accompanied by many references; I have cited obscure publications only where I found it unavoidable to do so.

This book is primarily a guide to the imagery of the tombs. Picture and text were, however, inseparable in ancient Egypt; hence the numerous translations included, of texts and captions to the images, which allow us to grasp their meaning. In quoting tomb texts I have used brackets to indicate words that have been effaced, and parentheses for my own explanations and interpolations.

The numbers of the tombs, the plans, and the English versions of the tomb names are those used in the *Topographical Bibliography of Ancient Egyptian Hieroglyphic Texts, Reliefs, and Paintings*, volume I, *The Theban Necropolis*,

part 1, *Private Tombs,* compiled by Bertha Porter and Rosalind L. B. Moss (Oxford, 1970).

The directions indicated in the discussion of the tombs refer to the observer's left and right. The description of the scenes follows the sequence on the wall rather than any possible inner coherence, and thus many of the descriptions do not correspond to a logical or ritual sequence.

With the exception of dates relating to the discovery and publication of the tombs, all of the dates are B.C.; therefore this abbreviation has been omitted.

I thank all those who have aided in the creation of this book. Elisabeth Staehelin and Erik Hornung cordially welcomed me into the Seminar for Egyptology in Basel, Switzerland. Karl-Theodor Zauzich of the Egyptological Institute in Würzburg, Germany, gave me a great deal of help and encouraged me to write the book. Norbert Kutter, the chief librarian of the University of Applied Sciences in Buchs, Switzerland, supplied the rarest of books. Cooperation with Reinhardt Hootz of Wissenschaftliche Buchgesellschaft, Darmstadt, Germany, was instrumental in the production of the German edition. For the English edition, I gratefully acknowledge the skill and helpfulness of the staff of Cornell University Press and my editor Bernhard Kendler, especially for his numerous contributions in the interest of making the book more accessible to a general audience. I am also indebted to Peter Strupp and the staff of Princeton Editorial Associates for their exacting care and attention to detail. Last but not least, I owe special thanks to my husband, who not only drew all the plans but also inspired many of the thoughts expressed herein in the course of our long discussions.

The number of illustrations in the English edition is far greater than that in the original German edition, and where my own resources were insufficient, Kurt Werner and Monika Musolf of Nuremberg, Germany, were extremely generous with theirs. I must also mention the late Ursula Kintzel, who left me her large collection of Egyptian slides, which date from decades ago.

I owe particular thanks to the translator, David Warburton, for his agreeable and able cooperation. He skillfully translated not only the German text but also all of the original ancient Egyptian quotes. He suggested many references to English sources and was responsible for many other improvements and additions. He and I have worked closely together in thoroughly revising the original edition, incorporating into the text new interpretations as well as new references.

SIGRID HODEL-HOENES

Translator's Note

IT WOULD HAVE BEEN impossible to do the translations and provide additional references without the excellent Egyptological library of the Carsten Niebuhr Institute of the University of Copenhagen. I am also very grateful to the author, who listened to my views and frequently permitted their integration into the text. She also went over the entire translation very patiently and carefully.

DAVID WARBURTON

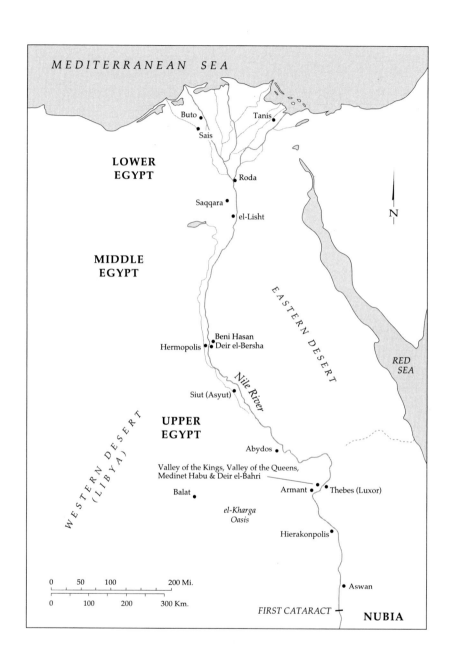

MEDITERRANEAN SEA

Buto
Tanis
Sais

LOWER
EGYPT

Roda

Saqqara
el-Lisht

MIDDLE
EGYPT

EASTERN DESERT

Beni Hasan
Hermopolis • Deir el-Bersha

Nile River

RED
SEA

Siut (Asyut)

WESTERN DESERT
(LIBYA)

UPPER
EGYPT

Abydos

Valley of the Kings, Valley of the Queens,
Medinet Habu & Deir el-Bahri

Balat

Armant • Thebes (Luxor)

el-Kharga
Oasis

Hierakonpolis

N

| 0 | 50 | 100 | | 200 Mi. |
| 0 | 100 | 200 | | 300 Km. |

Aswan

FIRST CATARACT

NUBIA

Chronology

All dates B.C.

Archaic Period	Dynasty I–II	(ca. 3050–2675)
Old Kingdom	Dynasty III	(ca. 2675–2600)
	Dynasty IV	(ca. 2600–2475)
	Dynasty V	(ca. 2475–2320)
	Dynasty VI	(ca. 2320–2190)
	Dynasty VIII	(ca. 2190–2130)
First Intermediate Period	Dynasty IX/X	(ca. 2130–2040)
Middle Kingdom	Dynasty XI	(ca. 2100–1991)
	Dynasty XII	(ca. 1991–1793)
	Dynasty XIII	(ca. 1793–1645)
Second Intermediate Period	Dynasty XIV/XV	(ca. 1645–1520)
	Dynasty XVII	(ca. 1600–1539)

New Kingdom (ca. 1520–1070)

	Dynasty XVIII	(ca. 1539–1292, unification ca. 1520)
	Ahmose	(1539–1514)
	Amenophis I	(1514–1493)
	Thutmosis I	(1493–1482)
	Thutmosis II	(1482–1479)
	Hatshepsut	(1479–1457)
	Thutmosis III	(1479–1425)
	Amenophis II	(1425–1397)
	Thutmosis IV	(1397–1388)
	Amenophis III	(1388–1351)

	Akhenaten	(1351–1333)
	Tutankhamun	(1333–1323)
	Aya	(1323–1319)
	Horemhab	(1319–1292)
	Dynasty XIX	(1292–1190)
	Ramesses I	(1292–1290)
	Sethos I	(1290–1279)
	Ramesses II	(1279–1213)
	Merneptah	(1213–1203)
	Sethos II	(1202–1197)
	Siptah and Tauseret	(1197–1189)
	Dynasty XX	(1190–1070)
	Setnakht	(1190–1187)
	Ramesses III	(1187–1156)
	Ramesses IV	(1156–1150)
Third Intermediate Period	Dynasty XXI	(1069–945)
	Dynasty XXII	(945–713)
	Dynasty XXIII	(818–710)
	Dynasty XXIV	(727–715)
	Dynasty XXV	(728–656)
Late Period	Dynasty XXVI	(664–525)
Persian Occupation		(525–404; 343–332)
Macedonian Occupation		(332–30)
Roman Occupation		(30 B.C.–A.D. 642)

Life and Death in Ancient Egypt

Theban Tombs of the New Kingdom

The Court that judges the oppressed:
You are aware that they are not lenient,
On that day of judging the miserable,
The hour of performing their duty.

It hurts when the prosecutor knows.
Trust not in the span of years:
They view a lifetime as an hour!

Their deed comes after the day of mooring,
When a man's deeds are heaped beside him.

The Beyond is forever.
A fool is he who does what they reprove!
He who reaches them without having done wrong
Will exist there like a god,
Striding like the Lords of Eternity.[1]

THE BRIEF SPAN of life on earth is a common theme in ancient Egyptian texts. The life of the Beyond was the true and lasting life. Death was merely the passage to the new life, the transformation everyone must experience.

Throughout their lives, the ancient Egyptians prepared themselves for this event. Temple services, the erection of royal monuments, and even the irreproachable conduct of the common man all testify to this concern.[2] Indeed, it can even be said that throughout their lives, death was constantly before the eyes of the ancient Egyptians. Death, "the day of mooring," was the decisive day.[3] Without this consciousness, they would never have built tombs and then filled them with offerings and funerary equipment.

On the other hand, they also loved life. Songs praise the pleasures of life; even these, however, rarely fail to mention death.[4] For the ancient Egyptians, the tomb was less a final resting place than a house for eternity.[5] "Decorate your house in the necropolis, make perfect your place in the West," are the words addressed to the living.[6] It was thus perfectly normal that the deceased were given furniture and food, as well as jewelry and cosmetics. These things were indispensable in this world, and in the Beyond as well.

The decoration of the tombs also immortalized an annual festival at which the relatives of the dead would visit the Theban necropolis.[7] It was celebrated by living and dead alike mingling together, and in the tomb decoration, it is frequently difficult to establish whether the tomb owner was enjoying the festivities while still alive, or as one of the dead.

To "strid[e] like the Lords of Eternity," the mummy must be revived.[8] This was done in the ceremony of the "Opening of the Mouth," recorded in numerous papyri and depicted in many tombs.[9] The mummy was the lasting container for the body, but in the Beyond, the deceased was also reborn from the mummy.[10] The mummy remained in the tomb, but the most important component of the human being was his freely moving soul.

The Egyptians had three concepts for what we term the soul—the *šwt*, *shut*-shadow; the *bȝ*, *ba*-power; and the *kȝ* or *ka*-soul—each of which moved about freely. It is impossible to translate these concepts into English, and the common use of the term "soul" is misleading. The *ba* itself is a difficult concept, and the *ba*s of gods and kings differed slightly from those of common people. Oversimplifying, we can suggest that the *ba* is the incarnation of physical and psychic powers. Frequently depicted as a human-headed bird, the *ba*-power began its existence after death, after all the necessary rituals had been properly performed. In the New Kingdom, the *ba*-power continues an earthly existence, while the corpse is bound to the tomb.[11]

The title of Spell 85 of the Book of the Dead runs:

> Spell of assuming the form of a living *ba*.
> Not entering the slaughterhouse.
> He who knows this will not perish in eternity.[12]

The explanation of the *ka* must be similarly oversimplified. In contrast to the *ba*, the *ka* was created at birth, together with the person. The image of the creation of the child and the *ka* at the same time by the god Khnum on a potter's wheel is preserved in several royal temple reliefs. The most famous of these is at Hatshepsut's temple in Deir el-Bahri, but the scene was also depicted at Luxor, and the concept is present in the Ptolemaic Mammisis. The *ka* is conventionally depicted as a pair of arms with open hands extended upwards. It is usually understood as being the vital power as well as a hereditary disposition. As the German

Egyptologist Hans Bonnet pointed out: "At the root of the *ka*-concept lies the conviction that conscious, active life is not the function of the body, but rather flows from a higher power which activates the body and is thus the actual vehicle of life. This vital power is the *ka*. There is no conscious life without it; it exists only by means of its effect."[13]

The funerary rites awakened the immanent, but dormant, powers of the *ka*. It is significant that the conventional offering formula is dedicated "for the *ka*" of the deceased and not for the deceased himself. The statues in the tombs are not only statues of the deceased but also statues of his *ka*. The New Kingdom tomb was thus an image of both this world and the Beyond, as will be seen in the imagery on the walls.

When studying the tomb's meaning, structure, decoration, and so on, it should not be forgotten that even the simplest of these tombs belonged to members of the propertied classes. Unable to afford custom-made grave goods, the poor peasants had to satisfy themselves with a shallow pit in the desert sand, and some personal belongings. The bereaved would have given them little more than the simplest nourishment for their long stay in eternity. Such graves will remain forever concealed beneath the sands of the desert.

Many of the tombs in Thebes reflect a very different world. The creation of an empire by Tuthmosis III transformed life in New Kingdom Egypt. Not only did it bring Egypt into contact with foreign ideas, but the new task of managing an empire in geographically distant and culturally alien regions also required a completely different type of official than in earlier periods. Luxury articles also flowed into Egypt, particularly from the Levant. As prosperity spread, the simple lifestyle idealized in the teachings of earlier ages (such as those of the sage Ptahhotep) was rendered quaint. Expensive clothing, luxurious jewelry, foreign musical instruments, Asiatic dancers, and servants expressed this as much as did the newly imported foreign words introduced into the language.[14]

In the New Kingdom, the wealthy class was largely made up of the officials and military officers who can be called the pillars of the state. Thebes began to assume a dominant position in religious affairs. The temple of Amun at Karnak was by far the wealthiest in Egypt, and its priesthood the most influential. This was made absolutely clear after the Amarna age, albeit at least partly as a reaction to that brief aberration (which cannot be treated here) during which some of the parts of the Empire in Syria were lost. This epoch led to financial constraints felt everywhere, and corruption became rampant as people tried to maintain the lifestyle to which they had become accustomed. The Ramesside era is dominated by tax evasion, unpaid salaries, and corruption (to which we will return). Connections appear to have played an important role, as these were indispensable for getting lucrative administrative posts abroad. The Ramesside maxim that an "office does not have a child" reflected uncertainty in the securest of

preserves, as every Egyptian always aspired to have his son follow him in his office.[15]

During Dynasty XX the hierarchy of Theban priests gained the upper hand, which later proved to be fatal to the political power of the royal family.[16]

All the conditions and developments of this epoch can be read in the tombs themselves: they mirror daily life in that distant day. The private tombs of the Theban necropolis belonged primarily to those exercising professions reflecting these developments. They wanted to have their homes of eternity in this hallowed city. During this period, the king or the royal couple appeared with increasing frequency in the decoration of private tombs. In most cases, these scenes do not reflect the king in any religious role, such as that of a mediator between the human and divine realms. These scenes emphasize the cordial personal relationship joining the deceased and his monarch during his lifetime, or tasks carried out at his monarch's behest.[17]

The size of a tomb does not reflect the financial resources or lifetime of the owner so much as his official position in society. His wealth, however, was to some extent related to his position. Viziers such as Rekhmire and Ramose were certainly wealthier than a mere "bread accountant" such as Userhat. The prevailing state of affairs and religious beliefs also had a decisive influence on the scenes and the architecture of any given tomb.

Location of the Private Tombs

The Theban necropolis lies on the edge of the Libyan desert, on the west bank of the Nile, across from modern Luxor. The most famous of all Egyptian royal burials, the tomb of Tutankhamun, lies in the Valley of the Kings behind the first ridge of mountains. The magnificent tombs of many New Kingdom officials are in the same Theban necropolis, on the western slopes, facing the Nile (fig. 1). A few private tombs of New Kingdom date will also be found in El Kab, just north of Edfu on the east bank, and in Saqqara, the Memphite necropolis south of Gizeh. Among the important tombs in Saqqara is the private tomb General Horemhab built for himself before ascending the throne at the end of the Amarna age, when he built himself another, royal, tomb in the Valley of the Kings. However, virtually all of the well-known private tombs of New Kingdom date are in the Theban necropolis.

There are 414 numbered private tombs in the Theban necropolis. Half a century ago, it was assumed that 371 dated to the New Kingdom and the Late Period: 173 to Dynasty XVIII and 153 to Dynasties XIX and XX of the Ramesside era; 7 to Dynasties XXI and XXII, and a few to Dynasty XVII. Although some tombs also date to the Old and Middle Kingdoms, and more to the latest periods of Egyptian history, the Theban necropolis can justly be termed the cemetery of the New Kingdom élite. The German Egyptologist Friederike Kampp now numbers

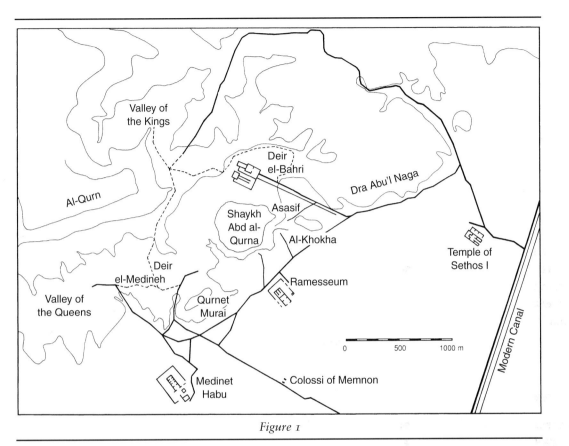

Figure 1

906 tombs and estimates that there are perhaps another 300 tombs that are either unknown or used as cellars in modern houses. There are even Dynasty XVIII tombs accessible in the last century that can no longer be located today.[18]

From an architectural or aesthetic standpoint, however, most of these other tombs cannot be compared to those discussed in this book. Craftsmen, workers, and ordinary people were also left to rest in narrow pits covered with a mound of sand and stones or a small monument of mud brick. A simple mass-produced tombstone may have marked such burials, which have been found in Qurna, Deir el-Medineh, and the Valley of the Queens.

The tombs of the élite will be found in the following parts of the necropolis:

1. Dra Abu'l Naga. The Arabic name means something like the "arm of Abu al-Naga," an Islamic saint to whom a small mosque was dedicated. The tombs of this area are not open to the public. The main royal tombs of Dynasty XVII were found here, but the most famous New Kingdom private tomb here is that of Bakenkhons, the High Priest of Amun during the reign of Ramesses II, whose cube statue is in Munich.[19]

2. Asasif. The meaning of this Arabic term probably relates to a Coptic ritual in which palm leaves are waved. Although right beside Hatshepsut's temple at Deir el-Bahri, it is seldom visited. This part of the cemetery was particularly popular during the Late Period (Dyn. XXVI), and large mud-brick structures of this period line the route to Hatshepsut's temple. The Dynasty XVIII tomb of Kheruef is open to visitors and well worth a visit (TT 192).

3. Al-Khokha ("honeycomb"). This part of the cemetery is just south of Asasif, with the tombs of Neferhotep (TT 49) and Samut, nicknamed Kyky (TT 409), open to visitors.

4. Shaykh Abd al-Qurna. Named after the domed tomb of the local saint. Most of this book is dedicated to this, the most frequently visited cemetery on the Theban west bank, with the largest concentration of private tombs, including those of Nakht (TT 52), Menna (TT 69), Ramose (TT 55), Userhat (TT 56), Sennefer (TT 96), and Rekhmire (TT 100).

5. Qurnet Murai. Named after a local saint buried here, Sidi Murai. The tombs are inaccessible to tourists. The most interesting is the tomb of the viceroy of Cush and Overseer of Foreign Lands under Amenophis IV/Akhenaten and Tutankhamun, named Amenophis but nicknamed Hui (TT 40).

6. Deir el-Medineh. Called the "Monastery of the City" (as opposed to the "northern monastery," Deir el-Bahri), it is named after a Coptic monastery once located here. Situated to the south of Shaykh Abd al-Qurna, the tombs are primarily those of the craftsmen who excavated and decorated the royal tombs in the Valley of the Kings. Only two of these tombs can be visited, those of Sennedjem (TT 1) and Inher-kha (TT 359).

7. Valley of the Queens. This part of the cemetery has been used only since Dynasty XIX; the name is a misnomer, as princes were also buried here, but it is still assigned to the nonroyal part of the cemetery and lies just south of Deir el-Medineh. The finest tomb here, that of Ramesses II's favorite consort, Nefertari, was closed for a long time. In 1985, the Egyptian Antiquities Organization and the Getty Conservation Institute in Malibu, California, started preparatory work to save this singularly beautiful and well-preserved tomb. The actual restoration was started in 1988, and the tomb was opened again after the $3 million project was brought to a successful conclusion in 1992. Although it is open to the public, only a few visitors may enter it daily. However, the tombs of two sons of Ramesses III (Khaemwaset and Amunherkhepeshef), as well as the heavily damaged tomb of Queen Titi and another, unknown, queen are open.[20]

The Layout of the Tombs

All the New Kingdom private tombs in Thebes were cut into
the limestone cliffs on the western slopes of the mountains and
are thus termed "rock tombs." They are therefore funda-
mentally different from the familiar *mastaba*-tombs of the
Old Kingdom. Although termed "tombs" in this book and else-
where, it must be recognized that the actual burial chamber lay
below the "tomb chapel," which is the part usually called a
"tomb" and usually decorated in the New Kingdom—although
there are exceptions where the burial chambers were deco-
rated (see, e.g., Sennefer TT 96, Sennedjem TT 1). For the sake
of simplicity however, the rock-cut chapels are called "tombs,"
and the term "shrine" is reserved for architectural elements
within the tomb chapel.[21]

The basic architectural scheme of the tomb is almost always
the same T-shape (see fig. 2). The tomb can vary from a single
simple chamber to a chamber with a niche; it can even include
an elaborate niche that is itself a shrine with one or more statues. Occasionally
a stela or a false door formed part of the niche. Contemporary fashion in tomb
architecture dictated many aspects, but the tomb-owner's own ideas could also
be expressed. Many tombs served as models, being copied by later tomb-owners.[22]

The typical layout, with the long corridor ending in a niche or shrine, can be
recognized in the tombs of Nakht, Userhat, Menna, Rekhmire, and Samut. The
entrance to the tomb was in the cliff forming the west wall of the courtyard. The
path thus leads symbolically from the east into the "beautiful West." The actual
burial chamber was also occasionally reached via a passage from this corridor.
It is thus hardly surprising that the decoration of the long corridor is frequently
dominated by scenes of the funeral and burial.[23]

One or two transverse halls were excavated in front of the deep passage, and
these are occasionally so large that "supporting" pillars and columns were added
to the decoration, as in the tombs of Ramose (TT 55) and Kheruef (TT 192). The
ends of these halls are frequently adorned with false doors, as in the tomb of Nakht
(TT 52), or stelae, as in the tombs of Menna (TT 69) and Userhat (TT 56). Such
arrangements can be understood as secondary shrines. They usually show the
deceased receiving offerings or worshipping Osiris and Anubis. The deceased
is thus virtually omnipresent.

While the upper rooms remained accessible after the burial and thus per-
mitted the living and the dead to keep in touch, the burial chamber was closed
after the funerary ceremonies. Only the *ba*-power and the *ka*-soul could actually
reach the mummy within. The burial chamber was reached by a sloping passage
from the final room or a shaft from the northern side of the courtyard. It would

Figure 2
Conceptual scheme of
an "ideal" Theban
private tomb.

appear that the vertical shaft was the only type of "entrance" during the early part of Dynasty XVIII until the reign of Tuthmosis III. The fashion in which the shafts were sealed can no longer be established. It can be assumed that they were covered with slabs of sandstone or limestone. The sloping passage (known since the Middle Kingdom) was increasingly common after the end of the reign of Tuthmosis III, and shafts were correspondingly rare thereafter. In contrast to earlier assumptions, the most recent research suggests that the entry to these shafts— and the associated burial chambers—was actually quite prominent.[24]

Changes in the understanding of the tomb and religious conceptions gradually led to architectural changes during the Ramesside period.[25] The sloping passage became the most common approach to the burial chamber. The scene of the funerary procession in the tomb of Ramose (TT 55) leads straight to the entry of the sloping passage, and the entry is equally clear in the tomb of Samut (TT 409). Neither of these burial chambers is, however, accessible today, and the ordinary visitor does not usually notice the entrances. In the New Kingdom these sloping passages were not straight, as in the Middle Kingdom, but rather bent and curved; some even have steps. The entry is frequently emphasized, occasionally with a door frame or decoration.[26]

The German Egyptologist Karl-Joachim Seyfried suggests that the choice of a sloping passage in the Ramesside period can best be understood in terms of beliefs concerning the tomb of Osiris and the Beyond, but above all in terms of the fourth hour of the *Amduat*. The *Amduat* was a book describing the twelve hours of the nightly voyage of the sun through the Netherworld and was found virtually exclusively in New Kingdom royal tombs. Although the book itself was royal property, the concepts must have been familiar, and this hour of the *Amduat* describes the descent of the corpse into the fields of the Beyond, the descent illustrated with sloping passages. The opposing accessible and inaccessible realms are linked and identified as the "world above" and the "world below."[27]

There are, however, some serious arguments against this theory. Erik Hornung suggests that the paths in the desert land of Sokar are mere zigzag tracks leading nowhere, not "sloping passages." The principal difference in the interpretations stems from the fact that Egyptian art did not really depict distinctly the difference between a path in the desert and a tunnel; either interpretation is therefore permissible. The principal feature of the lowest register of the fourth hour of the *Amduat* is the oval in which the last remnants of the primeval chaos that preceded the creation are confined. In contrast to the sloping passages of tombs, where the spirit of the dead would travel from the shrine to the burial chamber, the secret ways of Sokar are frequently inaccessible; the inscriptions in the fourth and fifth hours of *Amduat* note: "The secret path of the Land of Sokar: . . . gods, *akh*-spirits and the dead do not use it."[28]

As mentioned, most of the tombs were cut into the slopes, and a rectangular courtyard was hewn out of the cliff; the façade was thus framed by the stand-

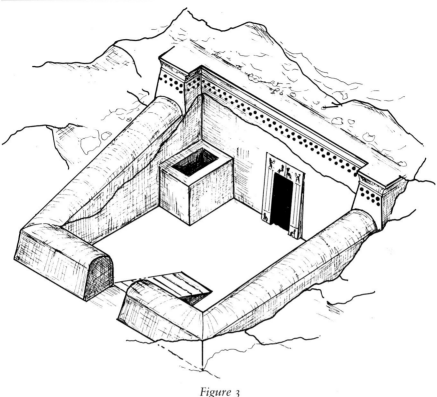

Figure 3
Simple sunk forecourt (suggested reconstruction).
Courtesy Friederike Seyfried.

ing rock. Such courtyards were particularly common during Dynasty XVIII, and each had its own character. It could have been supplemented with brick walls, the front wall defining the east—true or fictive. The tombs of Userhat (TT 56) and Menna (TT 69) are two fine examples of this type of arrangement. Some courtyards had no front wall, as can be seen in the tomb of Sennefer (TT 96).[29] In order to gain the necessary height for the façade at the base of the slopes— and even more so in the valley—the courtyard was set below ground level and was reached via a ramp or stairway. The tombs of Ramose (TT 55) and Kheruef (TT 192) still convey an idea of such a layout (fig. 3). During the Ramesside period, the entrances to these courtyards passed through pylonlike gates on the east side. A peristyle colonnade frequently framed the courtyard (see fig. 4).

The modern visitor, however, will not usually catch a glimpse of these arrangements, as the walls have suffered through the ages and been victims of the easy accessibility of those tombs open to the public. In any case, the walls of the courtyard itself were not usually decorated.

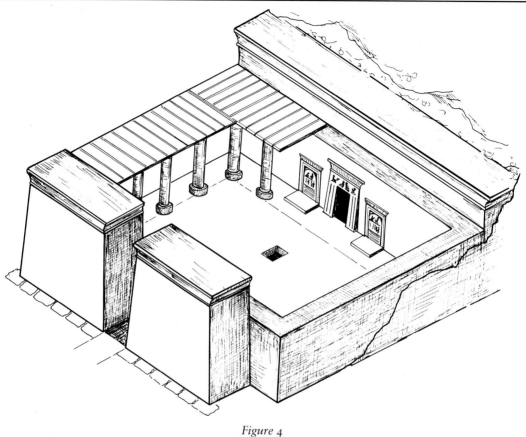

Figure 4
Enclosed forecourt (suggested reconstruction).
Courtesy Friederike Seyfried.

The façade of the courtyard cut into the western cliff was decorated, how-ever. The tomb entrance led the deceased and visitors symbolically from the east into the "beautiful West." From the latter part of Dynasty XVIII, two stelae occa-sionally flanked the western entrance to the tomb (see fig. 4). During the early part of Dynasty XVIII, stelae inside the tomb usually showed the deceased before a table heaped with offerings, as in the Old Kingdom. From the end of Dynasty XVIII, these stelae flank the tomb entrance and show the deceased in an attitude of prayer, as in the tombs of Neferhotep and Samut. From the reign of Amenophis III onward, these stelae frequently emphasized solar worship, while the lower part depicted scenes from the ritual of the Opening of the Mouth. Hymns were inscribed at the base.

Changes in the placement and content of the stelae can be traced to a change in meaning. From the reign of Amenophis III, these stelae were increasingly dominated by religious texts and scenes. As the ends of the transverse hall had become shrines as well, they were no longer the proper place for stelae of this type; statues frequently replaced the stelae, which were moved to the exterior façade. Statues were also occasionally placed in niches in the outer façade. Some Dynasty XVIII tombs had large low platforms, suggesting that the courtyard was used for rituals, perhaps even the ceremony of the Opening of the Mouth.

The door frame of the tomb entrance was occasionally sculpted out of the limestone cliff, as in the tombs of Userhat and Samut, or it was made of sandstone masonry, as in the case of Sennefer. During the Ramesside period, and particularly after the reign of Ramesses III, a brick structure was added. In general, however, the courtyard walls of brick or stone rubble were left unadorned.

From the reign of Amenophis III, Osiris beds and plants become increasingly common. The courtyard may also have been the scene of Osirian rituals, such as the grain mummy ceremonies of the Festival of Sokar, the falcon-shaped god of the Memphite necropolis.[30] An image of Osiris was formed of sown earth during the festival; the green sprouts symbolized his resurrection.

In general, the progressive changes from the reign of Amenophis III into the Ramesside period suggest a kind of "temple architecture." The façade loses its importance, while the courtyard itself assumes an increasingly sacred character; it had already been a "cult stage" in Dynasty XVIII.[31] "The tomb is no longer centered on the deceased as a person so much as being itself a monument of the Beyond."[32]

Hitherto, in accordance with Georg Steindorff and Walther Wolf, it was thought that a mud-brick pyramid usually surmounted the tomb, dominating the complex.[33] Only fragments of such pyramids have been preserved, but they are depicted in some of the tombs themselves, so that we can imagine what they looked like. It had been widely assumed that, by the beginning of the New Kingdom, kings had abandoned the pyramid form, freeing it for private use.[34] Kampp's recent research suggests, however, that this interpretation requires modification.[35] Superstructures are commonly preserved on tombs in the various cemeteries of the Theban west bank, but these are difficult to identify with certainty. The tombs at Deir el-Medineh are an exception; there it was frequently possible to demonstrate archaeologically the existence of a pyramid-shaped superstructure, as in the tombs of Sennedjem (TT 1) and Inher-kha (TT 359).[36] It was assumed that a pyramid crowned the structures earlier as well because of various scenes in tombs, on papyri, and even on coffins. It was, however, neither pointed out in the literature nor noted that none of these images showed tomb complexes before the reign of Amenophis III. On the other hand, it has been archaeologically established that TT 131, a tomb of User-Amun, the vizier of Hatshepsut

and Tuthmosis III, did have a pyramid-shaped superstructure during the early part of Dynasty XVIII.[37]

It is, however, only from the reign of Amenophis III that the performance of the Opening of the Mouth was depicted on the tomb façades, which underscores the increasing importance of the courtyard. It is only after the Amarna period that there are pictures of pyramid tombs in Thebes. It is therefore possible that they should be understood in the context of the increasingly prominent solar cult. The pyramid thus links the tomb with the solar orbit, symbolizing the Heliopolitan primeval hill, and thus the beginning of the world.[38] It is also in this period, that of the Ramesside Pharaohs, that tomb pyramids have been archaeologically discovered, in both Thebes and Saqqara.[39]

Two structures can be distinguished. First, scenes in the tombs show a pyramid surmounting a tomb chapel or façade. Second were the pyramids with their own shrines. These pyramids were topped with pyramidions of a contrasting hue or adorned with figures holding stelae. Imaginative reconstructions of the tombs at Deir el-Medineh can suggest what such tombs looked like (see figs. 173–174).

Pyramidions also have been found near tombs. Most are between 30 and 60 cm in height, with an inclination exceeding 50 degrees.[40] It has thus been suggested that they are too steep to have capped small pyramids.[41] Some do bear a resemblance to the tips of obelisks rather than to pyramids.[42] Pyramidions are known to have been ex voto offerings in earlier times, and one New Kingdom example was even found in a coffin.[43] It is therefore conceivable that these pyramidions were erected in the courtyard, or even inside the tomb, as substitutes for real pyramids. These pyramidions probably existed along with the pyramid-shaped shrines known from early Dynasty XVIII until the Ramesside period. Some of them may have topped diminutive steep-sided mud-brick pyramids.

The Theban Tomb of the Early New Kingdom

During the first part of the New Kingdom, a Theban tomb probably had only a simple façade topped with a torus molding and a cavetto cornice. These could have been complemented with decorated bricks or funerary cones, conical baked bricks with a round (or occasionally square) base. A decorative effect was accomplished by sinking the points perpendicularly into the façade so that the bases were exposed. The bases usually bore the names and titles of the tomb owner, and occasionally also his wife's name, prayers, pictures, or even dedicatory formulas. The significance of these funerary cones remains uncertain. Some opinion associates them with "solar symbolism"; others consign them to the realm of profane architecture as mere relic imitations of wooden roof beams.[44] It is also possible that they were originally purely architectural but later acquired the

solar aspect. The latter is clear in scenes on such cones that depict the worship of the sun god, the solar bark itself, and prayers to the sun god.

The courtyard was open, with a pedestal and a shaft enclosed by a low brick wall. A door frame highlighted the entrance.[45] There were even tombs with vaulted entries or shrines (see fig. 4).

The tomb-owner stood at the center of the tomb decoration. Divine representations were not usual, aside from the gods of the necropolis and the dead: Osiris, Isis, Anubis, Nephthys, Hathor, and the goddess of the West, who led the funerary procession.

Tombs were generally oriented from east to west, so that the tomb paved the way into the "beautiful West." Local geology and topography frequently rendered this orientation impossible, however, so tombs sometimes observed fictional directions. Significant monuments like the temple of Karnak on the Theban east bank could also inspire a deviation from the usual orientation. (Such variations will be mentioned where relevant.)[46]

Just as the layout of a tomb corresponded to a plan, the decoration of the walls also followed certain rules. One must bear in mind that the Egyptian tomb joined this world and the Beyond, the world above and the world below, the historical and the enduring. A treasury and monument for the deceased, after the Amarna age it was also the place where he met the divinities who ruled the Beyond, where he went after death. Hope for continued existence was shifted from the society of this side to the world of the gods on the other. After the Amarna age social position and performance in office—particularly in the service of the king— were no longer decisive, as they had been in Dynasty XVIII: the deceased owed his future life to divine resurrection in the Beyond. After passing the gates of the Beyond, he had to be declared "justified" in the court of the Beyond.[47]

All of the doorways of the tomb are thus passages into and out of the Beyond and therefore have a particular religious significance. The hymns and symbolic images here were intended to reach the gods. In the outer doorway, leading into the tomb, the deceased himself worships the sun. To the east, the hieroglyphic characters face outwards toward the rising sun, and to the west, the signs face inwards, toward the setting sun, and Osiris, the god of the dead in the Beyond. On the sides of the door frame leading into the long hall, the deceased enters the tomb on one side and leaves it on the other.[48]

The decoration of the upper rooms, where the living and the dead were to mingle, corresponds to the nature of the rooms. The scenes in the transverse hall reflect the tomb-owner's life in this world: professional life, agriculture, craftsmen at work, hunting, and other ordinary amusements. Highlights of the career of the deceased—such as a royal audience, rewards, or other significant events— are recounted here. In the tomb of a vizier, his professional activity is particularly

emphasized, with scenes showing the manufacture of royal statues and the delivery of taxes and foreign tribute underlining the expansion of the Egyptian horizon. Altogether these scenes are a mirror of the age and therefore of inestimable value, as they introduce us into life in that distant time. This transverse hall, however, is also the room visited by relatives and others who could read the "Appeals to the Living" sometimes written on the walls here.[49] Certain professional groups were addressed so that the literate could come and pray. Rekhmire says to the visitor:

> Any excellent scribe, skilled in writing, who reads in the texts [and understands with] his heart, sharp-tongued, open-faced, [who can penetrate] things, educated by an overseer to make things happen, calm but sturdy of heart, courageous in [inquiry]. Every one is a sage who can listen to what the ancestors have said. The gods of your city will praise you, as does the king [of] his [day]. . . . You will bequeath your offices to your children after a long life without [regrets]. . . . Your images will be where they belong if you repeat.[50]

This appeal was followed by a litany of requests.

The decoration of the long hall can include funerary ceremonies, the ritual of the Opening of the Mouth, and the voyage to Abydos. The scene of the deceased at the Judgment of the Dead is also here. If there is a shrine, it has scenes of the deceased before a table of offerings, alone, with his family, or facing his family, who bear offerings.

These general guidelines, however, were rarely observed, as the layout was usually simplified. What can be said is that, in general, the first room depicted scenes of daily life, and the decoration of the inner rooms was dedicated to the Beyond, in the broadest sense.

The banquet scenes frequently encountered in the first room include celebrations and festivals, depicted on tomb walls as early as the Old Kingdom. The tomb-owner, either alone or accompanied by his wife, was usually shown standing in festival attire, enjoying the sight of food, drink, flowers, dancers, and musicians—all there for the "pleasure of his heart." In the New Kingdom, these scenes were refined and broadened. These parties reflected the contrast between leisure time and working. They also underscored the social distinctions between the elite, who could afford such festivities, and the lower classes, who could aspire only to provide food and drink for them, and perhaps to participate as servants, if they were lucky. Another aspect of spending a "beautiful day" were the erotic undertones. In ancient Egyptian tales and texts, the party with its fine clothing and elaborate wigs is the precursor to lovemaking, probably reflected here as well, as in the scenes of hunting in the papyrus thickets (see pp. 36–39).[51]

Whether such a banquet took place during the life of the deceased or as part of the "Beautiful Festival of the Desert Valley" can rarely be established with

certainty.[52] This festival was an important event in the necropolis. Once a year, in the tenth month, in summer, Amun crossed the Nile from Karnak to the west bank. The goal of this journey was the bay of Deir el-Bahri, where the temples of Menthuhotep I and Hatshepsut stand today. For ages the goddess Hathor had been worshipped here, and in the New Kingdom there were several chapels dedicated to Hathor at this site. The "Mistress of the Heavens," Hathor was also a god of the dead and of the West, frequently represented as a cow living in the mountains or in papyrus thickets. She is depicted as a cow in the Hathor chapels from Deir el-Bahri, including the one attached to Hatshepsut's temples, and another originally built by Tuthmosis III and Amenophis II that stands in the Egyptian Museum in Cairo today.

This festival was the largest celebrated in the necropolis on the west bank, and it must have been spectacular. In a ceremonial procession, the bark of Amun was removed from the sanctuary of the temple and taken to the quay. Since Dynasty XIX, Amun's bark was accompanied by that of his female counterpart, Amunet; his consort, Mut; and their son, Khons. Thus it was a grand procession that passed the royal shrines on the way through the temple. At the river, the bark was placed on the magnificent river bark, "Amun-the-Strong-of-Head." Towed by the royal ship and accompanied by countless other vessels, Amun was ferried to the other bank, where canals led to the landing place at one of the royal mortuary temples on the west bank. The portable bark was unloaded and carried to the various temples. It was an honor to bear the bark during the procession, or to help row the royal ship.

Statues of deceased kings were also borne in the procession. Together with the priests, the living king performed ceremonies in full view of the gods and the residents of the city of the dead. Some of the glory of this event struck the whole necropolis. Ordinary people may have made burnt offerings in tomb courtyards and then gone to the tombs of their deceased ancestors and relatives, together with priests and musicians. Sacred bouquets were then brought and offered, preceding the actual feast within, in the "reception hall" of the tomb.[53]

The banquet scenes in the tombs can thus show the tomb-owner celebrating the festival during his own lifetime and also sharing the meal with his relatives after his death. According to the Egyptian view of the world, the events of life were repeated after death and thus not distinguished iconographically, as there were no distinctions. A rare caption indicates that such scenes depict the "annual rowing to the West" or "his Beautiful Festival of the Desert Valley." Other inscriptions record "this splendid god Amun coming from Karnak." This festival was only immortalized in Dynasty XVIII tombs before the Amarna period, although it is known to have been celebrated since the Middle Kingdom and continued to be celebrated much later.

The Excavation and Decoration of the Theban Rock Tombs

The construction of private tombs is not documented, but records exist concerning the excavation and decoration of the royal tombs. The procedures were quite similar, the primary technical difference being one of scale. When planning a royal tomb, the layout, measurements, and other specifications for each room and its decoration were noted on papyrus or on limestone flakes called ostraca. A plan of the tomb of Ramesses IV is preserved on a papyrus in Turin, and one for the tomb of Ramesses IX is on an ostracon in Cairo.[54]

It is inconceivable that private tombs were completed without any written plans at all. Yet the friability of the Theban limestone meant that alterations were inevitable, as happened even in the meticulously prepared royal tombs. The situation is best illustrated by tombs at Deir el-Medineh, where rigid adherence to a plan was virtually impossible. There, tombs perforated the entire mountain, and it was inevitable that the plan for a new tomb had to be changed when older tombs were encountered during excavation.[55]

Excavation itself was also difficult because of the bad quality of the limestone. Only at the foot of the mountain is the stone harder, permitting the execution of reliefs; but even here, the addition of stucco and fine limestone was necessary to achieve acceptable results. Retaining walls were occasionally used, and gaps were filled with rubble and plaster. In the tomb of Sennefer, workers simply painted over a large cavity in the ceiling, probably created when a boulder fell while they were working in the tomb![56]

The excavation of the tomb began with a narrow tunnel whose ceiling was at the height of the ceiling in the planned tomb. A red guideline on the tunnel ceiling led straight along the axis of the proposed tomb. The width of the rooms was determined by measurements from this line, and the lateral enlargement on both sides of the tunnel followed immediately. The hardest initial work was done with stone hammers; spikes and mallets were used thereafter. Debris was carried away in baskets and leather sacks. The walls were evened out with bronze chisels and then burnished with a kind of pumice. Where the quality of the natural rock itself was poor or inadequate, the walls were covered with limestone slabs, as in the tomb of Ramose. Generally, however, the walls were simply finished with plaster. The ceilings were necessarily plastered before the walls. In private tombs, the rock itself was covered with chaff-tempered mud, and a plaster-and-lime mixture was spread over this. Clay, sand, and lime mixtures were also employed. It was only toward the end of Dynasty XIX that paint was applied directly to the mud layer. Ineni, the official responsible for construction of the tomb of Tuthmosis I, said: "I brought into existence fields of stucco to embellish their tombs of the necropolis. It was a project which had not been done since the time of the ancestors."[57]

As soon as the surfaces had been prepared, a draftsman set to work making a preliminary plan of the architecture and thus the decoration. First of all, he had to establish the cardinal directions; the positioning of each variety of decoration was not arbitrary. The statues of the deceased or the scene of "Entering the West" from the Book of the Dead had to be on the west wall. With a brush and red-brown paint, the directions were indicated. A string dipped in the paint was pulled taut and released against the surface of the wall. These lines are astoundingly straight and aided in establishing the grid pattern that determined the placement of decoration and inscriptions.

Guidelines were used for human figures, generally arranged in a series of grid squares. Traces of these guidelines are common in unfinished reliefs, not only as in the tombs of Ramose (TT 55) and King Sethos I (KV 17), but also even in Old Kingdom tombs at Saqqara. At the beginning of the New Kingdom, the height of a standing male figure—from the soles of his feet to the hairline—was 18 squares; a seated figure was 14 squares. In this scheme, wigs and other headgear were purposely disregarded.[58]

The squares then dictated the proportions, determining the number of squares assigned to the head, torso, arms, and so on. The craftsmen used the grid as an aid but then quickly sketched the outline of the figure in red with a few broad strokes. This accounts for the numerous exceptions to the ideal rule. In many tombs the corrected outlines can be seen in black ink, over the red primary outline.[59]

To emphasize the distinction between the sexes, the small of the back is generally higher in the figures of women than of men. Women's shoulders are also not as broad as men's, and their graceful limbs are slimmer. In contrast to figures in the Old Kingdom, however, the men's muscles are not indicated.

Unfinished scenes reveal that the preliminary outline of secondary figures was sketched with a few lines, or not even sketched at all. In a scene with figures of differing size, the draftsmen sometimes employed a separate grid for the smaller figures, but sometimes also simply sketched the figures freely into the larger grid. Both methods can occasionally be observed in the same tomb, possibly suggesting that several craftsmen were involved.[60]

The proportions differed over time as well, as the Egyptian image of the human body evolved. At the beginning of the New Kingdom, the proportions of the standing male figure were still much the same as those of the male figures of the Middle Kingdom. A change gradually appeared from the reign of Tuthmosis III, however, and it becomes clearly visible under Amenophis II. The American Egyptologist Gay Robins terms this process the "feminization" of the male figure.[61] The change is most apparent in the small of the back and the lower edge of the buttocks, which are raised about half a square, optically lengthening the legs. The change has been identified in both the private and royal spheres,

and in both it also includes a growing propensity for finer clothing; women's clothing never receives the detail awarded men's. Yet Robins's term is perhaps not the best. It is remarkable that this "feminization" not only begins under Tuthmosis III but accelerates under Sethos I, Ramesses II, and Ramesses III. These were precisely the most illustrious royal generals in Egyptian history, all renowned for glorious battlefield victories.

By the end of the New Kingdom, the human figure was refined to fill 19 squares, rather than the 18 hitherto conventionally used. In Dynasty XXVI the number of grid squares for a standing person was again changed, this time to 21. At the same time, seated figures were changed from 14 to 17 squares, the distance being measured from the soles of the feet to the upper eyelid. Seated, kneeling, and even animal-headed divinities were subject to the same rules.[62]

Where reliefs were part of the design plan, the sculptor followed the draftsmen. Beginning at the top of the wall and working his way down, the sculptor usually completed a small section before proceeding to the next. For raised relief, the outlines of the figures were defined with a sharp chisel, and then the background hollowed out. When the masons were finished, everything was covered with another fine layer of plaster. Another sketch followed, and only then was the scene painted. Color was first applied to the background and the skin, before details were tackled.

Where the tomb was only painted, not sculpted, the painter followed the draftsmen. The colors were applied directly to the wall.[63] All of the Dynasty XVIII royal tombs were only painted, except that of Horemhab, the last king of the dynasty. His unfinished royal tomb is the first with reliefs.[64]

The deeper that workers cut into the earth, the less sunlight penetrated into the tomb, until finally the workers found themselves in complete darkness. Almost every visitor to an Egyptian tomb soon remarks that most of the paintings lie in the darkest part of the tomb, yet not a trace of soot or smoke can be seen. For artificial light, the Egyptians used what they called a *khebes*-lamp. It is a simple, flat, clay vessel filled with animal or vegetable fat. The wick or wicks were made of linen. In his studies of work in the royal tombs, the Czech Egyptologist Jaroslav Černý thought it improbable that such lamps were either held in the hand or placed on the floor. He suspected that several of them were probably put together in a shallow bowl.[65] In the royal tombs, the supply of oil was carefully recorded to prevent anyone from taking some home. Although Herodotus lived centuries after the period discussed here, he may have seen an ancient method: "These lamps are saucers filled with salt and oil, upon which the wick floats."[66] The salt prevented the oil from smoking (fig. 5).

Figure 5
Lamp (Tomb of Neferabet).

COLORS

The primary colors used in painting the tombs were white, black, red, green, blue, and yellow; hues were made by mixing. The Egyptians generally used mineral colors; many pigments were produced from the numerous and abundant minerals lying on the surface of the desert in wadi Maghara in Sinai.[67]

White was known since the predynastic era, as can be seen on pottery vessels. It was made with calcium carbonate (lime) or calcium sulfate (plaster), both of which are common in Egypt. Black consists of carbon in various forms. This was usually charcoal or soot, generally scratched off cooking vessels, which explains the impurities occasionally found in the paint. Black was likewise used on predynastic vessels. Pyrolusite (a black manganese ore common in Sinai) and oxide of manganese were also employed.

Red was produced almost exclusively from natural iron oxides abundant in Egypt. Although the two are distinctly different, both red iron oxide and red ochre (anhydrous and hydrated oxides of iron, respectively) are occasionally termed hematite and confused with chemically different materials.

Green was usually made from copper. Powdered malachite was used, along with ground green frit. Frits are artificial compounds of silica heated together with calcium carbonate and natron (i.e., finely ground calcium-bearing desert sand), along with a color-producing metal-oxide agent. Heated in an oven, the individual particles on the surface are bound together before reaching the melting point. The resulting porous mass could then be either made into jewelry or ground and mixed with water to make glazes or paint. The green color resulted from a copper-bearing mineral (probably malachite), together with the metal content of the silicates.

Blue was originally azurite, called chessylite. Primarily resulting from the erosion of copper sulfide, it is common in Sinai and in the eastern desert. When exposed to moisture and carbonic acid, it is transformed into malachite. Blue-colored paint, however, was mainly produced from a frit based on silicates with a low iron content (as opposed to the green frit). This product is called "Egyptian blue." Dating back to the Fourth Dynasty, it has been the subject of countless studies.[68]

Yellow was produced from yellow ochre and from orpiment. A hydrated oxide of iron, yellow ochre is abundant in Egypt. Orpiment is a natural sulfide of arsenic termed realgar. It is apparently not native to Egypt and was not used before the middle of Dynasty XVIII. Although occurring in Asia Minor and Armenia, it was probably imported into Egypt from Persia.

Brown was produced from ochre or iron oxide. Red paint applied on black also produced an acceptable brown. Good-quality brown ochre is found in the Dakhle oasis. Gray was produced by mixing black and white. Orange resulted from painting red on yellow, or mixing yellow and red ochre.

The pigments were bound together with resins, usually myrrh, therebinthe, acacia, or that of ebony from Nubia or Punt. Beeswax was also employed. The details of the process and mixture have not been completely resolved, and it must suffice to state that the Egyptians employed the tempera technique, mixing colors with water and adhesives.[69]

Two types of brush were used in painting, both of which have been found in tombs as part of the painter's equipment.[70] Coarse brushes were made with plant fibers, usually alfalfa and split palm leaves, folded in half and bound together at the fold. The chemist Alfred Lucas, who is the authority on the subject, noted that these brushes look very much like certain modern shaving brushes.[71] The finer brushes were made with fibrous stems, usually the central ribs of palm leaves or reeds. These were crushed at one end, usually by chewing until the fibers split. Traces of paint have been found on such brushes, indicating that different brushes were used for different colors.

Backgrounds were usually painted gray-blue until the middle of Dynasty XVIII, then white, and then, in the Ramesside period, yellow.

The colors of objects and persons depicted in Egyptian paintings were not arbitrarily chosen.[72] Black was the color of fertile land and the Netherworld. As the source of the fertile waters of the Nile and ruler of the Netherworld, Osiris is generally shown with black skin. White symbolizes purity of character. Egyptians were clothed in white, contrasting starkly with the colorful garments of foreigners. White is also the color of joy and celebration. The crown of Upper Egypt was white. Red was the symbol of chaos, called "typhonic" after the Greek god Typhon, whom the Greeks identified with Seth. The terrifying desert was red. Red was also used for headings and emphasis in written texts on papyrus (the origin of our word "rubric"), but divine names in such phrases were occasionally written in black to ward off evil. In some cases, as with the red crown of Lower Egypt, green occasionally replaces red for the same reason. Green was a positive color symbolizing the budding shoots of health and well-being. Protective amulets, including those in the form of the "whole" eye of the god Horus, were green. Green is a common metaphor for joy. Blue symbolized divinity but was otherwise less laden with meaning than other colors. It was used for the skin color of the air god Amun. Divine beards and wigs were usually blue. Yellow or gold symbolized excellence and the imperishable. Military and civil decorations were gold; divine flesh was theoretically gold; the goddess of love, Hathor, was frequently called the "Golden One."

The symbolism of colors was reflected in precise rules for painting. The natural color of any given object was not necessarily relevant. This can be seen in the unreal yellow tone of women's skin or the red brown of the men's, and in the variations of skin color where rows of people are depicted.

The colors of the individual hieroglyphs were subject to the same pattern of rules as that applied to paintings of people. That the sign for water was blue is relatively logical. It is also comprehensible that animals are usually assigned an appropriate color, but parts of the human body are usually shown as red. Diverse nuances of color in the hieroglyphs remain puzzling and require investigation.[73]

NEW KINGDOM WALL DECORATION

Egyptian art is timeless.[74] To a certain extent, the Egyptians lived for eternity and therefore strove against being confined by time and decay, seeking the timeless, ideal, and ageless. Action is completed, and therefore if we see crafts-men working on an object, the object is already finished: in vain would we seek pictures showing an unfinished sarcophagus or bed.[75]

The Egyptians showed everything as it typically had to be, but not neces-sarily as it really was. In viewing any ancient Egyptian relief or painting, it must never be forgotten that "artists were not reproducing the world as they saw it but were interpreting it as a series of concepts. This means that they reproduced images that had no direct relationship with reality but were constructed according to known conventions in order to convey desired information to the observer."[76] Perspective was therefore superfluous, as things would not be shown as they really are. Boxes are painted with perpendicular and parallel lines, with no allowance made for perspective, and the contents of closed boxes (including sarcophagi) are also commonly depicted. The burdens borne on both sides of the backs of animals are also shown, although this is impossible to see in reality for an animal viewed in profile. As in children's drawings, trees are folded out around a pool, as can be seen in the tomb of Rekhmire. The German Egyptologist E. Brunner-Traut termed this system "aspective," and she adduced numerous examples in her work. According to her, artistic aspective is the opposite of optical per-ception, which leads to perspective representation. The term has been used to describe many intellectual phenomena of ancient Egypt, but in ancient Egypt-ian art it implies "understanding of the whole through simple, discreetly out-lined and sensibly employed parts which are paratactically distributed across the surface."[77]

When viewing an Egyptian relief or painting, one must abandon the ordi-nary way of viewing the world to which Europeans have become accustomed over the centuries. It is only thus that one can develop an appreciation for Egypt-ian art, which faced problems unrelated to those of Western art. As the German Egyptologist Wolf explains it: "All artistic problems expressed in pieces of art are rooted in the basic problem, 'form and nature.' This is because, ultimately, every work of art must reinvent the world of appearances, which is naturally infinite. It is only possible to accomplish this task by constraining the depiction

of this infinite wealth within a form. Works of art thus equalize the polar opposites of 'form' and 'nature.'"[78]

The concept of depth was generally avoided, and thus both foreshortening and overlapping, although deliberately employed on occasion, are rare. Humans, animals, and objects are placed in rows or side by side. The dreary effect is relieved by having one of the participants turn his or her head. It is, however, comprehensible that perspective art was always closed for the Egyptians, as it did not suit their needs. The idea that objects were bound to the surface is directly tied to the tangible character of Egyptian art, as is the result that optical effects were not sought out. The lines outlining every form are thus fundamental. They draw attention to the inner character of a person or object. It is thus hardly accidental that the Egyptians referred to something as itself being "characteristic" or "rendering" something "characteristic."[79]

The Purpose of the Decoration and Contents of the Tomb

Like other cultures, the Egyptian culture expressed intellectual evolution through stylistic development. During the early part of the New Kingdom, paintings of scenes from daily life dominated the decoration, but these gave way to scenes of a more funerary character during the Ramesside period. Earthly joys and parties thus give way to the Beyond. Fears of the Beyond were anticipated with religious spells, such as can be found in the Book of the Dead. The dread of evil demons is almost tangible.

Magic thus assumed an increased importance. It was believed that images could not only represent reality but in fact be real. Images of the tomb-owner will frequently be found defaced, with the eyes hacked out and names effaced. People were thus able to damn their foes to a second, unavoidable death by depriving them of life in eternity. Tuthmosis III's attempt to eliminate Queen Hatshepsut's memory is the most prominent example. But the custom can also be seen in the tombs of ordinary officials like Menna and Rekhmire. Even the Christians observed this custom when hacking out the images of the ancient gods.

For magical reasons, certain potentially dangerous hieroglyphic signs were avoided in mortuary texts and captions. It was not without reason that King Sethos I replaced the Seth-animal with a "harmless" sign in the writing of his name. In the tomb of Inher-kha in Deir el-Medineh, as in many others, the evil Apopis serpent is pierced with knives even in hieroglyphic texts, rendering it incapable of causing injury.

Such thinking also influenced Egyptian optical impressions. A bodily member could only be depicted from one characteristic view; anything else could be dangerous, because it would be incorrect. The human figure was thus composed of several different characteristic parts, and it was impossible for the Egyptians

to portray a torso alone, as such a thing would be incapable of life. It can be said that all Egyptian images were religious and their depiction determined by magical practices; none were purely aesthetic or artistic in inspiration and execution.

In his tomb, the deceased was immortalized in his prime, along with all of the most important events of his life, recorded for eternity. Family scenes appear because one did not want to miss relatives in the "beautiful West." The idea of continuing one's life in one's children meant that begetting children in eternity was also important. "Hunting in the papyrus thickets" is the motif of a common scene in the tombs, hinting at this desire. The papyrus thickets were the home of the goddess of love, Hathor, and love songs frequently refer to secret meetings in the thickets.[80] In contrast to the festival scenes, where children are generally excluded, these hunting scenes almost invariably include children. Their presence not only strongly hints at the erotic character of the scenes, but also suggests a magical fiction for the Beyond: the fiction of continued life, the extension of the cult of the dead. Hathor was a goddess of the necropolis, as well as the goddess of love.

Originally, however, the thickets embodied the ancient Egyptian concept of order, as hunting animals implied the elimination of chaos.[81] The traditional royal act of smiting foes belongs to the same world.[82] Royal hunting scenes on temple walls must likewise be understood in this fashion, with animals signifying enemies.[83] Hunting thus came to signify the defense against—and elimination of—enemy powers, and thus the preservation and accomplishment of Maat. For the ordinary person, this was very important in the realm of the dead.

There is, however, another aspect hidden in the hunting and fishing scenes, for they also characterize the tomb-owner as a wealthy member of the propertied classes who could enjoy such pursuits in this world, without having to worry about procuring food. Such scenes preserved the same social status in the next world, where he could amuse himself by using a throw stick to strike birds and a spear to catch fish. Food for eternity was generally procured by fowlers using traps and fishermen with nets, and they are also shown in the same scenes. But these too can have apotropaic functions. The nets caught not only the food for the dead tomb-owner, but also his enemies, rendering them harmless and unmenacing.[84]

All of these beliefs and depictions are true only of ordinary people, however; such ideas cannot apply to a dead king. A king had both a different social role and different tasks in the Beyond. The decoration of the royal tombs thus differed distinctly from that of tombs of ordinary people. Although officials usually paid for the construction and furnishings of their tombs, the king frequently donated some of the equipment for them. Both kings and ordinary people shared the same types of tomb offerings and equipment, but the scale differed by several orders of magnitude.[85]

Tomb offerings and equipment are an important element in ensuring safety and quality of life in the Beyond.[86] The offerings are intended to satisfy the needs of the deceased in the Beyond, guaranteeing a life of the same quality he enjoyed on earth. This guarantee was dependent on cult and ritual. Much of the tomb equipment is of a ritual nature, used precisely for the mortuary cult. The offerings and the equipment were thus both essential for continued existence in eternity. One group of grave goods consists of ordinary objects used in daily life: furniture, baskets, clothing, food, and ointments. For us, these are extremely important for understanding not only the material culture but also the culture in general, for economically these goods placed in tombs represent an enormous waste. It is hardly accidental that many of the objects were replaced with images, which could perform their roles magically.

The funerary equipment was far more significant, and magical images could not substitute for the coffin, sarcophagus, offering tables or niche, statues, false doors, or stelae. Protective measures were also taken against undesirable outside influences. These included technical arrangements such as suspended stones and trapdoors, but magical—apotropaic—means were also employed. Protective figures were also placed in a corner of the burial chamber.

The sheer quantities of grave goods increased during the New Kingdom. Substitute mummies in model coffins, amulets in the form of *djed*-pillars (symbolizing enduring permanence), headrests as protective amulets, and *ushebtis* have been found in abundance. According to the popular etymology, *ushebtis* were "answerers." This tradition traces the term back to the Egyptian verb wöb, *wesheb,* "to answer," and thus *ushebtis* were those who could substitute for the deceased when some god called upon the deceased to perform certain unpleasant tasks in the Beyond. They were originally termed *shabtis,* and later *shawabtis;* the real meaning of these terms remains to be satisfactorily established. *Ushebtis* were inscribed with a spell from the Book of the Dead enabling them to replace the deceased.

The Book of the Dead itself, however, was the essential item of funerary equipment required to reach the Beyond. The name commonly given to this collection of spells is modern. The ancient Egyptians termed it "the book of going forth by day." Some elements of these spells can be traced back to the Pyramid Texts of the Old Kingdom, which were first carved into the walls of the burial chamber in the Saqqara pyramid of King Wenis, the last king of the Fifth Dynasty. Originally intended for the exclusive use of the king. During the New Kingdom, a selection of spells were written on papyrus rolls. At Deir el-Medineh, the workers excerpted some the spells on the walls of their tombs.[87]

In principle, every Egyptian could purchase a Book of the Dead, but it was too expensive for most. Papyrus was the most highly appreciated writing material in ancient Egypt and always very valuable. Students had to be content with

writing on bits of limestone and were allowed to touch papyrus only when they had mastered their field.

A finely illustrated Book of the Dead could cost around one silver *deben* (91 grams). During Dynasty XVIII, the same sum could purchase a slave, a couple of cows, or about 15,000 m² (3.5 acres) of land. It was roughly half the annual salary of a worker at Deir el-Medineh, and thus illustrated editions were beyond the means of most of the population of ancient Egypt. The necropolis workers buried in the tombs at Deir el-Medineh may have owed some of their prosperity to the production of funerary goods, which apparently also enabled them to purchase expensive Books of the Dead. Cheaper editions could be had at about a fifth of the price.[88] No kind of initiation governed access to such papyri, but the opposite applied to knowledge of the royal texts, which were familiar only to the select few. Neither mystic initiation nor secret knowledge could substitute for social position and hard cash.

The Book of the Dead was intended to guide the deceased through the Netherworld and the Beyond, where he had to undergo magic transformations with the aid of the spells or to use the spells to open doors. Both the king and the ordinary mortal sought to be able to "come forth by day," so that they would not be obliged to spend eternity in darkness. They wanted to ascend, to regenerate—always conscious that the mortal remains stayed behind in the tomb.

In the Book of the Dead, the ferryman interrogates the deceased, requiring that he identify every single piece of the bark by its divine name, assembling it magically and thus making it usable so that the river of the Beyond could be crossed. The deceased also had to be able to name every part of the gate, from the threshold to the architrave, before being permitted to enter the Hall of Judgment.[89]

The German Egyptologist Jan Assmann identified the purpose of such spells, using the title of the *Amduat* as an example. The *Amduat* is a royal guide to the Beyond, but the concept upon which it was based should be equally valid for the works used by private people. Assmann thus concludes:

1. Knowledge of the conditions of life in the Beyond opens the possibility of sharing it. . . . Those who know the denizens of the Netherworld belong to them and share their fate.
2. Knowledge of the dangers of the Beyond is protective. . . .
3. Knowledge of the Netherworld offers unimpeded freedom of movement in the Beyond.[90]

All these thoughts and images are only one aspect of ancient Egyptian reflections about death and life on the other side: these thoughts were responsible for the creation of the tombs that absorb our attention. Another fundamental aspect, however, is the fundamental fear of death, which was responsible for this obsession with the Beyond. Although mentioned earlier, this was only clearly expressed

in the New Kingdom. During the reign of Ramesses II we find, for example, "He who loved drunkenness is (now) in a land without water, the proprietor of numerous storehouses has rushed off." Or "Woe to him who (had) many people. He has left all his relatives—he has hurried to the land of eternity and darkness, where there is no light."[91]

It was known that death was impartial, not distinguishing rich from poor, young from old: "well-off is he who is ready: when your envoy arrives to take you, he should find you ready. Indeed, he will not wait for you. Say, 'Yes, here comes one prepared to meet you.' Don't say, 'I am too young for you to take.' You know not the coming of your death! When death comes, it overpowers the child in its mother's embrace like the one who has spent a long life."[92] These quotes confirm that death was always regarded as an enemy from which there was no escape, regardless of all preparations.[93]

The German Egyptologist Siegfried Morenz may have been correct when remarking that the Egyptian landscape played a role in the development of the concepts of the Beyond. The narrow Nile Valley is circumscribed by the pitiless desert. In Upper Egypt, the empty wastes were never out of sight, and the cemeteries were on the edge of the cultivated fields. The Egyptians' short life expectancy simply brought the consciousness of death even closer.[94]

The detailed descriptions of the Netherworld may have originated in these visions; what one knows is not as terrifying as what is unknown. It is impossible to believe that it is finally over, that one can say, "He who goes does not return." It was the Egyptians, more than any other people, who reflected most profoundly on this fact. In the Nile Valley, the injunction "to enjoy a beautiful day" always followed thoughts about "that land which loves silence."[95]

Nakht

NAKHT WAS A SCRIBE and "Observer of the Hours [of the night]" at the temple of Amun and is thus generally credited with having been an "astronomer." He may, however, merely have been responsible for assuring that the rituals of the hours were carried out at the correct times. The name "Nakht" means "the strong one." His wife was Tawy. The tomb was unknown to the earliest visitors (fig. 6). Eugène Grébaut left a wooden door after he worked at the tomb in 1889. The ideal state of preservation at that time suggests that the tomb had been discovered by local people only shortly before Grébaut's time (fig. 7).

A number of objects were discovered in the burial chamber while the Englishman Norman de Garis Davies was preparing a publication for the Metropolitan Museum of Art in New York between 1907 and 1910. These included a stelophorous kneeling statuette, depicting Nakht holding a stela with a hymn to the sun god Re. Only copies are preserved today, as the steamship transporting the statuette to the United States was torpedoed and sunk by a German U-boat in 1915 (before the United States entered the war). Nothing therefore remains of the original funerary equipment, except the bits left by the tomb robbers of antiquity.

Although some of its scenes are both striking and famous, the tomb was never finished. The passage was only plastered and not painted, so that the funerary scenes that should have appeared here were never done; the statue niche probably never had a statue. The tomb has since suffered from "protective measures." Nothing remains of a small stone wall on the left side, which has suffered the same fate as the courtyard and façade also described by Davies. Bits of a fitted sandstone door frame are today in showcases inside the tomb's courtyard.[1]

For stylistic reasons, Davies concluded that it would not "be far wrong" if the tomb was dated "to the end of the reign of Amenophis II or early" in that

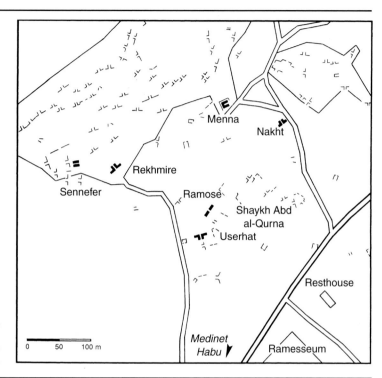

Figure 6
The cemetery at Shaykh Abd
al-Qurna.

of Tuthmosis IV.[2] Recently, the tomb has been assigned to the end of the reign of Tuthmosis IV, or even into the early years of the reign of Amenophis III. Part of the case for changing the date is based on the figures of the musical scene: the large almond-shaped eyes and tip-tilted noses of the women's profiles fit the later date, along with the sinuous hourglass curve of their backs and the conscious nudity of the lissome bodies.[3]

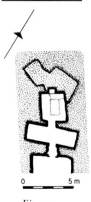

Figure 7

These musicians are in the transverse "reception" hall, the only part of the tomb that was painted, after being covered with a layer of fine plaster. These walls are protected by glass plating today. The residential impression is heightened by the "carpet-patterns" on the ceiling. A "*kheker*-frieze" tops the paintings on the walls.[4] *Kheker* is the Egyptian word for "ornament," and the friezes are common decorative designs, simply depicting stylized bundles of reeds or plant stems that were typical of the mats hanging on the walls of ordinary houses. Even today, such reeds are used for the decoration of modern Egyptian wall tops. The friezes were originally used only in the royal tombs but were later adopted by private people as well; the custom can be traced back to the Third Dynasty. King Djoser was the first king who

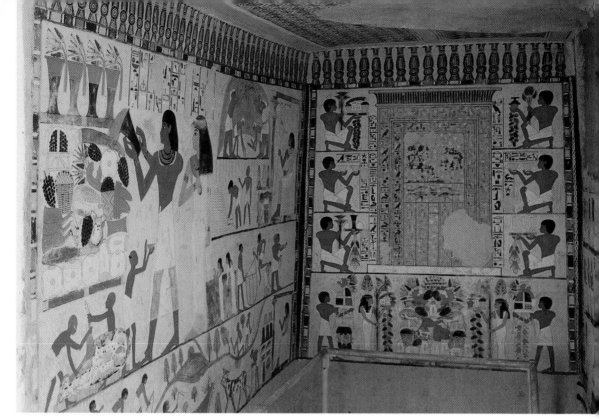

Figure 8

it is certain used the stylized reed-mat decoration, in the northern chamber of his tomb complex.

As a tomb was the residence for eternity, the images recall this world, but they also have an apotropaic function. The tomb-owner thus assumes a prominent place in the tomb decoration. Because of his importance, he—and frequently his wife or relatives—is depicted as disproportionately large in comparison to other people, animals, and objects. This naturally bears no relation whatsoever to their actual physical sizes.

Just to the left of the entrance are heaps of offerings on two mats (fig. 8). The lower mat is covered with grapes, fowl, vegetables (such as lettuce and cucumbers), loaves, and choice bits of beef, such as haunches and ribs. Four tall vessels stand on the upper mat. Decorated with lotus blossoms, they held oils and ointments. From a cylindrical vessel, Nakht pours a brown mass of myrrh over the offerings. Behind Nakht is his wife with a sistrum and *menit*. The sistrum is a musical rattle generally played by women in cult ceremonies. It still rattles today in Ethiopian church services. The ancient Egyptians thought that the sound of this instrument would assuage the gods. The sistrum also offers magical protection and transfers the powers of the goddess Hathor to distinguished women.[5] Both the verb and the noun are the phonetically onomatopoetical *sesheshet*. The *menit* was a broad pectoral with a counterweight that had a particular significance in

the cult of Hathor. Its quiet clatter soothed the goddess, like the sistrum with which it frequently appears. It is also associated with the joy of life and vital strength, which particularly suits Hathor, who gives both as the "mistress of drunkenness."[6] Among the offerings, the front leg of a black-checked cow is being cut off. A small man is turning to the tomb-owner, passing him incense, depicted as a tall narrow triangle.[7]

This type of scene with burnt offerings forms part of the Festival of the Valley. These are thus always found in the front room, as they link the deceased to the world of the living more than do the scenes in the passage. Accompanying the scene is an inscription: "Offerings of every good, pure thing: bread, beer, cattle, fowl, long-horned and short-horned-cattle, thrown upon the brazier [for Amun, for] Ra-Harakhte, for Osiris the great god, for Hathor above the desert, for Anubis on top of his mountain, by the Observer of the Hours of [Amun], the scribe [Nakht], justified and his wife (literally, "sister") beloved of the seat of his heart, the Chantress of [Amun, the Mistress of the House, Tawy], justified."[8]

As life in eternity is not burdened with the woes of this world, it is understandable that the deceased are always shown dressed for a festival. At the time, it was fashionable for the tomb-owner to wear a transparent mantle over his kilt. Women preferred a tight-fitting white dress. Both wore multitiered necklaces and bracelets. The wife had a blossom diadem in her hair, from which a lotus bud has become detached, hanging over her forehead. The lotus bud is common in tomb decoration, as it symbolizes rebirth, regeneration, and the gift of life. As a symbol of regeneration, it is particularly important to the dead who wish "to assume the form of the lotus bud" in a spell of the Book of the Dead.[9]

To the right of the entrance is an analogous scene, but without the servant bearing incense. The cow being offered is already cut into pieces, and three rows of offering bearers approach from behind the couple, bringing delicacies for the offering table. The red lines of the grid pattern used to paint the tomb-owner and his wife can still be seen.

Ordinary workers and bucolic life in the countryside are the subject of another scene, entitled "Sitting in a booth, viewing his fields by the Observer of Hours [Nakht], justified before the great god."[10] The accompanying composition consists of four registers with wonderful details, on the left wall immediately adjoining the offering scenes just mentioned. The whole is to be "read" from bottom to top, enabling the tomb-owner to take a prominent place in the top field. This scene is also a divider for the adjoining scenes of the cultivation of the fields, aligned in several registers beside and beneath it.

The work commences in the lower strip, which extends under the offering scene (figs. 8 and 9). The tomb-owner sits on the right under a baldaquin supported by slender papyrus poles. Unkempt workers in unadorned kilts hoe the earth and sow grain. Although the Egyptians may not have been class conscious

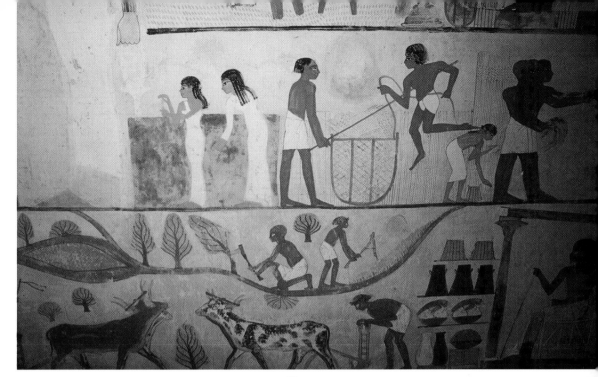

Figure 9

in the modern sense, the tombs underline enormous disparities in social standing. The scene not only shows activity and social disparity, but also exemplifies the Egyptian fashion of artistic expression. A wave in the earth hints at the uneven terrain. The aspective character of Egyptian art is apparent in this scene in the tree folded over on the river bank, and in the way that the yoke borne by the oxen seems to float in the air above their horns.

In the scene itself, a tree is being felled. The work is very strenuous, justifying a rest in the shade of a tree and a drink from the waterskin (fig. 10). The earth is not only hoed (fig. 10), but also plowed by a team of oxen. In figure 9, a spotted ox is just visible behind a brown one, a simple device that allowed the artist to portray the second animal, which was not really visible. That animals were not always obedient in Egypt can be seen in the way the animal holds its head aside from the raised whip. The field has be sown after plowing, and two laborers, one of them naked, have already started. The pictures are also symbols: the trees and water in the background suggest that the land is fertile and irrigable.

It is constantly emphasized, however, that the successful harvest is the result of labor. The field workers had to work hard, as the scene with the pair of spotted oxen clearly shows. The worker's body is bent, symbolizing the backbreaking toil of cultivation; his unkempt hair and simple kilt document his low social rank. When the grain is ripe, it is cut with sickles just below the ears. The Egyptians did not need straw because they did not have cattle stalls. The climate was so mild that the herds could be left in the open all year round. The ears of

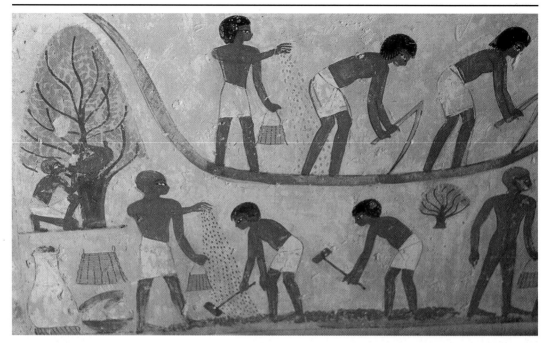

Figure 10

grain were placed in baskets that were easily carried off and easily measured. Taxes and rent had to be measured in kind. Harvest registers and even records from threshing floors have been preserved from the New Kingdom. The amount to be delivered depended upon whether it was taxes, rent, or the production of fields belonging to the state. The Egyptians reckoned in terms of "sacks" per *aroura* of land, taking an amount somewhere between a small fraction of the harvest to well over half the entire yield, depending upon ownership and social position.[11]

In this scene, a worker appears to vault with a pole under his left armpit, but he is in fact simply trying to press it down with his body (see fig. 9). The basket was too full and the carrying pole fit through the left loop of the basket, but not the right one. This device gives life to both the scene and the spatial distribution. Almost beneath this "leaper"—and thus part of the scene—is a girl gleaner putting grain into her basket on the ground. The Egyptian peasants were pushed to the limits only under Roman rule, but the importance of every single ear of grain to the poorer people even during the New Kingdom can be seen in the activity of these women, who rarely fail to make an appearance in these scenes. Despite their charm and delightful simplicity, such details are surprisingly stereotypical. It was the ability of the artist that determined whether or not the scene came to life. To the left are two girls plucking flax, artistically reduced to a sea

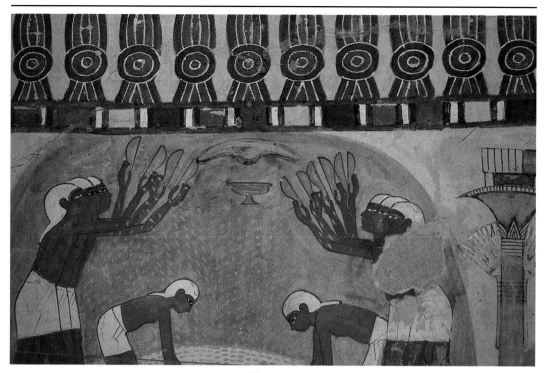

Figure 11

of green. Clean white linen clothing would appear to have been a completely ordinary facet of life in ancient Egypt. Two workers are measuring grain under the watchful eye of a supervisor.

When the harvest was finally delivered and registered, the chaff had to be separated from the wheat (fig. 11). The winnowing is done by rows of men lined up as they toss the grain in the air. White cloths protect their heads from the dust accompanying the process. Such scenes can still be seen in Egypt and the Orient today. The two objects at the top, between the two winnowers, can be understood as offerings to Osiris.[12]

The measuring and winnowing are being done before Nakht, who is again sitting under a baldaquin supported by poles with papyrus tips. This scene is thus no mere picture of life in the countryside, but rather a guarantee that sufficient fresh bread and food will be available in the Beyond. And cultivating the "fields of the blessed" is an important part of Spell 110 of the Book of the Dead (see p. 254).

At the left end of the "transverse hall" is a false door topped with a cavetto cornice (see fig. 8).[13] The red dots of paint were an attempt to imitate expensive

red granite, which was probably beyond the means of the tomb-owner. Here, as well, the hieroglyphs are painted blue green. It was here that the tomb-owner's descendants were supposed to deposit their offerings. In these pictures, however, it is, servants who present the offerings; Nakht and Tawy may not have had any offspring. Each servant is depicted in the usual form of the hieroglyph for "man"; the one at the top brings lotus blossoms (symbolizing Upper Egypt), bread, vegetables, grapes, and water; below, another is offering ointments, incense, and flowers. To the right are papyrus stems (symbolizing Lower Egypt), beer, wine, and clothes. Below the false door is a heap of offerings: fruit, loaves, meat, fowl, papyrus, and lotus. On one side is a man, and on the other a woman, each bearing offerings and symbolizing the masculine/feminine duality that forms a unity. The woman's head is symbolically topped with a fruit-bearing tree. Tree divinities are usually feminine and commonly associated with Hathor or Nut, mother goddesses par excellence who give birth to the sun and thus promise the deceased rebirth after death. This picture also hints at Spell 59 of the Book of the Dead, where the deceased hopes to breathe air and control water through the sycamore goddess, Nut.[14]

The theme of food, water, and air hints at revival. It is therefore hardly accidental that the famous banquet scene faces scenes of cultivation (fig. 12). But it takes us into a completely different world than that of the field workers. In the usual row formation is a series of three women. As with the offering bearers, the number "three" need not be taken literally, since "three" also represents the Egyptian concept of plurality (see fig. 8). The arrangement here was very carefully thought out, however. The slightly rising level of the heads, which starts at eye level, gives an impression of space. The nude servant girl who anoints her mistress joins these women to the next group, giving the composition an unusual charm.

The slender guests are clothed in fine dresses of thin cloth, and the women are adorned with necklaces and earrings. Generous wigs with blossom diadems and salve cones top their heads. These salve cones are generally assumed to be pomade that slowly melted in the warm evening air, salving the guests' torsos with a fragrant aroma. The yellow color of some party clothing has thus been ascribed to this salve. Siegfried Schott has correctly pointed out, however, that people normally pulled their clothing back when being anointed, precisely in order to keep the garments clean. In addition, salve cones have the color of the myrrh used in burnt offerings. It is therefore more reasonable to suggest that the Egyptians did not really wear melting cones, which would have messed up both their hair and their clothing, and that the cone symbolizes hair scented with myrrh and bodies anointed with oil.[15]

This group of women is sitting gracefully on mats laid out on the ground, with their arms charmingly crossing each other's. One hands a fruit to her neigh-

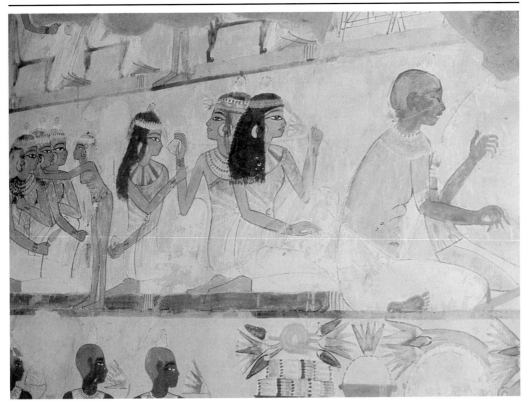

Figure 12

bor, while the woman on the far right enjoys the scent of a blossom. The refined artistic overlappings—the lady on the left grasps the wrist of the one in the middle, who is herself half concealed behind the one on the right—bring the scene to life. The whole arrangement reflects the refined life-style that prevailed in Egypt in those days. There is even a certain fin de siècle weariness of life that the field workers could not possibly have felt, as this sensation is reserved for those who already have everything and for whom nothing is ever enough.

Beside this group is a blind harpist with crossed legs. His instrument is a six-stringed ladle-shaped harp. A larger version of this harp, with from seven to eleven strings, was commonly used solo by singers; it had to be placed on a stand. Here, the deep sound box is finely ornamented and the neck colorfully painted; the piece joining the neck and the body is decorated with lotus blossom motifs. The sole of the harpist's left foot is clearly visible, having passed under his right thigh. Such a position is anatomically impossible. His empty eyes are only hinted at with a line. Like most male harpists, he is overweight and appears to bear his sorrows

within him while his fingers deftly play on the strings. Those at the party do not seem to affect him very much.[16]

Among the women, three men (and thus also "many") sit at a generously covered table where they enjoy the fragrance of lotus blossoms. They are, however, very schematic and differ strikingly from the women and the badly damaged scene just below, which shows more women guests. All of the guests are seated on mats, while the musicians and dancers either sit or stand on the bare earth.

The centerpiece of this banquet is a group of three women musicians—the flutist (who is actually playing a double oboe), lutenist, and harpist—whose grace and charm can hardly be overstated (fig. 13). These three epitomize the over-refined, almost decadent life-style of the day, charming us as they did the ladies at the party. The delights of lithe bodies, both naked and finely clad, could not be more pleasantly obvious. The rich, heavy jewelry and luxurious shoulder-length wigs form a refined contrast to the thin dresses and overt nakedness. The movement of the bodies is emphasized with the crossed leg and the turned head of the lutenist, but the artist went further and broke the rules by shifting the lutenist's navel and depicting her left breast frontally.[17] There is no caption for this scene, as for most of the scenes in this tomb, but a caption would have destroyed the harmony of the composition. This means that we will never know whether this is the "Beautiful Festival of the Desert Valley" or a banquet with the deceased or one arranged in his honor.

At the entrance of the passage to the "long hall," Nakht and his wife receive food offerings and a bouquet. A charming detail of the scene, which is largely destroyed, is the little cat eating a fish beneath Tawy's chair.

To the right, beside the passage, in the upper and lower registers Nakht and Tawy are seated before generously laid tables (fig. 14). As a sign of marital alliance, even in eternity she has placed one hand on his shoulder, while grasping his arm with the other. The official art of ancient Egypt never showed more intimacy than this, but everyone understood the language of the pictures and knew the significance of these gestures. Nakht himself is sniffing a lotus blossom; in the upper register, his wife is holding one in her hand, while in the lower register, she has hung it over her arm. In the scene below, the couple is comfortably settled beneath a baldaquin supported by lotus-stem poles. Offering bearers bring delicacies related to the scenes immediately to the right. At the top are large numbers of ducks and geese, while grapes, fowl, and fish are below. The dark grapes shine, and the fowl are still vibrant. Eggs and chicks in the nest lie among the offerings, which include cucumbers, figs, and freshly caught fish. The fish lie separately on a mat, probably reflecting the practical experience of life.

To the right, in the top register, is a scene of hunting in the papyrus thickets (see figs. 14 and 15). This had been a common part of tomb decoration since the Old Kingdom, a thousand years earlier, and could not be omitted from the

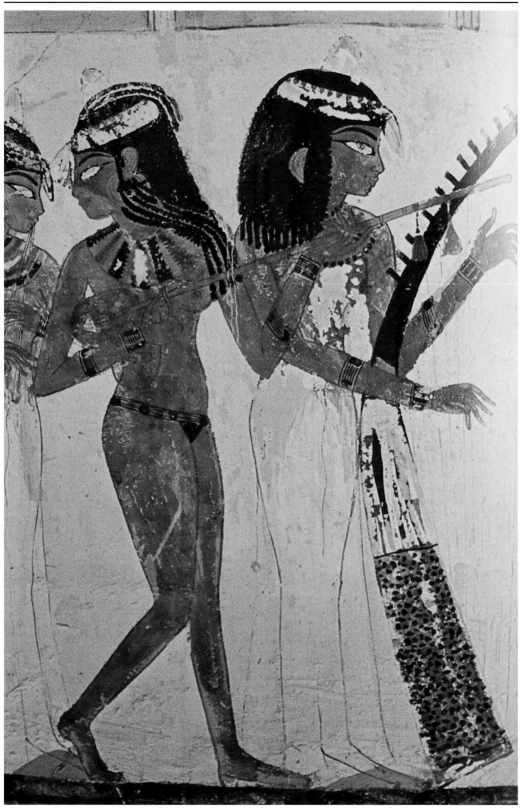

Figure 13

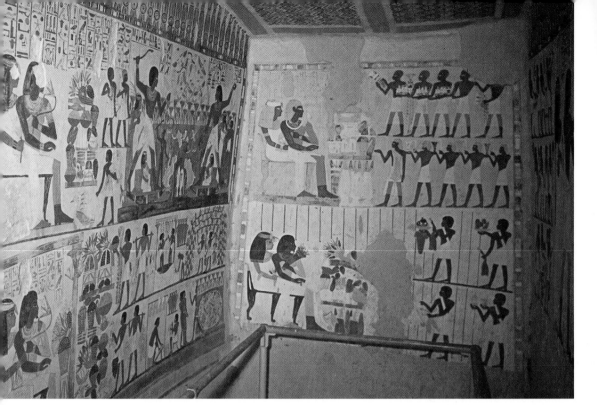

Figure 14

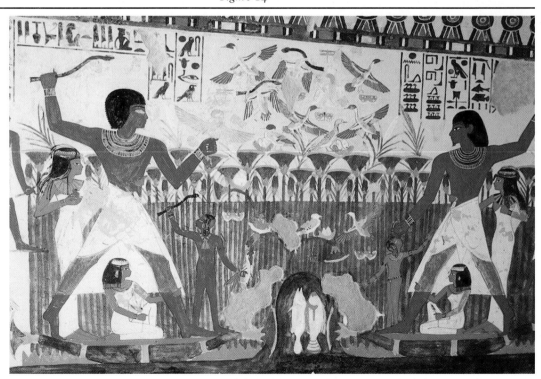

Figure 15

inventory in this tomb. The papyrus thicket is only schematically sketched, with alternating open and closed papyrus umbels. The thicket itself is merely a closed field of even-toned paint. On the left, Nakht is launching his throw stick at birds, while his wife and two children look on: "Enjoying and beholding beauty, spending leisure with the work of the marsh goddess by the confederate of the Mistress of the Catch, the Observer of Hours of A[mun] the Scribe, Nakht, justified. His wife, the Chantress of [Amun], the Mistress of the House, Tawy, she says, 'Enjoy the work of the goddess of the marsh! Waterfowl were assigned to him, for his time.'"[18] Disturbed, the birds flutter about, leaving their nests. On the right, Nakht is spearing the fish in the middle of the scene. His hands should have been clenched around the hunting weapon; strangely, the spear was omitted. "Crossing the marshes and wandering through the swamps, amusing himself with spearing fish, the [Observer of Hours of Amun] Nakht, justified."[19]

The deceased is standing, his legs bent, in a small papyrus boat, accompanied by his wife, dressed in party finery, and three children. Behind the tomb-owner is a girl—who was probably supposed to be a daughter—holding a chick. The appearance of children in this scene need not contradict the suggestion made earlier that the couple may not have had any children. It could be suggested that any children may have died young, having still been alive when this scene was painted, but dead by the time the false door was painted. But it is more probable that these children were a magical fiction for the Beyond, part of the erotic undertones of the hunting scenes. Comparing scenes showing women facing left and right reveals an additional erotic detail visible here and elsewhere in the tomb (see figs. 8 and 13), as it would appear that Tawy's right shoulder really was exposed, with the knot of her garment tied gently below the breast.[20]

Below this hunting scene, grapes are being picked and "pressed" (see figs. 14 and 16). One of the grape pickers has a basket in which he carries the bunches, while his companion holds them in the palm of his hand. To the left, the grapes are being trampled in a "press." The vintners stand barefoot in the press, the roof of which is supported by poles with papyrus ends; they keep their balance by holding ropes. The division into groups of three and two would have been deliberate, as the pair is thus bound to the activities on the right, where the precious liquid flows out into a basin, where it is collected for bottling. The wine was then poured into the tall amphorae with pointed bases, ready for the tomb-owner. The mud sealings on top of the jars are clearly visible.

As in the scenes of work in the fields, the workers' hair is not well cared for—in stark contrast to the well-tended elegance of the tomb-owner and the rest of his class. It is striking that this scene of the grape harvest and pressing is frequently found with the hunting scenes and not among the agricultural scenes.[21] This pairing suggests that some profound meaning should be sought in these scenes. In temple rituals, wine offerings symbolized the killed enemy. Wine would also be

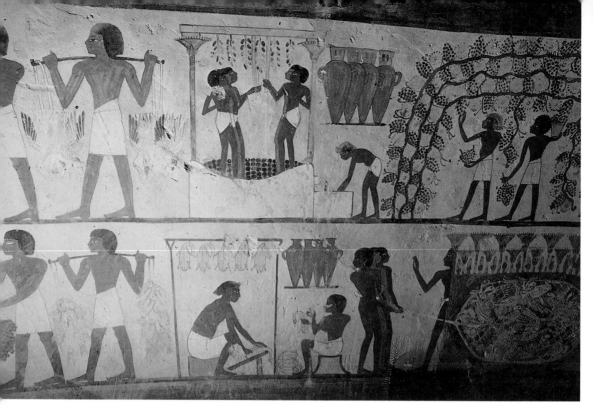

Figure 16

used for the ritual calming of a divinity, in particular the goddess Hathor, the "mistress of drunkenness." She was the goddess whom the sun god Re instructed to destroy the human race.[22] Shesmu, the god of the wine and oil presses, had also been associated with wine and blood since the earliest times.[23] On the one hand, he protected the justified dead, but on the other, Shesmu had to eliminate the enemies of the gods and the dead, and he used his press to squeeze the blood out of the heads of the murdered enemies.

Below this scene is one centering on food provision (see fig. 16). Birds are caught in the papyrus thicket using a trap. At the command of a foreman, three (and therefore several) naked men pull the trap closed. To satisfy the Egyptian mind, the net is filled to overflowing, as probably never happened in this world. The ideal is conjured up and immortalized for the Beyond. The birds still had to be plucked and prepared. The five birds already roasting on a skewer look quite appetizing. And here again the socially inferior are immortalized in a precious, almost cartoonlike fashion. Once the preparations are complete, the birds are placed in clay jars before being brought to the table further left, where the tomb-owner is standing, so that he can enjoy them in the Beyond. Heavy burdens were carried on the shoulders using a yoke of the kind still used today.

The right end of the hall is badly preserved and incomplete, with only a few lines of text (see fig. 14). In the upper part, five men bear food and tall bouquets or ointments in each of two half registers. The final series is led by a *sem*-priest,

who can be recognized by the panther skin thrown over his shoulder. *"Sem"*-priests are known throughout Egyptian history. Originally the title identified the oldest or "main" son closest to the father, but this changed in the course of time and the title became an "official" one. *Sem*-priests came to play a central role in both royal and private funerary rituals, but the *"sem"*-priests officiating in these private family ceremonies may have been the sons of the tomb owners, performing a socially important act of filial piety. The lower part of each half register shows an offering bearer before the deceased. Nakht and his wife are depicted as usual.

Ramose

RAMOSE WAS VIZIER under Amenophis III and Amenophis IV/Akhenaten. His mother was named Ipuya, and his family may have come from Memphis. His father Nebi bore titles related to that region. Ramose's wife is named Merit-Ptah, meaning "beloved of Ptah (the Memphite god)," while his own name means the Heliopolitan sun god "Ra is born." Ramose and Merit-Ptah themselves appear to have been childless.[1]

In 1879, Henry Windsor Villiers Stuart drew attention to the tomb. Before this, others had detected the upper part of the inner door opening, which was visible above enormous heaps of stone and sand. Until then, however, no one had done any further investigating. The tomb complex was left unfinished, as Ramose was only appointed vizier after the 31st or 35th year of Amenophis III, and then he probably followed Akhenaten to Amarna, less than a decade later, although a tomb at Amarna has never been discovered.[2]

Leading down to the courtyard before the tomb was a broad stairway with a ramp in the middle, cut out of the rock. The courtyard was irregular in form because the architect chose to respect earlier tombs, but a later tomb passage descends from Ramose's courtyard. Its original walls can hardly be seen, however, and two stelae are really all that remain to mark it. The layout of the tomb itself is conventional, but its dimensions are far more generous than usual, corresponding to the high rank of the tomb-owner (fig. 17). The transverse hall was transformed into a large columned hall. Four rows of eight papyrus-bundle columns once supported the roof, but they are almost all lost today and have been partially replaced with replicas. The persecution of the god Amun under Akhenaten led to extensive damage in this tomb. This damage was crudely rectified after the Amarna period, when the names and images of Akhenaten and

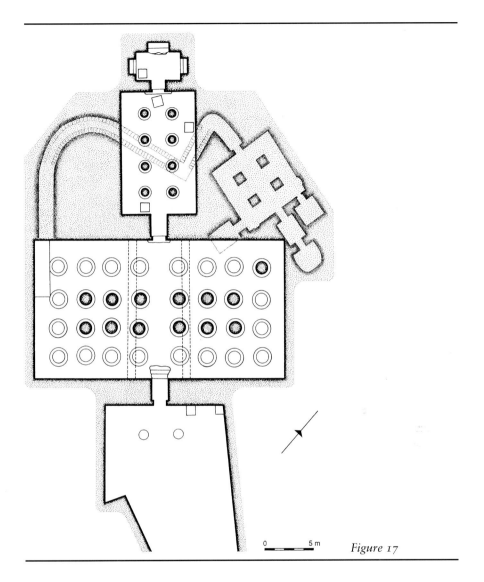

Figure 17

Nefertiti were in their turn effaced. Ramose himself does not seem to have suffered the same fate; his family may have been quite influential.

It was not much later that the rock ceiling of the tomb collapsed. The tomb was inaccessible and thus the reliefs and paintings are extremely well preserved. The tomb's inaccessibility did not prevent another individual from converting the tomb into his own. To this end, he erected two parallel walls of mud brick in the middle of the transverse hall, separating the route to the burial chamber from the heaps of rubble. The reliefs were hardly affected by this construction,

however. It is probable that the two columns in front of the entrance should like-wise be assigned to this usurper, but their stumps are hardly visible today.

Only three walls of the transverse hall were decorated, while the northeast wall and the rest of the tomb were left blank. The wall with the funeral procession is painted, while the others were executed in relief cut into limestone slabs. Except for the eyes, the reliefs were not painted, although more was originally planned. The tomb's size and elaborate decoration reveal that the owner both was impor-tant and had significant financial resources at his disposal.

The façade was almost completely destroyed. At the top of the heavily damaged outer side of the entrance Ramose is shown kneeling, his hands raised in a gesture of adoration. On both door posts, below, he is seated in an armchair with lion's feet; his hands hold a *sekhem* scepter and a staff; as the word *sekhem* means "authority" or "power," the former symbolizes power and the latter hints at his high rank.[3]

The entry passage itself is likewise badly preserved; on the left, the couple worships the sun god, as bits of the text confirm. On the right, Ramose strides into the tomb. The few traces of the text that remain contain words suggesting that he is appealing to Osiris, as would be expected. Our modern taste finds the well-preserved reliefs of the southern wall and the northern part of the east wall (the inner surfaces of the walls immediately to the right and left of the entrance) among the most beautiful and subtle ever produced by the ancient Egyptians. The Egyptologist Wolf has described the opulence depicted:

> The fine, harmonious faces, the dazzle of the wigs and the marvelously flimsy pleated garments all belong to the most refined and most intellectualized met-ropolitan society, the sensitive, but almost morbid representatives of an over-ripe culture approaching its end. These people led lives enshrouded in beauty and dignity, celebrating a never-ending banquet. Their attitude toward life is expressed in the beautiful, softly rounded lines. . . . One suspects that the age must have had a fin de siècle mood, and that boredom with life itself was con-cealed behind their luxury and elegance, a fatigue which threatened to break through the balanced delicacy of these beautiful faces.[4]

On the walls to the left and right of the entry, Ramose presents offerings to "Amun-Re, King of the Gods, Ra-Harakhte, Atum, Khepri."[5] In this scene, as in most of the others, the tomb-owner is wearing sandals and a long smooth mantle reaching up to his chest, suspended by narrow shoulder straps. This is the official dress of the vizier, the highest minister in the land.[6]

Three high offering stands, between which are three lotus bouquets, are heaped with geese, meat, and bread. The surrounding tongues of flame indicate that these are burnt offerings. Above are two other offering mats supporting vessels with food and ointment, on which papyrus blossoms have been laid. The number "three"

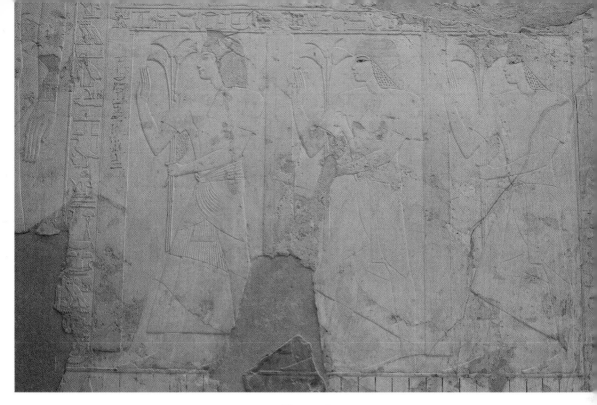

Figure 18

again symbolizes the plural and thus indicates that there are many bouquets. Ramose is followed by three rows of attendants, but the top row has been completely destroyed. The tender bodies are emphasized by the thin garments; their noble visages, enhanced by luxurious wigs, are lifelike solely because of the modeling of the stone. Each attendant holds three papyrus stems and a leaf bouquet (fig. 18).[7] The bottom row shows nicely dressed attendants carrying breads, fruits, poultry, papyrus stems, and lotus blossoms (fig. 19).

Under this scene is another register. On the left are three singers, shown in the usual array; "three" again symbolizes the plural (fig. 20). The accompanying text reads:

> Adoration in heaven, acclaim in the great palace, applause in the midst of the hall. The Two Banks of Horus are in joy. [Amun] is on the great throne. He rises as [Amun-Re Lord of Heaven]. He lets Amenophis III (given life) endure, giving him his lifetime, united with eternity, his years totaling hundreds of thousands. The Mayor (of Thebes) and Vizier, Ramose, justified. Your lord Amun praises you in your house of the living. [The gods, the Lords of the West] proclaim their love of you, for you have offered a royal offering to [Amun]-Reharakhte, Atum, Lord of Heliopolis, his eye, his hand and his body, to Osiris President of the Westerners (i.e., the dead), to Hathor, the Above the desert, to Anubis, the Lord of the Sacred Land (i.e., the necropolis), [and to the gods, the lords] of the Netherworld.[8]

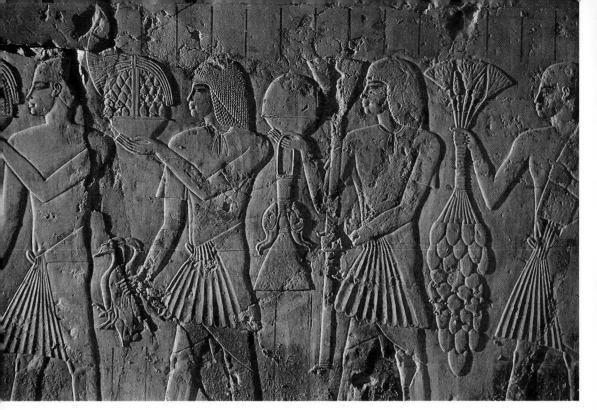

Figure 19

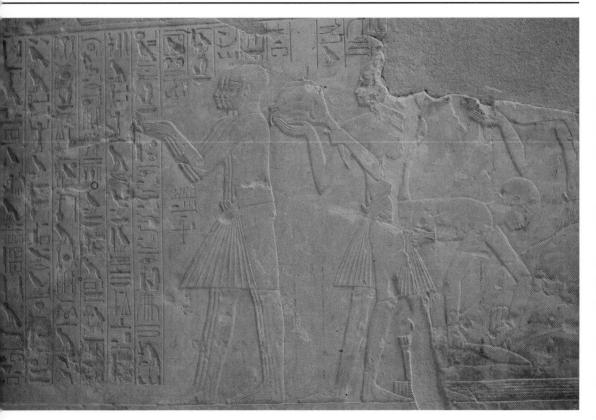

Figure 20

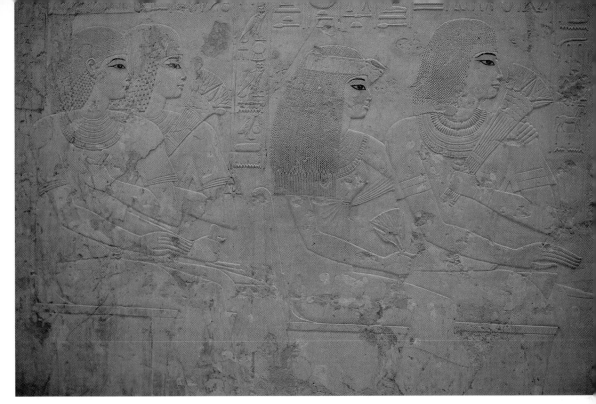

Figure 21

To the right of these singers, a servant brings the head of a cow. A man bends down and, with a knife, cuts up a bull on a mat. It is worth remarking that in this scene, the legs and lower torsos of the two men overlap, giving the scene an unusual liveliness (see fig. 20). Ordinarily, the Egyptians avoided devices of this kind, as they meant that the portrayal was incomplete. Here, they are used in a conscious and refined manner, as the two men are walking in opposite directions. The two torsos are separated, as the one is leaning right while the other is striding to the left. Another, bearing the haunch of a cow, can just be discerned.

In the corresponding scenes to the right of the door, Ramose and his wife are making offerings themselves. They are followed by three more rows of men bearing offerings. The lowest part is relatively well preserved and shows fowl, bread, fruit, vegetables, and lotus blossoms.

To the left of the entrance are the best-known reliefs in this tomb: the party guests. The accompanying texts suggest that this was no ordinary party, as there are repeated references to the offerings received by the guests. The description of the couples proceeds from left to right, just as the visitor sees them.

The first pair are both men (figs. 21 and 22). The text before the one in front reads: "Offerings from the provisions daily, as the offerings of the Lord of the Gods, for the *ka* of the Overseer of the Hunters of [Amun], Keshy, justified."[9] The inscription for the man in the rear was never inserted, so it is not clear who he is. It is evident that the faces have been carefully and harmoniously executed.

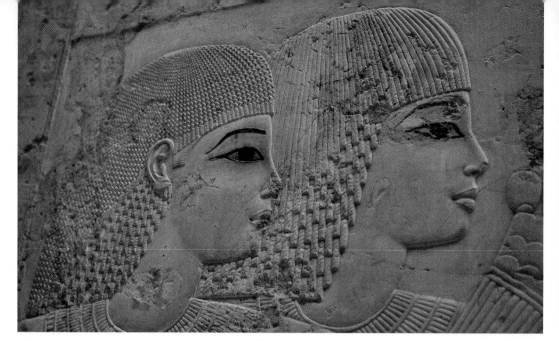

Figure 22

Attention was given to every detail of the wigs. A preliminary sketch can still be seen at the eyes; this should have been done last. Both men are wearing fine necklaces and fine thin clothes. Keshy is holding a tall bouquet in his hand.

Beside the next couple is written: "Receiving the offerings daily (and) what comes forth before [Amun]. They are twice pure, for the *ka* of the Overseer of the horses of the Lord of the Two Lands, Royal Envoy to all Foreign Countries, excellent confidant of the sovereign, (whose) favor lasts with the Lord of the Two Lands, May, justified. His beloved wife (literally, 'sister'), praised by Mut, the Mistress of Isheru, the Mistress of the House, Werel (or Werener), justified" (fig. 21).[10] They too are dressed in their best festival finery, the wife's luxurious wig having a diadem of blossoms, from which a lotus blossom has dropped onto her forehead. In her right hand is a lotus-blossom bouquet, and with her left arm she embraces her husband in the gesture of marital alliance so common in tomb decoration. The knot of her dress, beneath the breast, subtly emphasizes her graceful figure. May himself is wearing a smooth kilt and a fine thin short-sleeved shirt. Both he and his wife have necklaces, and he is also wearing two chains of the "gold of honor," awarded him earlier by the king himself, for his services. Like Keshy, he is holding a tall bouquet.

Seated before them are Ramose's parents, likewise dressed in their very best (fig. 23). Like Werel, Ipuya has blossoms in her hand. The differences in the wigs are worth examining, as they show the variations in contemporary fashion. Nebi has a small handkerchief in his hand, probably as a symbol of his rank. The caption reads: "Everything which comes forth from the altar of Wenenefer, the Lord of Eternity. Breathing the sweet breeze of the north wind. Receiving the offerings from his altar like the great ones who are in his entourage, from the daily require-

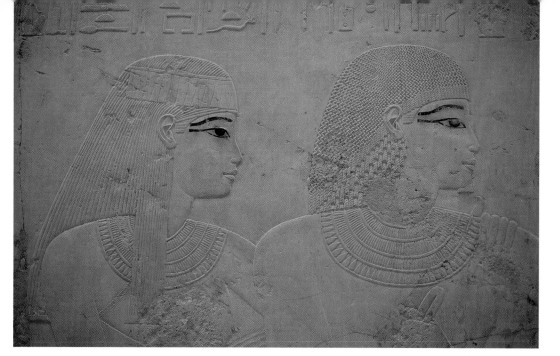

Figure 23

ments of every day; for the *ka*-soul of his father, the Overseer of the Cattle of [Amun], and the Overseer of the Double Granary of [Amun] in the provinces which are in the northern Delta, the Scribe, Nebi, justified before the great god. For your *ka*-soul! His beloved wife [literally, 'sister'], praised by Hathor, the Mistress of the House, Ipuya, justified, Possessor of the Revered State by Osiris."[11]

The final couple in this row (fig. 24) is "the prince and noble, Confidant of the Good God, Overseer of all the Craftsmen of the King, Great Overseer of the royal domains in Memphis, Scribe of the King, truly beloved of him, Amenophis, justified. His beloved wife, Chantress of [Amun, royal ornament], the Mistress of the House, May, justified, Possessor of the Revered State."[12] They are also dressed for a party, like the other guests. Amenophis, Ramose's brother, has a *sekhem*-scepter in his hand, and the gold of honor around his neck. His wife is embracing him lovingly, and this couple's facial features are likewise compellingly ageless and noble. Each of the last two couples is seated before a table well laid with vegetables, bread, meat, and lotus blossoms.

These four couples all look to the right. Ramose and his family have taken up their places across from them, separated from them by a table and a vertical line of text. They all look to the left. Ramose is portrayed here in private, without a wig, but still holding a *sekhem*-scepter in his left hand. The table before him is piled with offering loaves. His wife, seated beside him, is depicted in the same fashion as the other women. She grasps her husband's arm with her right hand, holding a lotus blossom in her left. A tall bouquet is under his chair; hemispherical vessels on a stand covered with blossoms are beneath hers. Ramose's brother Amenophis is here with his wife and daughter (fig. 25). They too are seated before

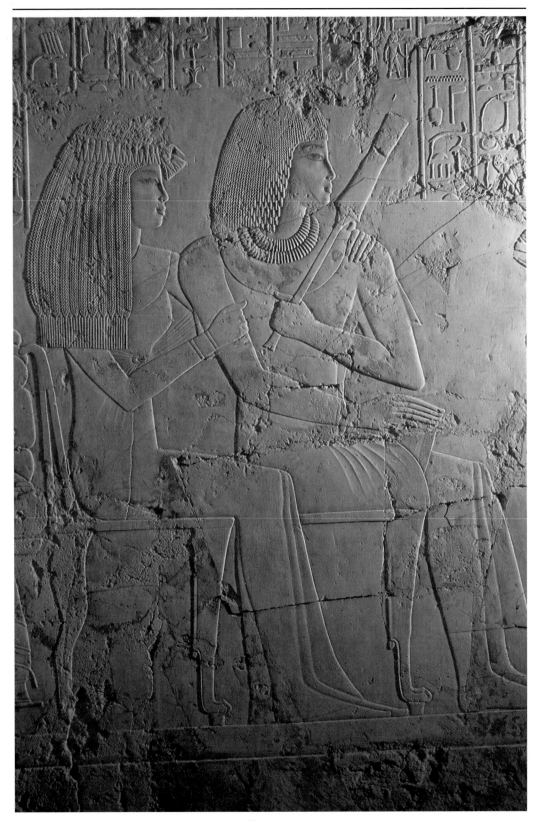

Figure 24

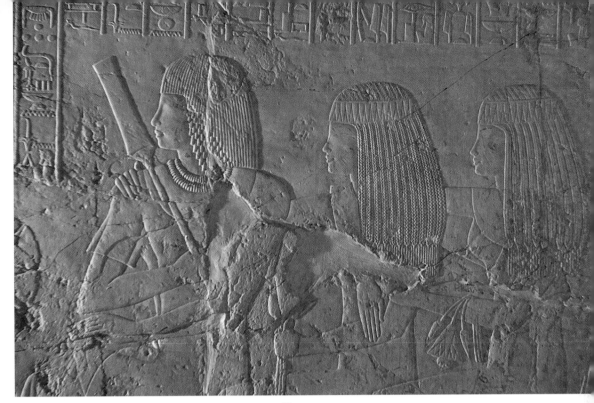

Figure 25

a table. In a particularly pleasant scene, the mother is lovingly embracing her daughter, who is tenderly grasping her father. Both are elegantly dressed, with similar wigs. The daughter has some blossoms in her hand, and her mother has draped some over her arm. Under her chair is a very damaged picture of a cat with a bird in its paws.

The accompanying texts are quite informative:

> His brother, count, prince, praised and beloved by the Lord of the Two Lands, Excellent Confidant of the Sovereign, whom the king made greater than his elders, whose ability made his place, the Overseer of the Treasuries of Gold and Silver, Overseer of all the Craftsmen of the King, Scribe of the King, beloved of him, Great Royal Steward who directs the festivals of all the gods in Memphis [Amen]ophis, justified. His beloved daughter, at the seat of his heart, the Chantress of [Amun] Mistress of the house, Meryt-Ptah, justified before Osiris. Her Mother, the Chantress of [Amun], Lady of the House, Praised of the Lady of the Two Lands, May, justified, Possessor of the Revered State.[13]

This text clearly states that Ramose married his brother's daughter, and that he was therefore also his brother's son-in-law. This could be the reason why Amenophis is pictured twice, once as brother and once as father-in-law of the tomb-owner.

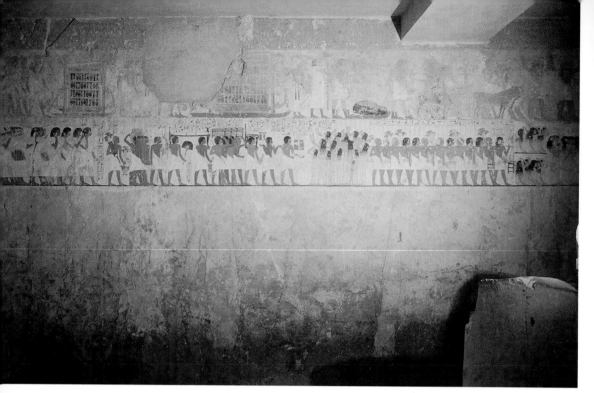

Figure 26

The register above this scene is not as well preserved. The people are depicted in the same way as those in the scenes just described. At the far left are four seated individuals, who are almost completely destroyed. In front of them is a man who cannot be identified, as only traces remain of the caption. Ramose's brother, Amenophis, and his wife follow. In front of them is another Amenophis who need not, however, be the same Amenophis, for his titles do not match. Another unnamed woman, perhaps his wife, is seated on a low stool at his feet, sniffing a lotus blossom.[14] A generously laid table divides this group from the others, led by Ramose and his wife. The tomb-owner is wearing the same long smooth mantle with narrow shoulder straps. Under his chair is his pet, a goose. Merit-Ptah's low stool has a soft cushion, and beneath it are flowers and a fruit bowl. Separated by another table—beneath which are two ointment and oil vessels and two heads of lettuce—is yet another couple, at the extreme right. They may have been Ramose's parents, as the woman's name can just be made out as I[p]uya.

The funeral procession is painted in two registers at the left end of the "reception hall" (fig. 26).[15] Its continuation is the sloping passage leading to the large burial chambers below. This is the only decoration in the tomb that was not executed in relief. The colors are unusually fresh. Unlike the banquet scenes, such funerary scenes existed since the Old Kingdom. The wealth of diverse details and particular scenes in all these tombs enables us to follow the general sequence of events, and to perceive those changes made over the course of time. The funerary scenes are part of the basic repertoire decorating Theban private tombs.

At the top, from left to right, a shrine with the canopic jars and a sarcophagus are drawn on sleds. This was the ancient and proven method of moving things across sand. The canopic jars are those containing the internal organs of the deceased, removed during embalming.[16] The term can be traced back to the Jesuit Athanasias Kirchner (A.D. 1602–1680). The Roman scholar Rufinus (c. fourth century A.D.) referred to a god named Kanobos, understanding the god as being the cult image of the god he identified as a particular form of Osiris. The oldest known instance of the custom can be traced back to Queen Meresankh III of the Fourth Dynasty, the wife of Khafren and the daughter of Kawab, the oldest son of Cheops. Her well-preserved tomb can still be seen at Giza.

During the New Kingdom, and afterwards, there were specifications about which organs belonged in which jar. The human-headed Imset protected the liver; the word *imset* has a feminine ending, suggesting that this must have been part of a divine couple where only the masculine member was originally present.[17] Hapi was originally anthropomorphic but acquired a baboon's head during the New Kingdom; he was responsible for the lungs.[18] The jackal-headed Duamutef preserved the stomach, and the falcon-headed Kebehsenef had the intestines. The heart was not placed in a special jar but left in the body. The four gods were also called the "sons of Horus" and were later all depicted with human heads.[19] The jars were frequently placed together in a canopic box with four compartments. The oldest example of such a box also dates back to the Fourth Dynasty. This belonged to Queen Hetepheres I, the wife of Snofru and the mother of Cheops. Part of her tomb furnishings were found in a cache and are now on display in the Cairo Museum, in the rooms near those with Tutankhamun's treasures, which include what is probably the most famous of all canopic boxes.

The procession goes toward the goddess of the West, into the tomb. It was not by chance that the entrance to the passage leading to the burial chamber lay at the foot of this wall, which continues the procession to the West. The canopic shrine with painted protective amulets was accompanied by the four "men of Dep," who are followed by officials. Women representing Nephthys and Isis can be seen both in front of and behind the sarcophagus, as with the canopic shrine. In the form of small wooden figures, these goddesses protect the head and foot ends of the bier bearing the deceased. The three men following the sarcophagus are almost fully destroyed. In front of these is the *tekenu* on its sled. It is drawn into the tomb behind sacrificial cattle led by a priest bearing a milk vessel with which he is purifying the route.[20]

Tekenu may be derived from *teken*, "to be near." The *tekenu* is part of the funerary ritual, being known since the Old Kingdom. Originally it may have been the body of the deceased in the fetal position, wrapped in a skin, before coffins were widely used. The *tekenu* does not symbolize human sacrifice but is rather a symbol of rebirth. It was played by a priest wrapped in a skin, or perhaps simply

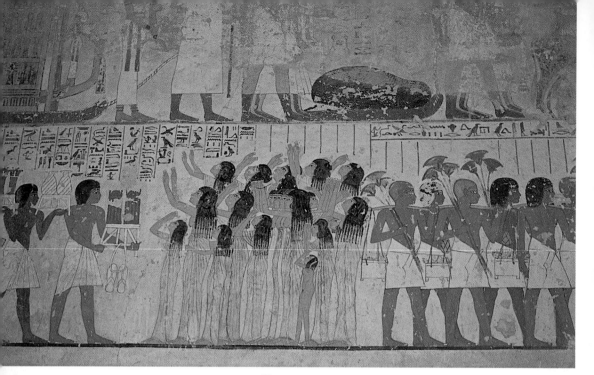

Figure 27

crouching on a sled beneath a skin. Another very plausible view of the *tekenu* is based on the premise that an Egyptian did not want to lose any part of his corporeal existence. Parts of the body that were neither left in the body nor consigned to the canopic jars may well have been retained and used at the funeral in some fashion. According to Erik Hornung's interpretation, the *tekenu* was the ideal recipient for such remains, as it accompanied the coffin and canopic jars.[21]

The *tekenu* is drawn by four people, but the text mentions only the action, revealing nothing about the significance of the scene. Behind the *tekenu* are another four men, from Pe and Dep (ancient settlements in the Delta, at Buto), from Hermopolis, from Sais, and from Heturkau (which has not been localized). They are followed by the "Great of the God" who is striding in a long tight mantle, holding a staff vertically in his hands. This figure is elsewhere identified as the "priest of Sokar," the god of the Memphite necropolis.

In the lower register, the tomb furnishings are being brought into the tomb. Some are packed in boxes, while others are borne on carrying poles. One can recognize a bed with a headrest, a chair, vessels with ointment, sandals, and, in the hands of the first porter, a *ushebti*-box. Fans and writing utensils are also carried along, underlining the high social rank of the deceased.

It would appear that the center of the whole funerary procession was the wailing women (fig. 27). Despite the image of deeply felt mourning, the picture is exquisitely closed by a group in the middle. According to ancient traditions, this group is five deep, and thus five layers dominate the movement of the scene. These women are torn by pain. Their hair is undone, and tears gush over their

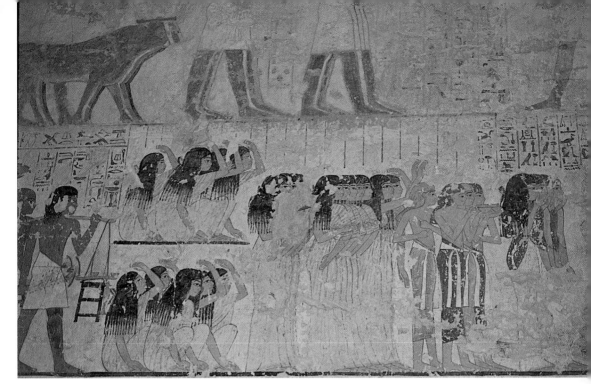

Figure 28

cheeks. At the front of the group is an old woman with a sagging breast exposed, perhaps Ramose's wife;[22] a grief-stricken cowering girl clings to her. The text reveals nothing about the wailing women: "His relatives, they say, 'the great guardian is gone, he has passed by us.'"

The more conventional group of nine kneeling wailing women is shown further right (fig. 28). They are also throwing ash on their heads, and tears pour forth from their eyes as well. But the rows convey an impression of rigidity. Yet another group of wailing women is front of them, but they too appear to be schematic and lifeless. It looks as if they were striking themselves on the arms and thighs, while two others toss ash on their hair. At the far right are four women clad in red and yellow dresses that leave their chests bare. Their head scarves are the same colors. Two of them are beating their breasts, and the two others hold bowls in their hands. Further right are another four women, likewise clad in red and yellow. The caption for this whole scene was never completed, so we will never know anything about these women. Identified are only the diverse offerings that Ramose was destined to receive.

The two compositions of the groups of wailing women are linked by a procession of offering bearers; the yokes on their shoulders bear the most diverse objects. In their hands are flowers. The funeral procession ends in front of the goddess of the West (cf. fig. 67).

Ramose himself can be seen four times on the southern half of the west wall, that is, the left part of the wall across from the entrance. In each case, Ramose

appears without a wig. The two figures on the left are difficult to recognize: the first may have borne a staff with an image of the moon god Khons, and the second a staff with an image of the goddess Mut. In the Theban triad, Khons was viewed as the son of Amun and his consort, Mut. As these gods are mentioned in the accompanying captions, the proposed restoration is virtually certain, but it is impossible to recognize what the next figure was bearing (fig. 29). At the far right, Ramose is carrying a staff decorated with the ram's head of Amun. The scene is accompanied by texts recording blessings and praise for the ruler seated in the adjoining booth, crowned with a double uraeus frieze. "Uraeus" is the Greek term for the Egyptian cobras associated with several Egyptian goddesses. They were generally understood to be magical serpents particularly responsible for protecting the king and kingship.

The base of this booth is adorned with nine images of enemies (see p. 220, where the image is clearer). The king himself is wearing the blue crown, and holding the royal insignia, the shepherd's crook and flail.[23] The effaced first cartouche and the epithet "great in his (life)time" following the cartouche "Amenophis" make it clear that this is an image of Amenophis IV/Akhenaten—although executed in the style of his father, Amenophis III. Behind the king is the goddess Maat, the "daughter of Re" and thus the king's sister, because all the kings of Egypt, since the Fifth Dynasty, were sons of the sun god Re (see p. 212).

The left reveal of the passage leading to the unfinished inner chamber has Ramose and his wife on the left, but only their legs striding into the chamber are preserved. They worship the sun god Re. On the right, Ramose stops on his way into the tomb, to address the gods (fig. 30). An impression of the ideals and ethics of a vizier are conveyed in the biographical inscription recorded here: "I have come in peace to my tomb enjoying the praises of the good god. I have done what the king of my day praised. I have not infringed on the guidelines he commanded. I have not committed sin against people, that I may rest in my tomb on the west bank of Thebes."[24] In the following lines, he appeals to various gods of the Netherworld, emphasizing his immaculate character.

A completely different attitude is revealed in the pictures to the right of this passage. The new style of Amenophis IV appearing here is, however, only a reflection of the great changes that had overtaken Egypt. That this stylistic change can be seen on the walls of a single tomb is one of many proofs that during the Amarna period the king not only employed hitherto unknown individuals, but also had recourse to—and the support of—longtime servants of the state. There were also artists who adopted the new style. A certain Bak says that the king personally instructed him; as his parents and career are well known, it is certain that he was a sculptor before Akhenaten came to power, and that he changed his style to conform.[25] It can also be assumed with a reasonable degree of certainty that the same people who worked on this tomb years before also worked on this wall.

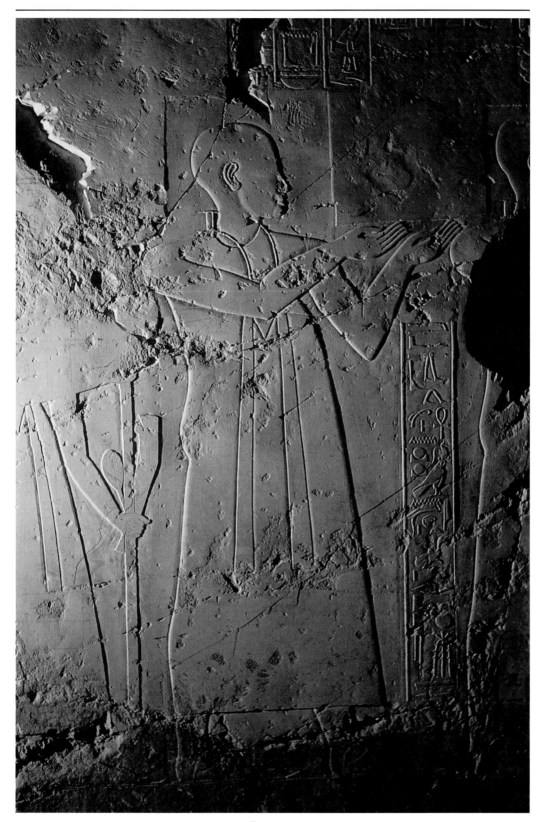

Figure 29

Figure 30

This scene is badly preserved, being substantially destroyed; in places only the preliminary sketch is preserved. Ramose—now with the deformed "Amarna head"—can be seen bowing deeply before the king together with his wife, Nefertiti, who are leaning out of the Window of Appearances (fig. 31), having given Ramose his gold of honor. The gold is put around his neck further to the left, but still in the palace, as indicated by the palm-leaf columns. Ramose is then enthusiastically received by his own people. The rayed Aten above the royal couple, and the various cartouches, including those with the Aten's name, can still be recognized, despite effacement. This scene, found in virtually all of the tombs at Amarna, reveals how the king changed the mode of royal imagery in private tombs, from passive to active. On the left side of the wall, the king was depicted statically with the goddess Maat, with Ramose in the conventional attitude of worship before him. This scene on the right is filled with motion, yet it is striking that all of the dignitaries, admirers, and foreigners are bowing still lower with respect. The whole scene was not finished, but the dignitaries, including two policemen, can still be recognized behind the royal couple (fig. 32). After being received by the king, Ramose turns to the approaching emissaries of the foreign peoples, coming to pay homage and offer tribute. These four Nubians, three Asiatics, and a Libyan are easily recognizable, although preserved only in the form of a preliminary sketch (fig. 33).

This is doubtless a new style, but the change in the behavior of the king, Akhenaten, shows that it is also the expression of a new belief, a new understanding of life: Akhenaten was the only link between man and god; he alone had knowledge and true belief, and it was he who provided everything for his people. (We will probably never know whether or not the tomb-owner shared this attitude, and, if so, to what degree.) This is a revolutionary change from the previous era, when kings depicted themselves bowing before Amun, as did Hatshepsut at her temple in Deir el-Bahri, or Amenophis III in his temple at Luxor. There is also a difference from even earlier times, when the king himself was a god, although the earliest royal statue of a king kneeling before a divinity antedates the end of the Old Kingdom. In the New Kingdom the king could only be godlike. Although the office was divine, the king was not, and thus kings always seem to be rather human. Akhenaten was completely different. He had himself depicted in family scenes, but he nevertheless remained unapproachable and distant.

The right end of the reception room was not decorated. At the left, in the upper register of the wall at the entrance, Ramose and his wife can be seen seated, with his parents behind them. The representation is similar to that of the southern half of the wall. The deceased and his wife each sniff a vessel of fragrant oil, which was probably brought by one of the 14 offering bearers shown in two groups coming from the right. Stereotypically, each has a caption identifying the product being borne, with the statement "for your (Ramose's) *ka*-soul."

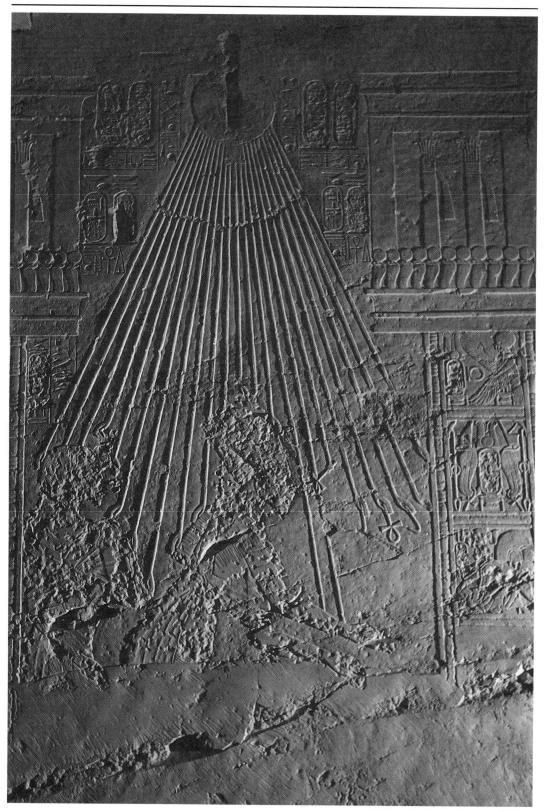

Figure 31

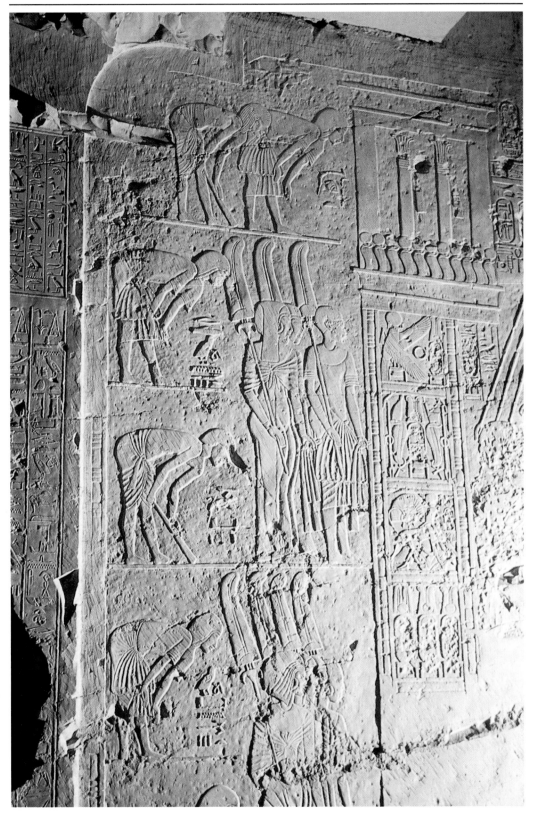

Figure 32

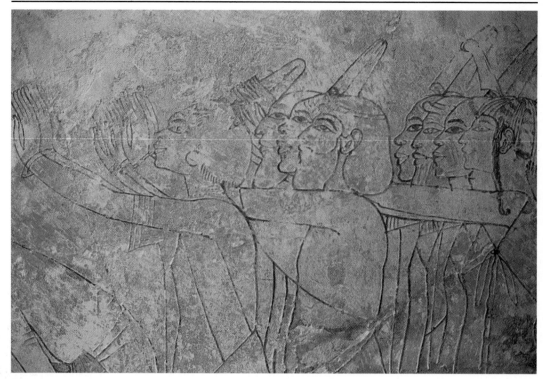

Figure 33

It is worth noting that the pet goose once depicted beneath Ramose's chair has been hacked away. One of Akhenaten's more dedicated and thorough supporters must be responsible for this: Amun is associated not with the ram alone, but also with the goose. And thus this innocent creature also fell victim to the persecution of Amun.[26]

In the lower register, Ramose and his wife are shown in the conventional fashion, with his brother Amenophis and his wife below them. Before them is a list of everything that should be on the heaped table before them, the necessary daily requirements of the deceased. From *hes*-vessels a priest pours purifying water over those objects that must be ritually cleansed. To the right and behind is a priest wrapped in a panther skin, handing over "thousands of breads, beer, fowl, cloth," and so on. This "*Iwenmutef* Priest purifies like (the god of Wisdom) Thoth." The *Iwenmutef* Priest can be understood as a ritual incarnation of the oldest son, the title being a divine name, meaning literally "pillar of his mother." He plays an important role in the purification and the provision of the deceased.[27]

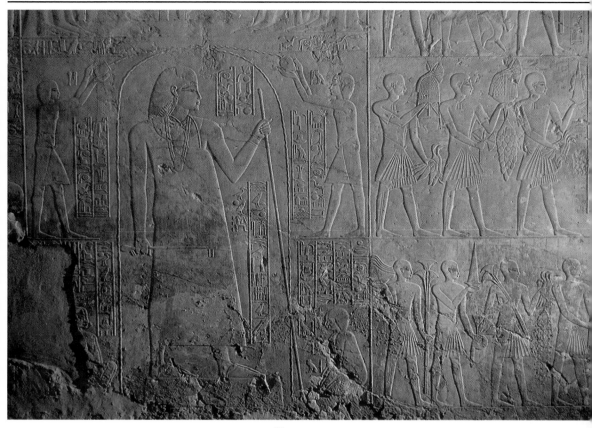

Figure 34

Such a purification of the deceased or his statue is depicted in the next scene on the right (fig. 34). One priest stands in front of and another behind the statue, each pouring the purifying water from a *nemset-* or *desheret-*jar: "Recitation by the Lector-Priest, the *Sem*-priest. Circulation for him (Ramose) four times with four water-jars. To be recited four times: Twice pure: the Osiris Mayor, Vizier Ramose, justified."[28] Ramose is dressed in his usual long, smooth mantle and standing on a mat. In the right hand at his side is a staff reminiscent of a key, which probably signifies the hieroglyph for natron. Natron was widely used as a cleanser in ancient Egypt. Ramose has a heart-shaped amulet around his neck (for the rites, see pp. 128–129 and 165–168).[29]

The couple is shown above the purification scene. Merit-Ptah is standing behind her seated husband, Ramose (fig. 35). Before them are three girls holding out sistrums and *menit*, and the tomb-owner is already reaching for them.[30]

Figure 35

These girls too are depicted in the wonderfully tender relief that characterizes this tomb. Their fine dresses are knotted just below the breast, and their luxurious wigs hang heavily. The accompanying text explains the scene, stating that these are the sistrums of Amun-Re, which Ramose should put to his nose. Amun gives him life, "so that you endure like heaven, that you be firm, that you live, that you repeat youth like the freshness of the waters."[31]

Userhat

ALTHOUGH THE INSCRIPTIONS were never finished and the statues not completed, Userhat's tomb is one of the few tombs that was architecturally complete, with well-preserved and beautiful murals.[1] During the reign of Amenophis II, and perhaps even under that of his father, Tuthmosis III, Userhat was the "great confidant of the Lord of the Two Lands, his truly beloved royal scribe, deputy herald, overseer of the cattle [of Amun]."[2] His most important title was "bread-accountant," or more precisely, "scribe who counts breads in Upper and Lower Egypt," which is why he is frequently dismissed simply as a "bread accountant" in the literature. His duties must have included checking the incoming quantities of grain, accounting for the number of loaves produced, and then assuring that the weights of the various measures were all correct. Grain was delivered as grain and then had to be ground into flour before being baked into bread, and the danger that grain could disappear en route was certainly a familiar possibility to those in charge.[3]

The name Userhat means roughly "strong of head." It is also the name of the bark of Amun. Userhat's wife was named Mut-neferet, meaning "(Amun's consort) Mut is beautiful." Their daughters, Henut-neferet and Nebet-tawy, are also named in the tomb. The former evidently enjoyed social prominence, as her titles include "Lady of the Court, beloved of her lord" and "Praised by the Good God (Pharaoh)." When the tomb was completed, she was probably still single, as she does not bear the typical designation of the "housewife," "mistress of the house." Given her origins, it can be assumed that she grew up with the princesses at the court or was at least given easy access to the court, and that she thereby drew the particular attention of the ruler whose favor she enjoyed. One son of

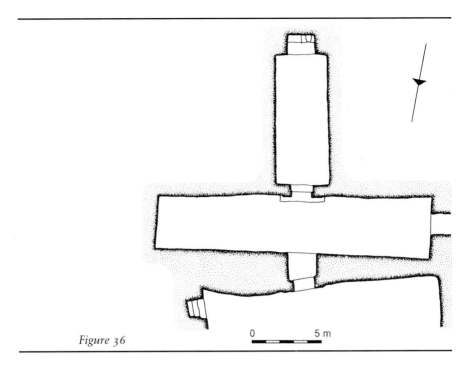

Figure 36

0 5 m

Userhat was a *web*-priest of Ptah. His name was effaced in the tomb inscriptions, perhaps indicating that he predeceased his parents.[4]

The tomb was studied by George Lloyd in 1899 and Sir Robert Mond in 1903–1904, but it was well known before then, as Sir Gardner Wilkinson copied some of its inscriptions in 1827 and 1828. It is easily reached today, but the German Egyptologist Richard Lepsius noted that in 1843 it could be entered only through a hole in the wall of a neighboring tomb.[5]

Peculiar to this tomb is the light, brisk style of painting and the generous use of pink. Most of the men and women share the same Venetian-red skin color.[6] Like many other tombs, this one was unfortunately used as a home by Christian monks, who destroyed and painted over pagan and unseemly figures. There are quite a few crosses covering the original paintings; they even added the awkwardly painted animals appearing in the scene of hunting in the papyrus thickets in the passage. It is nevertheless possible to discover interesting and unusual scenes in this tomb.

It is worth noting that the tomb is not oriented in the usual fashion, because geological realities compelled an orientation to the south rather than the west (fig. 36).[7] A fictional east-west orientation was observed in the execution of the scenes, however, and this necessarily resulted in problems in the proper arrangement of the decoration. As in the tomb of Nakht, the ceiling decorations draw

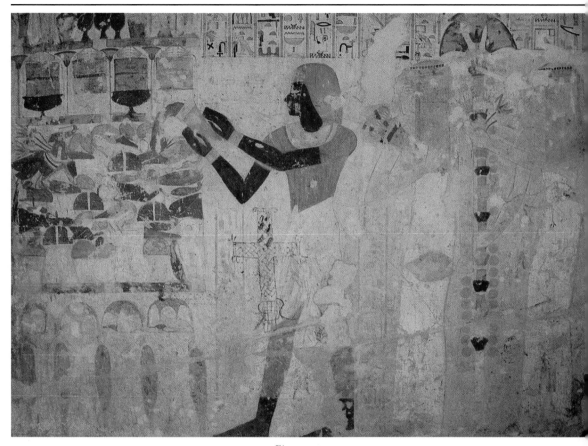

Figure 37

on the ceilings of private houses, with imitations of wooden beams and mats. Each side of the passage into the tomb is lined with three columns of inscribed text. On the left are offering formulas for Amun-Re, Ra-Harakhte, and Osiris. On the right Osiris, Anubis, and Hathor are addressed. The lintel has two antithetic scenes with Userhat and his wife worshipping Osiris, the god of the dead. Although executed in sunken relief, the whole of the door frame decoration has unfortunately disfigured by damage.

The left entry of the passage into the transverse "reception hall" shows Userhat in the company of his wife Mut-neferet and a daughter preparing burnt offerings for the god of the dead, Osiris, and for Hathor, who was the "mistress of the West" in Thebes, and thus also a goddess of the dead (fig. 37). Four stands for burnt offerings are lined up side by side with offering bowls, right next to the entry. Each contains a heap of charcoal among which breads and ducks can

be made out. Between each of the altars is a head of lettuce, which was assumed to have aphrodisiacal powers and was thus associated with the fertility god Min. A whitish juice poured forth from the lettuce plant when cut, and this was associated with the semen liquid of the god.[8]

Above all of these are the offerings: bread in various shapes, fruits, and vegetables, along with heads, haunches, and ribs of cattle. A calf can even be recognized, lying roughly at left center. The middle offering mat is shown above, rather than beside, the one below it. It bears four bowls filled with bundles of herbs. At the top are nine tall vessels for oils and ointments, decorated with lotus blossoms, as was usual. The painting of these various objects was never really completed, so that details are still lacking and some details are difficult to recognize. Userhat stands to the right of these offerings. He is wearing a knee-length kilt over the usual short white kilt. Over these is a short-sleeved long garment of fine cloth. His pink-red skin is still perceptible through the layers. As was usual, Userhat is also wearing a long wig. His raised hands pour a brownish substance from a vessel, probably myrrh. His wife is behind him, with a small bouquet in her hand, and her daughter Henut-neferet has an enormous tall bouquet.[9] Both women are clad in tight-fitting white dresses, are wearing wigs, and have bejeweled themselves generously for the festivities. The text above the scene explains: "Placing myrrh on the flame for Osiris, Foremost of the Westerners (the dead), for Hathor, Mistress of the western desert."[10]

Userhat's duties are the subject of the adjoining scenes, divided into five registers (fig. 38). The upper three are devoted to counting cattle and the two below to grain accounting. Seated on a stool at the extreme right, Userhat supervises each of these tasks. The staff in his hand is the symbol of his rank.

Agricultural scenes have appeared in private tombs since the beginning of tomb decoration, as the guarantee that the deceased be provisioned, but they may also give a glimpse into his responsibilities in this area, as in this case. It should never be forgotten that all of the tomb decoration that records scenes from daily life is intended to portray what was important for the second, eternal life. No one wanted to do without either fresh bread or the luxurious accouterments of an elegant life-style.

The scribes are registering the cattle before Userhat. Two are busily making notes, and one is bending over the round-topped boxes where the files are kept. The Egyptians' love of recording and writing was almost singular in the ancient world, and their bureaucracy could justly be compared with modern ones, with all of the accompanying features. The cattle to be registered are milling about in the pastures above, with calves jumping enthusiastically but unwisely, and a cow chewing cud. The landscape is dotted with small trees. In this register and the one below it, the light and red-brown cattle are shown lined up in rows. The rigid lines of cattle are slightly eased by the galloping calves or the cow licking its off-

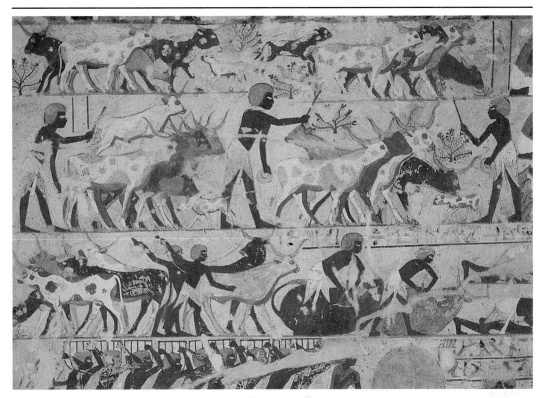

Figure 38

spring. In the second register, the herdsmen have gathered the animals with sticks and lassos, so that they can be branded, shown in the third register. Two of the animals are already on the ground, being branded, and the others are waiting but disquieted by the expectation of what is to come. Branding had only been done since the beginning of the New Kingdom.[11] To the right of this scene are two herdsmen "kissing the earth" before Userhat, who is the official responsible. They are presenting him with various offerings, perhaps in order to change his mood.

Grain is delivered in the fourth register from the top: "Receiving the income of the granary of the [herald] by the great confidant of the Lord of the Two Lands, the true royal scribe whom the king loves, deputy herald, overseer of the cattle [of Amun], Userhat, justified."[12] The nine bearers are accompanied by their supervisors; the ancient Egyptians appreciated the virtues of careful supervision. These supervisors are distinguished by their fine clothing, thin overgarments, and the staff, always useful. Another official is standing in front of this column, verifying the measurement of the grain, while the scribes note down the results. Below this

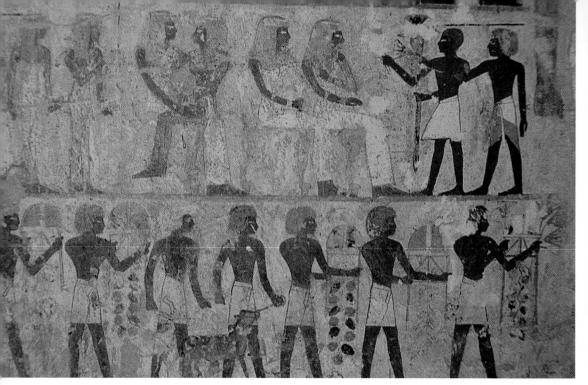

Figure 39

(in the fifth register, not shown in fig. 38) are the harvest scenes, as we have already seen in the tomb of Nakht. Three women plucking flax can be seen on the right. On the whole, however, this scene is not as detailed or as well done as that in Nakht's tomb.

To the right of the entrance is another offering scene, placed antithetically across from the one described earlier and not differing significantly from that one. The tomb-owner is holding two small altars with a duck and breads. The bluish background around these offerings hints at the heaps of charcoal. His wife is standing behind the well-dressed Userhat, who is wearing a necklace with lotus blossoms. A small man is turning to Userhat, perhaps his son. The diminutive size of the representation shows that he was not important in this scene. He is holding up a small table, which is probably heaped with incense. In the upper register, Mut-neferet is followed by three striding men. The first two belong to the ordinary lower-class *web*-priests. They are holding bouquets, one of flowers, one of stalks. To the left is a *sem*-priest performing a burnt offering in front of two men. The *sem*-priest is easily recognized by his spotted leopard skin. The two men beside him could be relatives of the tomb-owner. As the accompanying text was never finished, nothing more can be said about these individuals.[13]

Although the accompanying inscriptions for the middle register were likewise never executed, it too is intrinsically interesting (fig. 39). On the extreme right are two men bearing offerings: the one in front has a stalk bouquet and another of leaves, while the other has a lotus blossom. Such extreme overlapping as can be seen here is very rare. The right forearm of the rear offering bearer com-

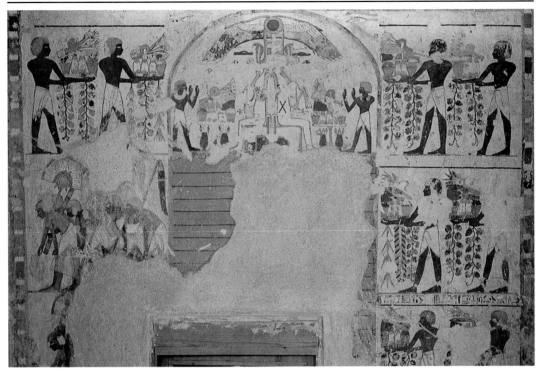

Figure 40

pletely disappears behind the body of the one in front. Across from the two men are five seated and four standing women, the latter being servant girls. The first two ladies are seated beside one another on a single couch. Each of the other three is holding a child in her lap: the child in the middle could be a boy, and the other two are girls. As the Egyptians generally depicted children naked, with the "lock of youth" holding the forefinger in the mouth, these are evidently not real children. Therefore, this is probably a picture of three wet nurses with their charges, the three children of Userhat. Wet nurses were highly ranked socially, and being the royal nurse assured not only the chief nurses but her substitutes a good position. The wealthy always had milk nurses, and the degree to which these were integrated into the family is apparent in this scene. Merely by virtue of their presence in the tomb, they too would be able to profit from the benefits of Userhat's mortuary cult.[14] The lowest register shows a long row of offering bearers.

A painted stela dominates the right end of the "reception hall" (fig. 40). In the pediment, the tomb-owner is placed antithetically, making offerings and gestures of reverence to Osiris. The arch at the top of the stele is formed by the wings of a winged sun disk. Two uraeus serpents are coiled around the sun disk with

their puffed up bodies hanging on each side. This winged disk is designated as "he of Behedet (Egyptian *behedeti*), Lord of Heaven and the Two Lands."[15] Behedet is the Egyptian name of Edfu, and "He of Behedet" is the name of an ancient falcon god who was later amalgamated with Horus, another falcon god. Such winged disks are common at the tops of stelae, or above temple entrances. It is worth noting that here, as usual, the wings are spread over the god and his offerings but do not extend over the worshipper. This shows that the winged sun disk belongs to the divine and royal spheres.

The text here was likewise never inscribed. As in the tomb of Nakht, offering bearers approach the stele; to the right are three rows, one above another. On the left, offering bearers appear only in the uppermost row, as the two registers below are reserved for the royal body guards. These six men are bowing deeply as they stride in. They have long, thin mantles over their kilts starched in the middle. In their hands are fans (like those from the tomb of Tutankhamun in the Cairo Museum) and a pole with fluttering strips of cloth, as well as bowcases, quivers and battle-axes.

These two rows make a refined transition to the right side of the rear wall, where King Amenophis II is seated in a booth topped with a frieze of uraeus serpents (fig. 41). He is accompanied by his bodyguards, a circumstance not pictured very often. The scene shows the living king, as is apparent from his clothing and behavior. His wig is surmounted by the "Anedjty-Feather-Crown" and his torso clad in the "royal jacket" with its yellow dots. The battle-ax in his right hand is quite distinctive; weapons are nowhere else found in such scenes.[16]

Although the king was evidently living, the Userhat displaying his reverence must be thought of as deceased, as his name is followed by the epithet "justified." A wall in the background shows that he too was in a building. In his hands he is carrying a two-level altar laid with grapes and persea fruits, as well as two stalk bouquets. His red hair may be natural and not a wig.

To the left of this is a scene where soldiers are provisioned, a task for which Userhat would probably have been responsible in his role as bread accountant (fig. 42). This scene is divided into two parts. In the right half are 14 officers in the four upper registers, seated before generously filled baskets of food and jars of wine and beer. That ranks differ can be seen in the uppermost row, where the officers are seated on the bare earth, while the others enjoy the comfort of mats. A few of them sniff lotus blossoms, and all of them are wearing kilts beneath thin mantles. In the lowest of these registers a servant is offering a bowl of wine to the officer on the far left.

In the two registers of the lower half are bare-chested men carrying heavy baskets filled with bread. As they are headed left, these must be for the soldiers waiting there. A supervisor with a whip is checking that the rations are in order (see fig. 42).

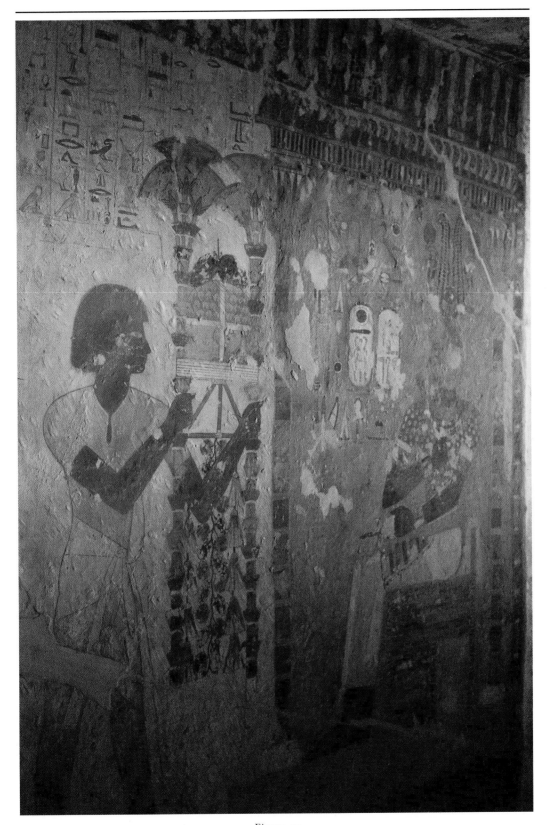

Figure 41

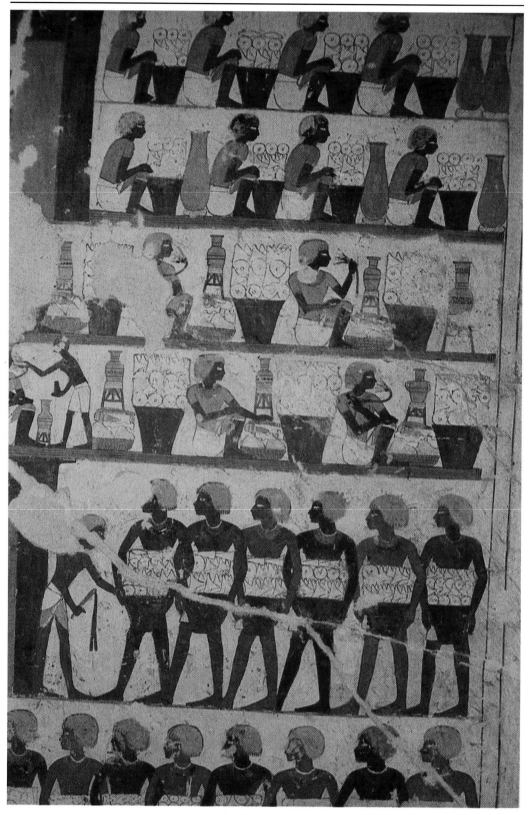

Figure 42

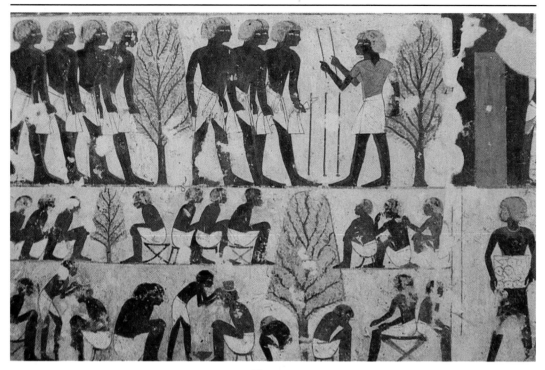

Figure 43

The left half of this scene shows simple soldiers in the three upper registers (fig. 43). They have bags with provisions in their hands and are lined up before the supply depot waiting for their food. The entry is clearly visible, as are the officers receiving them, with staffs in their hands. These officers are clearly distinguished by their superior clothing. The recruits are lined up in rows of two, but the ones behind can hardly be distinguished from the ones in front, as their skin color is only marginally lighter. They are all wearing simple white kilts. The profession of arms was not highly regarded in ancient Egypt, but there have always been adventurers seeking a life abroad, even though the most dreadful possible fate for an Egyptian was to die outside Egypt. However highly respected and necessary the officers may have been, their social position was always below that of military officials.

A parody written toward the end of Dynasty XX relates of the soldier's life that

He is awakened after only an hour and they are after him like a donkey. He works until the sun sets, bringing the twilight of night. He is hungry, his belly aching: he is dead while alive. He receives his grain wages when dismissed from duty,

but it is not sweet because of the grinding. He is ordered off to Syria without a pause. There is neither clothing nor sandals when they assemble the weapons of war and supplies at the frontier fort of Sile. His march is high in the mountains and only on the third day can he drink foul water which tastes like salt. Diarrhea rips his belly. The enemies come and he is surrounded in combat. Arrows whisk his life away from him. He is rushed: "Attack, brave soldier! Get a good name for yourself!" but he is unconscious of his body or his limbs, and his wretched knees collapse because of it. When the victory happens anyway, the booty and captives are handed over to his Majesty for transport to Egypt. The foreign woman is exhausted from marching and put on the soldier's neck. His baggage is abandoned and seized by others because he is burdened with the Asiatic slave while his own wife and children await him in their town. He is dead, however, and never reaches it.[17]

However exaggerated this account may be, it would certainly appear that even in ancient Egypt a military career began with a proper haircut. The two lowest registers (fig. 43) show the open-air barber shop with all kinds of precious details. The painter's easy strokes bring this image to life. As in Egypt today, the barber's shop was outdoors, and as today, the client had to wait awhile before his turn finally came. But patience came easily in those days; some of those waiting are seated on the ground, and a few are taking a nap in the shade of the trees. Some have managed to find a chair, which they share with others, but at the bottom on the far right, one egoist is trying to force his partner off the chair.

The left end of the reception hall was reserved for the false door (see pp. 33–34). As in other tombs, the red granite of which the false door should be made is illusory, having been executed in paint (fig. 44). In a refined manner, the text is written in light blue, as would have been done if writing on red granite. Above the entry we see the tomb-owner with his wife before a table with offerings. The texts themselves consist of various offering formulas. At the very top are two antithetically placed couples separated by a table. Of the couple on the right, only the name of the woman, Biki, can be read. Dressed as a *sem*-priest, their son Usi performs ritual offerings for his parents. The fine wickerwork of the upended basket and the large-bodied blue vessel under the chair merit a close look.

The other couple is the "first royal herald of the Lord of the Two Lands, Iamunedjeh . . . and his beloved wife, the mistress of the house and courtier Henutneferet." It has been shown that this cannot be Userhat's daughter of the same name.[18] Both the couple and the offering table heaped with offerings are conventional, but the two large golden wash sets under the chair are an attractive detail. "For your *ka*, a bouquet of Amun-Re!" says their son Meri, as he hands it to them. The text adds that the bouquet comes from Henket-ankh, the mortuary temple of Tuthmosis III.

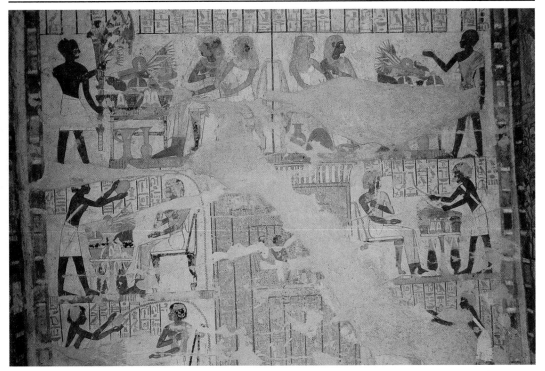

Figure 44

To the left of the false door, beneath this couple, Userhat's purification is performed twice. This is the commencement of the ritual of the Opening of the Mouth. In the upper scene, the light-blue water painted with the zigzag pattern is poured from a *nemset*-vessel, and in the lower scene, the water is poured over the deceased from a *desheret*-vessel. The ceremony of the Opening of the Mouth is continued to the right of the false door. The mouth and eyes are touched with the *nua* and *wer-hekau* instruments. By means of this ritual, all bodily functions were magically returned to Userhat. The captions explain each of the procedures, and its purpose.[19]

The viewer's eye is caught by the "Beautiful Festival of the Desert Valley" on the left rear wall of the transverse hall. As usual, it is impossible to say whether the deceased was taking part in the festivities while alive or after his death. In the main scene, right beside the entrance, he and his wife are receiving party offerings from their three children (fig. 45). Userhat and his wife Mut-neferet are seated on a couch. She is wearing a long thin white dress with shoulder straps, and he has put on a transparent linen garment over his short kilt. Both are wearing luxurious wigs with salve-cones on their heads. Mut-neferet is embracing her

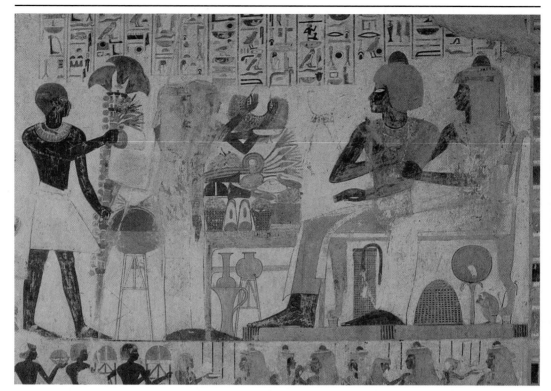

Figure 45

husband in the usual manner, but the embrace appears unusually rigid and conventional in this scene. The saucy little monkey eating what may be a pomegranate under the chair looks unusually lifelike and contrasts with the rest. Beside this favorite is the mistress's mirror, which she could hardly do without, along with an overturned basket. Userhat has his quiver with his writing utensils under his chair.

Offerings including vegetables, fruits, bread, and wine are heaped up in front of them. Beneath the table is a washing set.[20] With proudly raised hands, two daughters are offering a bowl of wine and an exquisite necklace to their parents. The uplifted arms of the foremost daughter are crossed by the extended arms of her sister, and thus the hieroglyph for *ka* is cunningly concealed and announced in this picture. Behind them is a son with a stalk bouquet, and in front of him is the usual stand with offerings. The caption remarks that one should have a nice day of celebration as "Amun-Re praises you when he rests in the *Ab*-Horizon (the mortuary temple of Amenophis II) at his festival of the western valley," which is a clear enough reference to the festival.[21]

To the left, behind the son, are three registers. The top one shows a libation presented to the tomb-owners' daughters. A girl passes a shallow bowl of wine across the table to the two daughters. She may be holding a small wine jar in her left hand hanging at her side. And the hungry little monkey is here too, serving himself from a basket of fruit. Musicians follow, with a girl playing a double oboe behind the harpist, along with two other girls. The lowest register shows the ladies of the assembly; at the far left is a servant girl salving her mistress. Others enjoying the festivities will also be found beneath the main scene just described. The upper register shows the women receiving their drinks and being salved. A long line of offering bearers is coming from the left.

At the bottom, Userhat and his wife are alone, being adored and receiving offerings.[22] The wall is unfortunately largely destroyed, with a large gaping hole to the left of these pictures, but something remains on the other side. Among these, the second register is worth emphasizing, for there some of the men invited to the festivities can be seen resting in a grape arbor.

The passage leads to the long hall behind. Above the entry, Userhat is depicted twice, worshipping the gods of the dead, Osiris and the jackal-headed Anubis (fig. 46). On the left wall is a masterpiece: the desert hunt (fig. 47). Userhat's following is on the wall with the entrance, but its members play ony a subordinate role. In the main scene, Userhat is standing in a chariot, having wrapped the reins around his hips, freeing his arms for *la chasse*. In reality, however, a charioteer would have driven the two horses—one red and one white—galloping with the chariot behind them. The movement of the animals is perfect; the Egyptians understood how to reduce it to the absolute minimum, capturing an animal's characteristic behavior. Userhat himself has drawn his bow to commence the annihilation of the desert animals, desperately fleeing their pursuer. Although stylized, the wild, terrifying confusion is incredibly realistic. Pierced by arrows, the animals are falling by the wayside or exhausting their last reserves to escape. Beneath a horse's belly is a rabbit making its getaway past a hyena that has been struck. A gazelle transfixed by death lies contorted before the horses' hooves. A cunning artistic device heightens the piercing quality of the scene: the red outline around some animals emphasizes the curvature of their bodies, a device particularly successful at bottom right where a fox hobbles helplessly into a bush.[23]

By comparison, the hunt in the papyrus thicket is disappointingly conventional (see p. 23 and fig. 48). As in the scene of the desert hunt below, the inscriptions here were never finished, although the lines are already in place. In the first scene, Userhat is catching birds with the throw stick. In the next he is spearing fish, standing in a papyrus boat accompanied by his wife and daughter. Remaining traces of the papyrus thicket reveal, however, that this scene lost its character because the artists left off their work, not because of their lack of ability. The awkward animals in the boat were contributed by the Copts.

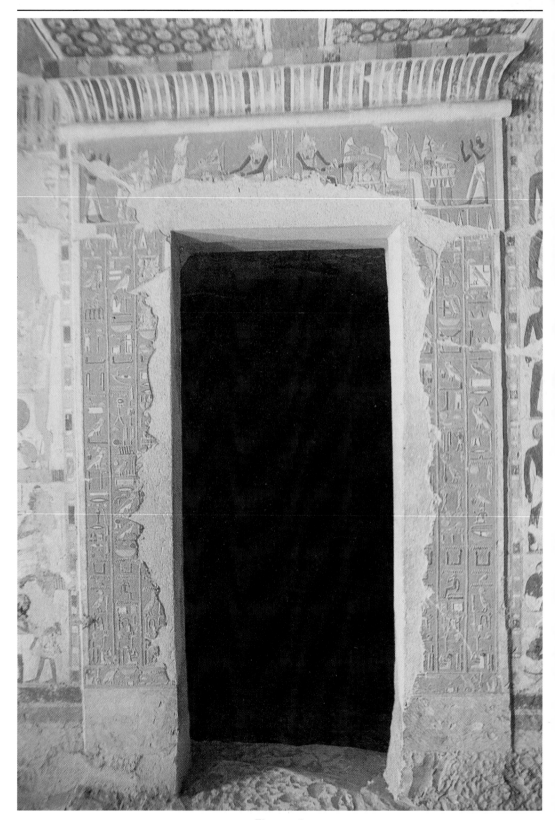

Figure 46

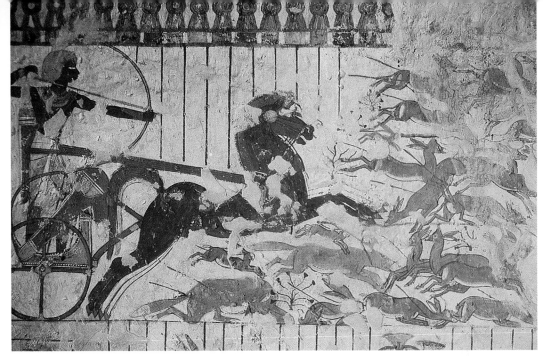

Figure 47

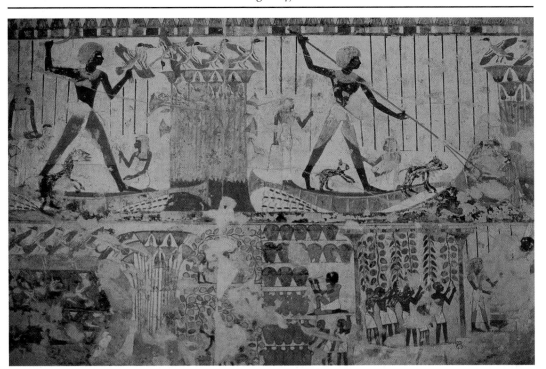

Figure 48

Birds are being trapped in the scene below the fowling with the throw stick. Eight ducks are flying away, above the hexagonal net, toward Userhat and his wife, who are receiving the yield of this catch at the far left. The group of fowlers make the transition to the offering scene. Two are looking to the right, toward the net, while the third glances left to the two offering bearers. All of them have the rope in their hands, ready to close the net, but they do not seem to be really concerned, and the picture remains conventional.

To the right is the grape harvest (see pp. 39 and 114–115). The scene of the harvest itself is largely lost, but beside it are preserved 14 baskets filled with grapes, and the jars below waiting to be filled. Inevitably, a scribe is recording every detail, as everything had to be put in order. Even in that day, the origins and year were recorded on the seal of the wine jars. Artistically characterized as socially inferior, the workers hold onto the branches that hang from above; they stamp the dark grapes with their bare feet, as is shown in many tombs over the centuries. The people have apparently already had enough wine, especially the two last fellows, who can hardly stand up straight. The slightly opened mouth and the strange, stupid look strengthen the impression. The third from the left is leaning forward, as if standing straight was already too challenging, and the others are hanging heavily on the branches. Or are they merely dead tired from the hard and boring work?

To the far right, Userhat is making an offering to the serpent-shaped harvest goddess, Renenutet. At the end of the wall, and all but unrecognizable, is an incomplete and damaged picture of fishing with the drag net.

The right wall of the passage is reserved for the funeral procession and mortuary rituals (fig. 49). The shrine with the deceased is towed into the tomb in the top register. This scene is similar to that of Ramose (see pp. 52–56). Bearers with offerings and others with cultic instruments precede the oxen towing the coffin, guiding them. The schematic depiction of the wailing women (only partially and faintly seen in the figure) contrasts starkly with the lively hunting scene or the workers stamping grapes. This may have been deliberate, however, consciously distinguishing them from the scenes of daily life on the other walls, for there are many more moving scenes of mourning. This one is only brought to life by the first three kneeling women; those behind are also pulling their hair or standing with crossed arms, but without being released from their schematic rigidity. In front of the wailing women is a hint at the ceremony of the Opening of the Mouth, performed on the mummy before the actual burial (see pp. 169–172). A *sem*-priest and a lector priest are carrying the necessary cultic instruments and food. All the abundant offerings and funerary equipment appear in the register below. Even the horse and chariot are not forgotten (fig. 50).

The coffin's voyage to Abydos in a bark is also included in the funeral procession in this tomb (fig. 51). The boat in the middle at the very bottom is the

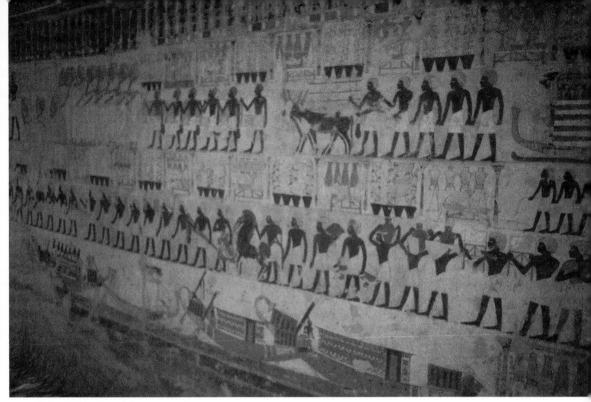

Figure 49

Figure 50

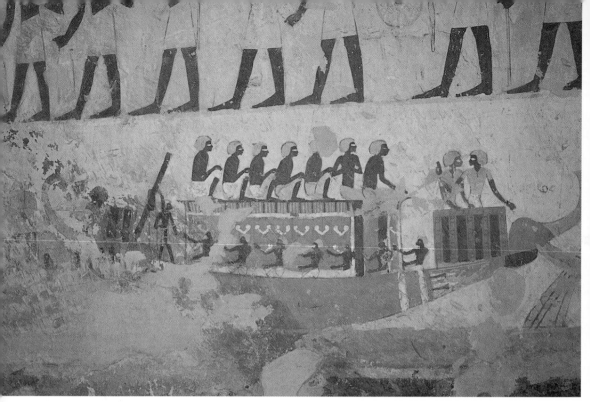

Figure 51

bark of the deceased, being towed by the other four. The crew and rowers are quite lively. The long row of people sitting in the boat is broken by the second from the right, who is spreading his arms, and by the first one, also striking a pose of his own. At the prow are two others who were apparently responsible for the success of the ship's voyage, which they seem to be discussing at this very moment. Was there a problem with the depth of the Nile? This was entirely possible, given the sand banks just beneath the surface of the river. The measuring pole is missing, however. This could be an accidental omission, or the two could be discussing the current.

The cult niche once sheltered statues of Userhat and Mut-neferet, but these are almost entirely lost today.

Menna

MENNA WAS "Scribe of the fields of the Lord of the Two Lands of Upper and Lower Egypt."[1] He is thus generally assumed to have been a surveyor or archivist responsible for the records of land ownership, that is, a "cadaster scribe." The name Menna means, roughly, "lasting." His wife was the Chantress of Amun, Henut-tawy. His sons were the *web*-priest Kha and a "Scribe of Reckoning of Grain" whose name was effaced. His daughters were Imn-em-weskhet and Nehem-awayt.

There are no inscriptions in the tomb itself that can offer any help in dating it directly. Hitherto, it has usually been ascribed to the reign of Tuthmosis IV, which would make it roughly contemporary with the earlier dating of the tomb of Nakht. Based on the decoration, there has been a recent tendency to propose dating both tombs a decade or so later, and thus assigning them to the reign of Amenophis III.[2] This dating is also supported on architectural grounds, as Kampp has pointed out that the slightly inclined ramp leading to Menna's courtyard was particularly common during the period at the end of the reign of Tuthmosis IV and early in that of Amenophis III. The descent to the sloping passage at the end of the passage also fits a slightly later date quite well.[3]

The tomb is distinguished by its wonderfully lively paintings with numerous informative details, although the work itself is not of the highest quality. It is one of the few tombs where all of the scenes are on the "correct" walls, meaning that the decoration scrupulously observed the ideologically correct orientation (fig. 52). (This orientation was fictional, however, as the tomb is oriented northeast-southwest and not the ideal east-west.) Aside from being "oriented"

0 5 m

Figure 52

correctly, the tomb was nearly finished. After this time, however, a personal enemy
with malicious intentions hacked out the face of the tomb-owner in order to
deprive him of eternal life.

On the left side of the entry to the tomb is a hymn to Amun-Re:

[Hail to you, Re, at your rising!
Amun, divine power!
You Rise that you illuminate the Two Lands,
You traverse the heavens in your dawn (*Mandjet*)-bark for your daily voyage,
Your heart as wide as the *Mandjet*-bark.
You pass by the sand-bank of the Double-bladed-lake,
Your foes overthrown.]

You have appeared in the Mansion of Shu,
Having rested in the Western Horizon,
Your majesty has received veneration,
The arms of your mother behind you,
Every day, as a daily custom.

I behold you at your beautiful festival,
At your sailing to Deir el-Bahri,
When your excellence is manifest, resounding,
I worship you,
Your perfection in my face.

You let me repose in the house that I have built,
In the favor of the good god.
You let me be in your entourage,
That I be content with the bread of your giving,
As is done for the just on earth.[4]

The deceased, along with his wife and daughter, was depicted here wor-
shipping the god. This is unexceptional, and like other tombs this one is almost
cozy, with the carpet patterns on the roof; a *kheker*-frieze and a colorful, striped
ribbon line the upper border of the walls.

Just to the left of the entry is the scene "Relaxing with the work of the fields
by the great confidant of the Lord of the Two Lands, Friend of [Horus] in his house,
eyes of the King in all places, Overseer of the fields [of Amun, Menna], justified
before the great god."[5] The tomb owner is seated on a stool with a seat covered
with skin, itself placed on a mat (fig. 53). Menna is conscious of his official busi-
ness, bearing the staff and handkerchief as symbols of rank. As usual, he is dressed
up, wearing a long thin garment over his short white kilt. Along with this fes-
tival clothing, the table before him, luxuriously laid with chicks, eggs, vegetables,
and fish, emphasizes that this tangible world is being recorded for the Beyond.
The distinctions in social rank in ancient Egypt are laid bare by the men to the

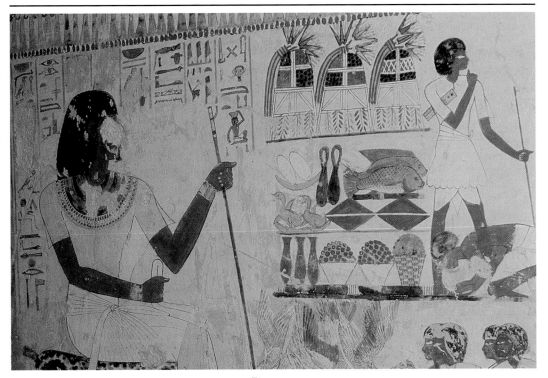

Figure 53

right of the table. The two well-dressed scribes have their palettes under their arms and staves in their hands, likewise attesting to their high rank. Opposing them, spatially and socially, is the petitioner in a short kilt who has prostrated himself before Menna. He has probably neglected something and hopes for mercy. The stylistic device of overlapping has been skillfully employed, guaranteeing the closed nature of the scene, while also forming the link to the next—the greatest part of this wall is dominated by the harvest scenes.

Before turning to these, we can return to the scene beneath Menna and his table. This is unfortunately largely destroyed. On the left is the tomb-owner with two elegantly dressed girls with magnificent headdresses, behind whom is a smaller girl. The two in front are his two daughters, each holding a sistrum. This gesture hints at the "Beautiful Festival of the Desert Valley." As chantresses of Amun, the two ladies took part in the festival processions from the temple to the tombs. Sistrums and, frequently, necklaces are offered to the tomb-owner. He takes them as one receives something beautiful. The swinging of the sistrums and *menits* with the accompanying blessings is not shown in this tomb, although it is part of the ceremonies.[6]

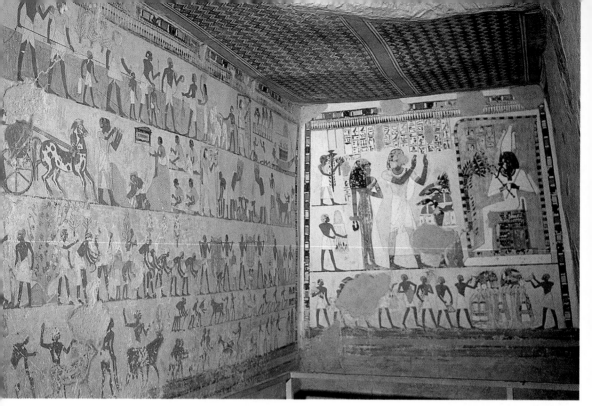

Figure 54

The rest of the wall is devoted to agricultural pursuits (fig. 54). The many lightly painted and carefully noted details make this wall impressive. (While we enjoy the pleasures of these delightful scenes, however, we should never forget that Egypt did not produce any "art pour l'art," art for its own sake. Even the most delightful paintings are merely a mirror of daily life and not intended to give joy to the beholder, in the modern sense.) At the very bottom is the flax harvest. The earth is broken, plowed, and sown. Flax is rippled; the flax comb and the linseeds can be seen falling to earth (fig. 55). The use of linseed oil is not documented before the Graeco-Roman period a thousand years later, but it is virtually inconceivable that the Egyptians did not find any use for the seeds before that time. The fibers were sorted according to their ripeness and used accordingly for the finest cloth, ropes, or even mats. The trees lining the fields characterize the land as fertile. One girl is pulling a thorn from the foot of another, who is stretching her leg out to her (fig. 56). Above this lowest level, grain is being mowed with sickles and packed into baskets (see fig. 55). One of the bulging baskets is being carried away. Beneath this basket are two girls gleaning the grain that fell to earth, who have started to fight over an ear, pulling each other's hair (fig. 57). However amusing the picture might be, it throws light on another aspect of ancient Egypt. Collecting those ears was doubtless a bitter necessity for many. It is possible that the Egyptian artist consciously placed the bulging and overflowing basket right above them. The better-dressed supervisors can be recognized among

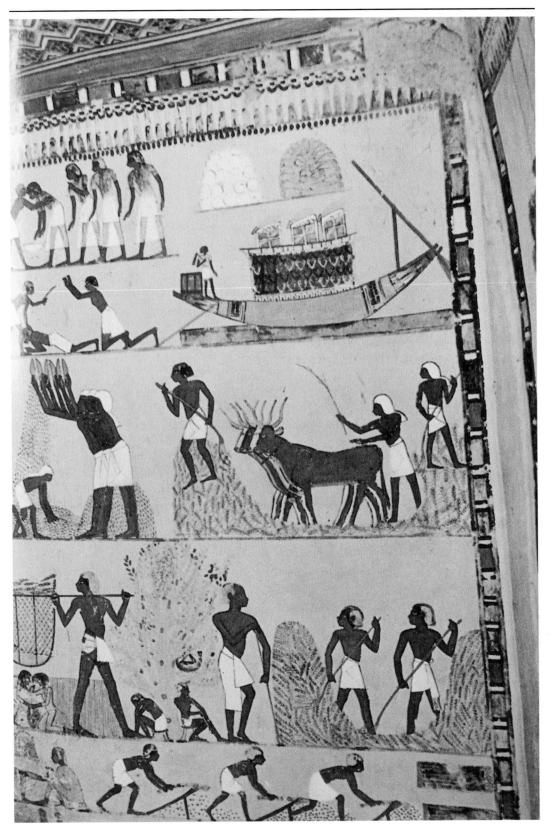

Figure 55

Figure 56

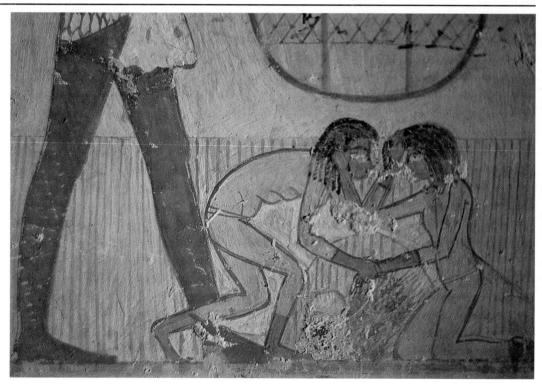

Figure 57

the field laborers (see fig. 55). In the second register, one of them appears to be reporting to Menna, partially visible, seated beneath a baldaquin on the left (fig. 54).

Laborers on the far right are spreading the harvested grain on the threshing floor, using large pitchforks. Their unkempt hair and carelessly tied kilts betray their low social status. The supervisor—who also has a unique hairdo—is leaning on a staff. He may have just urged his people on, as can be read in many other tomb inscriptions, or he may have just scolded them, as the two workers have turned to him in anger. The face of the one on the left displays his irritation clearly, and the saucy tip-tilted nose and opened lips make him look particularly indignant.[7]

To the left of this scene is the very image of tranquillity. A field worker is taking a rest under the shade of a tree and plays a tune on his flute. Another seems to be taking a nap. A water skin is hanging from a branch of the tree, but no one has worked hard enough yet to be thirsty.

A mother and her child are seated on a stool under one of the trees in the harvest scene (fig. 58). The mother has wrapped her dress around the child as a sling. The head is just visible, as are hanging legs, while the short arms grab the mother's hair. A vessel, perhaps containing food, is standing in front of the mother.

The grain is being trodden by cattle in the register above (see fig. 55). It is then winnowed as in the tomb of Nakht. The man standing on the heap of grain can hardly keep himself upright, and it looks as if he is supporting himself on his pitchfork. The workers around him have bound white cloths on their heads to protect themselves from the dust, as was the custom when winnowing. Even the cattle do not seem to like the work, as they have to be driven on by the stick. In the adjoining bit (see fig. 54), a laborer is bringing two jars in a net to Menna, who is standing under a baldaquin. The inundation, sewing, and harvesting were the basis of the Egyptians' life cycle and their calendar.[8]

Eight scribes are recording the harvest yields, measured by four workers (see fig. 54). As a surveyor, Menna would appear to have particularly appreciated the work of the scribes. Easily identified with their writing equipment are three of the officials in front of the grain heap on the left; another is seated on the heap to the right. He must have had some difficulty counting, for he does not seem to be able to do it without using his fingers. Four others are seated at the right of the scene. The prominently placed box with a rounded top probably contains all the relevant files.

The steward may have come on the magnificent wagon drawn by a red-checkered horse (see fig. 54). His driver seems to be waiting for him. This picture leads to the officials who are standing respectfully in front of Menna. At the same time, it skillfully enables a smooth transition to the representation of the tomb-owner seated at table, as seen at the beginning.

Figure 58

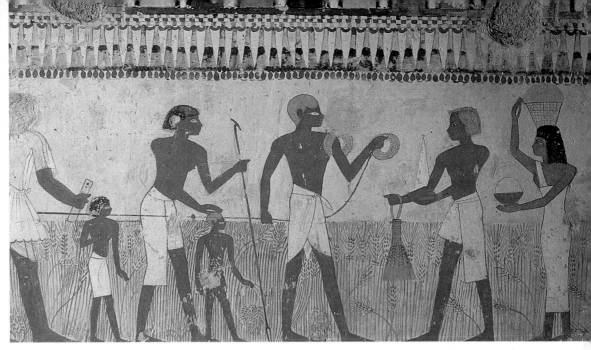

Figure 59

The surveying work shown in the top register underlines social distinctions (fig. 59). Written sources show that the cadaster scribe was in charge of a team that included two scribes of the fields, a rope bearer, and a rope stretcher.[9] The Scribes dressed in fine white are probably supervisors, who are followed by diminutive servants carrying their sandals, writing equipment, and a white bundle of cloth like the food bundle in Userhat's tomb. At the two ends of the scene, in short kilts, are the assistants measuring the fields with a rope (fig. 54). The rope would have had knots at regular intervals to simplify the process. An old man with a long staff is leaning on a boy's head to steady himself. The trees in the background (see fig. 54) symbolize fertile land.

Every autumn, after the Nile inundation, the land had to be surveyed again. The scribes were measuring not the height of the grain, but rather the size of the fields; taxes and rents were levied by the surface area of the fields, not by the volume of the harvest. Such measurements usually took place after the inundation, before plowing, when the boundary stelae were still visible. The grain is shown ripe, as the Egyptians were already producing the anticipated harvest. When harvest time came in the spring, a few months later, the officials returned to note down and collect the taxes. The experience has been graphically described:

> The snake has seized half the grain, and the hippopotami have eaten the rest. Mice abound in the fields, the locusts descend and the herds devour; the sparrows steal—woe to the farmers! The remains on the threshing floor are for the thieves. The team is dead from threshing and plowing. The scribe moors at the riverbank, and goes to record the harvest. His guards have clubs and the Nubians accompanying him have palm branches. They say: "Give the grain!" "There is

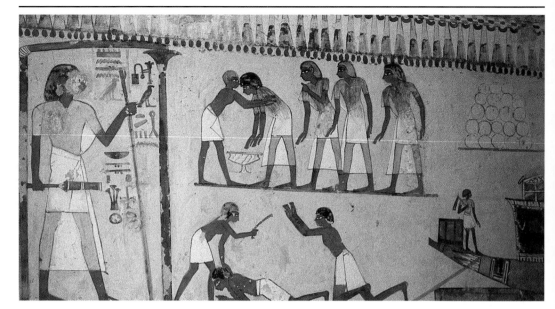

Figure 60

none!" They beat the peasant furiously, and bind him and throw him into the ditch. The scribe controls everyone's work.[10]

It is obvious that the officials in our picture have drawn the better lot.

Such a poor peasant receives the officials, to the right of the surveyors in the wall's upper register (fig. 59). He carries a triangular bread and woven strands of grain, which is still used as a talisman—the "grain bride"—in Egypt today and offered for sale to tourists. Originally it must have been a sacrificial offering for the harvest goddess Renenutet, who is frequently worshipped in scenes adjoining those of the cultivation and harvesting of fields. It is certainly the farmer's wife who is bringing food and drink in a basket on her head and a bowl in her hand. It is not improbable that these are small gifts intended to cheer the officials. The family is rounded out with the little boy driving a donkey and offering the miniature goat held in his arms. The donkey was later effaced, perhaps by a religious fanatic, as the donkey was considered to be the animal of the detested god Seth.[11] Menna himself has turned his back to the survey scene, shading himself under a baldaquin borne by papyrus columns (fig. 60). His shorter white kilt can be clearly seen beneath the long short-sleeved garment. The *sekhem* scepter and his staff identify him as an official of rank. One is almost inclined to recall the guardians just mentioned when noting that a delinquent is being beaten on the ground before him. Others who have not performed their tasks are being brought as well.

Their attitude of submission says everything. There must have always been people who did not bring, or were unable to produce, their quotas. Beatings were a proven means of dealing with such people.

It was not just the commoners who risked punishment, however. The officials of the survey commission could be punished by being deprived of their own fields as a consequence of a complaint about shifting the borders of a plot of land.[12]

To the right of this scene is a heavily laden ship floating with the current down the Nile (see fig. 55). The river was the main communications artery in ancient Egypt, and cargoes of all kinds were always entrusted to the Nile boats.

At the left end of this room, Menna and his wife can be seen making offerings to, and adoring, the god Osiris (see fig. 54). The tomb-owner is dressed in a fine garment, worn over his kilt, as was fashionable at the height of Dynasty XVIII. "His wife, the Mistress of the House, the Chantress of [Amun], Henuttawy, justified by the great god," is also fancily dressed, with a perfumed incense cone on her head, and a diadem of blossoms adorning the hair falling luxuriously on her shoulders. Peeking out of her wig are large earrings. Fine necklaces make the outfit complete. Her tender frame and noble face are among the most attractive feminine images of this age and can be favorably compared to the guests attending the party in Nakht's tomb. She is holding the sistrum and *menit* as insignia of her office (see pp. 29–30, 117, and 200). Between the tomb-owner and the god is the generously laid table. Two servants with offerings are behind the god's adorers. The caption explains: "Giving adoration to Osiris, kissing the earth before Onnophoros by the scribe and overseer of the plow-lands of [Amun, Menna]. He says, 'I have come to you, my heart being *maat*-just through and through, my breast bereft of sin. May you purify my corpse in the sacred land, and my soul for eternity. . . .' The overseer of the fields of the Lord of the Two Lands [overseer of the fields of Amun, Menna], he says: 'I give you adoration that your beauty be raised and made firm, that I be allowed to rest in the beautiful west in the favor of your *ka*-soul.'"[13]

Osiris, the god worshipped here, is seated in a shrine, his hands holding his insignia, the shepherd's crook and flail, with the *atef* crown on his head. A stalk bouquet stands before him in the shrine, the poles of which can still be seen. His title and name are inscribed in carefully executed hieroglyphs above him: "Osiris, Onnophoros, the great god, Ruler, Lord of Eternity, Eye of Everlastingness." The black color of his face characterizes the god as the donor of the inundation and thus of the fertile earth, but also as the lord of the Netherworld.

Beneath are the offering bearers with lotus blossoms, fowl, a calf, a jar, and possibly vessels of food. One is carrying the head of a cow, and the one in front of him has placed the haunch on the generously laid table. The two tall altars are piled with fowl, meat, breads, vegetables, and fruits. The two large vessels on the left are probably wine jars, while sharp cones of incense are on the high bowls

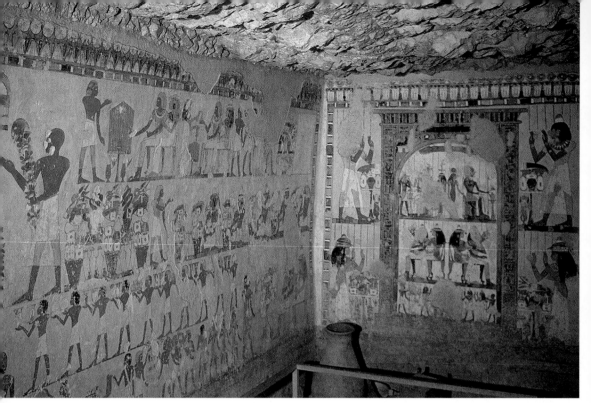

Figure 61

to the right. Each of the cones is flanked by a head of lettuce. That these are burnt offerings is shown by the red tongues of flame above the offerings, as well as by the man at the extreme right: he is holding a pan with a spoon to the flames, slightly lifting the handle of the spoon. Such instruments were used to put incense on a burnt offering.[14]

The adjoining wall is almost entirely destroyed. Slight traces of scenes from a banquet can be recognized. Menna was shown with his wife, and a girl presenting wine. They suffice to indicate what has been lost.

On the wall to the right of the passage are the tomb-owner and his wife. Although not themselves visible in the figure, they are receiving a stalk bouquet from the hand of a *web* priest with a shaven head (fig. 61, far left). The table between them is luxuriously heaped with meat, breads, fruits, and above all a bunch of lotus blossoms. The offering mats above show a vessel in the form of a lotus blossom, and a tall one for ointment and a shallow bowl. A lotus blossom was laid on each of these. Beneath the food heaped on a mat are four tall jars entwined with grape vines.

The adjoining part of the wall is divided into four registers. In the first, on the left, a priest is handing Menna and his wife a very schematically painted offering table. To the right, a daughter is offering a sistrum and *menit* to her father, who is being tenderly embraced by his wife (fig. 62). Between the girls and the couple is a low offering table. The closing scene on the right is now lost.

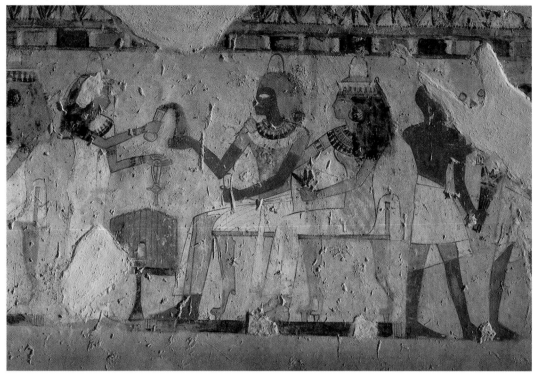

Figure 62

Two men are bringing offerings, walking off toward a building that can hardly be made out.

In the second register is again a heap of the precious produce of the land, bread, meat, and ointment vessels (see fig. 61). To the right are the guests. A few face tables and wine jars, and the whole should probably be understood as part of the "Beautiful Festival of the Desert Valley."

The two lowest registers depict offering bearers heading for the large scene with the offering table. Below, on the extreme right, is the deceased with his wife. Ointment vessels and fans are being brought to them.

The end of the room has been shaped as a stela (see fig. 61). On each side is Menna, his hands raised in token of adoration. Below him is his richly bejeweled wife, Henut-tawy, in a long dress and with a perfumed incense cone on her head, above the heavy wig. Before them is a table laid with the usual offerings. Under the table are vessels bound by coiling lotus stems. The stela itself is closed at the top with a cavetto cornice, with a winged solar disk in the curvature (see pp. 71–72). In the upper register are Anubis in front of Osiris and the

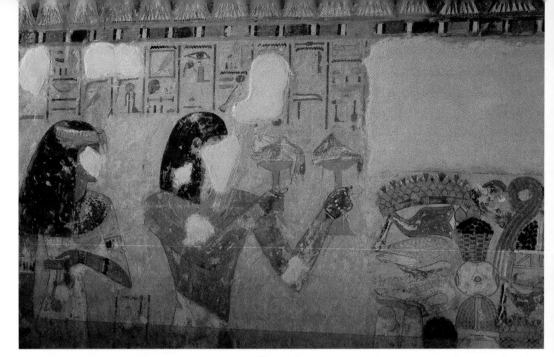

Figure 63

goddess of the West (on the left), and Hathor standing behind Ra-Harakhte (on the right).

Beneath them are two antithetical couples, with the deceased and his wife performing a gesture of adoration in the last register, followed by priests. The captions of the stela were never finished.

To the right, beside the tomb entrance, the tomb-owner and his wife are performing a burnt offering (fig. 63). Not shown here is the scene with their sons and daughters heading for their parents, holding various blossoms and offerings. The slim figures of the daughters are emphasized by their heavy hanging wigs. They are also adorned with broad necklaces, large earrings, and blossom diadems. Beneath are butchers and a row of offering bearers. Among them is one carrying a small antelope on his shoulder. He has laid it like a collar around his neck and is holding on to its legs. Three chantresses are clapping their hands and singing a song to accompany the burnt offering: "Beautiful day! The mountain is opened, the seal broken. The doors of your house are open. The incense reaches to heaven. You have offered. The doors are opened. What you have offered is accepted. My lord, Lord of the burnt offering, something beautiful which (the tomb-owner) did daily for you, for which you must . . . show him every favor."[15]

On the left, a stalk bouquet is being offered to the tomb-owner by Henut-tawy, enchanting with her fine figure and magnificent clothing. Beneath her chair is a scribe's palette, which probably belonged to Menna, and a colorful, high, woven covered basket reminiscent of the wares available in Aswan today (fig. 64).

In the passage to the long hall, the tomb-owner and his wife leave the tomb, on the left, for the Beautiful Festival of the Desert Valley. In accordance

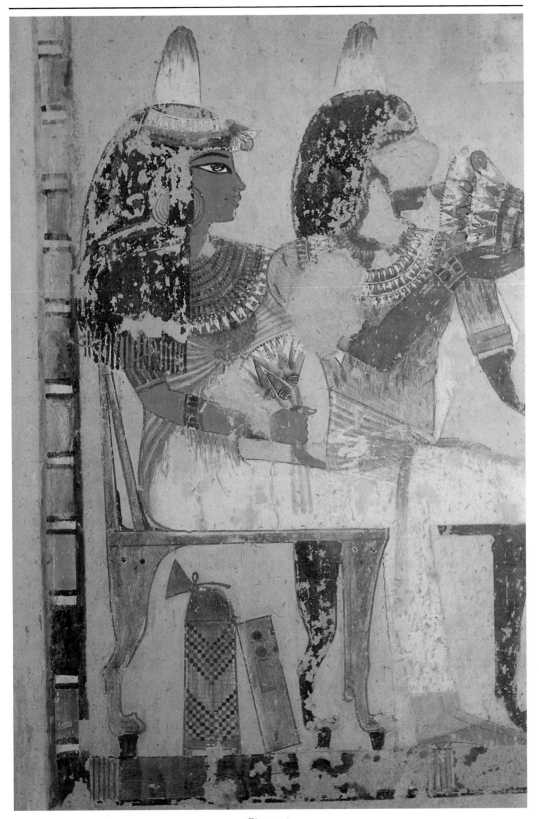

Figure 64

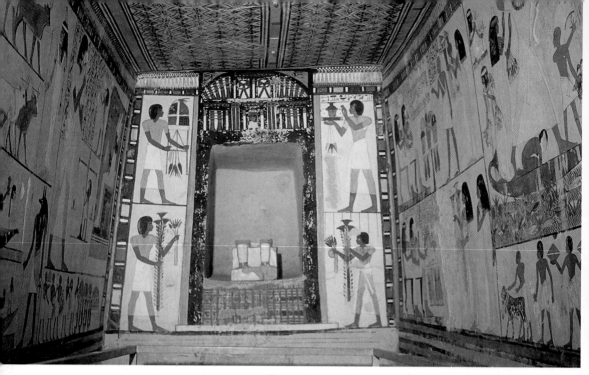

Figure 65

with the rules, the decoration in the long hall is generally dominated by scenes relating to the Beyond. The chapel is reduced to a small statue niche, which offering bearers approach from each side (fig. 65). The two below bring blossoms and stalk bouquets, and the two above have fruits and blossoms. The ceiling has the common carpet pattern. On the left wall is the usual funerary procession, with just a few chosen scenes from the whole ritual (figs. 65 and 66). (The ritual is discussed in detail with the tomb of Rekhmire.) Organized in two rows heading for the goddess of the West (fig. 67), funerary equipment such as ushebtis, ointment vessels, caskets, furniture, blossoms, and food are being brought in (see fig. 66). The whole is led by four oxen being driven toward the tomb. That the second cattle driver is half bald is quite striking. Beneath this on the left is a bark with the sarcophagus on the Nile. The three oars on the stern are particularly magnificent. This ship is towing a papyrus vessel with a white cabin—probably a shrine. Aside from the crew there are two wailing women on the latter vessel, both of whom are tossing dust on their hair in distress. Another has lifted her arms, overcome with misery.

Because of damage, the scene with the procession is incomplete, but a journey over land can also be recognized, where the sled-borne sarcophagus is drawn by four oxen. Beneath this are more funerary rituals performed before the god Anubis (see fig. 65). To the left a lector priest is supervising the workers butchering and purifying a bull lying on a mat (see fig. 66). In front of this are two other priests in a boat with a divine shrine. At the end of the register, another boat is carrying a haunch of beef, and a vessel for the heart (see pp. 164–173). In the low-

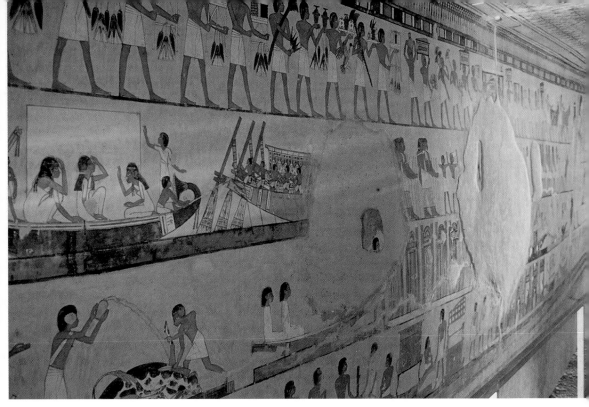

Figure 66

est register, the shrine lying on a lion bed which is sailing in a boat is worth atten-
tion, as is the splendid sarcophagus with the mummy bed being towed on a sled
to its final destination. The coffin itself is being brought in another boat. Three
priests are holding it, with the two kites, Isis and Nephthys, at the two ends, as
was usual (see pp. 164–165). The voyage finally ends on this wall with the scene
of the Judgment of the Dead, which replaces the more conventional adoration
of Osiris. Menna has to account for all his actions. This was the first time in Egypt-
ian history that the Judgment of the Dead was depicted in a tomb, although dur-
ing the later Ramesside period it became an essential part of the repertoire used
in tomb decoration.[16] In place of the usual offering formula, the tomb-owner
recites Spell 30B of the Book of the Dead, which begins: "Spell to prevent the
heart of so-and-so from resisting him in the Necropolis. Heart of my mother,
heart of my mother! My heart of transformation there: Do not stand up against
me as a party or as a witness! Do not resist me at court! Do not perform
crookedness against me in the presence of the guardian of the balance!"[17]

The idea of a court where the dead faced judgment may go back to Dy-
nasty V, but it did not really take hold until sometime during the First Interme-
diate Period, when texts confirm the emergence of the concept of a compulsory
court where judges would examine the behavior of the deceased. Without the
collapse of the Old Kingdom and the spiritual shock that accompanied it, the
court of the Beyond as it appears in the New Kingdom would be inconceivable.

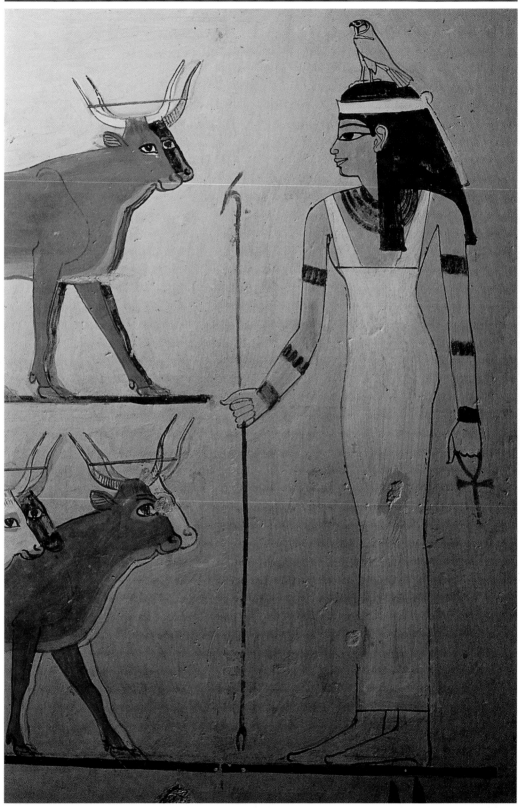

Figure 67

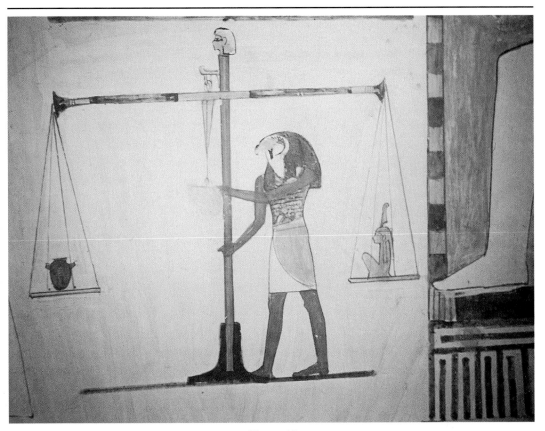

Figure 68

The insecurity of the deceased's material provisioning after death supports the conjecture that a generally competent court of the Beyond—where judgments would be based on correct ethical attitudes and behavior—opened the way for the idea of evenhanded justice for all, regardless of social status. In the Old Kingdom, it is conceivable that the king might have been judged—the collapse of the Old Kingdom gave birth to the concept that others would be judged as well.

Because a man's heart was the seat of reason, insight, perception, and thought, it was the heart that was weighed against Maat, the goddess who personified cosmic order and justice (fig. 68). The two always balance out when placed on ancient Egyptian scales, and thus also here, confirming that Menna has acted in accordance with the prevailing ethical norms. Horus serves as the master of the balance here, but the office is usually assigned to Anubis. Thoth, the god of wisdom, is always the court clerk, recording the result of the balancing act (fig. 69). The president of the court is almost always Osiris, as here, with a tribunal of

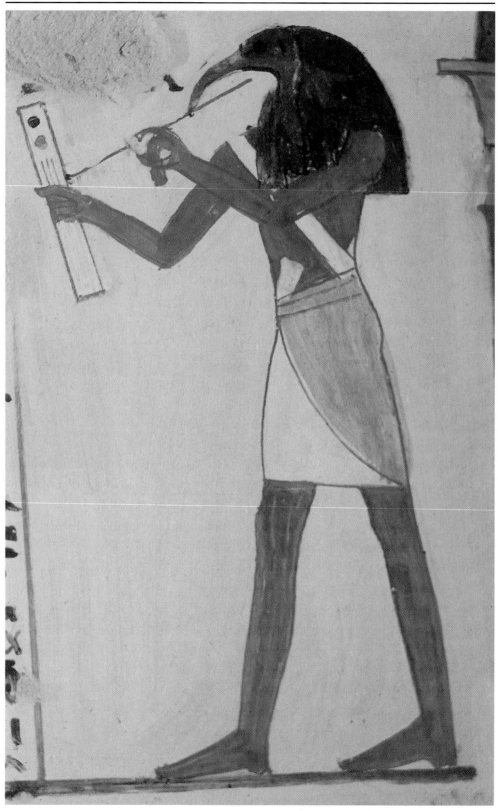

Figure 69

42 judges at his side. If the result is positive, the dead can expect rebirth and guaranteed provisions. Those who fail the ordeal are delivered to punishing demons or the "devourer of the dead."

The right, northern wall shows the deceased before a well-laid table, with his wife seated behind him (see fig. 65). Family members are bringing offerings in two rows, each led by a son, followed by two daughters (fig. 70) in the lower row and one in the upper row. All have heavy earrings, which stick out of the long wigs, and all are wearing long, tight garments. The girl in the upper register has two fine vessels, each topped with a lotus blossom. Milk is in the first vessel. The two girls in the lower row are bearing a stalk bouquet and a sistrum, respectively.

The most impressive scene of the entire tomb is the hunt in the papyrus thicket (figs. 65 and 71). The tomb-owner is killing birds with a throw stick, and fish with a spear (see pp. 23 and 36–39).[18] In each scene, he is standing in a light papyrus boat, accompanied by his wife, who is behind him, and their children. The fowling was particularly successful: the son is holding a few birds, and so is the daughter at the stern of the boat. The youngest, who is naked because of her tender age, is plucking a lotus bud (fig. 72). Everything in and around the water has been terrified by the hunt. The ducks cackle excitedly, having only just returned to the water. Only the crocodile continues to chew away at his fish contentedly. Things were disturbed even in the papyrus thicket itself (figs. 71 and 73). A genet grasped the opportunity and crept into a nest that the birds had momentarily abandoned because of the throw stick. He is followed by a mongoose whose weight bends a papyrus stem.[19]

The painter has masterfully captured the lives of the animals in the Nile and the papyrus thicket with a minimum of effort, reducing everything to essentials. Elsewhere the thicket is a blob of color, but here various shades of green open it up; even the water was gently set in motion, although formed by a conventional series of zigzagged water lines. In the Egyptian writing system, an individual water line merely signified the sound *n,* while three together were *mu,* "water." The artistic success was thus also linguistically correct.

The register immediately above shows the voyage to Abydos (pp. 124–125). The boat is returning from Abydos under full sail (fig. 74). At the bow is the pilot using his testing pole to help the boat avoid the shoals of the Nile. At the stern is the steersman holding the rudder ornamented with two *udjat*-eyes (see p. 133). A sailor is in the rigging, passing on the pilot's instructions. The rowers are taking a break, but to prevent their relief from distressing the viewer with boredom, the artist has one of them satisfying his thirst by reaching for some cool Nile water. The overlap of his body with that of the man behind is refined; it was apparently not very easy for the Egyptian artist to catch such a complicated movement.

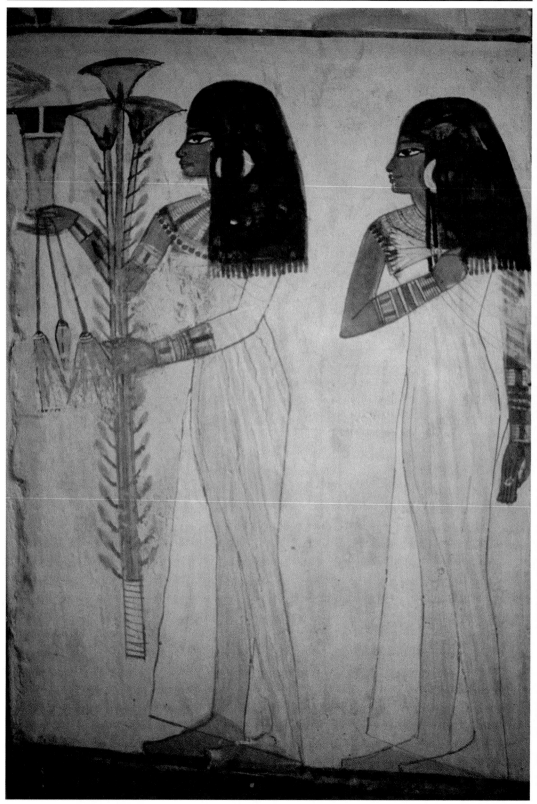

Figure 70

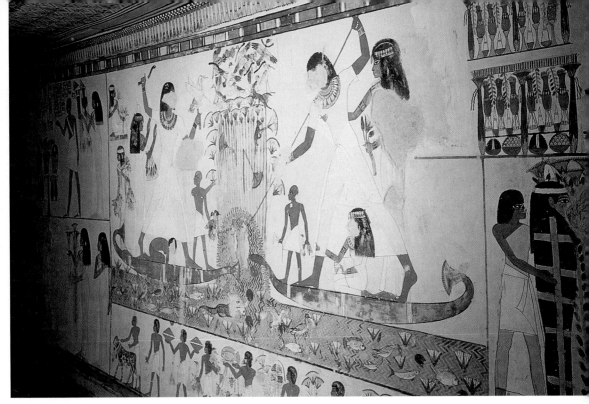

Figure 71

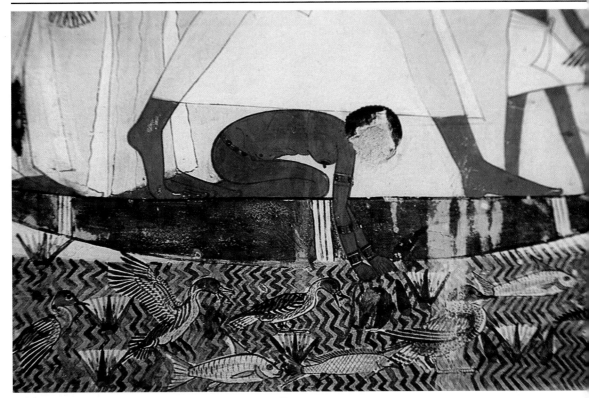

Figure 72

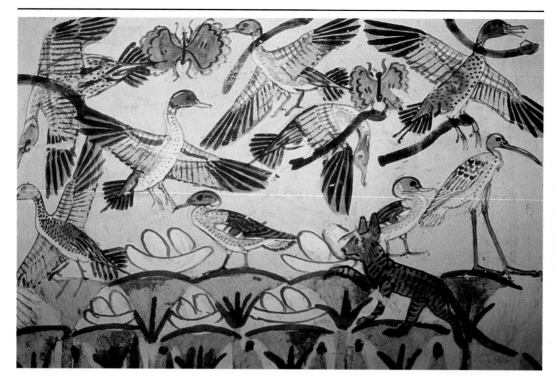

Figure 73

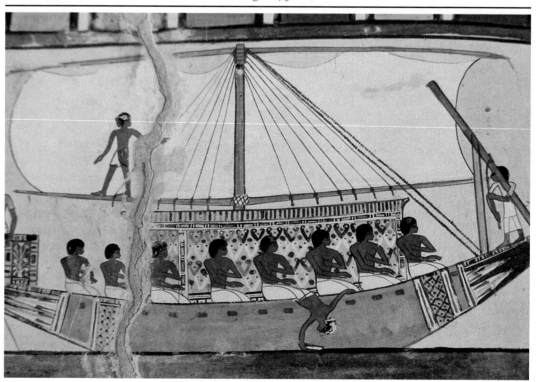

Figure 74

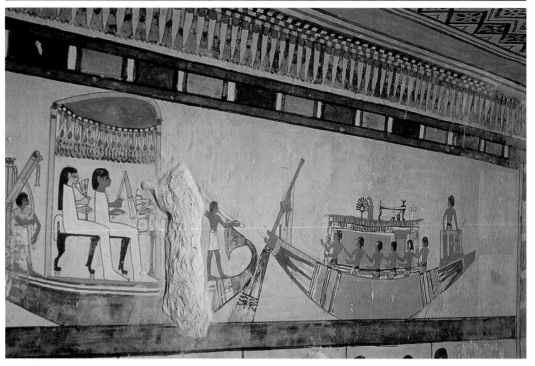

Figure 75

Behind is the boat in which the deceased and his wife are traveling as statues (fig. 75). He is holding a flail, and she is enjoying the fragrance of a lotus blossom. The deceased are going northwards toward Abydos, and the accompanying rowboat carries grave goods along with the shrine, such as a bed with a headrest. Below this are two registers with a selection of 11 scenes of the ceremony of the Opening of the Mouth, performed on the mummy (fig. 76).[20]

The magnificent black sarcophagus held by a priest during the ritual is well worth looking at (see fig. 71). The lowest register has a long line of offering bearers, which continues beneath the scene of the hunt in the papyrus thicket (fig. 77).

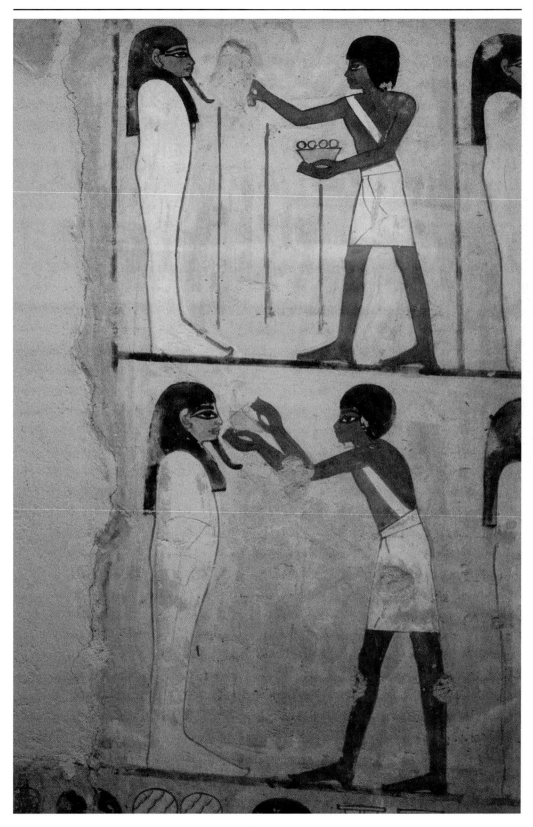

Figure 76

Figure 77

Sennefer

<div style="text-align: right;">TT 96</div>

SENNEFER WAS MAYOR of the "southern city," Thebes, during the reign of Amenophis II. He and his brother Amenemope (TT 29), vizier of Upper Egypt, may have grown up together with the prince who eventually became king. In later years, the king did not forget the comrades of his youth, offering both of them lucrative offices. One generally has the impression that Amenophis II gave more weight to personal relations and ability than to origin and connections. It is striking that Sennefer's father is named without a single title, hinting that he must have come from the lowest social classes. The Egyptians had such a passion for titles that they usually mentioned every single title held during one's lifetime, including even the most insignificant offices, in long chains. We know, however, that this Ahmose, called Humy, whose tomb (TT 224) is known, later actually managed to become overseer of the queen's harem and tutor of princes. Nub, his wife and Sennefer's mother, was a lady of the court.[1]

The names of Sennefer's parents and of his wife Senay (also Senet-nay), a royal milk nurse, are found only in the upper rooms of the tomb. The wife named in the burial chamber is Merit, "the great chantress of Amun," and in the antechamber leading to the burial chamber is another wife, Senet-neferet. In addition to these four names, Senet-mi and Senet-em-iah also appear, once each. Except for Merit—meaning "beloved"—all of these names are formed with *senet*, "sister," which could also mean "spouse." It is thus probable that all of these various names actually refer to one woman, as so many wives would have been improbable in Egypt, despite the high mortality rates. Merit, the "beloved," is used for his wife as the divine beloved and is thus not yet another wife. She had a very special role in the rebirth of the dead in the Beyond. There are some who conjecture that Merit was Sennefer's first wife, however, and that he only married

Senet-neferet after Merit's death, when the burial chamber had already been decorated. It is possible that Sennefer's own name, meaning "good brother" or "good spouse," induced him to change his wife's name to form the feminine counterpart to himself. Or Dynasty XVIII may have had some special systems of belief concerning the names in the burial chamber. The tomb is one of the few Dynasty XVIII tombs with a decorated burial chamber, and this peculiar feature may have led to some of the confusion.[2]

The tomb has been known at least since 1826. In that year, the Englishman Robert Hay of Linplum copied the tomb decoration; his copies are in the British Museum today. The tomb was also known to the German Egyptologist Lepsius, who traveled in Egypt and the Sudan during the 1840s at the behest of the Prussian king. It was finally published by the Frenchman Philippe Virey in 1898. None of these early scholars mention any grave goods. It is possible that Sennefer received an unusual favor from the king personally and was allowed the extraordinary privilege of being buried in the empty tomb of Tuthmosis II in the Valley of the Kings; vessels with the names of Sennefer and his wife—the royal nurse Senetnay—were found in tomb KV (King's Valley) 42. Tuthmosis II had already been buried in another tomb at this time. It is not certain that Tuthmosis II was ever buried in the tomb that he had excavated for himself, and so this burial in a second tomb, which is unknown to us, may not have entailed a second burial.[3]

As the modern entrance to Sennefer's tomb leads directly to the burial chamber, the upper rooms of the tomb are inaccessible to visitors today. His biographical inscription is in this upper part:

> I reached the revered state of old age under the king while a confidant of the Lord of the Two Lands: my excellence was recognized by the king. He knew my beneficent performance in the office he placed under my charge. He investigated in every way, but he found no evil deed of mine. I was praised because of it. . . . He placed (me) above the highest, as the great chief of the southern city, overseer of the granaries of [Amun], overseer of the fields of [Amun], overseer of the gardens [of Amun], High Priest of [Amun] in Men-isut (the mortuary temple of Queen Ahmes-Nefertari), the mayor Sennefer, justified before the great god.[4]

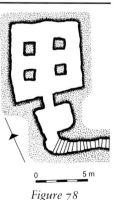

Figure 78

A steep stairway leads to the antechamber and burial chamber, which were—exceptionally—both decorated, in Sennefer's tomb (fig. 78). Although painted, like the ceiling, the walls were plastered with a layer of chaff-tempered Nile mud, which was not evened out. Topographic conditions prevented the tomb from observing the east-west orientation, and thus the cardinal

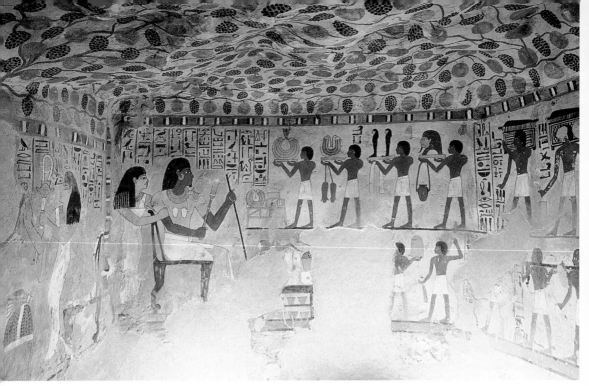

Figure 79

directions observed in the decoration are fictive. The upper rooms are inaccessible, however, and thus the unusual burial chamber is the center of attention. Given its role, the decoration of the burial chamber was funerary in character. The inaccessible and heavily damaged upper rooms had the usual repertoire of scenes such as the banquet, harvesting, or the harvest festival honoring the serpent-formed harvest goddess, Renenutet, themes familiar from other tombs.[5] What is accessible today in Sennefer's tomb is precisely the part that was inaccessible to visitors and relatives in antiquity, while what is today inaccessible was the part they visited.

The architectural form of a burial chamber with four pillars was borrowed from the royal tombs. This is related to changes in religious beliefs that had already been realized in the royal domain and were just reaching the private sphere.[6] The pillars are now behind glass, due to protective measures in the burial chamber which considerably reduces the space in the room; the dusty glass is also an obstacle to appreciating the bright colors.

While the representations on the walls and the four pillars are quite conventional, devoid of exceptional features, the decoration of the tomb's ceiling in both of the subterranean chambers is absolutely singular. Sennefer's was once called the "tombeau des vignes," the "vine tomb," because the visitor has the impression of standing in a grape arbor (fig. 79). Wine is closely associated with Osiris, who was "lord of Drunkenness at the *Wag*-Festival." This festival was celebrated at the season of the grape harvest, shortly before the inundation. This

symbolized the return of Osiris and that of the ancestors. Osiris was originally
a vegetation god and thus closely associated with the renewal of the land (see
p. 95).[7]

The ceiling on which the grape arbor was painted is not even and is in fact
quite irregular, rendering the decoration even more charming. Vines even hang
into Osiris's shrine in the burial chamber. As the dark grapes were painted with
bold but light and vivacious strokes, small details—such as the red tendrils—
were not omitted. Extremely unusual however is the vulture of the goddess of
Upper Egypt, Nekhbet, who spreads her wings among the vines. This motif actu-
ally belongs in a royal tomb, whence Sennefer has borrowed it. A geometrical
carpet design replaces the vines in the middle of the burial chamber.

Standing on the left wall of the antechamber is Mut-tui, offering her father
two necklaces, along with a heart amulet that was probably made of lapis
lazuli (fig. 80). On the day of judgment, the heart has to account for the deeds
of the deceased. For the Egyptians, the heart was not merely an organ, but the
home of all feeling, incorporating spirit and will. The gods conveyed their
instructions to people through the heart. "Narrow of heart" and "wide of
heart" are common Egyptian expressions, in the same way that we say that some-
one is "openhearted" or a "heartthrob." In old age, the heart becomes "weary."
Given the significance assigned the heart (which can only be noted in passing),
it is hardly surprising that the heart testified as the witness of truth before the
tribunal of the dead, and that it was left in the corpse when all the rituals were
completed.[8]

The tomb-owner's short beard is that usually worn by private people. He
is wearing a white kilt covered with a transparent garment, allowing the skin
to shimmer through. The *sekhem*-scepter in his right hand is a symbol of his high
rank. Behind the daughter are five priests in two rows. The ones in the upper
row are holding "pure breads of Amun of Karnak, of Atum-Re, of Osiris, of Anu-
bis, of Hathor for the *ka*-soul of Sennefer." In the lower row they are bringing
torches, strips of cloth, and a haunch of beef. The third priest has an incense ves-
sel and is probably pouring myrrh onto the small altar. To the right of the entrance
the deceased was shown doing something that can no longer be deciphered. To
the left "he enters in peace into the Realm of the Dead" wearing his best party
finery and jewelry again. Two rows of servants are bringing various pieces of funer-
ary equipment. They are headed toward the couple to the left of the observer:
"his beloved daughter, the Chantress of Amun Mut-tui" is tenderly embracing the
deceased (see fig. 79). She is standing in a tight white dress with shoulder straps,
behind her father who is seated on a chair. She is wearing a wig, as was usual,
as well as a broad necklace. Sennefer has the official's short beard; around his
neck is the gold of honor, a distinction awarded to deserving officials and offi-
cers by the king. His festival dress includes both a wig and earrings, as well as

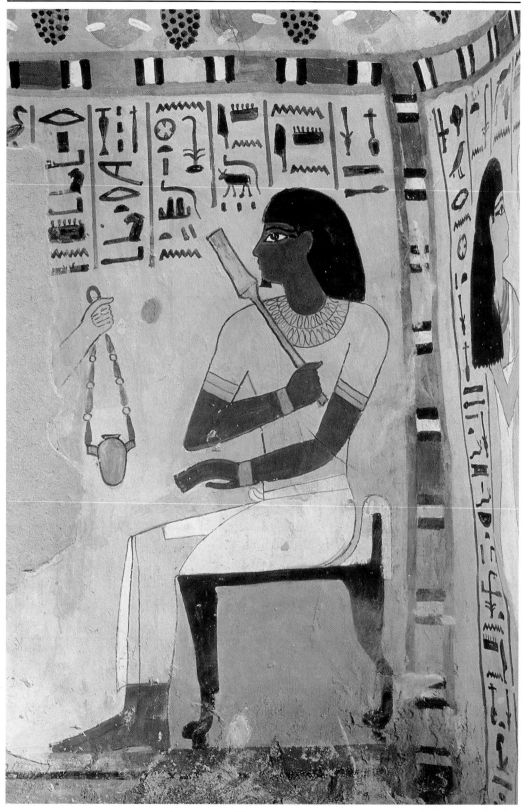

Figure 80

the *sekhem*-scepter in one hand, along with his staff in the other. An amulet in the form of a double heart is hanging around his neck.

The accompanying inscription reads: "An offering which the king gives, Amun-Re, the Lord of the Thrones of the Two Lands (the name of Amun-Re of Karnak), Osiris, the great god, the Lord of Eternity, Anubis, Imiut, Lord of *Ta-Djeser:* may they let the *ka*-soul of the one praised by the great god, the Mayor of the southern City, Sennefer, justified, come and go in Rosetau." Rosetau was originally the name of the Memphite necropolis but later came to signify a specific part of the Netherworld; *ta-djeser* means literally "sacred land," which refers to the necropolis, particularly that of Abydos.[9]

The two groups of bearers approach in two registers, but the lower one is destroyed (see fig. 79). The upper group bears two pectorals (one of gold and one with faience beads), a pair of sandals, two ushebtis, a strip of cloth, a mummy mask, and a heart amulet on a string. Sennefer's name and title are above one of the bearers. The register is divided by two vertical lines reading: "Leading all the good things into the tomb, as is done for the first friend, the mayor of the southern city, praised by the good god (king), Sennefer." Two finely worked caskets follow. The offerings would then be placed on a table before the deceased.

In the lower register, a priest is making a libation offering before a generously laid table, toward which offerings are being carried: a basket, vessels with ointment, an amphora, and, at the far right, a bed, Sennefer will require all these in the Beyond.

Again dressed in their best festival attire, the deceased and his wife Senet-neferet appear on each side of the passage into the burial chamber. The image on the left has been slightly damaged: Senet-neferet, the royal nurse, is holding a sistrum and a *menit* (fig. 81). The image on the right is remarkable in that an empty cushioned chair stands behind the couple. Has Sennefer just gotten up to go through the gate into the burial chamber and thence to eternal life?

The reliefs of the passage leading into the magnificently painted burial chamber are unfortunately rather heavily damaged. The doors of the passage were framed by two columns of text with the conventional offering formulas, naming the divinities of Thebes and the realm of the dead. Vines wound around everything and extended halfway into the next scene, establishing the connection between the two (figs. 82 and 83). Above the door are two Anubis jackals enthroned on pylons, between which was a tall altar with lotus blossoms (see fig. 82, pp. 249–250, and fig. 177).[10] These two jackals guarded the necropolis, and the tomb in particular, and they lead to the tomb-owner and his wife, who walk toward them to the left of the door on their way out of the tomb. Both of the deceased are richly bejeweled and hold symbols of their ranks in their hands (see fig. 83). He has a long staff and a small cloth; she has her sistrum and *menit*. "His beloved wife (literally, 'sister') whose place is in his heart, the Chantress of Amun,

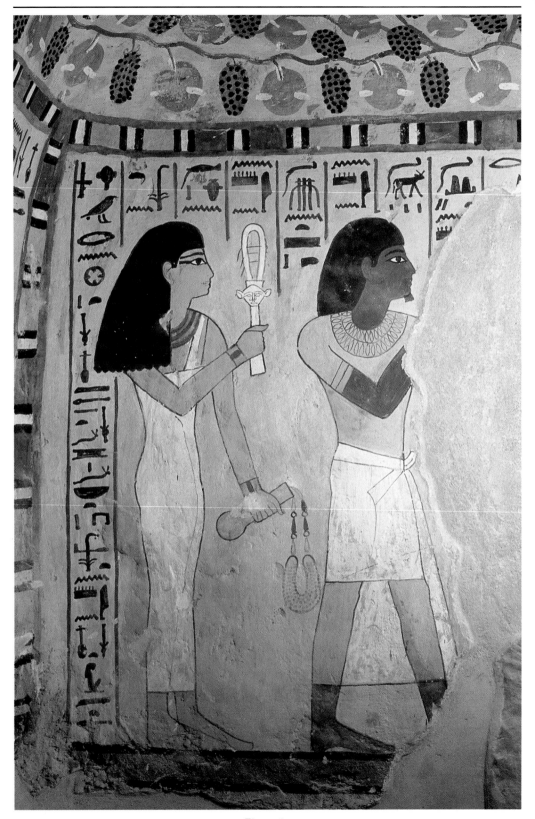

Figure 81

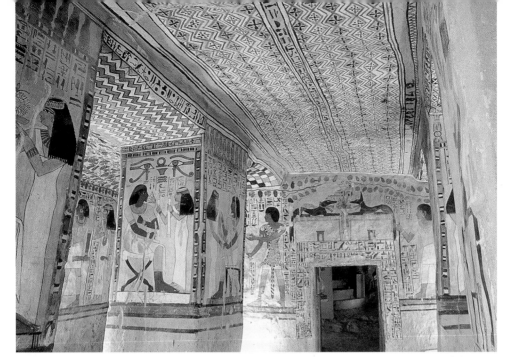

Figure 82

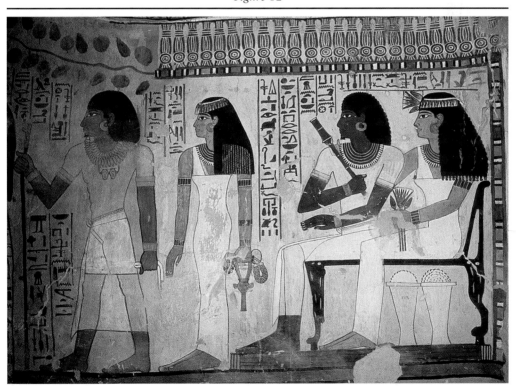

Figure 83

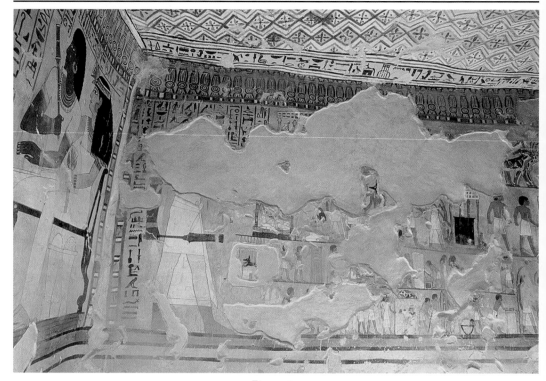

Figure 84

Merit, justified." Beside the couple's names and titles, the line of text in front of Sennefer refers to "Going Forth to see the solar disk (Aten) every day, and to wander on earth daily." This is at once the end and the quintessence of the funerary rites. The deceased is now able to step out of the tomb, to sacrifice before Amun-Re. He participates in the daily offerings made in Karnak in the form of his statues set up there.[11]

In the adjacent scene, Sennefer and "his beloved wife . . . Merit" are seated on a couch with lion's feet, itself placed on a reed mat (see fig. 83). Both are dressed in festival apparel with jewelry and symbols of rank. He has his *sekhem*-scepter. Merit embraces her husband as a sign of marital alliance; in her hand is a lotus blossom, the symbol of rebirth (see pp. 30, 34, and 278).[12] Beneath the couch are two tall vessels; as the left one bears the hieroglyph for "gold," the right vessel could have been silver. The text in front of the couple has the usual offering formulas. The scenes are capped with a *khekher*-frieze.

The left wall is unfortunately very badly preserved, but it has some interesting details (figs. 84 and 85). At the extreme left, Sennefer is striding "into the beautiful West." In reality, however, the entire funerary procession is on the south

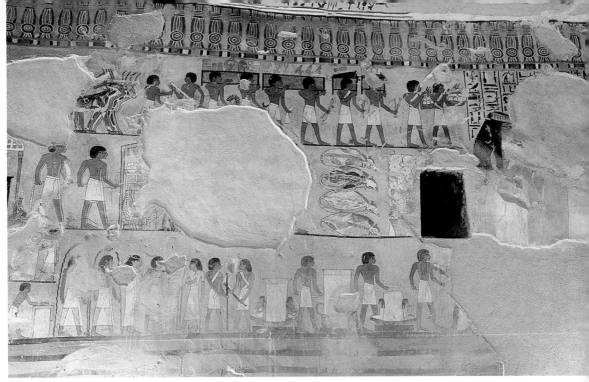

Figure 85

wall. In contrast to the scene beside the entry, here the tomb-owner is going into the tomb. Unfortunately, only traces remain of the torso, so that only the lower part of the torso, legs, and right forearm with the *sekhem*-scepter are preserved. He is supposed to be dead here, as he "follows the transport of (his) coffin." The revitalization has therefore not yet occurred.

The funerary procession is depicted in three registers, before the tomb-owner. At the top on the left (see fig. 85) are the four oxen that once towed the sarcophagus, which is lost today. The tow rope once attached to the sarcophagus can still be seen wound around the oxen's horns. Traces of the hands of the wailing women can be made out behind them; in front are the men with offerings (see pp. 52–55). On their shoulders are various caskets with their contents shown in detail so that these too would exist in the Beyond: pectorals, sandals, kilts, and emblems. In their hands, the bearers have fans, a headrest, strips of cloth, a bow and arrows, axes, and the symbols of rank, the scepter and flail. The weapons were supposed to be used to protect the dead from enemy demons. The food bearers appear at the very front.

It is probable that the second register showed, on the left, Sennefer and his wife on a boat traveling to the necropolis. In front of them are sleds bearing the divine figures and the canopic shrine. Among those being towed is the jackal-headed Anubis, receiving incense offerings. As the lord of embalming and the watch hours, Anubis played an important role in the funerary rites. On the far right are four sacrificial cattle and other food offerings.

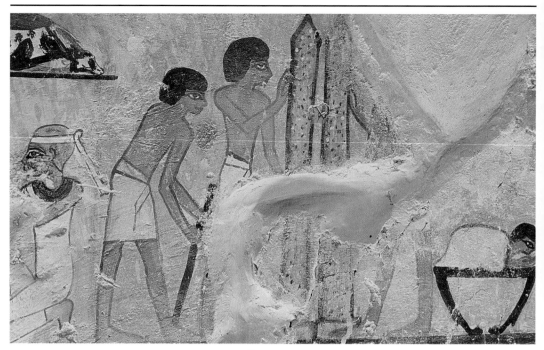

Figure 86

The scenes below this have been interpreted as the "Buto Burial."[13] This ancient ritual was supposedly performed for the predynastic rulers of the Delta, but the Delta city of Buto was rapidly reduced to no more than the symbolic ritual center. Originally only a royal prerogative, after the Fourth Dynasty these rites were usurped by private people, and their real meaning was gradually lost in the course of time. Among the rituals is the purification scene, already seen in Ramose's tomb. The two registers show dancers who usually wear tall crowns (although not here), the *muu*-dancers identified as the ancient kings of Buto, incense burning, offerings, the *tekenu,* and the erection of two obelisks (fig. 86).

The arrival in the Beyond is shown with Sennefer and his wife making offerings and gestures of adoration before Osiris, the god of the dead, and the mistress of the West, who are unfortunately almost impossible to recognize today. The sign for "west" on the goddess's head can just be seen. Above these two is the Nekhbet-vulture mentioned earlier (fig. 87).

The adjoining rear wall of the tomb shows the offerings for the dead (fig. 88). In three registers, priests present the deceased with *hes*-vases used for purification, torches, and censers. The tomb-owner is before a table, seated on a chair beneath which are a table and a casket inscribed with blessings. This signifies a

Figure 87

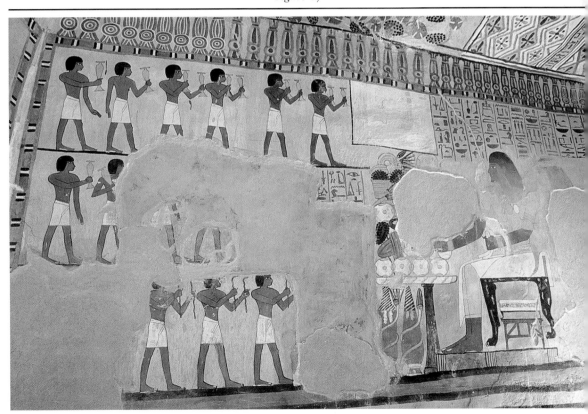

Figure 88

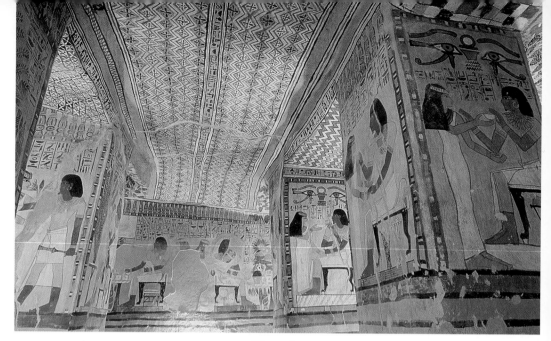

Figure 89

board game called *Senet,* the game of passing through," which had been imbued with religious significance since Dynasty XVIII. If one can beat the invisible partner, rebirth, prosperity, and provisions are assured in the Beyond.[14]

In the adjacent, antithetical, scene on the right, Sennefer is seated on a lion-footed chair (fig. 89). As in the scene just mentioned, Merit, who was standing behind him, has been almost totally destroyed. In front of them is the table heaped with foods found in every tomb: vegetables, cuts of meat, grapes, and so on. Below the table are various vessels, probably for wine and oil or beer. The heads of lettuce beside these vessels belong to the ithyphallic fertility god Min and symbolize the recovery of the reproductive capacities (see p. 68). Beneath the chair is a giant ointment vessel and a mirror, like those seen in museums today. Along with its role in cosmetics, the mirror also had a symbolic meaning: its ability to reproduce gave it associations with renewal and life.[15]

To the right in the two upper registers is the voyage to Abydos (fig. 90). The watercourse on which the boats are sailing is clearly drawn. The upper one, the cult bark, is being towed to Abydos by a rowboat.[16] The cult bark's rudder is richly ornamented. A pilot is on board, along with the priest holding a libation vessel and presenting offerings to the deceased. The inscription above the priest notes that an offering should be given "twice pure to Sennefer who has become Osiris." The dead, or rather their statues, are seated beneath a baldaquin in a small pavilion inscribed with their names and titles in front of and above them. From Thebes they had to float with the current northward to Abydos, but rowing against the prevailing north wind; the return voyage was made under sail, as the picture below shows. Sennefer and Merit are not here because they did not go living, and they stayed in Abydos. And that is why the cult bark and priest

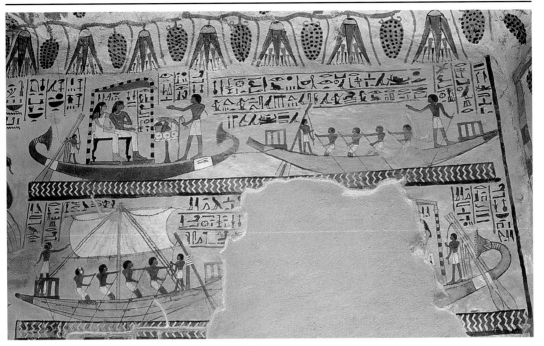

Figure 90

are also absent. In reality, the voyage was probably undertaken within the The-
ban necropolis, and thus probably not to Abydos. The journey to Abydos was
the wish of every Egyptian: to be buried here, to participate in the mysteries and
the holiness of the main cult center of Osiris, the god of the dead. The interest
in Abydos had grown since the closing years of the Old Kingdom when the Osiris
belief began to spread. Scenes of the voyage to Abydos are common in New King-
dom tombs; it had become an integral part of the funerary rituals.

The accompanying inscriptions on the cult bark name the usual offerings.
The text above the boat describes what is going on: "Sailing north in peace to
Abydos, to conduct the festival of Osiris by the mayor of the southern city, Sen-
nefer. Landing at the temple of Osiris, that I may be in the following of the gods,
and stride in the *Neshemet*-bark together with the great god." The caption for
the lower bark runs, "Coming in peace" and so on.

Virtually nothing remains of the lowest register. It is probable that Sennefer
and his wife returned to the necropolis as statues borne on sleds.

On the right wall, Merit has hung her sistrum over her arm and, together
with Sennefer, she worships the gods of the dead, Osiris and Anubis (fig. 91).
Both are seated in a shrine into which vines are hanging. The two chairs are on
a reed mat and were once identical, with the symbol for "unite" on their sides,

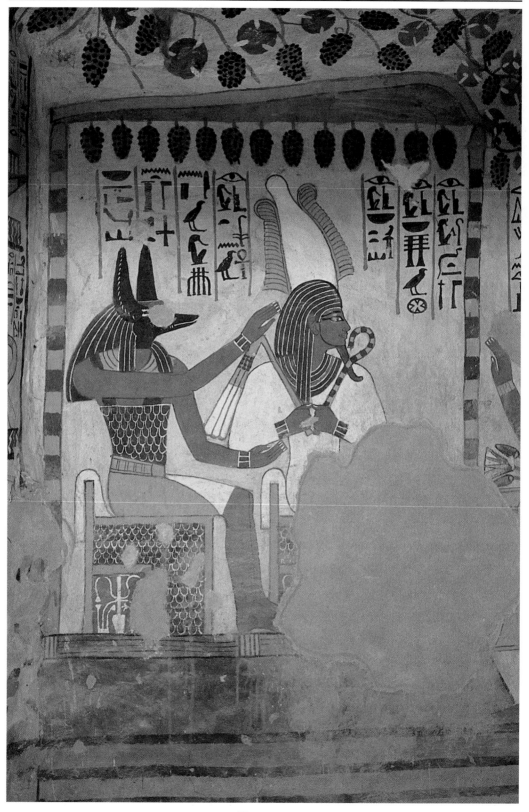

Figure 91

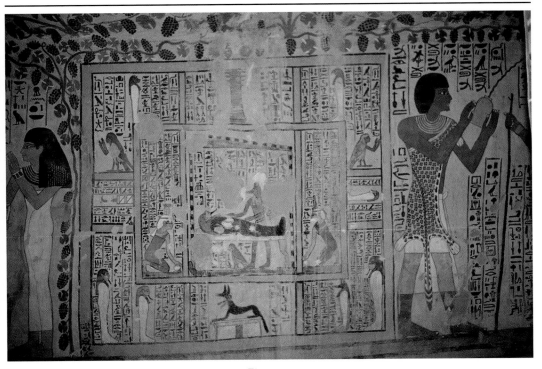

Figure 92

suggesting that they were copies of the royal throne. Osiris is depicted as usual, purely human in form with the *atef*-crown on his head and the shepherd's crook and flail in his hands. The gods are labeled as "Osiris, Lord of Eternity, the great god, Osiris, the Lord of Buto (in the Delta), Osiris, Lord of the West, Osiris, King of the Living (meaning 'the dead')," and "Anubis, foremost in the divine hall, Imiut, Lord of *Ta-Djeser*." In front of Sennefer: "Adoring Osiris, kissing the earth before Imiut, the Lord of *Ta-Djeser* by the Mayor Sennefer, justified." In the context of these funerary scenes, the deceased Sennefer is thus magically introduced into the world of the Beyond, being accepted by the gods of the West: Osiris, Anubis, and Hathor.

Sennefer did not want to do without the Book of the Dead, a collection of funerary spells intended to aid in entering the Netherworld and in rebirth (fig. 92). Spell 151, "the spell of the head of mystery," is painted on the wall, in a large square frame, with a smaller rectangle within it, just as in contemporary Book of the Dead papyri. In the middle of the inner rectangle is "Anubis the embalmer, Lord of the Divine Hall," laying his hand on the deceased as a mummy on the bier, within a shrine. As the deceased has become Osiris, "his" sisters Nephthys and Isis are in mourning at his head and feet, respectively.[17]

Beneath the bier is the *ba*-power. *Ba*-power birds can also be seen just above, on the far right and far left, in a gesture of adoration, with human hands. The arrangement of the whole composition is quite correct. The *ba* on the east side is turned to the East: "The living *ba* of the excellent deceased . . . justified before Osiris, praying to Re at his rising in the east horizon of heaven."[18] The *ba* on the left is the corresponding living *ba* "presenting a prayer to Re when he sets in the west horizon of heaven, day for day." Below the *ba* facing east is a mummy lying prone, and a flame is beneath the *ba* facing west.

The four children of Horus are arranged exactly according to the rules, outside the four corners of the inner rectangle. They are iconographically recognizable: the ape-headed Hapi, the hawk-headed Kebeh-senef, the jackal-headed Duamutef, and the human-headed Amset, but their names have been confused in the text (see p. 53). Two ushebtis are standing in the bottom corners on the right and left. A *djed*-pillar, symbolizing Osiris and durability, is at top center. Symmetrically at the bottom in the middle is a jackal, symbolizing Anubis, on a pedestal. On the left, a torch can be distinguished.[19] On the right is a mummy, or an ushebti, as is occasionally stated.[20] These four protective objects must be understood to have been concealed in four bricks, which protect the tomb to the west, east, south, and north, in the prescribed order. During Dynasty XVIII, the amulets were frequently placed in tombs; four small niches were made just above the floor of the burial chamber for the purpose. The niches were closed with a magical brick after the amulet was safely inside. Three of these niches are probably still concealed in the tomb of Sennefer, as only the one on the south side has been found and opened.[21] The niches were more numerous in the Ramesside period and contained figures of gods and demons as well.[22] Spell 151 of the Book of the Dead provides a commentary on the things depicted.[23]

In the next scene, Sennefer and his wife Merit are purified by a *sem*-priest using a *nemset*-jar (fig. 93).[24] The couple are dressed in their finest attire and jewelry. The deceased is wearing a double heart amulet in this scene too. A later visitor has inscribed the name "Alexander" in hieroglyphs on the right heart, showing that the tomb was visited many centuries after it was completed. Sennefer is holding stalk and lotus-blossom bouquets, and his wife has her sistrum and a blossom, as well as a *menit*. The inscription in front of Sennefer reads: "Coming in peace by the mayor of the southern city, Sennefer, justified, accompanying this august god, Amun, Lord of the Thrones of the Two Lands, when coming forth from Karnak to rest in Henqet-Ankh (the mortuary temple of Tuthmosis III), his heart joyous following his lord to rest in the interior of his tomb, your (actually, it should read 'his') house of eternity."[25] This is clearly a reference to the Beautiful Festival of the Valley.

And in front of Merit: "Coming in peace to make praise in the house (meaning 'temple') of Amun by the Chantress of Amun, Merit." The text above the

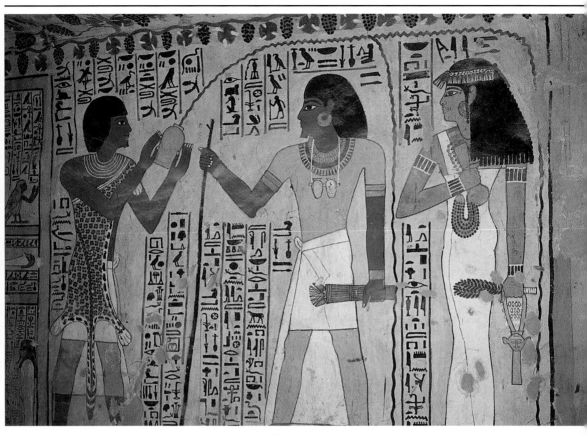

Figure 93

priest says: "your purification, your purification," "to be repeated four times"
for Horus, Seth, Thoth, and Sepa, the name for the centipede in Egyptian. The
god of the same name was frequently addressed in incantations against evil ani-
mals; since the beginning of the New Kingdom he is associated with Osiris.[26]
And there is a note that the recitation is "to be repeated": "The purification of
the Mayor Sennefer who has become Osiris in his house of Justification, his beau-
tiful place of eternity." That this purification symbolized the ritual ceremony of
the Opening of the Mouth—or rather the beginning of that ritual—can be read
in the text before the *sem*-priest: "He (meaning the deceased or his statue) is placed
on the sand floor in the House of Gold, facing south, naked on the earth, on that
day when the clothes are behind him."

At the right wall of the entry, one of their sons, dressed as a *sem*-priest,
burns incense and makes a libation offering for his parents (fig. 94). The offi-
cial leopard-skin uniform is painted with care for detail. In his hands are a censer

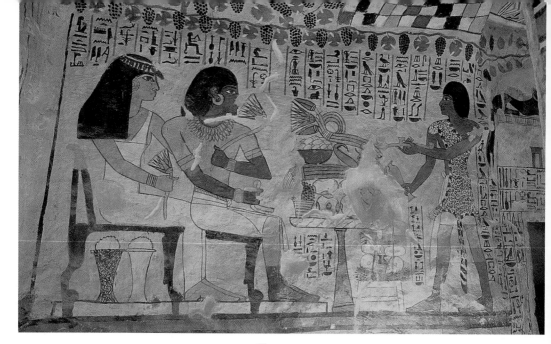

Figure 94

and *hes*-vase for libations. He pours the water onto a low table heaped with food beside another tall altar which is also generously provided with various kinds of food. Between the priest and the table is a vertical line of inscription: "1000 breads, 1000 beers, 1000 cattle, 1000 fowl, 1000 of all good and pure things for your *ka*-soul." A long inscription begins in front of the priest and continues behind him, explaining the scene: "Performing libations and burning incense. This is your libation, mayor of the southern city Sennefer justified, who has become Osiris. This is your libation. You go forth to Horus, you go forth to your son. I am come. I have brought the eye of Horus. Your heart is cool (meaning 'satisfied') with it. I have brought this for you, beneath your feet, under your sandals."

The scenes on the four pillars must also be understood as part of the funerary rites (see figs. 78 and 82). The description goes clockwise around each pillar. On the pillar on the left, Merit offers her husband a vessel with myrrh or another aromatic (fig. 95). Both are dressed and bejeweled as for a festival. Although standing, Merit is still shorter than her husband, as he is the main figure in this picture. The text says: "An offering which the king gives, Anubis at the top of the divine hall (meaning the embalming hall). May he give everything which comes to his table for the *ka* of the Mayor Sennefer, justified."

The next scene, where Merit offers a fruit platter, is similarly constructed (fig. 96). In the following scene (fig. 96), Merit brings Sennefer lotus blossoms on the occasion of the Valley Festival. The richly bejeweled tomb-owner is wearing the short beard of the official and enjoys the fragrance of a lotus blossom. A little woman seated on a mat is grasping his knee. This may have been a daughter, and she too has a lotus blossom in her hand. The inscription lists

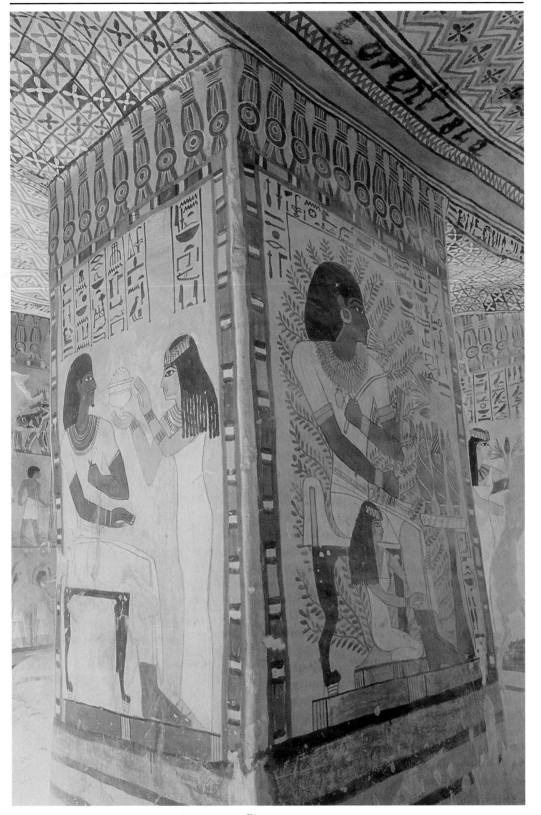

Figure 95

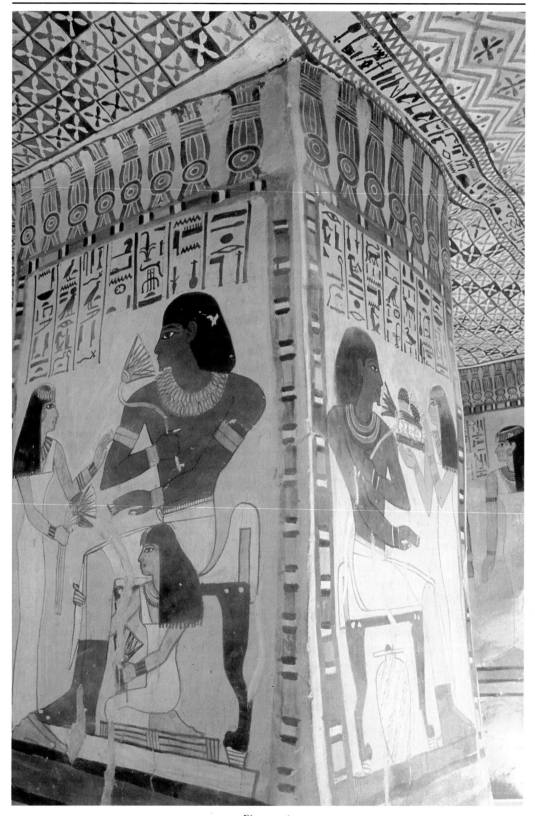

Figure 96

only the names and titles of the husband and wife. Sennefer is designated as the "Overseer of the Gardens of Amun" in one instance.

In the final scene on this pillar, the deceased is seated on a chair in the Ished-tree, with his wife seated at his feet on a mat, and embracing his calves (see fig. 95). Thoth, the god of writing, wrote the regnal years of the kings on the leaves of the *Ished*-tree, but the motif was also adopted by private people. The symbol was a guarantee of eternal life.[27] The couple is dressed for a banquet, with jewelry that includes the diadem of blossoms, earrings, and a heart amulet as well as symbols of their ranks. In one hand, Sennefer is holding a lotus blossom, which he is sniffing. As usual, the chair is placed on a mat, but Merit is kneeling on her own small mat. The table in front of the pair supports a number of tall vessels. The scene is closed with a *khekher*-frieze at the top.

On the rear pillar on the left, the first scene also belongs to the Valley Festival, with Merit handing lotus flowers to her husband (fig. 97). Exceptionally, Sennefer is also standing in this scene. And again, he has a double heart amulet hanging around his neck. In the next scene, Merit is holding a sistrum to her husband's nose, and a small daughter may be standing behind her (fig. 98). The next scene, in which Merit presents Sennefer with what may be a vessel of myrrh, is very heavily damaged (fig. 98).

In the final scene on this pillar, Sennefer—together with his wife, again much smaller and seated on her own low stool—worships the tree goddess, who is identified as Isis in the text (see fig. 97 and pp. 258–259). She offers food to the deceased and thus provides for his daily needs. At the top, the scene is closed by two Anubis-jackals lying on pylons, symbolizing the entry to the tomb.

On the front right pillar, Merit is bringing her husband a drink in a bowl (see fig. 89). The two touch one another gently, a symbol of the act of making love, begetting, which is part of life in eternity. Above the couple are the protective *udjat*-eyes, between which is the symbolically protective *shen*-ring, a *nun*-dish, and three water lines. According to mythical tradition, the *udjat*-eye is the sound eye of Horus, restored by Thoth after the god Seth injured it. Horus was a sky-god of the heavens; the sun and the moon were considered to have been his eyes. The *udjat* eye may be associated with the moon, which wanes and waxes until it becomes full. Having recovered, it became a healing symbol and the image of the power of Horus, who overcame all attacks. *Udjat*-eyes thus acquired amuletic character and are themselves a favorite and common form of amulet in ancient Egypt, and the Mediterranean.[28]

In the next scene, Merit is standing in front of her husband, touching him at the elbow, and he strokes her upper arm, while each grasps the other's other hand (see figs. 82 and 89). Again, this symbolizes the act of love. Sennefer has his double heart amulet, with the name of Amenophis II. Beneath the couch are two tall vessels with aromatics.

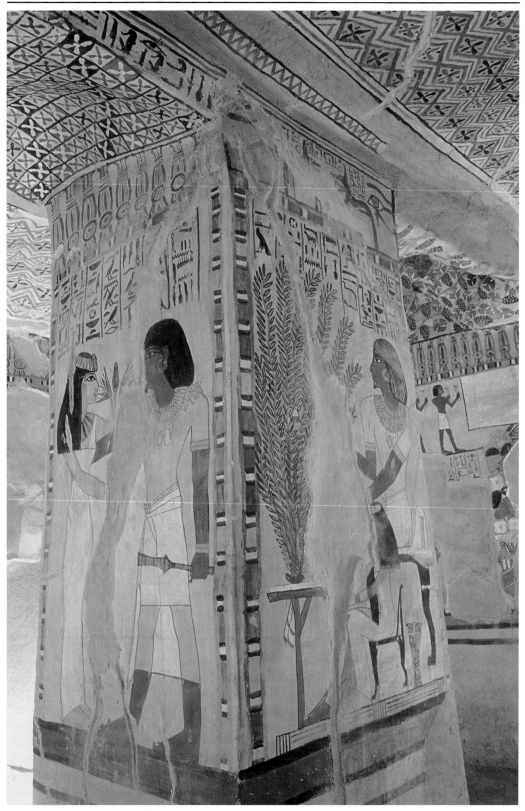

Figure 97

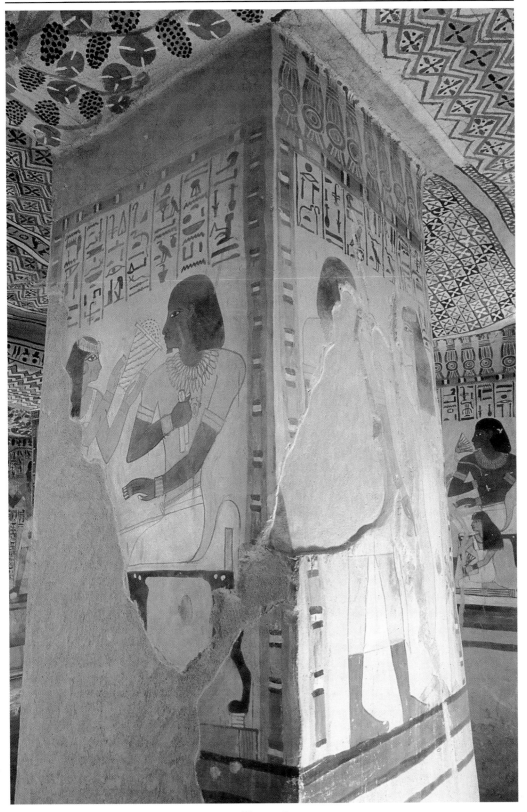

Figure 98

In the third scene, Sennefer is seated in a lion-footed folding chair, enjoying the fragrance of a lotus blossom. Merit is standing in front of her husband, passing him two strips of cloth (see fig. 82). Two *udjat*-eyes close the scene at the top of the pillar, with the *shen*-ring and *nun*-dish with water lines. This scene also symbolizes the act of love.

The scene on the fourth side of this pillar, in which Sennefer stands upon a hill of sand in the form of the hieroglyph for "mountain," belongs to the ceremony of the Opening of the Mouth (fig. 99). In front of him is a heavily damaged but originally personified *djed*-pillar, the symbol of stability. Four small priests perform the *henu*-gesture of jubilation, originally intended as a greeting for the waking, newly born sun god. Here, the action is directed at the awakening of the statue.

On the right rear pillar, Merit is offering her husband a bowl (figs. 89 and 100). The fingertips of her left hand graze his thigh. He is holding a lotus bouquet in which a mandrake—a symbol of love—has been bound.[29] This again symbolizes the act of love, embodying reproduction and continued life in the Beyond. The text suggests that the deceased's *ka* "have a nice day."

In the second scene on this pillar, Sennefer is presented with a necklace, probably the "neck ornamentation of Horus" mentioned in the Book of the Dead, giving the wearer protection (see fig. 100). With her right hand, Merit fingers the double heart amulet worn by her husband, "making the two hearts last," explains the accompanying text.

In the next scene, Merit brings her husband necklaces on a mat (fig. 101). As a pendant, a scarab, the symbol of resurrection, adorns one. Symbols of resurrection, revival, and life in the Beyond hang from the other. Sennefer holds his wife's wrist lovingly, while his feet rest on a low stool, below which is a small casket. The scenes are protected by the same symbols as the others.

The last scene is the performance of purification with *nemset*-jars as part of the ceremony of the Opening of the Mouth (see fig. 101). The deceased is standing on sand once again. Into the "mountain" hieroglyph, the hieroglyph for "festival" has been inserted. It also appears upside down three times above the deceased, as the purification had to be performed four times.

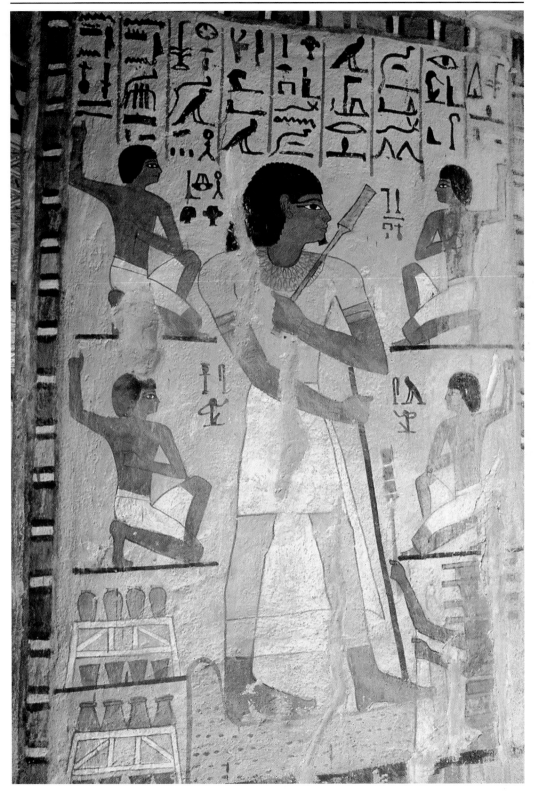

Figure 99

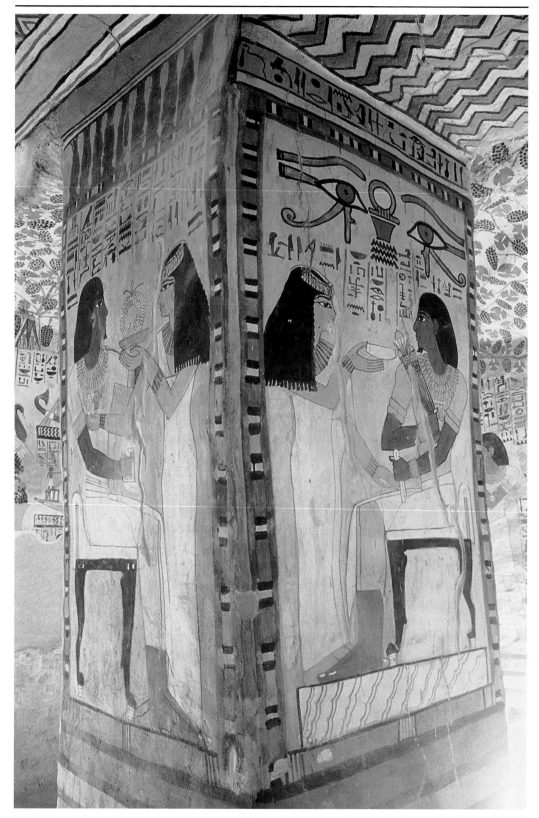

Figure 100

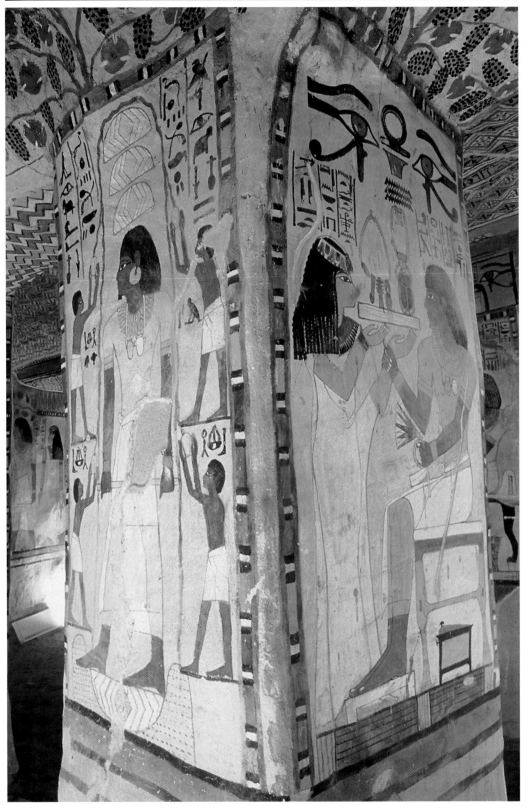

Figure 101

Rekhmire

REKHMIRE WAS VIZIER, the highest civil official of the land, under Tuthmosis III and Amenophis II.[1] The name means, roughly, "knowing like Re." His parents were Nefer-weben and Bet. His wife was named Merit. Both his mother and his wife bear the title *khekeret nisut*, "king's ornament," which has been interpreted as implying that they came from the palace harem. The title could have been ambiguous, however, occasionally designating a "concubine" and occasionally a "lady of the court." Regardless of the specific meaning, it reveals a favorable connection to the royal family or court. Such women sometimes came from the lower social classes, such as the families of soldiers. On occasion, the title was awarded to the wives of higher dignitaries, as in the case of Rekhmire's family.[2] The tomb-owner himself was the scion of an ancient family of officials: his grandfather, his uncle, and probably his father were all viziers. His name is effaced everywhere in the tomb, so it would appear that Rekhmire lost his job and royal favor during the reign of Amenophis II. His star may have fallen because of Amenophis II's policy of appointing his favorites to high political positions.[3] And this could explain why Rekhmire's burial chamber has never been found. It may have been very carefully destroyed to prevent the deceased from enjoying eternal life.

The tomb itself was known to the earliest visitors in Thebes. The first copies of its paintings were made by Robert Hay in 1832, and the decoration has not fallen out of scholarly sight since. It was made accessible and closed with a proper door in 1889.[4] The tomb was sunk into the southern end of the hill at Shaykh Abd al-Qurna, which was not part of the cemetery at that time (fig. 102). The high front is not very carefully done, as the natural cliff had to be complemented with an artificial wall. The interior is sufficiently spectacular to balance out this imperfection, however.

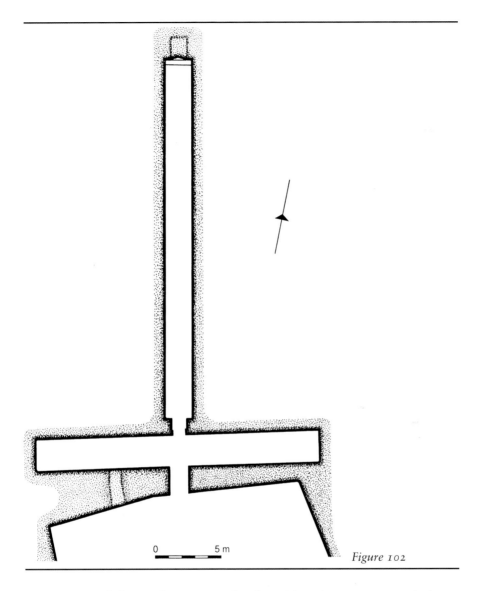

Figure 102

Because of the tomb's topographical position, it was excavated almost exactly north-south. The decoration does not correspond to the actual cardinal directions of the tomb, having been arranged as if the tomb was oriented from east to west. The "east" wall is thus really the *south* wall, the "west" the north, the "south" the west, and the "north" the east. In the following descriptions, the fictive directions will be employed and the cardinal directions ignored.

The long hall cutting into the mountain slopes upward at the same angle as the hill itself, so that the statue niche is about 6 meters above the courtyard. Like

the tomb of Ramose, this tomb was usurped; the southern part of the outer wall was damaged at that time.

The inner walls of the entrance passage are decorated with the usual prayers. The tomb itself is one of the most interesting of all the Theban tombs. Over nearly 300 square meters, the wall decoration has sacred and secular scenes and texts that make it incomparable to any other tomb. These enable us to learn about the career and responsibilities of the tomb-owner. Rekhmire celebrates himself: "I am the second noble of the king, . . . I was appointed priest of Maat. . . . Then praise of me was firm among the elevated and the joyous."

He records the king's words: "['My majesty] knows that the tasks are numerous and without end, words of justice do not fall to earth for him (who judges); if the utterances you make correspond to my speech, then Maat-justice will rest in her place.'" And then Rekhmire continues:

> He gave me a court under my authority . . . my decisions reached to heaven. . . . I satisfied him who desired, letting his need be accomplished. One said of me: 'Come,' they say, 'to restore the state of the two lands.' Every task for the welfare of the land: I awakened to perform it every day. . . . I did not allow evil to come in my wake. . . . I raised Maat-justice to the height of the heavens, and let its beauty circle through the breadth of the land so that she would be content with men's breath like the northwind warding off evil from the heart and body. I judged both the [miserable and] the powerful. I rescued the frail from the strong. . . . I protected widows who were without husbands. I secured the son and heir on the seat of his father. I gave bread to the hungry, water to the thirsty, meat, oil, and clothing to those who had nothing. I restored the aged, lending my staff, and thus made the old women say, 'This is a good deed!' . . . I did not suppress Maat-justice for money. . . . I judged the supplicant without placing myself to one side.[5]

When Rekhmire was installed in office by Tuthmosis III, the king said, among other things: "The (office of vizier) is the foundation of the whole land. . . . Look, it is not a pleasant office! It is as bitter as gall. Look! As for the official in public: water and wind report on all he does. Look, there is not one who does not know what he does. . . . Do not wrongly rage against a man. Let cause for anger anger you. Let yourself be feared, that one comes to you in fear!"[6]

The instructions for the vizier stated: "He [the vizier] is to be notified on time about the sealing of sealed rooms, and their opening. The state of the northern and southern fortresses is reported to him. Everything which leaves and enters the royal house is reported to him. Whatever enters into and exits from the region of the residence can enter or exit when his appointees allow it. The overseers of the hundreds and the administrators of the districts report the state of affairs to him."[7]

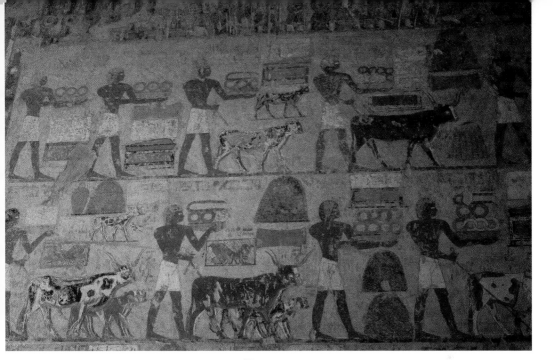

Figure 103

Precise guidelines follow for handling both secret and public documents required by the vizier, and instructions on property rights, and an explanation of the vizier's responsibilities for the royal house. It was also specified that "he is the one who makes the (higher) officials of Upper and Lower Egypt . . . reporting all events to him from their administrative districts on the first day of each of the three seasons of the year. They bring to him their documents in order, together with their colleagues. . . . He dispatches the magistrates of the rural districts to make weirs in the entire land. He sends the mayors and district officers to plow at harvest time. He names the supervisors in the hall of the royal house."[8]

Tomb decorations on both sides of the entrance of the tomb show the produce of Egypt being delivered to Rekhmire (fig. 103). All of the goods are taxes, whose receipt was a responsibility of the vizier. To the left, on the southern wall, are the products of Upper Egypt, south of Thebes. The introductory text reads: "Observing the counting: the accounts of the office of the vizier of the Southern City. Accounts . . . from the 'Head of Upper Egypt' beginning with Elephantine and the fortress at Biggeh."[9] The text to the right of the entrance on the northern half of the wall has the corresponding deliveries from the regions to the north of Thebes: "From the land of Coptos (north of Luxor) reaching to the land of [Assiut]."[10]

The five taxation registers on each side are unfortunately not well preserved. The deliveries from the south, in the upper register, include long-tailed monkeys, gold, cloth, cakes (the balls in the baskets), grain, and cattle. In the second register, there are various kinds of cattle, grain, and beads; honey; cages with about

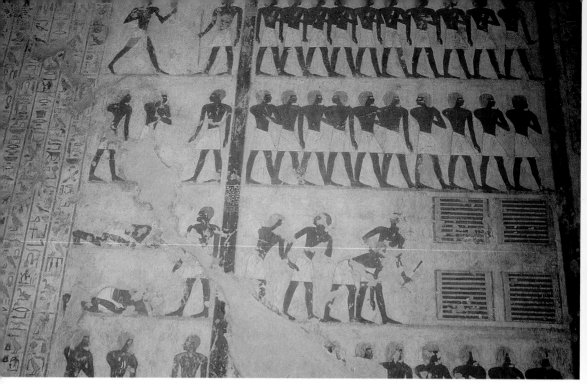

Figure 104

30 and 40 pigeons, respectively; as well as boxes with four-ply cloth. Similar items are being brought in the three lower registers, with the weighing of gold depicted in a heavily damaged scene in the fourth register (not shown).

The region to the north of Thebes sent similar products. Just how precisely it was all recorded can be seen in the second register of the taxation of the south. The "Scribe of reckoning income of Esna" noted "*Deben* gold, a half *deben* silver (ca. 45 gr.), a gold necklace." He is leading a short-horned *wendju*-cow with a calf on a line. He is followed by another bureaucrat, whose origin is illegible, with a basket full of gold rings and a box filled with four-ply cloth as well as two heaps of grain. The upper heap has "2 *heqat* (ca. 10 liters)," and the lower "1 *heqat* (ca. 5 liters)." This is followed by the "scribe of reckoning income in the 'Head of Upper Egypt,'" who has a heap of grain, a grass mat, two long-horned *nega*-cattle with five calves, a basket with 30 pigeons, a bead necklace, and gold rings which weighed two *deben,* according to the inscription.

Following the southern taxes are the "Instructions of the Vizier" already mentioned. Beside this text are the officials, supplicants, and tax dodgers who come to the vizier's court (fig. 104). The common people evidently had to wait outside the hall. From the long texts of the tomb, excerpts have been cited that explain what is going on in these various scenes. They also indicate the relative positions of the notables in the audience chamber. The four large rectangles are mats, and on each there are 10 red staffs. These may be the 40 *sheshemu*, the leather law-books, spread out in front of the vizier. The 40 *sheshemu* are assigned to

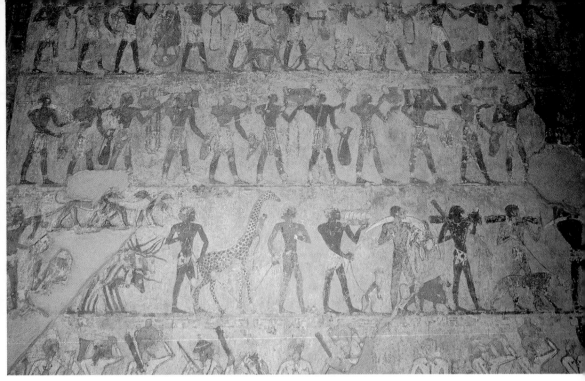

Figure 105

the 40 officials (although there are only 20 in the two upper rows in the picture), representing the 40 tax districts.

On the far right was once the seated image of the tomb-owner, which was hacked out. The only thing left is the reed mat on the floor where his "pet goose" stood. At the end is Rekhmire's autobiography.

Historically important is the detailed representation of the foreign peoples bringing their wares to Egypt (fig. 105). This follows on the southern part of the west wall, that is, the wall to the left, across from the entrance. Tuthmosis III was the founder of the Egyptian Empire, and his campaigns brought Egyptians into closer contact with foreign lands and peoples than ever before. The Egyptians had a gift for observing the typical, and these scenes display this talent to good effect, although it sometimes verges on the cartoonlike, with gentle humor immortalizing the "strange." Rekhmire receives the "tribute" of the foreign peoples, which is heaped up before him and is recorded by Egyptian scribes.

A caravan is approaching from Punt in the top register (see fig. 105). Punt was the most distant and mysterious land with which the Egyptians had contact and must have lain somewhere in the eastern Sudan or northern Eritrea. This, at least, is the origin of the products its people are bringing: myrrh, a myrrh-tree, ivory tusks, gold, precious stones, a cheetah, leopard skins, a hamadryas baboon, a small monkey, and ostrich eggs and feathers. The animal between the two monkeys is an ibex. Two small red-and-white-dotted obelisks stand out among the tribute, as they are made of incense. Did they actually choose this form, out of

homage to Egypt? The men are dark skinned, some with their heads shaven, some with a full head of hair, Egyptian style. They are wearing kilts alone, with the ends hanging down between the legs; the hems and middles are decorated with colorful stripes. The text notes that the prince of Punt is coming with his tribute, bringing it to the Egyptian king "for all foreign countries belong to his Majesty." Rekhmire had to receive this as he received the tribute of all the other countries.[11]

Beneath the tribute of Punt come the "Princes of Crete and the islands of the Mediterranean" (see fig. 105).[12] The chiefs are "bent and bowing before the might of his Majesty." They too have the typical products of their land, such as decorative vases, but also silver ingots, silver rings, and baskets of lapis lazuli, which they had acquired by trading with others. The vessels are mostly pitchers and drinking bowls, amphoras, and rhytons shaped like the heads of lions, bulls, and ibexes; they also have a sword and chains. These are all things that have actually been found in Crete.[13]

The people are strikingly light skinned with long, hanging braids; their fringed kilts are made of animal skin or colorful cloth and their decorated sandals bound with thongs. Although scenes of foreign tribute are common, this particular scene is historically interesting because only here were the Cretans repainted as Myceneans, for the Myceneans instead of the Minoans suddenly appeared in Thebes during Rekhmire's day. The Egyptians painted the Minoan kilts as if they were adorned with a phallus sheath, and thus they had to be changed into "Mycenean" kilts.

Taking account of previous research, the German Egyptologist Wolfgang Helck concluded that the tomb must have been completely painted when this transformation took place. Rekhmire appears in historical texts for the first time in regnal year 34 of Tuthmosis III, about 1445 B.C. He served only briefly under Amenophis II, as can be seen from the tomb itself, where the new sovereign is mentioned only twice, so the tomb must have been finished around 1426 when Tuthmosis III died. The repainting must have taken place around 1436–1426, indicating that the Myceneans conquered Crete around 1435 B.C. The Mycenean kingdom on the Peloponnesian Peninsula sent gifts under Tuthmosis III, and thus there was direct contact with Mycene without Minoan middlemen. Trade relations with Crete itself would appear to have ceased entirely shortly after Rekhmire's lifetime; they do not appear again among the foreigners bringing tribute.[14]

Below this register follow "the princes of the southern foreign lands, the troglodytes of the extreme south," meaning the inhabitants of Nubia and the Sudan (figs. 105 and 106). They are easily recognized, with their characteristic black skins, curly hair, and narrow kilts made of animal skins. Like their neighbors from Punt, they are also bringing the produce of nature. Dogs and *zebu*-cattle can be recognized, as well as a giraffe, with a monkey bounding up its neck. In front of these are a basket filled with ostrich eggs and feathers, a small grass

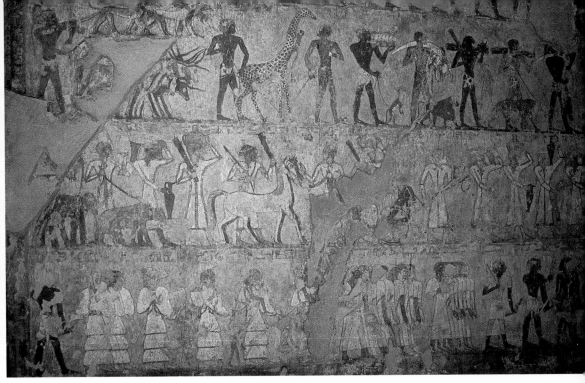

Figure 106

monkey, and a baboon. More monkeys are springing around on the elephants' tusks and the ebony. Animal skins, a cheetah, baskets with gold rings, and electrum can be recognized through the yellow and red bags lying side by side in the basket. These also belong to the tribute, along with the Nubian oil in the tall white jars, if they are correctly labeled. The baskets are filled with dark red grains and a green material, which may have been amethyst and malachite respectively. A monkey that looks as if it would have been capable of anything is perched atop the offerings being recorded by a scribe (fig. 107).

These southern products are followed by those from Syria, in the next register. "Bearing homage and coming with bowed heads are the princes of Retjenu and all the northern foreign lands reaching to the far north" (see fig. 106). They are dressed in long, white, long-sleeved garments decorated with colorful strips adorning the seams and hems. Some of the men have short hair while others would appear to have bound their disheveled hair with a headband. They are even more light skinned than the Cretans. The pointed beards typical of the Syrians can be recognized.

They are bringing a bear and an elephant (see fig. 106). The Syrian brown bear was only exterminated in the twentieth century A.D. The Syrian elephants probably died out during the first millennium B.C. The Syrian elephants were related to the Indian elephant, and the relative sizes of the animals in the picture need not be taken literally, but Tuthmosis III reputedly slew 120 of the creatures, which suggests that they were in fact both abundant and diminutive.[15]

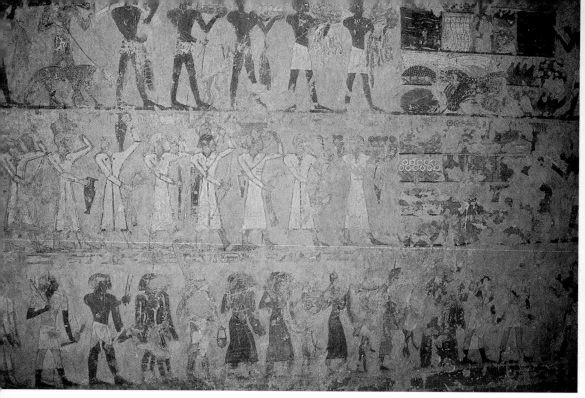

Figure 107

The Syrians' real tribute, however, consists of copper ingots, harnessed horses with a wagon, weapons such as swords and bows with quivers of arrows, along with finely worked vessels of metal, incense, oil, and perhaps honey.[16] They also have rings of gold and silver, which are piled in heaps that an Egyptian scribe is carefully registering (see fig. 107). The pottery depicted is used to calibrate dates in Syria-Palestine, where it is found in excavations, but the chronology has never been established with the same certainty achieved in Egypt.

Captives and hostages appear in the lowest register (see figs. 106 and 107): "[Presenting] the children [of the princes] of the southern foreign lands together with the children [of the princes] of the northern foreign lands, brought as prisoners of war by his Majesty . . . Men-kheper-Re (Tuthmosis III) from all of the foreign lands, to fill the workshops as serfs of the divine offerings of his father [Amun], the Lord of the Thrones of the Two Lands, because he (Amun) has put all of the foreign lands together in the fist of his Majesty, and their princes have rendered themselves to him."

The women of Asia stride in on the extreme left (see fig. 106). Their puffy, bell-shaped, stepped dresses have broad sleeves and fringed hems. They too are light skinned, and their long hair falls over their shoulders. Naked children are borne in baskets on their shoulders or led by the hand. The men in front of them are Syrian captives, each preceded and followed by an Egyptian guard. The southern captives join them on the right, the Nubians preceding the Syrian men,

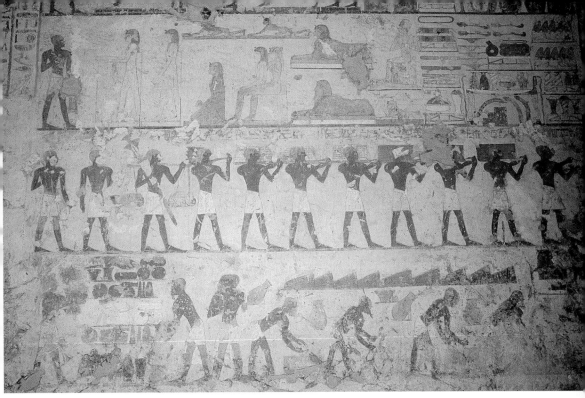

Figure 108

with their women in front of them (see fig. 107). Although the women were in long dresses with many folds, their torsos are naked. Some of the children are led by hand, while those who are too young to walk are borne in baskets.

The display of the tribute and the hostages is followed by the text of the "Installation of the Vizier," the prelude to the "Instructions of the Vizier," the text quoted at the beginning of this chapter. At the end of the wall was a picture of Tuthmosis III seated on a throne in a booth, with Rekhmire and his retainers before him. The scene is virtually invisible today, however.

The temple workshops follow, on the wall to the right of the entry, after the scenes of the northern taxes (fig. 108). The accompanying text states that the statues were destined for the temple of Amun and other sanctuaries. The vizier was deputized by the king to supervise this work. The two top registers show what the artisans were making, and it is difficult to believe that it was all for the temples, as some of it appears to be funerary equipment. In the top register are necklaces, quivers, ceremonial axes, various vessels, shields, three bundles of spears, and perhaps leather thongs.

In the second register are 10 helmets, censers, 5 large dishes, vessels, and 3 "magical ivories." Both ends of each magical ivory are decorated, one with a leopard head, and the other with a fox head. These items are above and below a high bed, below which is a small stair. Such beds can be seen among the treasures of the tomb of Tutankhamun. A similar small stair can be seen "in action"

on the Talatat wall in the Luxor Museum, from Amenophis IV's temple at Karnak.

Four shrines follow on the left in the top register, probably for the statues in front of them. A pair of stelae is below, with a standing statue. The next statue is in midstride, with a mace in the raised hand. These statues remind one of scenes showing the king conducting various ritual acts. Below is a seated statue of Tuthmosis III with one foot resting on a stool shaped like a prone Nubian (fig. 108, right top register). The other foot was probably on an Asiatic. In front, and below, are three sphinxes, two masculine and one feminine. On the far right is the sovereign with an offering tablet in his hands. There are also two statues of the king offering in a prone position, one of the regent kneeling and offering, another standing statue, and another that depicts the ruler seated with his queen. The tomb-owner himself supervises the work from the extreme left of each register.

An incense roaster leads a row of six men in the third register. Each is bearing a tray ornamented with a duck head, and loaves of bread. A man with triangular loaves and cakes is followed by another shouldering a yoke that also ends with duck heads; in one hand is a stalk bouquet. The ninth in the row is Meri, one of Rekhmire's sons, who is responsible for events here. The last is holding a sack of provisions and a staff. That all of these offerings are being brought to the door, that is, that they are being brought out of the tomb, could indicate that they are destined not for the deceased but rather for the temple of Amun.

Bread is being made in the fourth register. The dough is prepared, poured into forms, and baked in the oven. Someone is stirring something over an open fire above the one kneading dough at the extreme right. The various kinds of bread named in the two upper registers are heaped up on the left. They may have been brewing beer in the fifth register, but this is hardly recognizable. The scenes that followed were better preserved in the tombs of Nakht and Menna: the cultivation of the fields and the cattle inspection. The tomb-owner supervised all this but cannot be seen today.

The end of this room is not quite so well preserved as one would wish. It originally showed Rekhmire's family. The tomb-owner and his wife were in each register but can no longer be seen. The titles preserved in the inscriptions demonstrate that Rekhmire's sons, Menkheperreseneb and Amenhotep, were in the upper and lower registers. Behind, in the first register, is the tomb-owner's grandfather Ametju, called Ahmose, together with his wife (whose own tomb is TT 83). Below is the tomb-owner's uncle. Rekhmire's grandfather was vizier at the beginning of the reign of Tuthmosis III, and his uncle User was the grandfather's successor and Rekhmire's immediate predecessor, appointed by Hatshepsut while Tuthmosis was still very young.[17]

Four rows of smaller figures represent the families involved: at the top is Ahmose's family, followed by User's family below. Under them is the family of

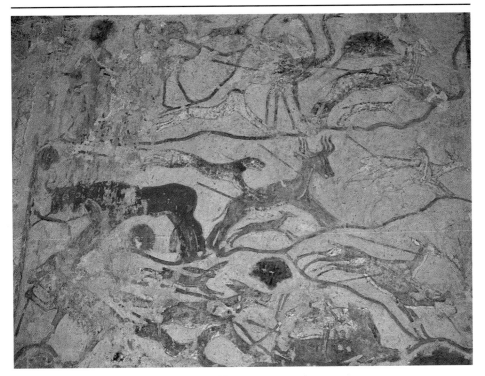

Figure 109

Nefer-weben, User's brother and Rekhmire's father. The second register follows the same pattern. The deceased's children and other relatives were shown here.

The scenes of the grape harvest along with fishing and fowling were discussed in the tombs of Nakht and Menna (see pp. 39–40, 82, and 105). The following scene in the upper register on the adjoining wall depicts hunting in the desert (fig. 109). The slain animals are piled in heaps and noted by a scribe. Along with the gazelles and antelopes are also hares and a fox.[18] The hunting hound has not been forgotten either. The scene actually begins to the left, with the lively hunt itself, although it does not approach the quality of expression seen in User-hat's tomb (see pp. 79 and 81). Peace, or better constriction, was created by the fence, with the hunt performed within the area it bounded; such methods were common in ancient Egypt.[19]

Motion was created by dissolving the ground line, which opened the way for the wild confusion; most of the game have already been pierced by arrows and are merely trying to escape with their last vestiges of strength. Ostriches, lions, gazelles, and antelopes are fleeing madly. A terrified little hare is speeding off with its ears literally bouncing off its head. As in the tomb of Userhet, the

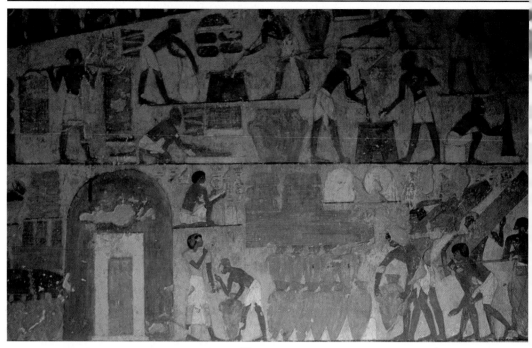

Figure 110

outline is deftly used to heighten the tension of the moment, but the animals are not as shockingly close as in that scene.

The left wall of the long hall is an introduction to Rekhmire's tasks in the temple of Amun at Karnak. One enters the "two houses of gold" on the upper left. This probably designates the treasury to which the ateliers would have been attached. Beside this are three entrances to storage rooms (fig. 110). Shown between the gates is everything that can be found in a magazine: jars with incense, oil, or wine; panther skins; living monkeys; elephants' tusks; ostrich feathers; gold rings; mats; sandals; and so on. In front of the right door of the magazine is a scribe registering the wares brought by various skippers. They throw themselves to the ground before the vizier and proclaim, "All your affairs are very fine. The treasuries are overflowing with the tribute of all the foreign countries: moringa oil, incense, Lower Egyptian wine [without] end, all the marvels of Punt, sacks and pouches are filled with good things, they being numbered in the millions and hundred-thousands."[20] Men are carrying wine jars on their shoulders, and one is exhausted and wants to set his jar down. He is driven on with the words, "Lift it, don't tarry." Two supervisors approach from the left, calling to the bearers, "Hurry up, you're being received while you're still coming out with the jar!" One of the supervisors seems to be holding an animal skin.

A jar in a net is being carried on a pole by porters bent under the burden. Bundles of reeds and mats are also being brought to the door of the magazine, where they are piled up. The unkempt hair and simple kilts hint at the social standing of the workers.

Rekhmire is seated on a simple stool behind his entourage, and the inscription above him notes what is happening: "Receiving legumes and honey in the treasury of the temple, sealing all the precious articles in [the temple of Amun] . . . in his office as the chief of writings."[21] In the uppermost register the pulses mentioned are measured and the results recorded. The onlooking peasants show their respect by "kissing the earth." Behind them are baskets holding wares. The legumes are crushed in mortars below, and "servants of the chamber of sweets" sieve them into vessels on the left. Another servant is working some dough while his colleague pours more into the trough. Triangular breads are molded below. On the left "fat is being added" and the "dough heated" and stirred on the oven. On the left above is a large vessel filled with honey. A man is bringing nets hanging from a yoke. These could be sweetened breads or cakes being baked in the ovens on the left.

Honey was the main sweetener in Egypt—sugar was still unknown. Beekeeping is thus an ancient activity. One Late Period tomb is famous for its scenes of beekeeping.[22] The products of apiculture are to the left of the oven. Men are sealing large jars that must contain the pure honey. Honey was also kept in relatively shallow wide dishes, which could be stacked in piles. The white strips separating them could be the wax with which they were glued together.

It is difficult to recognize everything in the lowest register. Oil and cloth are distributed. Foreign captives (who are probably obliged to work in the temple of Amun) and their children are being examined. Various kinds of linen are being delivered. Cattle are being driven in.

The work of the craftsmen is seldom seen in a fashion comparable to the scenes in the tomb of Rekhmire. They follow the previous scenes, on the left wall of the "long hall." Although the Egyptians truly appreciated and desired the products of skilled labor, the laborers themselves were despised. One of the texts praising the scribal career exaggerates the negative aspects of the craftsman's life, but there would still have been a grain of truth in it: "Every craftsman who takes the adz—he is more exhausted than a corvée laborer. His field is wood and his hoe an ax [. . .] He does more than his arms can and at night lights a lamp. . . . The lapidary drills into every hard stone, and when he has completed an inlaid eye he is utterly finished with fatigue."[23] The craftsmen—whom we would call artists today—shown in Rekhmire's tomb were quite privileged, however. Work in the temple of Amun may have given them some security, but this might have been lost quickly if any of the supervisors were not content with their work.

At the top, seated on low stools, are the jewelers, drilling and stringing beads (figs. 111 and 112). A bow-drill is being used, and they usually spun a stone-tipped

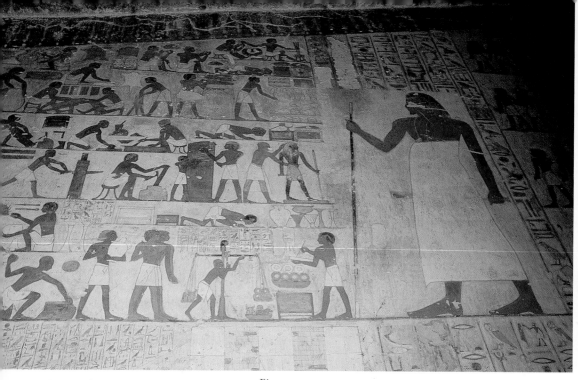

Figure 111

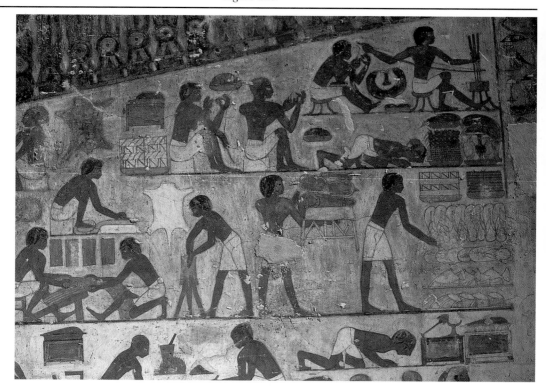

Figure 112

wooden shaft. But in this case efficiency allowed a single bow to drive three drills simultaneously. The yellow tips, the red shafts, and the bow string spun around all three drills are clearly visible. The baskets are doubtless filled with raw material. Beside them stone vessels are being hollowed out with the typical stone drill. The drill was the symbol par excellence of the craftsman, being the hieroglyph used for words relating to craftsmanship.

The scenes below the jewelers show depict tanning and the manufacture of leather goods (figs. 111–115). One worker is stuffing a skin into a tall tanning jar. Another man cleans a skin by spreading it on a block and rubbing or scraping it with a blue stone. Both shields and sandals are being produced; a single shield requires most of a small hide. Two men are cutting up a skin on a sloping board, which yields four identical pieces for sandal making; the remainder is then cut into straps. On another board the square bits are being cut into sandal soles with a saddler's knife. The same tool is also being used to cut the strips for the latchets. To the left, sandals are being crafted, and the finished product can be seen on the right. To the left of this scene, leather thongs and ropes are being prepared for ships' rigging and horse harnesses. Many tools of the trade are displayed: awls, a variety of knives, a marlinespike, a horn for enlarging holes, a comb to perforate the seams, a green smoothing stone.[24]

Beneath is the carpenter's workshop (figs. 111, 113–116).[25] On the left, a small shrine on a sled is being finished. To the right, they are cutting wooden boards; a wooden post struck into the earth serves as a sawing rig. The wood to be sawed is bound to it twice, the loops as far apart as possible. As the sawing proceeds, the thongs have to be shifted; wedges prevent the saw blade from binding. To the right is: "Making Furniture out of ivory, ebony, *sesnedjem*-wood, *meru*-wood, and real cedar from the top of the terrace (i.e., Lebanon). The prince gives directions and guides the arms of the craftsmen."[26] Egypt simply did not have trees suitable for lumber; the local palms and sycamores are inadequate. Good wood had to be imported and was thus precious. In the upper part of these scenes, lion-footed chairs are being crafted. One is already assembled, and the legs of another are almost ready. They have been shaped on a block with an adz; one of them is getting its final sanding under a slip of sandstone. A bow drill is used to cut holes into the seat frame for the covering. Beneath, two workers are dressing timber with an ax; most axes of the day were made of bronze and attached to the shaft with leather thongs. Another man is using a wooden mallet to drive a chisel fitted with a wooden handle. He is most likely cutting mortises for joints. These pieces presumably belonged to the huge shrine whose decoration is being finished by two workers using an adz and a chisel. The decorative elements are the two protective symbols (*djed*-pillar and Isis-knot) being carved in the foreground.

Further right is a wooden papyrus column lying on the ground. The adz has been laid aside, indicating that the shaping is now completed; the sanding thus

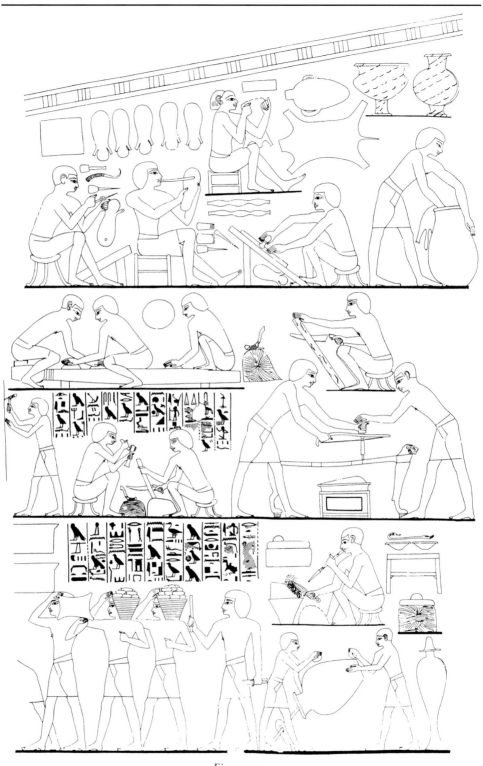

Figure 113
Scenes of craftsmen at work (adapted from Norman de Garis Davies, *Nefer-Hotep*).
Courtesy Metropolitan Museum of Art.

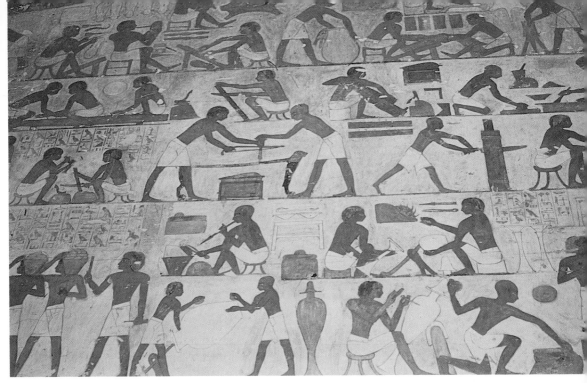

Figure 114

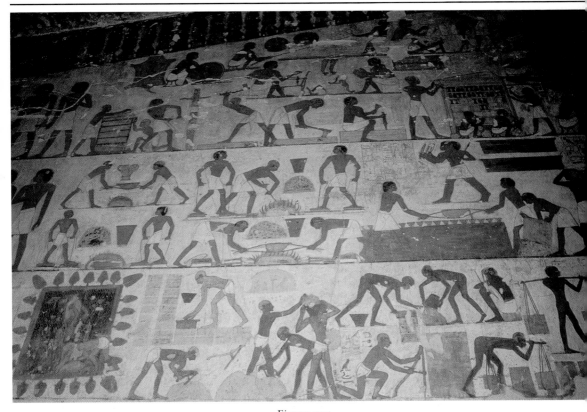

Figure 115

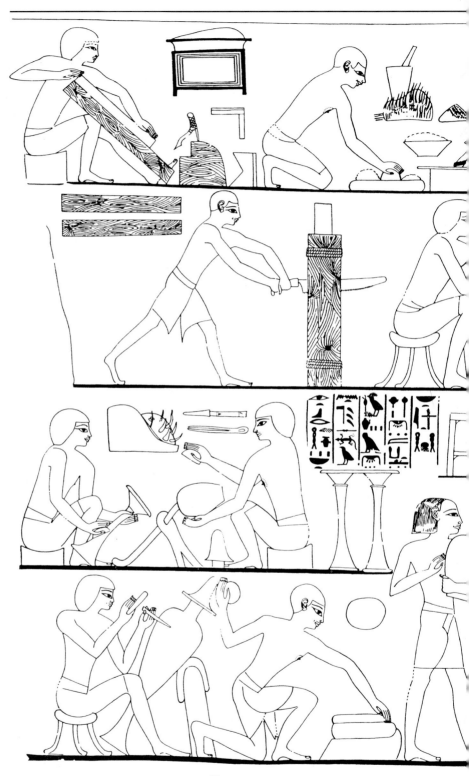

Figure 116
Scenes of craftsmen at work (adapted from Norman de Garis Davies, *Nefer-Hotep*).
Courtesy Metropolitan Museum of Art.

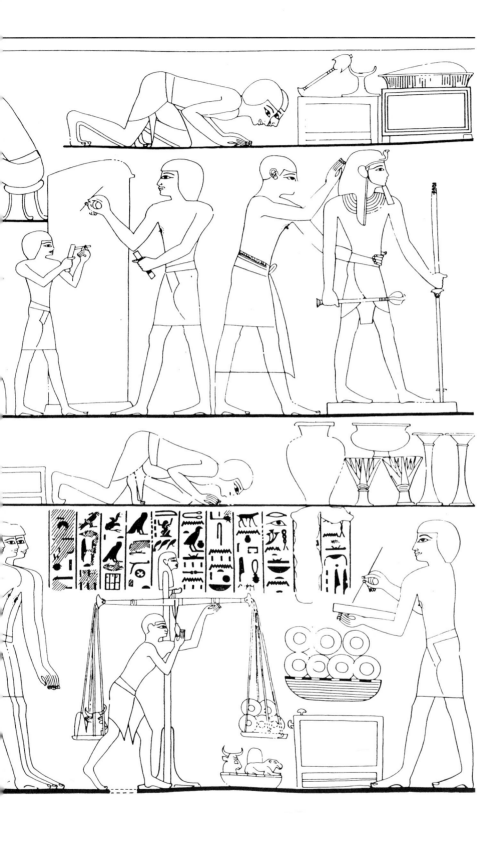

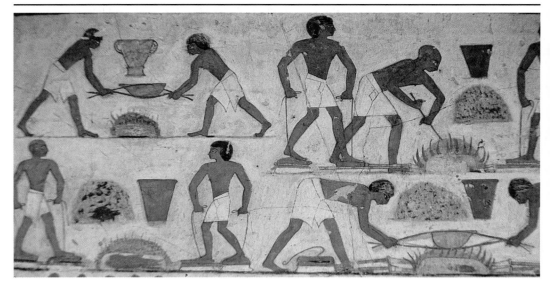

Figure 117

follows. Beneath a carpenter sawing a beam lengthwise are two men drilling holes into a bed frame, to take the thongs that will form its woven surface. Beside them are others making a trunk with a rounded cover; such trunks were used for goods or cloth. This form is shown in many tombs, and quite a few have actually been found. A cabinetmaker has just driven his adz into the workbench and is using a straightedge to make sure that the plank is flat. He is also equipped with a flanged square and something that looks like a miter box. Glue is being heated in a pot on the adjacent fire. A worker seems to be applying it to a piece of veneer. His colleague seems to be grinding whitening; however, he might actually be applying stucco as an undercoat for painting or gilding. Two trunks are also being presented; on the left are a headrest and a scepter. In the lower division of the register is another sawing post. Carved ornamentation is being sketched and executed on a shrine beside another cabinetmaker. A better-dressed fellow is applying gold leaf to a life-size royal statue. Its black skin hints at the Osirian aspect of rebirth, recalling the wooden statues from the tomb of Tutankhamun in the Cairo Museum.

Metal vessels are being made in the next scene (figs. 111 and 113–117). The activities should be viewed from right to left, but the sequence is not internally consistent. First, the gold- and silversmiths have to weigh and record the precious metal, mostly delivered in the form of rings. In the basket in front of the scribe are four gold and three silver rings. "Assigning the gold [of the temple of Amun]

in order to execute every commission of the residence, as is their daily obligation; they are numbered in millions and hundred-thousands; in the presence of the mayor of the city (Thebes) and Vizier, the overseer of the six large palaces, Rekhmire, justified."[27] Gold generally came from those mines in Nubia that made the region particularly attractive to the Egyptians, and thus Egypt itself became renowned as the Land of Gold throughout the ancient Near East. Silver was not locally available in Egypt and had to be imported, giving it a higher value in Egypt than in the Levant. Finished products are shown above the weighing scene.

The first operation was to hammer the rings into sheet metal. The pounding is done with a hard stone maul. Two anvil stones are visible, one of them showing the streaking of the wooden anvil block.[28] The disk of flat metal is the result. Gold and silver sheet were then formed, to make vessels. A stout metal rod fixed slant-wise into the ground is used as the chasing tool, with a simple stone serving as a hammer. After embossing and smoothing, the metal was finely polished, as the sparkling surfaces of surviving vessels demonstrate. The final polish was done with Egyptian agate. Objects were also engraved or embossed with ornaments, as the smith in the lower division of the register is doing. Two silver stands are already finished, while a third is still being polished.[29]

The procedure being performed on the left in the middle register is a matter of dispute (figs. 114 and 116). It is possible that an object is being made malleable by heat on a hearth, so that it can be further chased. It is also possible that furnace brazing, that is, hard soldering, is the real subject of the scene. Gold, silver, and sometimes copper were used as filler metal for brazing gold products. Varying proportions of shavings or grains would be mixed to achieve different melting temperatures and different hues. Together with a flux such as natron or grape yeast, the solder would then be preplaced on the joints.[30] Smaller objects would be heated whole on the hearth. The right brazing temperature at the desired place was achieved by blowing into the fire through a reed tube, itself protected from the heat by a metal or clay tip. The picture might thus depict the two brazing joints being held together by tongs. The bowls and the spoon on the table in the background would have served for holding and mixing the brazing materials and the flux. Evidence for the use of lead-tin solders acting at lower temperatures has not been observed before the Ptolemaic period.

Farther left they are "presenting the Asiatic ore ingots his majesty brought from the campaign in Retjenu, for the cast metal doors of the pylon of the Amun temple in Karnak. Its floors laid with *neby*-gold in the likeness of the horizon of heaven."[31] The basic casting metal was copper, being brought in the form of the typical "ox-hide" ingots. A small proportion of tin was blended with the copper to make bronze, which is superior for casting. Charcoal is being shaken out of a sack and used for the hearth on which the metal is smelted and blended. Above the various hearths are diverse casting products (figs. 113–115 and 117).

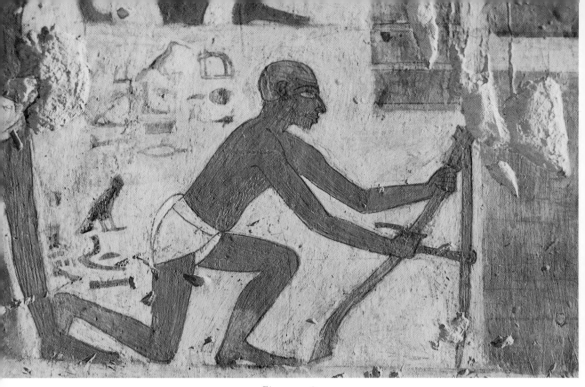

Figure 118

Generating the wind that enabled the hearth to reach the melting temperature required a special bellows: a wooden or earthenware pan fitted with a pipe was loosely covered with leather and the whole device attached at floor level (see fig. 117). A hole in the leather cover meant that, when the cover was lifted with a string, air was drawn into the cavity of the bellows. It was expelled by stepping with full weight on the leather, covering the air holes and driving the trapped air through a pipe into the hearth. Two such bellows set up in parallel can be operated by a single man in push-pull fashion.[32]

The casting of the door leaves mentioned in the text can be followed in the workshop scenes (see fig. 115). Two foundry workers pour molten bronze into the numerous runners of a fired clay mold. Two green rods were suitable for carrying the crucibles and tilting them from a safe distance. In casting such a large and heavy object, a premature temperature decrease posed serious problems. In order to secure proper fusion, the smelting had to be carried on at a number of hearths simultaneously and then the metal speedily cast. The unusually large number of runners hint at this problem. A number of men are around the mold, equipped with tongs and blowpipes, repeating praise of the king.

An inscription explains that Rekhmire himself is supervising everything, from the extreme right (see fig. 111).

In the fifth register are unkempt Syrian and Nubian prisoners of war, hard at work (figs. 115 and 118): "Molding bricks to build a magazine anew [for the Temple] of Karnak."[33] This workhouse and its construction ramp can be seen

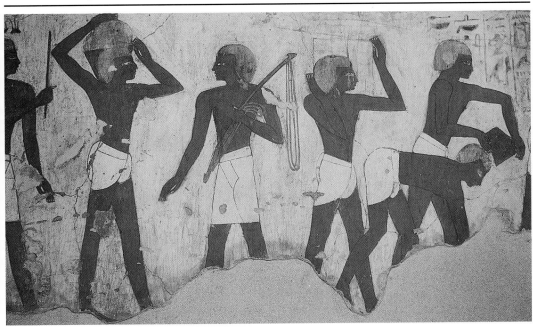

Figure 119

beneath the workers. The method of making bricks has not changed since: Nile mud was pressed into forms. The mud had to be moistened to achieve the desired consistency, and the water was drawn from a small pool lined with trees. The mud or clay was tempered with chaff. The formed bricks were left in the sun to dry and then stacked up, ready to be carried to their destination. "The supervisor says to one of the workers: 'The supervisor's staff fits my hand well: do you still not know how I hit?'" (fig. 119). The other parts of the scenes in this context are unfortunately almost completely destroyed.

The vizier was also responsible for supervising the manufacture of royal statues. Two red granite statues, one seated and one standing, are so large that the workers have to use scaffolding to get to the heads (fig. 120). Such monumental statues can still be found in Karnak today. Between these two, a sphinx and an offering table of white limestone are getting their final treatment. The surfaces are being smoothed and polished. Hammer and chisel are applied to details. The text on the back pillar of the standing statue seems to be getting painted in color. One of the workers is bent down, hammering away just above the earth below the offering table.

Three freight ships have arrived in the scenes below. They will soon be discharging their cargo of limestone; the stones are already being worked in the next

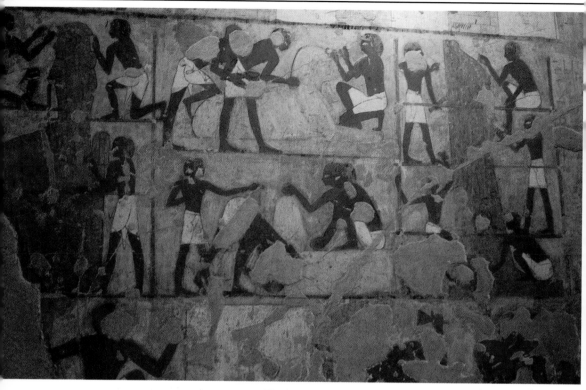

Figure 120

scene. Accompanied by supervisors and scribes, the gangs of workers below are more difficult to see.

The second half of the "long hall" is reserved exclusively for religious scenes. "A beautiful burial after death" is being prepared for Rekhmire in 11 registers (fig. 121). Unfortunately for us, many of these rituals are not completely understood. The sequence of scenes moves from bottom to top but does not quite match the sequence of events. Parts of this sequence have already been noted in the tombs of Ramose (TT 55), Menna (TT 69), and Sennefer (TT 96).[34]

The lowest three registers end in front of the goddess of the West. In the first and second on the left is probably the voyage to Abydos, which is unfortunately largely destroyed. Cattle are drawing the sarcophagus to the tomb. A priest of Sokar in a long tight garment leads the shrine with the deceased. Milk is being offered in front of him. Two women designated as kites are at the head and foot of the coffin. There follow the "nine *semer*," the "nine companions." Originally they were probably servants of the ruler; the ritual was originally developed for

the king, and only later adopted by ordinary mortals. In the scenes above, the usual offerings are being brought, and a cow is being slaughtered. Pieces of meat, including the heart in a bowl and a haunch, are being brought to the burnt-offerings altar.

On the far left is a statue wearing the Lower Egyptian crown and sailing in a boat. In the form of a bull's haunch, a "divine offering" is laid before it. The landing ceremonies are performed in the adjoining scene. The mooring posts are symbolized by the two mummiform figures with tapering lower parts. Beside them are the "*Kenemet-weret*-baskets," which probably had sieve bases; they were generally associated with purification rituals.[35] A lector priest, the coffin on the boat, and the statue in the shrine show the way to the tomb. Another lector priest is standing in front of a building crowned with a *kheker*-frieze. Reciting, he is receiving the deceased, who is approaching in a boat with a small baldaquin in the middle, flanked by the two kites. To the right is the landing place, defined by two buildings. The gate is characterized by two palms and two small "*khem*-chapels." Beside this is another building with a windowlike decoration and four slender pillars or columns on the roof. The whole scene is summarized as "guiding Rekhmire . . . landing in Sais, the place where the great god is." The *muu*-dancers follow; among other things, they must supervise the transport of the mummy, and they are also the ferrymen who must take the deceased to the eastern heaven, and thus into the realm of the sun god.[36] A boat is towed to a gate by four men. In the middle of the boat is the statue shrine, with a "kite" at stern and bow. The procession ends at a gate before which a haunch is sacrificed. The group of scenes should probably be understood as part of the "procession to the hall of embalming."

The activities in registers four to six take place before Anubis. The shrine is being drawn on a sled in the fourth register from the bottom, at left. Food is brought and piled up for Rekhmire's *ka*. Various goods are being brought in the register above: kilts, incense, ointment vessels, and two *ushebtis* (as in the tomb of Sennefer). The procession is led by three *semer*-companions and a lector-priest. "Nine *semer*" bear the coffin in front. They are followed by "the great kite." A boat full of priests follows, with another bearing the sarcophagus in tow. On the far right are sacrifices with Anubis. The sixth register, at the far left, shows the cow's heart and haunch again, a scene that actually belongs with the crossing to the west bank.

In the next scene in the sixth register, a building is erected and a garden tilled. The boat following symbolizes the crossing, which the two "kites" have already accomplished. Further right are purification ceremonies and the "erection of a divine tent," a shrine before which a lector-priest recites. A flame can be seen in another shrine. These lead to the "holy district," where a large building is situated, surrounded by a *kheker*-frieze. Four armless "gods of the great gate" are

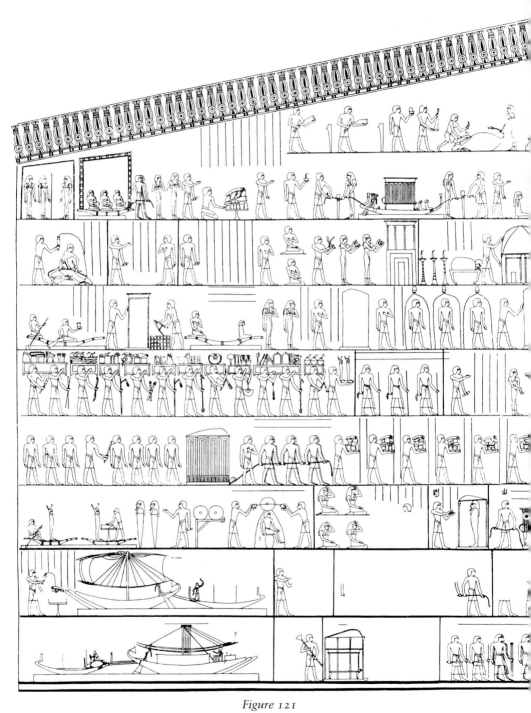

Figure 121
Funeral and burial scenes (adapted from Hartwig Altenmüller, *Begräbnistritual*).

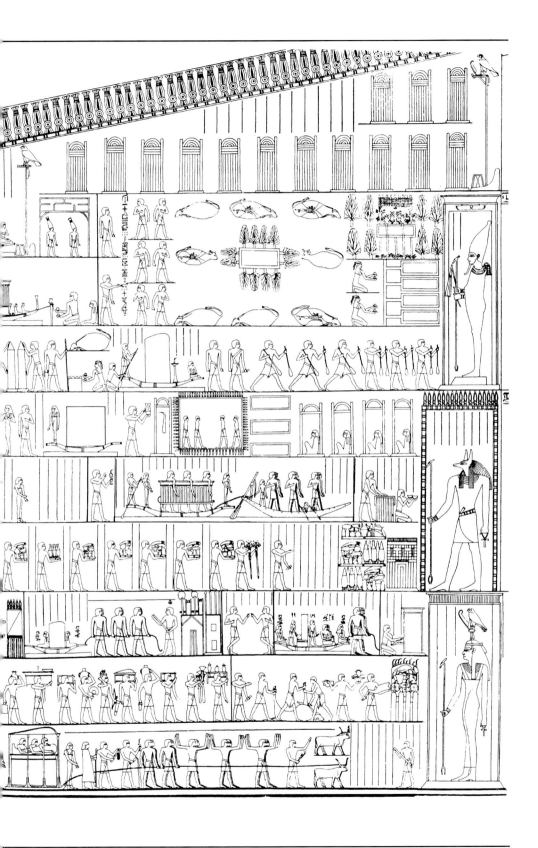

standing inside. Three pools destined for cultic rites are also visible, with four divine shrines at the far right.

Registers seven to nine end in front of Osiris. A cow is slaughtered on the far left in the seventh. Beside this is a lector-priest reciting in front of a *semer*. The following group is more difficult to grasp. The center is a high gate topped with four pillars on its roof below a cavetto cornice. Three altars for burnt offerings are beside the house. The action begins with a lector-priest landing across from the "*per-duat*" (House of Morning), a place where the rituals of the ceremony of the Opening of the Mouth are accomplished. The two "kites" perform the fumigation of the "*per-aau*," which must be a place of purification. The *tekenu* follows, crouching on a small bed, seen from one end. The following trio of scenes is shown in reverse order: it begins with the woman making sacrifices on the right. She has two spherical vessels in her hands, probably filled with "green eye-paint," as the inscription says. A lector-priest is beside the altar on the left. Two obelisks are erected in the following scene, and then the building is purified. The text confirms that these are the two crown sanctuaries. A row of men holding oars ends the register.

The "sacred district" is introduced in the eighth and ninth registers. On the left in register eight is the "women's tent," and the three women within could be wailing. Priests are being towed in a papyrus skiff; the two "kites" and a lector-priest are standing in front of it. Two pictures show the boat being bound to the mooring post. Above, in register nine, are other rituals and offerings for the mooring post, in front of the western falcon, followed by two *muu*-dancers standing in a great hall. A large slaughtering hall is to the right of both scenes. The pool is lined with sycamores, with eight bulls bound on the ground around it. Four rectangular interconnected basins form the end of the "sacred district," with two kneeling women making sacrifices before them. Above this is the garden pool lined with trees. At the very top are 14 divine chapels, before the western falcon again.

The end of this wall also ends the rites. In the uppermost three registers Rekhmire and his wife Merit are seated before a generously laid table. Their sons, Menkheperreseneb, Meri, and Amenhotep, are bringing it to their parents. The images of all the sons have been hacked away. In the lowest register are the lists of offerings and the priests, burning incense and making libations, dedicating the foods on the table before Rekhmire and his mother, Bet. The end of the hall has a niche at the top, bordered on all four sides by vertically inscribed offering formulas. At the top, the deceased is adoring Osiris with the West and East goddesses behind him. Behind that was a false door, which is in the Louvre today (Louvre C 74), and below that is another, which was larger but has been largely destroyed.

On the right side are analogous scenes. Amenophis is bringing Rekhmire and his mother, Bet, a table. Sesostris is below, in front of his parents, and then

Menkhepereseneb in front of his father and grandmother. The lowest register has offering lists and the dedication of foods again.

The ceremony of the ritual of the Opening of the Mouth follows, in 50 individual scenes (fig. 122).[37] The ceremony was originally designed to give life and soul to a statue. It was later used for objects associated with use in the beyond, including mummies and ritual instruments. It was mentioned in the Pyramid Texts, the oldest preserved version of which was inscribed in the burial chamber of the pyramid of King Unas, at the end of the Fifth Dynasty. The ceremony must have been an offering ceremony for private people during the Old Kingdom. Relatively detailed records of some 75 scenes are preserved for the New Kingdom.

The ceremony apparently took place in: (1) the "House of Gold," an atelier where statues were made; (2) the "House of Natron," a purification chamber; (3) an "Offering Hall," a place of sacrifice; and (4) the "chapel," the place where the shrine was erected, in which the statue was permanently placed.[38]

It is conceivable that the various localities are only figurative. The *sem-* and lector-priests play an important role in all this. The former performed the rite and—to oversimplify—represented the son who was closest to his father. The lector-priest recited. His office is probably not as that of ancient as the *sem*, as the office itself demands that the ritual be recorded in writing, yet some of the instruments used in the ritual probably dated to predynastic times, before the invention of writing.[39]

Although the sequence is incomplete, the version in the tomb of Rekhmire is among the best sources on this ceremony and was used by the German Egyptologist Eberhard Otto as the basis for his fundamental work on the subject; figure 122 is drawn from his book. The sequence begins at the lower right, and the subsequent registers should be read from the right. The deceased is always identified as "Rekhmire." The name was frequently effaced, however, condemning Rekhmire to anonymity and thus death.

The scenes are numbered in figure 122. The sequence of the scenes does not match the sequence of events. At the right in the lowest register: (8) This is actually an intermediate scene without a specific action; (1) an "explanatory gloss" notes that the ceremony should be carried out on the statue in the House of Gold "being set up on sand, facing south"; (2–3) purification with liquids poured from *nemset-* and *desheret*-jars; (4–7) purification with Upper and Lower Egyptian natron, and incense; (9–10) waking the *sem*-priest (in both scenes, the *sem*-priest is the figure enveloped in a mantle seated on a bed seen from one end; the three men behind the statue are the newly arrived craftsmen); (12) the *sem*-priest has changed his clothing, and the craftsmen are still behind the statue.

Second register from the bottom: (14) The *sem*-priest touches the mouth of the statue with his little finger; (13) the special craftsmen are assigned their tasks: *hwi* ("striking," working on the statue?) and *sehedj* (polishing the statue?);

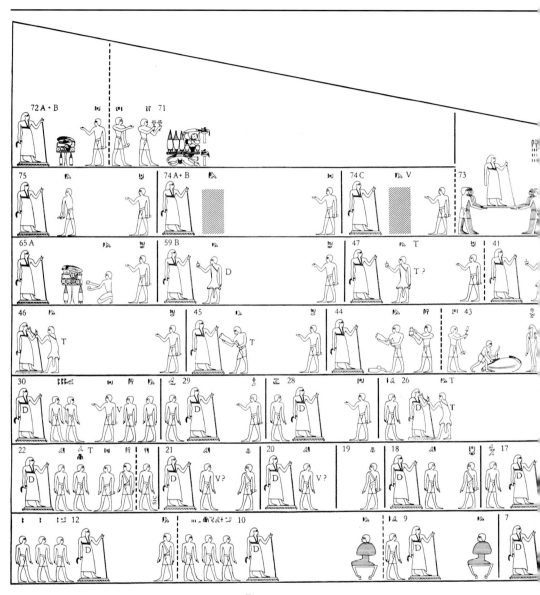

Figure 122

The "Opening of the Mouth" ritual (adapted from Hartwig Altenmüller, *Begräbnistritual*):
14. Touching the mouth with the little finger. 13. Assigning tasks to special craftsmen.
15. Performing "striking." 16. Performing "polishing." 17. Completion and delivery of statue.
19–22. *Sem* changes costume. 23–25. Butchering, presentation of heart and haunch. 27. Opening the
mouth with the long "magic wand." 26. Opening the mouth with the *neter-ti* tool (adzlike tool).
28. Presenting statue to the *r-pat*. 29. End of the report on statue. 28. "Polishing" again.

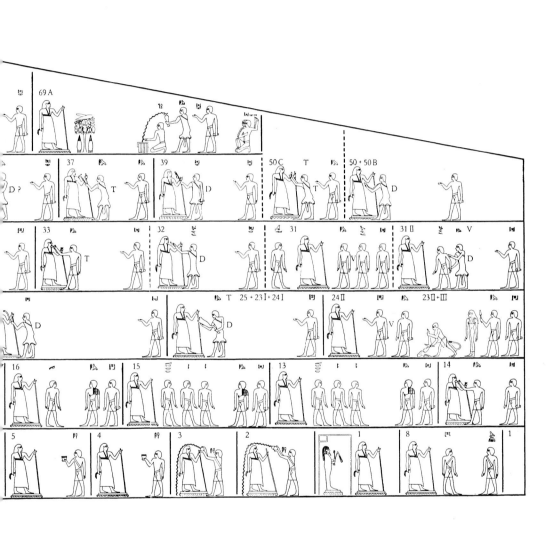

(15) the "striking" is performed; (16) the "polishing" is carried out (the two giving instructions on the right in these scenes are the *sem,* with the lector-priest behind him); (17) the craftsmen depart, having reported the completion of the statue and delivered it; (19–22) the *sem* changes costume.

Third register from the bottom: (23) Butchering, with presentation of heart; (23–25) severing and presenting the haunch; (27) opening the mouth with the long "magic wand"; (26) opening the mouth with the *neter-ti* tool (adzlike tool); (28) presenting the statue to the *r-pat* (the *r-pat* is designated as the son in the text; ordinarily, the word is translated as "prince," etc.); (29) end of the report on statue; (30) "polishing" again.

Fourth register from the bottom: (31) The "son who loves (him)" before the "House of Gold"; introducing him to the statue; (32) opening of the mouth with the *medjedefet*-tool (chisel-like instrument) and the finger of gold; (33) touching the mouth with the little finger again; (36) cleaning the teeth?; (43) second slaughter scene; (44) presenting the heart and haunch; (45) presenting the haunch; (46) opening the mouth with the adz.[40]

Fifth register from the bottom: (50) Presenting the white *menekhet*-garment and the spell of the *shesem*-kilt; (39) presenting an ostrich feather; (37) presenting the *peseshkhef* (fishtail-shaped utensil); (38) offering grapes; (41–59) burning aromatics, for the uraeus in (59); (65) request that the offerings be received.

Sixth register from the bottom: (74–75) Reciting spells.

Top register: (69–72) Making offerings and reciting the final spell; (73) bearing the statue to the chapel.

The lowest registers are not completely preserved. The text by the tomb-owner (who is no longer present) states that he is "seated in the great hall" after finishing everything that the king praises in the temple domains. "The officials of the councils of magistrates and the highest [supervisors] . . . [come] to eat with Rekhmire."[41] This meal is badly preserved, however.

Rekhmire's garden and pool were doubtless artificial, like those found adjoining palaces and the houses of the wealthy (fig. 123). The garden had a fine walled entrance and was surrounded by trees. It was so large that the tomb-owner could have himself towed around in it in a boat, as he is doing here in his lasting form as a statue. The trees are all standing upright around the pool, but the artists have folded them back so that one can get a bird's-eye view and a view from all the sides at once, in the usual way the Egyptian artists solved the problem of displaying as much as possible, without resorting to a perspective view.

The statue of Rekhmire in the *neshmet*-bark is in a shrine, in front of which is a mortuary priest making a libation offering and burning incense. The proximity of this scene—combined with the offering bearers in the upper register, the wailing women, and the female offering bearers below—suggests that this is no ordinary "pleasure trip," but rather the "mortuary festival in the garden." This

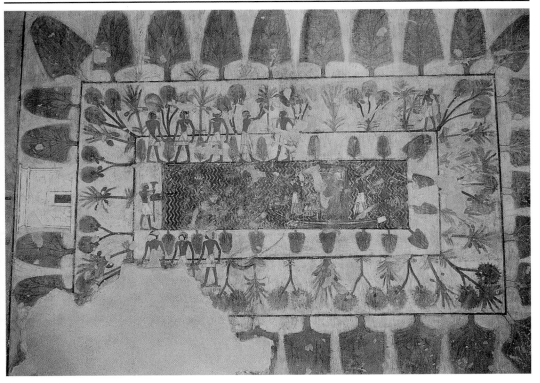

Figure 123

also accounts for the presence of the son, visible behind the wailing women. He is passing a papyrus stem to the statue of his father, symbolizing green, revival, and regeneration. [42]

The banquet below the pool is thus assuredly a mortuary meal. Such scenes began to appear in private tombs during or after the reign of Tuthmosis III and continued to appear until shortly before the Amarna period.[43] In Thebes, the ceremony is restricted to statues and separated from the actual burial, both spatially and temporally, as can be seen in the tomb of Rekhmire. The funeral scenes are on the west wall; the garden ceremony with the statue and the funerary banquet is on the east wall.

The annual repetition of the statue's voyage served to preserve the memory of the dead, recalling his funeral, but it was also important for his continued existence in the "beautiful West," as the proximity to the ritual of the Opening of the Mouth emphasizes.

Rekhmire did not deprive himself of immortalizing a festival, most probably the "beautiful festival of the desert valley." The rows of guests are led by the tomb-owner and his wife, who are separated from their guests and seated on a lion-footed

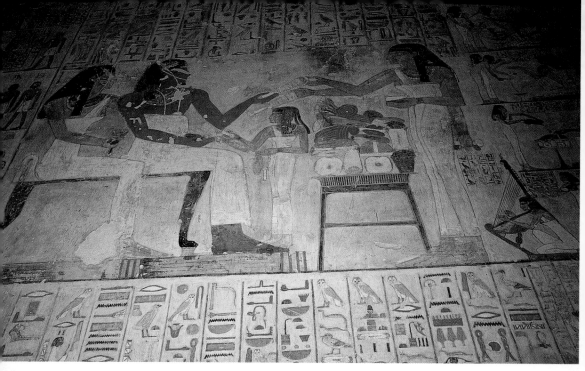

Figure 124

couch with a generously laid table in front of them (fig. 124). Their feet rest on a reed mat. "Enjoying the view of the beautiful event: singing, dancing and making music; being anointed with myrrh oil, rubbed with *qeb*-oil, a lotus-blossom to the nose, with bread, beer, wine, sweet wine, and every thing in the presence, for the *ka* of the prince and count, the mayor of the city (Thebes) and vizier, Rekhmire, justified. His sister (wife) is together with him, beloved of his heart, the mistress of his house. Meryt, justified."[44] Before them are two small girls handing Rekhmire a sistrum and a *menit*. Behind the table are two women, also offering sistrums to the couple. Each of the women is holding a *menit* in the other hand. They say, "Purification for the mayor of the city (Thebes). The daughter of Re (Maat) praises you and loves you. She places her protection behind you daily. She embraces your members. You support her (Maat's) majesty, while she embraces your breast. You spend a beautiful long life on earth, with life, prosperity and health embracing you."[45]

The tomb-owner was not depicted as the beneficiary of a mortuary cult here but rather is being provided with the same things as his guests. It is worth noting that "the tomb-owner's dignity is guaranteed. He never takes the drinks or the necklaces with outstretched hands [i.e., the eternal gesture of the dead], like food or sistra, or with both hands like the sacred bouquets. He is never shown being anointed like his guests."[46] These four females could be Rekhmire's daughters, but the text does not record it.

Men and women take their places separately at the festival (fig. 125); all the guests are seated on mats on the earth, with the exception of "his (Rekhmire's)

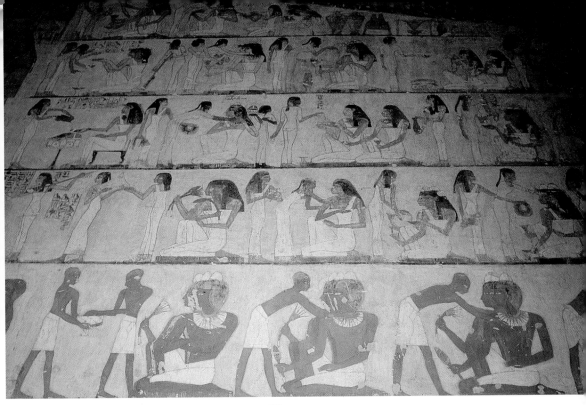

Figure 125

beloved mother, the royal ornament, Bet, justified," who is seated on a stool (fig. 126).[47] A luxuriously laid table assures her food, and a servant girl is pouring her a drink, to assure that her thirst is also satisfied. The inscription commands that she enjoy the festival: "For your *ka*, that you have a nice day while on earth. Amun has commanded everything. He praises you, whom he loves."[48]

Wreaths have a particularly festive character and are offered to various people here, some of whom have put them on. Men and women are also being rubbed with ointment, a sign of distinction.[49] Other guests are enjoying the fragrance of a lotus blossom. Among the festival scenes is a small servant girl behind Rekhmire's mother; she is pouring a drink and shown in a three-quarter view with her buttocks carefully delineated, while the shoulders and face are shown as usual. This is the only known instance of this view in the art of ancient Egypt, as it was not attempted again and Egyptian art kept to its aspective view.

Three ladies are playing and singing on the left in the fourth register (see fig. 126). "Myrrh oil on the wig of Maat: be healthy and live with her who is in me" are the words the harpist sings while her hands pluck the strings lightly.[50] The lute player sings, "Amun, the sky is raised up for you, the earth spread before you. Ptah has made the two chambers with his hand that the land be born for you."[51] The third musician sings, "Northwind! Come, it has been seen that I am in my villa!" while beating a small rectangular drum played only by women.[52] Each of the musical instruments is faithfully reproduced. The head

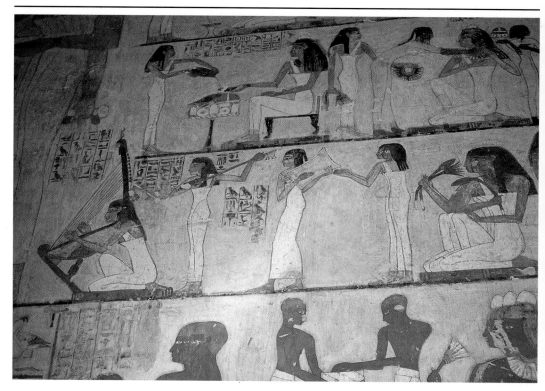

Figure 126

of the goddess Maat adorns the top of the harp, and the lower brace has the shape of a protective amulet, which was common. Over the centuries, harps diminished in size, so that they could be transported more easily, but the smaller size meant that the instrument could slip away, and thus it had to be supported.[53]

Below the musicians are three crouching male singers, and beneath them men playing the harp and the lute, like the women two registers above (fig. 127). The festival is not very lively; all the guests are looking in the same direction, with smaller groups shown in layers and isolated individuals left alone. The only variation is in the different ways the guests are being served.

To the right of the banquet are two ships (fig. 128). These two splendidly equipped vessels are the tomb-owner's traveling barks. The rowers are hard at work in the upper scene, driven on by overseers with whips.

Below, the ship has landed. Having just arrived, further right, Rekhmire and his entourage are met by a son along with some relatives. The inscription is quite remarkable, as it records that Rekhmire has just returned from *Sekhem*-hut (Diospolis Parva, or Hu), just north of Thebes in Middle Egypt, where the king

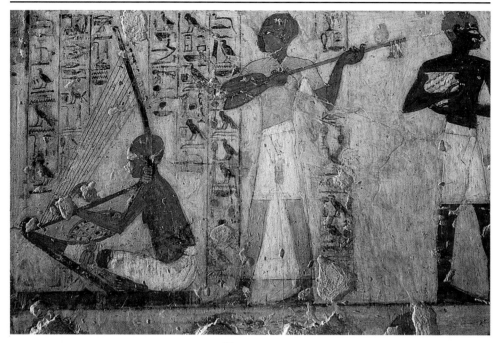

Figure 127

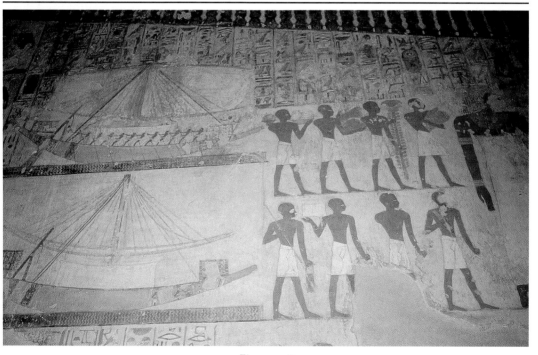

Figure 128

received him. The tomb-owner was confirmed in his office by the sovereign, and everyone is celebrating.[54] This king cannot have been Tuthmosis III but must have been his son and successor, Amenophis II. This confirms that the tomb was not completed at the time of Tuthmosis III's death, but also that Rekhmire was confirmed in his office—which must have been very important for his family and relations—and that he fell out of grace only later on. The enthusiastic reception is thus entirely comprehensible, but we know that the joy was quite brief and that when Rekhmire was relieved of his office it signified the end of this family of viziers.[55]

Neferhotep

NEFERHOTEP—"grace is beautiful"—was the chief scribe of Amun during the reign of Aya (fig. 129). His parents were Nebi and Iwy, his wife was named Merit-Re, and beyond that we know virtually nothing about the tomb-owner.[1] The tomb's T-shape is typical of Dynasty XVIII, while its four-columned hall hints at the Amarna age. A passage leads from the inner room to the subterranean burial chamber.

Although the paint was carefully applied, the low-quality stucco was already peeling off the walls in the Ramesside era, shortly after the tomb was completed. Immediately after completion it must have looked quite fine, however, for another appropriated the tomb for himself. This usurper had the unfortunate idea of restoring the damage with coarse plaster. Both the attempts at restoration of disfigured images and the new additions can hardly be termed anything but unsuccessful. Later tombs disfigured the setting as well (fig. 130).

The tomb was known to the earliest investigators, who widened the narrow entry passage to let in more light. A local family then moved into the tomb and used it as a residence until they were thrown out at the end of the nineteenth century A.D. Even then, however, they did not abandon the courtyard. The tomb is thus quite dirty, so that only a few pictures can be understood, and the ceiling decoration is no longer visible at all. The lower registers of the walls are nearly all destroyed, and the upper ones are covered with a thick layer of oily soot.

The earlier copies of the tomb permit us to recognize the bounty of scenes the tomb once offered, despite the damages of the distant past. The early copies are a welcome aid in reconstructing the images. The modern visitor can still find the tomb interesting, however, despite the badly preserved paintings, as the style preserves echoes of the Amarna age; the decoration also hints at the coming dynasty.

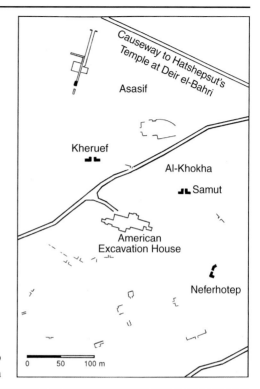

Figure 129
The cemeteries at Asasif and Al-Khokha

Each side of the entrance into the tomb from the back wall of the large court-
yard once had a stele (fig. 131). The situation of the tomb façade thus corresponds
to the changes appearing since the end of Dynasty XVIII (see pp. 10–11). The

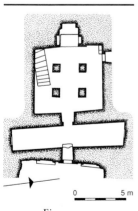

Figure 130

façade itself was cut out of the living rock, but masonry was
required to make up for defects. The text of the right-hand
stela is illegible today, but the significance of the courtyard
at that time and the frequent parallel constructions employ-
ing Re and Osiris in tandem suggest that the scene included
the adoration of the sun god Re,[2] as—on the left—Anubis
and Osiris were being worshipped by the deceased couple,
to the right and left, respectively. Both gods are also addressed
in the text, which also mentions the *wag*-festival that is
associated with Osiris (see pp. 114–115). The lintel of the
door shows Neferhotep and his wife and parents worshipping
Osiris. The god is accompanied by Hathor, the mistress of
the West, on the right, and Anubis on the left. Both door-
posts are inscribed with prayers and offering formulas. On

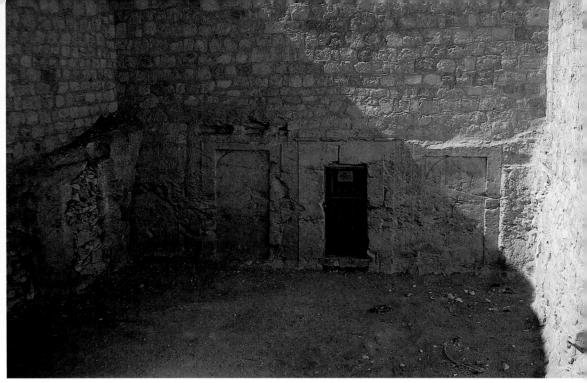

Figure 131

the left reveal is a long hymn preceded by an introductory text, of which excerpts follow:

> Worshipping Re at his rising from the eastern horizon of heaven . . . [by] . . . the Chief Scribe of Amun, the Overseer of the Cattle of Amun, [Neferhotep, son of the servitor of] Amun, Neby, born to the Mistress of the House and Chantress of Amun, Iwy.

He says:

> May the solar disk shine at dawn
> on the great summit of western Thebes
> "Who Faces her Lord,"
> the place of eternity,
> the desert of justice,
> this settlement of the venerated. . . .
> May I follow the majesty of this august god,
> Amun, Lord of the Thrones of the Two Lands
> at the beautiful festival of the valley.[3]

Wearing a long wig topped with an unguent cone, the tomb-owner has raised his hands to adore the gods (fig. 132). The short beard of the officials adorns his chin, and the gold of honor hangs around his neck over his elegant pleated garment. His equally festively attired wife is behind him, with a sistrum in her hand. Both are walking out of the tomb, toward the east. The other side of the

Figure 132

passage has an analogous scene, with Neferhotep and Merit-Re entering, worshipping the western sun. The wife's legs are particularly long, suggesting delicate and sensitive fragility. The pictures and texts are all done in shallow sunken relief.

Funerary ceremonies—like those in the tombs of Ramose and Rekhmire—can be recognized on the upper part of the wall to the left of the entrance (fig. 133). In the uppermost register, the coffin and the canopic shrine behind it are being towed into the tomb. The wailing women are between the two. The woman embodying Nephthys follows them, while the one playing Isis is walking in front of the sarcophagus. The priest of Sokar must have been in front of her, with another priest making libations and burning incense in front of him. In the next register, the cows with the dedicated calf can be seen, with four men walking behind them. In front of the cattle is a man with a vessel held on a string, sprinkling milk on the path of the coffin's sled. In front of this ritual purification is a lector-priest reciting parts of the ceremonial rites to be performed. After the *tekenu* are two offering bearers with the usual food offerings. The final element is the tomb-owner himself, who is already standing in a shrine with the "mistress of the West," who is welcoming him into the "beautiful West."

Beneath are the obligatory wailing women. While they can still be recognized, the priests burning incense and making libations are almost completely destroyed. Hathor in cow form can still be recognized, coming forth from the western mountain. This is a common portrayal of Hathor as the mistress of the Theban western mountain, the personification of the West.

The left end of the hall has a stela closed with a cavetto cornice at the top. It is assumed that Anubis was on the right at the top, with Osiris in front of Hathor as the mistress of the West on the left. Between the gods was a table. The stela was flanked by the tomb-owner and his wife, at the top and bottom, respectively. Both were dressed in finely pleated garments and wore unguent cones on their heads; they were seated and reaching toward the offering on a table.

The scenes on the adjoining southern part of the west wall must be followed from right to left. The reconstruction of the scenes depends upon comparison with analogous scenes from the tombs in Amarna. In his work, Norman de Garis Davies recreated many of the scenes based on the earlier drawings of Robert Hay (1799–1863), combined with his own familiarity with the tombs at Amarna. Recourse is had here to these reconstructions, to aid the reader in understanding the scenes (a visitor will also require a flashlight).

The representation of Aye is almost completely destroyed. Behind him is his queen; this is the last depiction of a queen in a Dynasty XVIII tomb.[4] The sovereign is leaning out of the "Window of Appearances."[5] This is just as in the Amarna tombs, but above the king's head to assure protection is a falcon rather than the embracing rays of Amarna's Aten see (fig. 31). Dignitaries would have

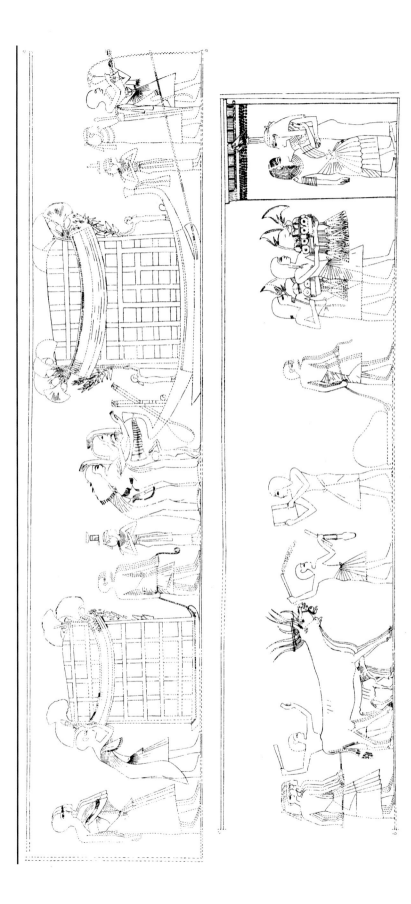

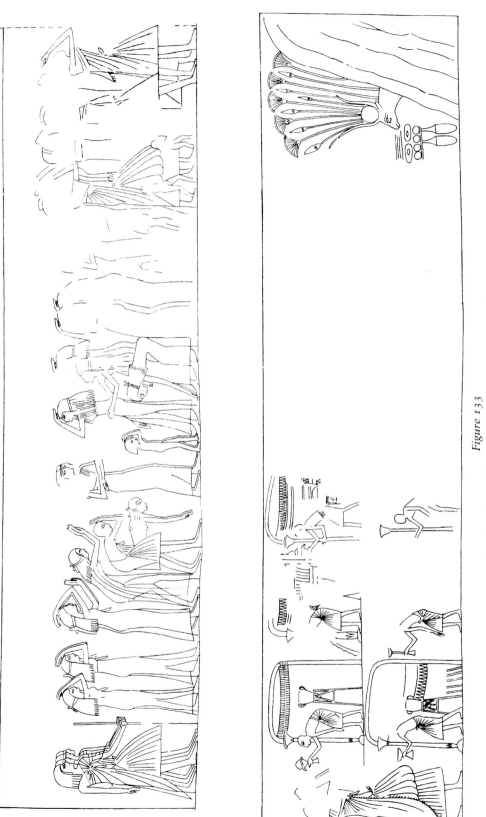

Figure 133

Funeral rituals (adapted from Norman de Garis Davies, *Nefer-Hotep*).
Courtesy Metropolitan Museum of Art.

been bowing before the king; Neferhotep is in the second register behind them, being offered the gold of honor as a distinction, and they may have been anointing him. His following may have been bearing gifts. The tomb-owner himself leaves the palace enclosure, however, on his way home. Followed by heralds, he drives off in a chariot to an enthusiastic reception that includes music and dancing. His route was marked with trees, some traces of which can still be seen.

Merit-Re was given her rewards in the middle, at the top of the wall (fig. 134). The harem where the queen is given what may have been presents can still be recognized. Traces of columns and a wall with windows indicate the building, which is seen from two sides. A garden with trees also belonged to the complex, which is to the left of the palace. The whole was enclosed with a wall yet was joined to the palace. The harem is in principle an impenetrable, protected district and is shown in a number of the Amarna tombs, such as the tomb Aye built for himself before ascending the throne.

Traces of Merit-Re's entourage can still be seen to the left of this scene. Women drinking can be seen in front of and to the right of the trees in the garden. The homecoming of the tomb-owner's wife as it should probably be reconstructed on the left.

The two upper registers were probably filled with festival scenes, but only the barest traces remain. Copies made by earlier scholars, however, show that the party guests were seated at the top of these registers. On the left was a lady who has wined and dined more than suited her; she has turned around and her neighbor has placed a sympathetic hand on her shoulder, while a servant girl runs up with a vessel to catch the mess. The girl is too late, even though she ran barefoot holding her sandals. This lively detail is largely lost and difficult to see. At the bottom are musicians and dancers.

To the right of the entry into the inner chamber, the tomb-owner and his wife were probably worshipping Osiris and Hathor as the mistress of the West. Only traces of the accompanying text are preserved today. The funeral rites can likewise hardly be recognized, but the offering bearers and wailing women below at the far right belong with these rites.

The right end was decorated like the left. The deceased was worshipping Osiris (at the right) and Anubis above the stela, but only traces remain.

The pictures of the funeral began on the wall to the right of the entry (fig. 135). In the top register, at the left, two of the four boats originally present can still be seen; bow and stern overlap at the center of the drawing. The mourners are very impressive: women are tossing ash into their hair in the first boat, and a few have exposed their breasts in a gesture of mourning. The first of the wailers here is shown as an old woman, in both body and face. She might be the widow of the deceased. In the next panel, nine rowers are propelling the boat along. In the third panel, men in mourning follow in the second boat, but two women can be seen in front

of the oarsmen. Another wailing woman can be seen at the captain's place at the stern. These are probably all relatives. The coffin draped with cloth will have been in the boat on the left. The other boats have cabins covered with mats. A small boat, floating on the Nile just above the second bark, was loaded with all the good food required by the deceased. Another boat can be seen to the right.

The following registers showed the delivery of the tomb equipment, but virtually nothing can be seen today (fig. 136). The scene of the making of the coffin in the lower register is largely destroyed. The carpenters could still be observed in the nineteenth century, but today only the very last touches on the coffin can still be imagined.

Prayers accompany the visitor as he passes into the inner chamber, where quite a few of the scenes are easy to recognize, and modern cleaning has made some of the scenes quite clear. The right wall of the inner chamber is worth examination, as the representations and colors are well preserved. There are no accompanying texts, so that it is not always possible to elucidate their meaning with certainty.

The temple of Karnak during the reign of Aye can be seen at the right in the upper register (fig. 137). Not yet built were the first two pylons—as we number them today—the great hypostyle hall, or any other buildings dating from after the end of Dynasty XVIII. Until the Ramessides and their successors continued to add to the front of the temple, the "third" pylon, built by Amenophis III, was the foremost. The one behind it, the "fourth," built by Tuthmosis I, was also decorated with flagpoles.

Between these two pylons were two pairs of obelisks—the first pair, in front of the pylon erected by Tuthmosis I, and the second pair, in front of his grandfather's, erected by Tuthmosis III. It is difficult to tell which of the two pairs is shown here, but it might be the earlier.[6] As the scene is shown in profile, only one obelisk and only one flagpole can be seen. As usual, the relative sizes bear no resemblance to the true dimensions of the temple. Neferhotep is striding into the temple with an unguent cone on his head and would appear to be but little shorter than the high entry. The artist has shortened the scene so that the visitor whizzes through the second pylon (of that time), and past the third (which is hardly visible), straight to the innermost sanctuary, which can be seen at the far right. This stood roughly where the shrine made by Philip Arrhidaios does today. Like that shrine and the obelisks, the sanctuary would appear to have been made of red granite. A priest is burning incense and making a food offering in front of the sanctuary. Neferhotep has only just passed through the entrance and entered a small covered building like several others that may have stood along the way. These may have been covered courtyards. The tomb-owner is suitably received, anointed, and presented with a tall bouquet, which he passes on to his wife outside the temple (left).

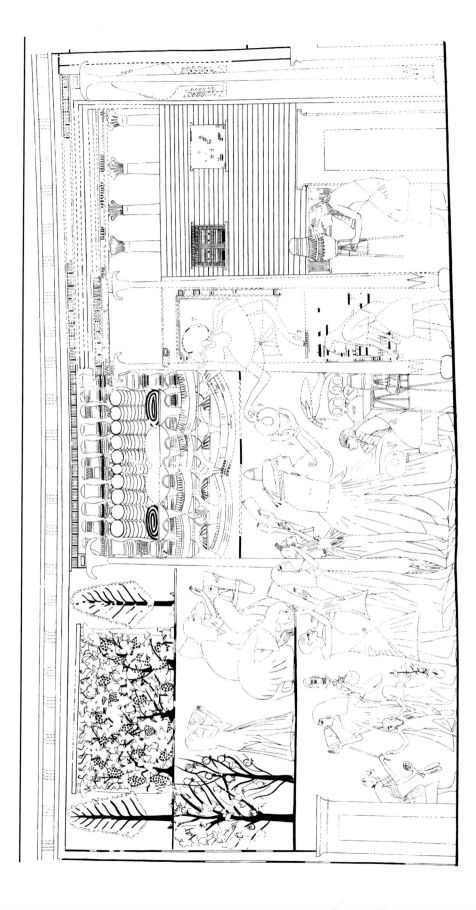

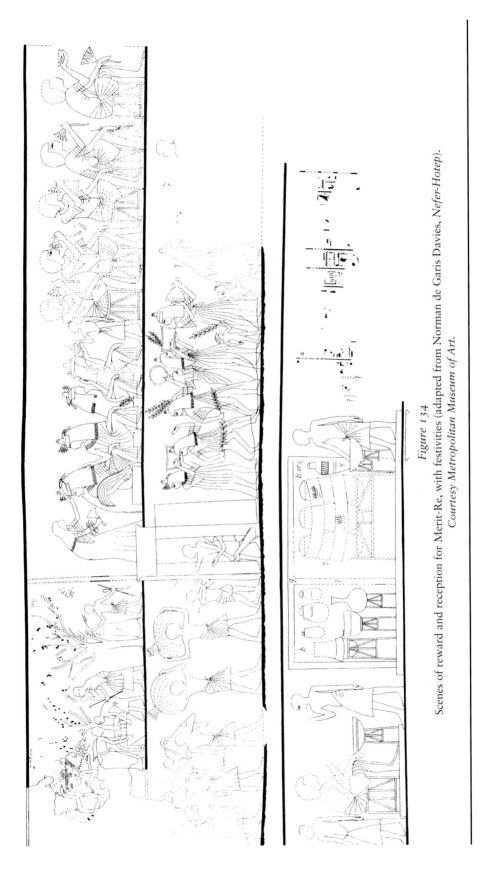

Figure 134

Scenes of reward and reception for Merit-Re, with festivities (adapted from Norman de Garis Davies, *Nefer-Hotep*).
Courtesy Metropolitan Museum of Art.

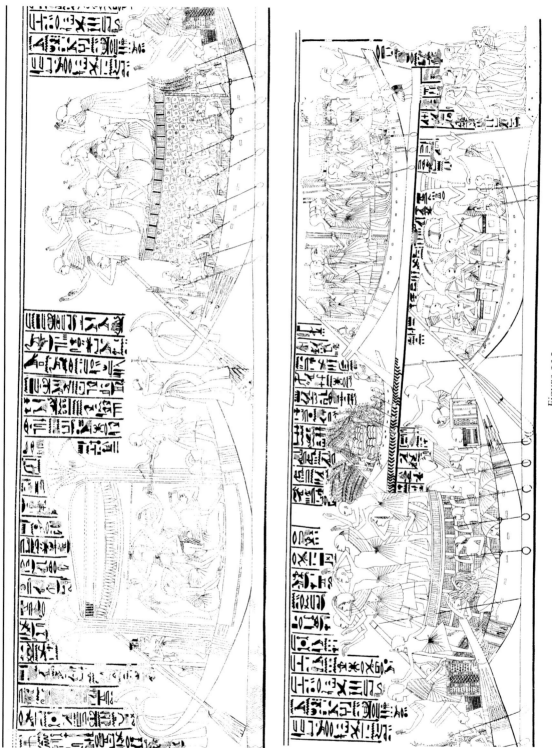

Figure 135

Scenes from the funeral procession (adapted from Norman de Garis Davies, *Nefer-Hotep*)

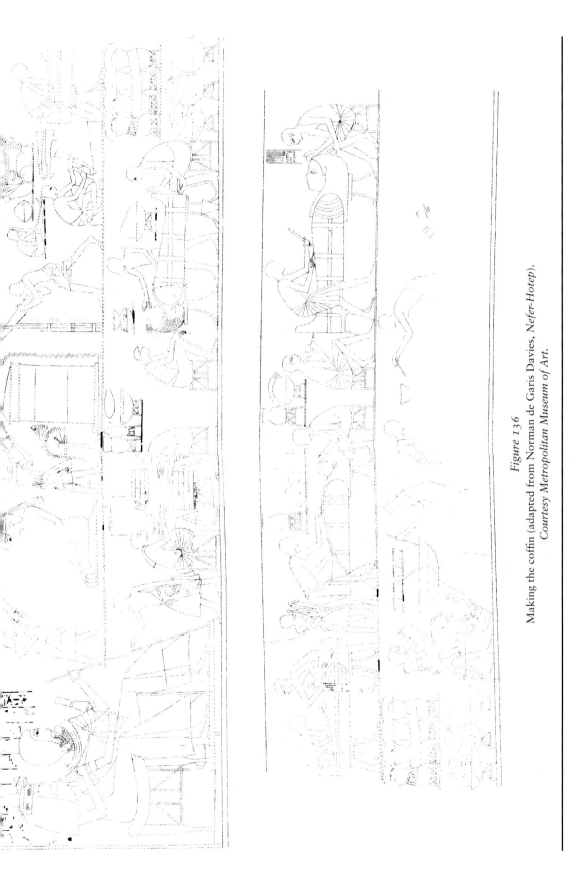

Figure 136

Making the coffin (adapted from Norman de Garis Davies, *Nefer-Hotep*).
Courtesy Metropolitan Museum of Art.

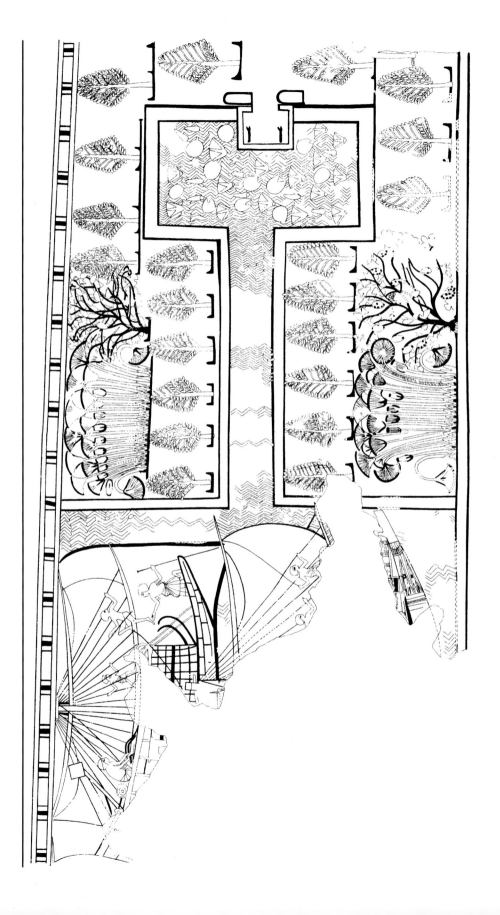

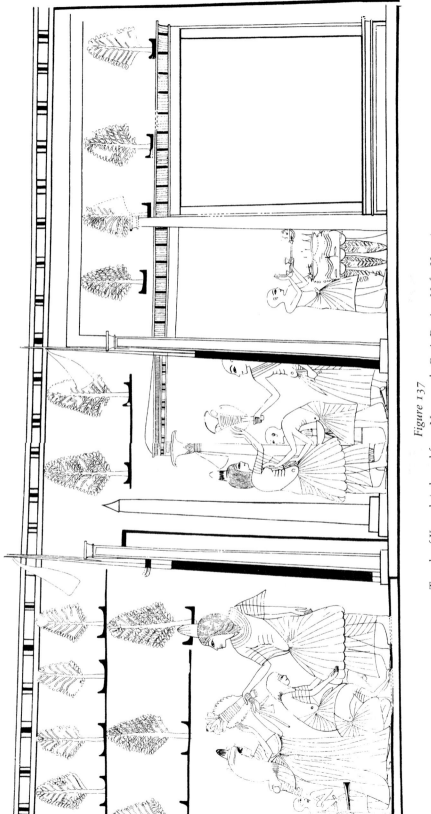

Figure 137

Temple of Karnak (adapted from Norman de Garis Davies, *Nefer-Hotep*).
Courtesy Metropolitan Museum of Art.

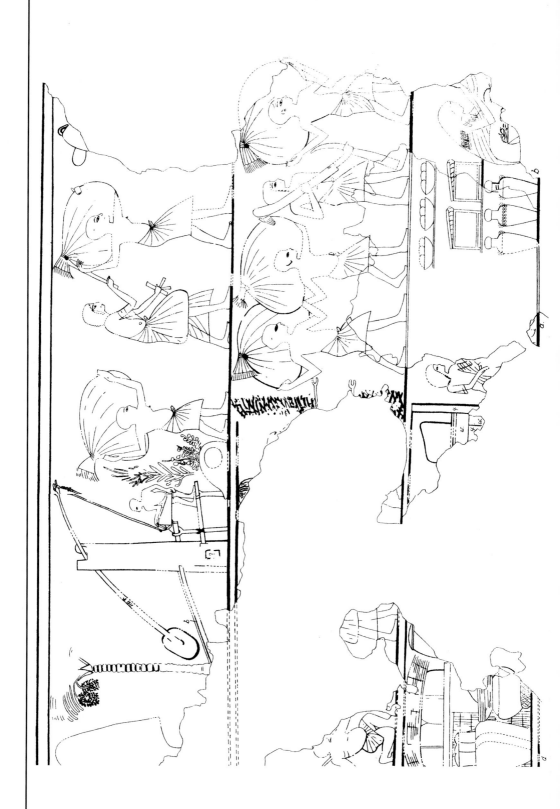

Figure 137 continued

The path from the Nile to the temple is depicted as a body of water that widens into a small lake in front of Karnak. Trees line the canal and were even planted in the temple. Lotus thrives in the lake, which is surrounded by a garden; trees, shrubs, bushes, and papyrus are growing luxuriously. This lake was where the great hypostyle hall is today, which is itself a petrified swamp with its enormous papyrus columns. in the next scene, the boats coming up have probably only just arrived from the other side of the river, likely having been sent from the estates of Amun on the west bank; the canal was shortened later, as the western bits of the temple were added. Farther left, slaves are entered on lists and cattle are being branded.[7] Herds of cattle can be seen, and papyrus is being cut in a thicket. A cow is being transported in a boat on the far left, and a few miscreants are even being whipped. All the activity on such an estate is thus depicted. The key is, of course, that Neferhotep was the overseer of the cattle of Amun, and thus scenes show not the tilling of the earth, but rather the cattle and the temple of Amun at Karnak, to whom all the estates on the other side belonged.

On the right, beneath all of these scenes, are pictures of the magazines. The entry is guarded by scribes who check everything that enters and leaves. It is tragic that these scenes have been heavily damaged, for it is difficult to recognize what is going on in these rare pictures. To the left, beneath the boats in front of Karnak, are irrigated fields and palm orchards. Three *shadufs* can be recognized, as they are used today. A *shaduf* is a simple mechanism by which a pole can be raised and lowered so that a bucket can be filled with water from a shallow well. The ancient Egyptians used them only in gardens and orchards. Freshly harvested dates may be in the sacks that are being carried off on the men's shoulders. Grain would appear to have been spread out in front of the *shaduf* in the middle row; it is being carried off in large sacks to the right. Hardly anything can be seen of the temple ateliers in the lowest portion of the wall. The same applies to the scribe's duties depicted on the left side of the wall.

The pictures on two sides of the front pillar can be easily grasped (fig. 138). The tomb-owner's finely pleated kilt and transparent garment are particularly striking, as these were fashionable during the Amarna age and similar to the images in the Amarna tombs. The artist's execution of the body with the slightly protruding belly and the softened edges belongs to the same tradition. Both Neferhotep and his "beloved sister (wife), his love, the Mistress of the House, praised by Mut, the Chantress of Amun of Karnak, Merit-Re, justified," share the same rather dark skin color, so that the usual distinction between the darker men and lighter women was extinguished. Their skins thus shine through their fine garments charmingly. Merit-Re's luxurious wig with its blossom diadem and unguent cone appears slightly oversized, compared to her delicate body. Both husband and wife, adorned with splendid and ostentatious necklaces and bracelets, stand in postures of adoration.

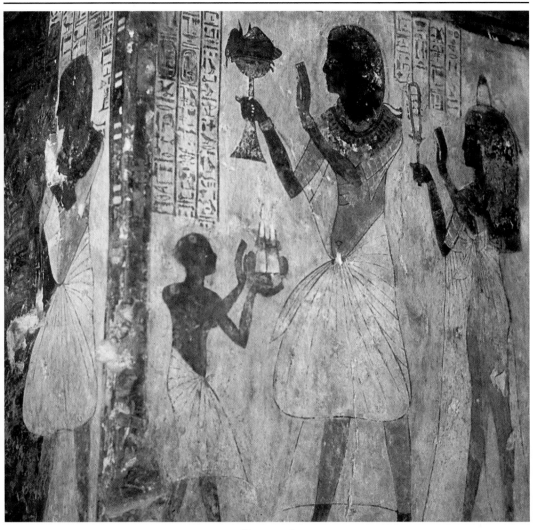

Figure 138

He is holding a tall footed bowl containing a bird, a loaf of bread, and three balls of incense. The "three" need hardly be taken literally, as the number simply signifies the plural in Egyptian. These must be intended as burnt offerings, as two red tongues of flame arise behind the bird. In Merit-Re's hand is a very carefully depicted sistrum, the instrument that women generally tended to rattle in cultic ceremonies. A servant is standing before Neferhotep, presenting a bowl with cake and two cones of fat. He is bald and wearing a simple kilt, but the position of his legs is striking, as one leg is bent while the other is straight. This

posture belongs to neither the traditional style nor the slightly more free Amarna fashion.

Although making gestures of adoration, Merit-Re and Neferhotep are worshipping not any common divinity, but rather deified people, as the three lines of inscription note: "Receiving good from the good god, the Lord of the Two Lands, Amenophis, the good son of Amun, whom he (Amun) loves more than any (other) king. Kissing the earth before the God's wife, the Mistress of the Two Lands, Ahmes-Nefertari, the king's mother, the king's wife, the hand of god, beloved of Re; may they give life, prosperity, health and skill in the presence of their *ka*-powers. May bread, beer and great quantities of meat be given from their altars for the *ka* of the First Scribe of Amun, Neferhotep." The two worshippers can be seen not on this face of the pillar, but rather on the inner face. It is thus only from one particular angle that the entire scene on both faces of the pillar can be viewed.

Amenophis I and his mother, Ahmes-Nefertari, became the patron deities of the Theban necropolis shortly after their deaths. Ahmose was the first king of Dynasty XVIII and thus of the New Kingdom, and his mother was one of the powerful women typical of the dynasty. They may have been the first rulers of the New Kingdom to have excavated tombs in western Thebes, probably in Dra Abu'l Naga, and to have erected mortuary temples for themselves there, but none of these monuments has ever been identified with certainty.[8]

Particularly interesting are the titles of Ahmes-Nefertari mentioned in the text. Before her, only her mother had borne the title "god's wife" or—precisely—"god's wife of Amun in Karnak," but the reference may have been posthumous as it dates to later in Dynasty XVIII. Originally, it was a priestly title borne by those royal daughters destined to be queens, who thus became queens because they had the title, rather than the other way around. It was only later, and particularly after Dynasty XXIII, that the institution of the "god's wives" achieved independent political significance. Ahmes-Nefertari may be the initiator of the institution, and thus she enjoyed the adoration arising from the divine liaison with Amun, together with her son.[9]

On the other face of the pillar, Neferhotep appears with a tall bouquet and lotus blossoms in front of the patron saints Amenophis I and his mother (fig. 139). He is again in festival attire, with a large wig and a wide necklace. Amenophis I is seated on a throne, wearing the blue crown with a uraeus serpent affixed to it. His hands grasp the ruler's insignia, the crook and flail, as well as an *ankh*-sign. Apparently seated behind him, but actually beside him, is his mother, "the god's wife Ahmes-Nefertari, beloved of Amun who formed her beauty. One who, when she says (of something) that all is done, the beauty of her speech gladdens the god." She is embracing him in the fashion otherwise customary between married couples. She is wearing a white folded garment knotted above the breast, from which two colorful ribbons hang down. Above Amenophis I are his two

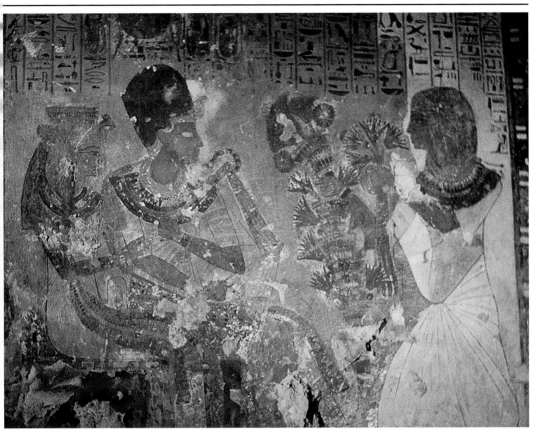

Figure 139

cartouches and various titles. "Presenting all beautiful and pure fresh plants, all the herbs of Punt, all the fragrant fruits, all sweet (water) plants, pure lotus blossoms and buds to your beautiful face, son of Amun (and) for the *ka*-soul of the God's Wife daily; that they permit the receiving of foods brought to them, for the *ka*-soul of the scribe of Amun, Neferhotep." This text explains the entire transaction.

Merit-Re is dressed in a similarly magnificent style on the back of the left front pillar. She is holding a tall bouquet and lotus blossoms; the small people behind her could be either children or servants. Traces of the painting of her husband can still be seen across from her. Virtually nothing more can be seen on the remaining surfaces of the pillars.

At the end of the pillared hall are three niches with statues of three couples. The two on the sides are so heavily damaged that it is impossible to say who they were. The pair in the middle is well preserved, however: the tomb-owner and his wife (fig. 140). These two statues were sculpted straight across from the

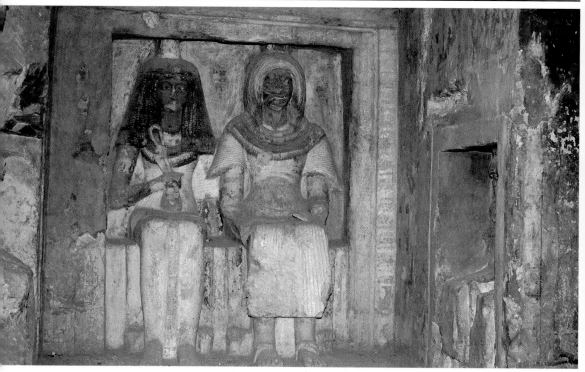

Figure 140

entrance so that sunlight fell right on them. They are both wearing fine pleated robes, as in the reliefs and paintings, making it easy to compare how differently the same things can be presented. Sculpture is incapable of showing a transparent garment. Aside from a broad necklace, Neferhotep is also wearing the gold of honor, below his large wig. One hand is lying flat on his knees, and the other is clenched in a fist. Although the face has suffered considerable damage, it is evident that it was very carefully worked.

Merit-Re is also wearing a pleated white dress, knotted above her breast. She also has a broad necklace and a long, pleated wig, topped with a diadem and an unguent cone, just like those worn by the women in the tomb of Ramose. In her right hand are a sistrum and a *menit;* she has placed her left arm around her husband so that her hand is resting on his shoulder. Despite the peeling paint and damage, the gradual erosion of the sensitivity of the Amarna style can be seen. In the inscriptions on their garments, the couple wish themselves offerings, he from the altars of Amun, Mut, and Khons, she from those of Mut and Hathor.[10]

A little patch has been cleaned at the top of the right niche, where a beautiful portrayal of the Hathor cow can be discovered (fig. 141). Coming forth from

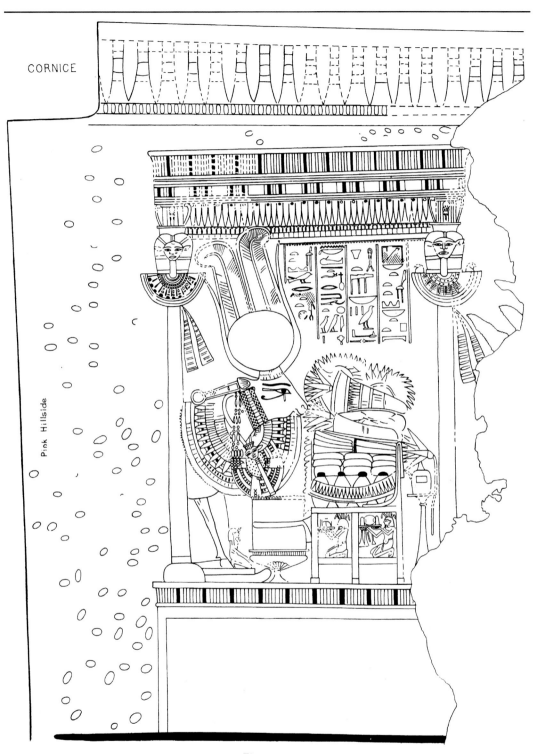

CORNICE

Pink Hillside

Figure 141
Hathor cow (adapted from Norman de Garis Davies, *Nefer-Hotep*).
Courtesy Metropolitan Museum of Art.

the western mountain, she is standing in a shrine supported by Hathor-capital columns. Between the cow horns is the solar disk with high feathers, and a *menit* and a sistrum are hung about the neck, along with a necklace. A generously laid table and a bowl of offerings are in front of the goddess. The Hathor cow itself is standing on a sled; the substructure reveals that the shrine should be understood as standing on an altar.

Kheruef

KHERUEF, CALLED SENAA OR NAI, was "Steward of the Great Royal Wife Tiye," "real royal scribe," and "First Royal Herald." He flourished during the reign of Amenophis III, who was married to Tiye.[1] This king's son and successor, Amenophis IV—Akhenaten—is also pictured in the tomb, but without Nefertiti. We may thus assume that Kheruef served him as well, if briefly.[2] The tomb-owner's parents were Seqed, "Royal Army Scribe," and Rui, a "Chantress of Isis." It is striking that no wife or children are depicted in the tomb; the tomb-owner must have been unmarried.

The complex was left unfinished, and we cannot know what happened to Kheruef after the death of Amenophis III, as he was not buried here. A ramp leads into the large forecourt, which is framed by a covered portico on all sides, but traces of pillars have been found only on the eastern and western sides. The tomb itself was cut not into a slope, but rather into the irregular surface of the desert rock (fig. 142). It is thus one of the very few tombs oriented exactly east-west, with its transverse hall thus exactly north-south and adorned with three rows of 10 columns. The easternmost row resembles fluted columns, and the first two columns, flanking the entry, bear texts. All the other columns are papyrus-bundle columns.

During the Amarna age, the name of Amun was effaced from the walls of the tomb, and the first columned hall collapsed later on. The graffiti of Ramesside visitors reveal however, that the tomb was still accessible, and visited, at that time. During Dynasty XIX another 8 tombs were established in the eastern part of the transverse hall and the northern and southern sides of the courtyard.

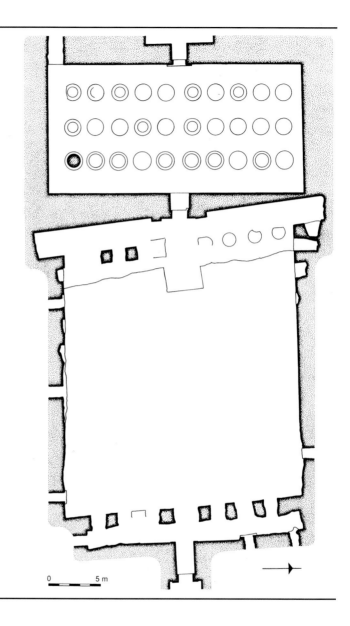

Figure 142

0 5 m

The great German Egyptologist Adolf Erman explored the tomb in 1886, but it was not visited again until Sir Alan Gardiner discovered an entrance in 1911 and then in 1913, together with Davies, entered the part visited by Erman. Before this, it was damaged by salts cracking the limestone, and some reliefs had been cut out: the "Princess Reliefs" must have gone to Berlin before 1908.[3] The remains of two statues of Kheruef were found later despite this plundering. The Egyptian Egyptologist Ahmed Fakhry published part of the decoration, unaware that Alan

Gardiner had preceded him, and then the University of Chicago Epigraphic Survey finally documented the tomb in the 1950s and 1960s.

The dominance of the sovereign in the tomb decoration is even more striking than in the tomb of Ramose, who was one of Kheruef's contemporaries. This accounts for the prominence accorded the scenes of Amenophis III's two jubilee or *sed*-festivals, in his 30th and 37th regnal years. The jubilee festival celebrated in his 34th year was not immortalized in the reliefs of Kheruef's tomb, however. The roots of the *sed*-festival lie in predynastic Egypt. It was a jubilee festival intended to renew and revitalize the sovereign's strength. The first festival was supposed to be scheduled for the 30th regnal year, after which it could be repeated every 3 years. One of the earliest indisputable references to the festival can be assigned to the reign of Djoser, from his step-pyramid complex at Saqqara.[4]

Due to the prominence of the *sed*-festival, Kheruef, the tomb-owner himself, assumes a lesser place in his own tomb. Although he would have played a significant role in the organization of the festivities, this tendency for royalty to dominate private tombs assumed unusual proportions in the private tombs at Amarna. On the other hand, the decoration of Kheruef's tomb is distinguished by the fine reliefs of the best pre-Amarna style and can justly be compared with the exquisite reliefs of Ramose's tomb.

Just to the right of the entry is a long hymn to Re:

> Worshipping Re
> when he sets in life
> in the western horizon of heaven
> by . . . Kheruef . . .
> who says:
>
> Hail to you!
> master of eternity,
> Atum, chief of everlasting time,
> You have united with the horizon of heaven,
> You have appeared on the western side
> as Atum in the evening.
> You have come in your strength,
> without an opponent.
> You rule heaven as Re,
> You reach your heavens in pleasure,
> You ward off clouds and storm.
> You descend into the body of your mother Naunet,
> and your father Nun performs the greeting,
> the gods [of the west] stand for you
> and those in the Netherworld are overjoyed
> when they see their lord,
> far-striding Amun-Re, Lord of all humanity.[5]

The lintel above the entrance shows Amenophis IV, followed by his mother, Tiye, "the great royal wife," presenting wine to Ra-Harakhte and Maat. Tiye is holding a sistrum in her right hand. In her left she is holding a papyrus blossom and the *ankh,* symbolizing life. The king burns incense for Atum and Hathor on the right, followed by Tiye again, who is holding a sistrum and a lotus blossom. As in the picture on the left, the goddess has laid her arm on the god seated before her. The texts explain the meaning of the scene and name the participants.

The offering formula is repeated four times, on each side of the doorposts, with a different god addressed in each case. The two seated figures of Kheruef are largely destroyed; they originally defined the lower limit of the texts.

The scenes in the passage itself can hardly be recognized: on the left was Amenophis IV presenting offerings to Ra-Harakhte, but he has since been hacked out. A kind of hieroglyphic "crossword puzzle" appears between the god and the king.[6] On the left, the sovereign was making libations for, and adoring, his parents, Amenophis III and Tiye. Kheruef can be seen twice below, kneeling with his hands raised in adoration. In the eastern half of the passage is a hymn to the rising sun, in front of the tomb-owner, who is striding out of his tomb. On the other side, as is to be expected, the tomb-owner is looking inwards, toward the West, with a hymn to Osiris, the god of the dead.

Straight ahead, on the north side of the passage, Amenophis IV worships gods of the Netherworld. The sovereign and his cartouches have been hacked out here as well, but one can still note that the king was not yet depicted in the Amarna style, and that his name had not yet been changed, so that it was still "Amenophis" (IV), and not "Akhenaten." It can therefore be concluded that work had ceased on the tomb of Kheruef by the fourth regnal year, as the change of name and style started in the third or fourth year.[7]

Scenes from the jubilee *sed*-festival can be seen on the left side of the rear wall of the court (fig. 143). This was celebrated on the 27th day of the 2d month of the Shomu ("hot") season, in the 30th year of the reign of Amenophis III. The text gives the complete titular list of Amenophis III and names the dignitaries who came to the *per-hay,* the "House of Jubilation" that plays an important role in the *sed*-festival. The gold of honor and fish of *nebwy*-gold (which could be lower-quality gold) are being awarded, and "every man stood according to his rank." Food was distributed from the royal table: bread, beer, beef, and fowl. The festival guests were led to the lake to row the royal bark. In the upper left of figure 143 they grasp the tow ropes of the evening bark and the prow-rope of the morning bark, and thus the royal bark drew these two other cult vessels, stopping at the steps of the throne. "His majesty did this as prescribed in the ancient records. Not since the ancient past of the ancestors have the preceding generations of kings celebrated such ceremonial rites at the festival."

It is possible to follow the activities described in the upper register, despite the damaged state of the reliefs. The dignitaries proceed to the bark and tow it in the middle left part of the register. One of these priests is bearing a standard topped with a canine form. This is Wepawat, "the Opener of the Ways." The king puts on his festival attire after having anointed the standard in its chapel. Accompanied by the standard, he then completes the *sed*-festival run. This is followed by processions where the divine standards are borne, with that of "the Opener of the Ways" at the forefront.

With the White Crown of Upper Egypt on his head, Amenophis III stands with Tiye behind him in the middle of the solar bark (which is the only one shown). The royal pair can be seen again on the right, in front of a vertical *kheker*-frieze (suggesting the palace) (fig. 144). The cartouches clearly state who they are. The king is clad in the traditional simple short mantle worn at the jubilee festival.[8]

In the heavily damaged scene below, the deceased is receiving rewards from the king, including a necklace (fig. 145). The king is seated in a booth surmounted by a uraeus frieze and supported by slender lotus and papyrus columnettes. The base is adorned with *rekhyt*-birds, signifying the Lower Egyptian subjects mythically conquered at the dawn of history, but they can also symbolize rebels whom the king has subdued (fig. 146). They are also widely associated with dependents and are regarded as being part of the court.[9] Below them are lotus- and papyrus-blossom columns symbolizing the South and North, respectively. The texts confirm that all of the foreign peoples praise the king.

The king is crowned with the double crown, holding the insignia of sovereignty in his hands: the crook and the flail (see fig. 143, far right). He is also wearing the long straight royal beard, as in the other scenes. His feet are on the *heb*-hieroglyph for "festival." The uraeus serpent coiling around the solar disk is stretching out so far that it faces the erect uraeus-serpent on the king's forehead. Beside him is the goddess "Hathor, the Mistress of Dendera," who is identified by her cow-horn attribute. Even the uraeus serpent on her forehead has its own cow-horn attribute as well. Hathor is wearing a *menit* around her neck. On the far right is "his beloved great royal wife, Tiye," holding a queen's fan and a lotus blossom. She has the vulture bonnet and the queen's tall feathered crown on her head.

It is significant that rulers and priests are all wearing sandals, but not the goddess. It is thus clear that the queen is not closely bound to the composition that includes the king and the goddess. Long before, during the Middle Kingdom, the goddess Hathor was designated the "lady of the *per-hay*" and was thus closely bound to the *sed*-festival; she can also appear as the king's mother. This mother role is particularly striking in the Hathor chapels of the royal temples at Deir el-Bahri, and in particular in the chapels of Tuthmosis III and Amenophis II, which are in the Cairo Museum today. In the Hathor cult of Deir el-Bahri, Hathor is suckling the king (including Hatshepsut), as mother.

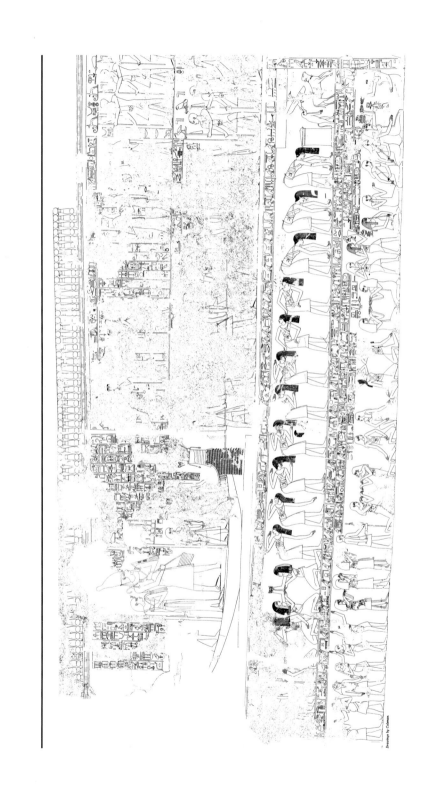

Drawings by Coleman.

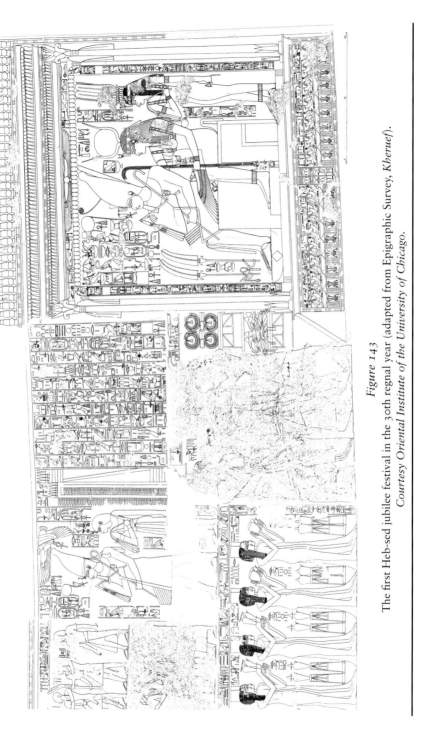

Figure 143

The first Heb-sed jubilee festival in the 30th regnal year (adapted from Epigraphic Survey, *Kheruef*).
Courtesy Oriental Institute of the University of Chicago.

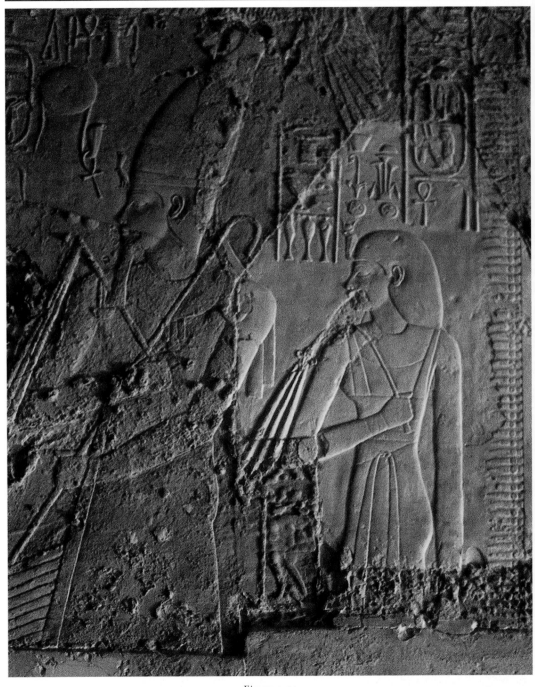

Figure 144

Figure 145

Figure 146

Gods were ordered into divine triads in ancient Egypt, and in this case the trinity consists of the king, queen, and Hathor. Maat, the goddess of justice, can also substitute for Hathor, the king's mythical mother, and thus she becomes the mythical counterpart to the king's consort. She can also be understood as a sister, since Maat is the daughter of Re, and the king had been considered to be the "Son of Re" since Dynasty V.[10]

Details show how subtly the claims to kingship could be emphasized. On the far right (fig. 143), with one hand, Hathor grasps the king's shoulder, while the other holds a stripped palm branch, the hieroglyph for "year," symbolizing the infinitely long reign of the sovereign. The signs for millions (a small seated figure with both arms raised above his head) and thousands (a tadpole) form the base of the bunch of palm branches, along with an amulet-like *shen*-ring (fig. 147). Below the goddess's arm is a ring with the same symbols. Amenophis III's everlasting life and reign are thus emphasized, and it is not without reason that the texts award the king an "eternal" lifetime, "like Re." A protective vulture goddess spreads her wings around the king, before Hathor. The vulture too is holding a protective *shen*-ring in its claws. This is most probably the goddess Nekhbet, the patron deity of the kingship of Upper Egypt, who is commonly shown spreading her protective wings on temple and tomb walls and ceilings.

To the left of this scene is a particularly charming series of four pairs of girls (fig. 148). The accompanying text explains: "ushering in the children of the great,

Figure 147

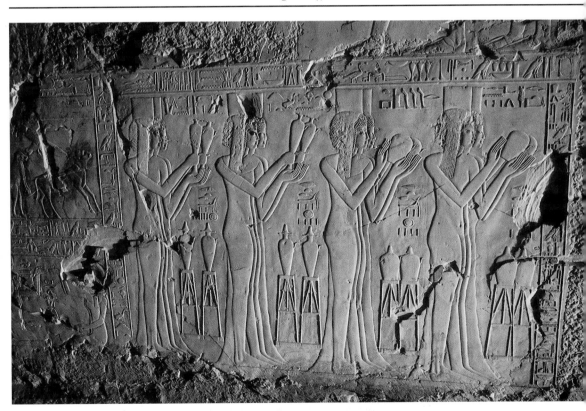

Figure 148

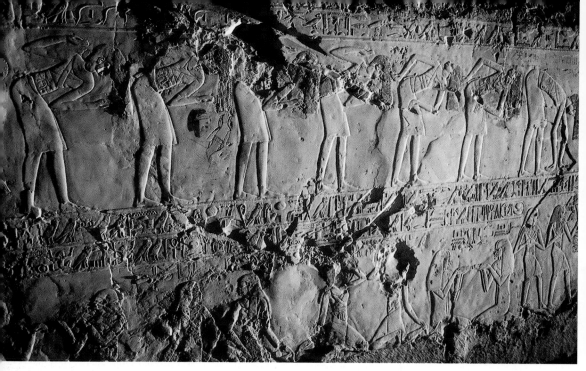

Figure 149

bearing *nemset*-ewers of gold and libation vessels of electrum: to celebrate the *sed*-festival. They must stand at the steps of the throne in the presence of the king." The horizontal lines above read: "Pure are your *nemset*-ewers of gold and your electrum libation vessels. The daughter of the Mentyw-tribe (to the northeast of Egypt): she gives you cool water, oh sovereign: Life Prosperity and Health you shall have forever."[11]

The inscription thus shows that the girls are daughters of foreign leaders.[12] They were probably raised at the Egyptian court, which would explain their Egyptian appearance. They would have been at court in order to guarantee the loyalty of their fathers and their tribes. The cult vessels, used for libations, that they are holding are the same as those on the stands in front of them. The captions accompanying the jars read: "Performing Purification four times." The fine tender faces and graceful bodies and the subtly executed hair make this relief one of the finest of Dynasty XVIII.

Behind these girls, and separated by a vertical line of text: "Ushering the women into the presence of the King, to celebrate the (*sed-*)festival before the throne dais," are two rows of dancers and musicians (fig. 149).[13] The upper row has two girls, perhaps Libyans, performing dances that are almost acrobatic (fig. 150). Their hair is flying forwards or to the side as they skillfully bend their tender bodies; even the movement of the hands is deftly shown. In front of them, beside a small chapel, are a baboon, a flying bird, and a small calf (see fig. 143).

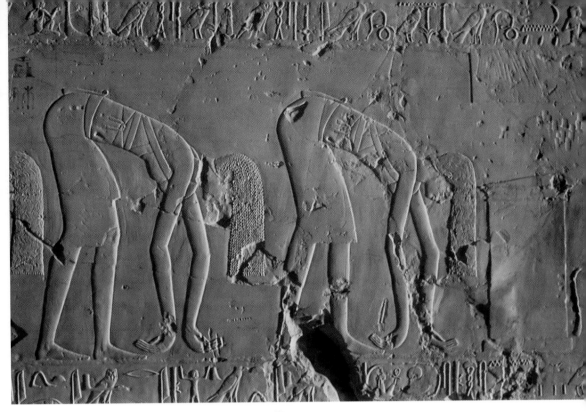

Figure 150

In the lower register are some charming singers clapping their hands to the rhythm. The inscription beneath them reads: "Applause. Applause. Singing and clapping. Being overjoyed." Among the seated singers are some graceful dancing girls, holding stick-formed castanets and papyrus flowers. "Dancing" (or "going slow"), explains in the caption. At a good distance away to the right is another songstress (fig. 151). As can be seen in the Orient today, she is covering one ear with her hand, in order to be able to pick up her own voice better. Behind and in front of her are flutists, lost in their music as they lean forward. The entire scene is under the heading: "This is his protection, that of the king, Neb-maat-Re (Amenophis III). Come, oh Sobek, to the son of Re, Amenophis, Lord of Thebes, given life, and do what he loves!"[14] Two men can be seen among the dancers and musicians: they are holding a cudgel-like staff and a *sekhem*-scepter. These are the chorus-leaders. Behind the one on the left are girls clapping their hands and one girl with a tambourine. Male dancers end the row: the ones on the far left seem to be wearing lion masks, and they are probably priests with the masks of the protective gods Bes or Aha. They were probably credited with apotropaic powers intended to guarantee the uninterrupted course of the festivities.[15]

A song to Hathor is inscribed in two horizontal lines between the two registers. One should "joyously greet 'the Gold' (Hathor) and make peace for the 'Mistress of the Two Lands,' that she make Neb-maat-Re (Amenophis III), given

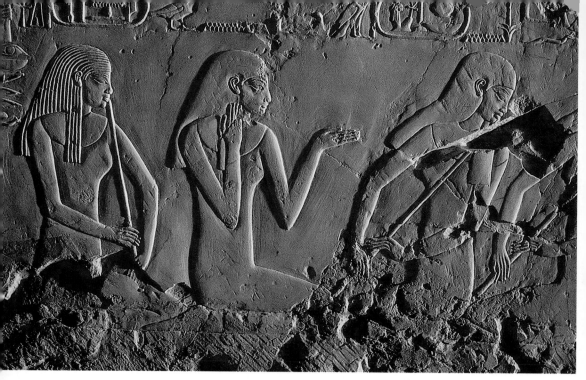

Figure 151

life, endure." She shall be given praise at dawn and music at twilight. "Oh Hathor, you are exalted in the hair of Re, you are exulted in the hair of Re (probably hinting at her manifestation as the eye of the sun, or as an uraeus-serpent). The heavens, the depths of night and stars have been given to you. Great is her majesty when she appears, the adoration of 'gold' when she appears in heaven. Everything in heaven belongs to you while Re is in it; everything on earth belongs to you while Geb (the earth god) is in it. There is no god who does not do what you desire when you appear in glory." The goddess is then bidden to protect King Amenophis III. "Make him healthy on the left side of heaven (i.e., in the East, on this side)" is the final request. At the end of the hymn is more praise for the goddess, who should perform various good deeds for the king.

The wall just to the right of the entry shows scenes from another *sed*-festival celebrated during the king's 37th regnal year (fig. 152). Seated in a chapel similar to the last one are the king and his "great royal wife" Tiye (fig. 153). The reed mat on the ground is clearly visible. The king is holding the crook and flail along with an *ankh*-symbol, signifying "life." The blue crown is on his head and he is clad in a simple, smooth garment. A necklace and the gold of honor are around his neck. Affixed to his waist, and lying in his lap is a bull's tail, a symbol of power. A winged sun disk and another with uraeus serpents holding the *shen*-ring and an *ankh*-sign are above the king. Both he and his consort are wearing sandals, as in the other *sed*-festival scenes. The sovereign himself is on

a simple throne, the back of which was formed in the shape of the Horus falcon, who is protectively embracing the king. The king is "the living Horus on earth" and thus close to the god of kingship. The association is the same as that portrayed in the Old Kingdom statue of the Dynasty IV king, Khafren, in the Cairo Museum.

Tiye is enveloped in a simple tight dress and wears the vulture bonnet with the tall feather crown; she holds the queen's fan and an *ankh*-sign. Her throne is far more splendidly ornamented than that of her husband. The armrests depict a female sphinx, before which Tiye's name is inscribed. Egyptian sphinxes were "grammatically" masculine, in contrast to their Greek namesakes, with whom they in fact shared nothing but the name; this is the reason for the distinction here. This female sphinx is trampling female enemies, and the inscription following reads "trampling all foreign countries."

A uraeus serpent wearing the White Crown of Upper Egypt has spread its wings protectively behind the sphinx. The uraeus is itself seated on a lotus blossom, symbolizing Upper Egypt. The caption underlines what is clear from the imagery: "The white one from Hierakonpolis." Between the lion-paw feet of the chair is a bound Nubian woman with closely cropped hair, and an Asiatic with long braids. Traces of the Nubian's dark skin color remain, and the hanging breasts of both women can be clearly seen. The women are bound together by the intertwined plants symbolizing Upper and Lower Egypt, lotus and papyrus blossoms, in exactly the same fashion as were male captives. The entire composition thus forms the hieroglyph for "unification," *sema tawy*: the unification of the Two Lands, of Upper and Lower Egypt. The reunification was accomplished by every king when he ascended the throne, and thus this is a common theme for the lateral decoration of throne bases.

Below the booth is a row of enemies with their arms bound behind their backs (fig. 154). These are the "Nine-Bow-Peoples," representing the peoples defeated by the Egyptians, including both external and internal foes of the Egyptian king. They are common on the pedestals of statues and throne bases, where they will be literally "under the king's soles"; Tutankhamun even had a pair of sandals with the "Nine Bows" on them, so that he was constantly treading on them. In place of bodies, those depicted here have ovals (representing walled cities), enclosing the names of the subjugated tribes and settlements. These names had been more or less canonized since the reign of Amenophis III.[16] From right to left they read: Hau-nebu (those of the islands and peninsulas of the Mediterranean), Shatyw (Upper Nubians), Ta-Shema (Upper Egypt), Seshtyw-im (people of the oases), Ta-Mehu (Lower Egypt), Pejtyw-shu (Eastern Desert), Tjehenu (Libyans), Iwentyu-sety (Nubians), Mentywnu-sejet (Asiatics)." The facial features are portraits of the peoples of each of the various subjugated nations.

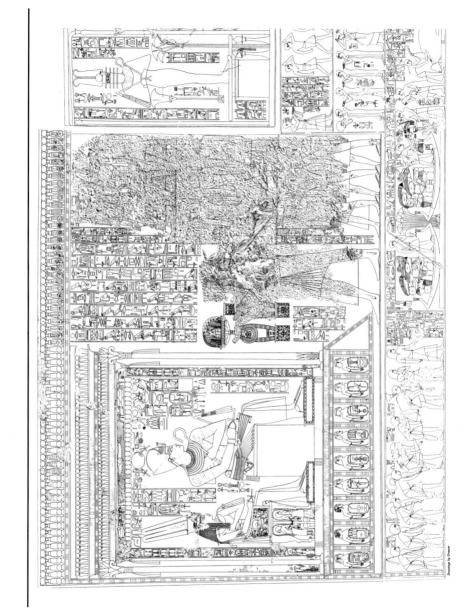

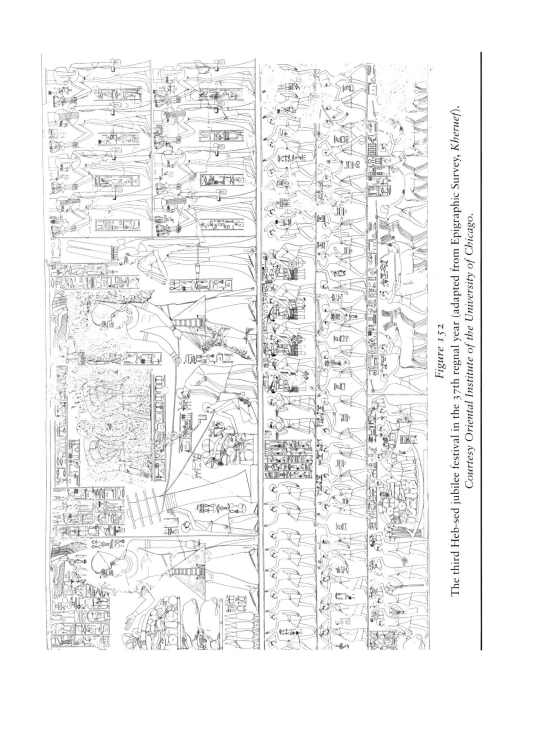

Figure 152

The third Heb-sed jubilee festival in the 37th regnal year (adapted from Epigraphic Survey, *Kheruef*).
Courtesy Oriental Institute of the University of Chicago.

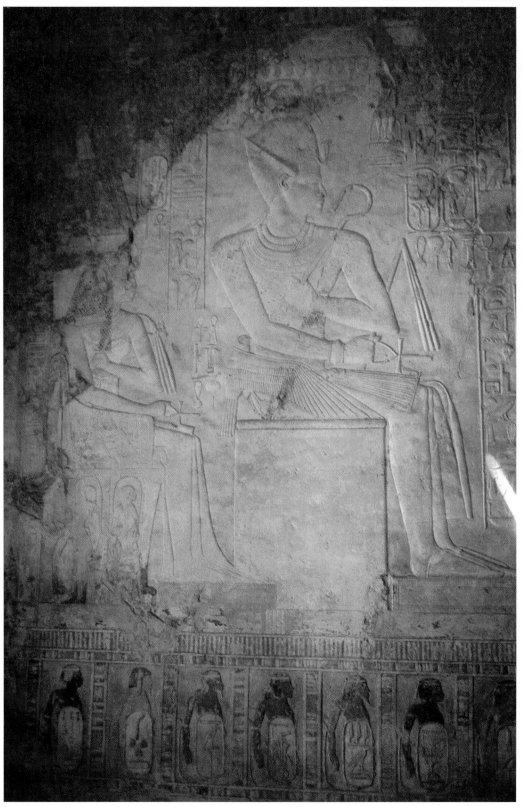

Figure 153

Figure 154

The texts in front of the sovereign and behind Tiye (see fig. 152) name them and include epithets. In the scene to the right, Kheruef and three men behind him approach the royal pair. They are almost all destroyed, but the gifts in Kheruef's hand can still be recognized. In each hand is a pectoral similar to those of Tutankhamun on display in the Cairo Museum. The cartouches bear the throne name of Amenophis III, Neb-maat-Re, "Re is the Lord of Justice," as well as his personal name, Imen-hotep, that is, Amenophis. Uraeus serpents with the crowns of Upper and Lower Egypt flank the cartouches. The pectoral the tomb-owner has in his left hand bears the cartouche "Tiye" at the upper right. The one in his right hand is particularly beautiful: a scarab beetle symbolizing birth and renewal rises on the breast piece, and a horizontal cartouche encloses the king's name.[17] A solar disk can be clearly seen above the scarab's head. In mythology, this beetle rolls the sun up the horizon at dawn, and it is therefore hardly accidental that the beetle is the manifestation of the morning sun. Along with the necklace, Kheruef has a large vessel in his hands. It has the form of a lotus blossom and its rim is adorned with ibex heads. Lotus and papyrus blossoms spread forth from the vessel, with the king seated among them.

A *djed*-pillar is being erected just to the right of the scene just described. This ceremony can also be followed in the Osiris chapels of Sethos I's great Osiris temple in Abydos. The *djed*-pillar was probably originally a post-shaped fetish wound about with floral materials.[18] It becomes a symbol, *djed* meaning "enduring," "lasting," "eternal." This meaning led to an association with Osiris, "the lord

of eternity," and thus the *djed* symbol became Osiris's backbone. As a popular amulet the *djed*-pillar protected the backbone of the dead and was thus an aid to resurrection. It also provided temporal endurance. Erecting a *djed*-pillar is an essential element of the royal cult. In this tomb, the scene shows the "erection of the *djed*-pillar for Ptah-Sokar-Osiris," which was performed on the morning of the *sed*-festival. This act can also be understood as representing Osiris's triumph over Seth. The anthropomorphized pillar stands at the middle left, in a shrine. It has taken the shape of a human body with the *djed*-pillar as its head; the eyes are *udjat*-eyes. The hands hold the crook and flail, the usual insignia of Osiris, the god of the dead. On its head is the tall feather crown with the solar disk. The pillar is on a high base reminiscent of the platforms visible today in many temples, on which the cult barks once stood. In front of and behind it are lotus and papyrus blossoms. Beneath the large slab of the base are two tall offering stands—one bears a libation vessel, while flowers have been laid on the other. To the right is the king himself, presenting a generously laid table. Fowl, cucumbers, blossoms, breads, and heads and ribs of beef are all lying on the upper mat, while a cow and an antelope can be seen on the lower one. Beneath these mats are four tall vessels containing unguents and oil, with bundles of lettuce sticking out among them. The vulture goddess, "Wadjyt, the Mistress of the *Per-nu* shrine," has spread her protective wings above the sovereign, with the blue crown on his head.

The scene further to the right is not very well preserved. It once showed the sovereign, followed by his consort, raising the *djed*-pillar with a rope. He is being aided by three men who are probably Memphite priests, according to the rites. Another is supporting the pillar, before which offerings are being presented, beneath the ropes. Each of the royal pair is being followed by four pairs of young ladies resembling those of the *sed*-festival. Each is rattling her Hathor sistrum and holding a *menit* in the other hand. Each row has an accompanying line of text, the hieroglyphs standing just above the girls: "Children of the king praising (or "charming") the noble *djed*-pillar." These are then in fact the daughters of the king.

Below these scenes are three additional registers. Men are dancing with heavy steps in the top one. Between them are offering bearers with foods (fig. 155). Singers are lined up on the far left (fig. 156); a short hymn to the creator god Ptah is written beside them. The captions state that singing and dancing girls are in the middle register, but one notes that they do not have the graceful bodies of those at the other *sed*-festival. Only the raised hands and the foot swinging in the air hint at the movements of a dance. The men on the right are conducting a sort of boxing match (fig. 157), as well as performing a cane dance (fig. 158) such as can still be witnessed in Egypt today. Such games were part of the ceremonies surrounding the erection of the *djed*-pillar.

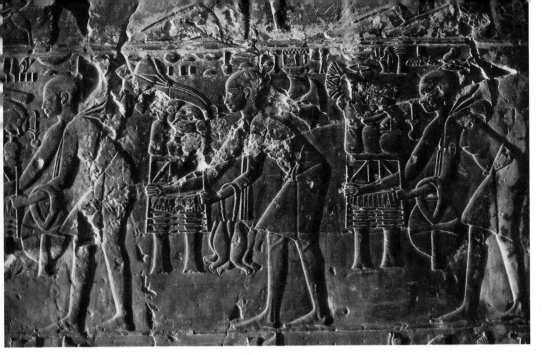

Figure 155

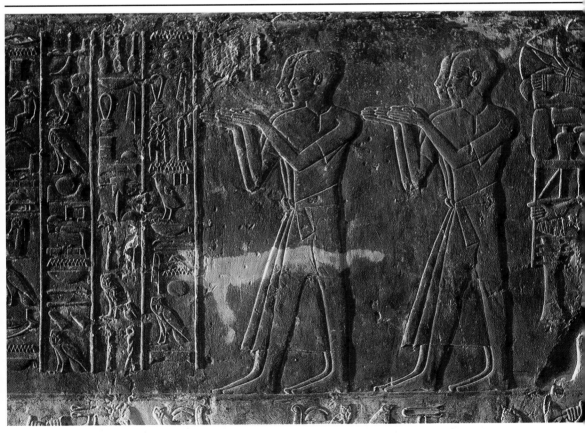

Figure 156

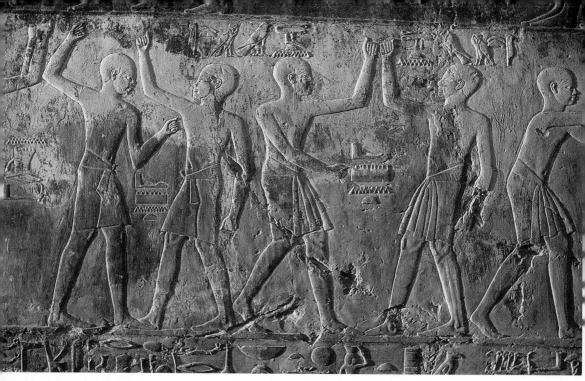

Figure 157

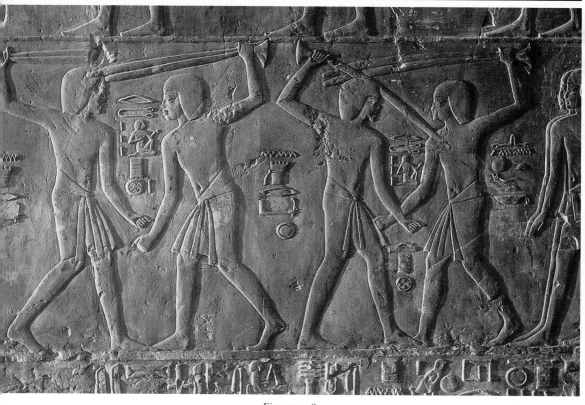

Figure 158

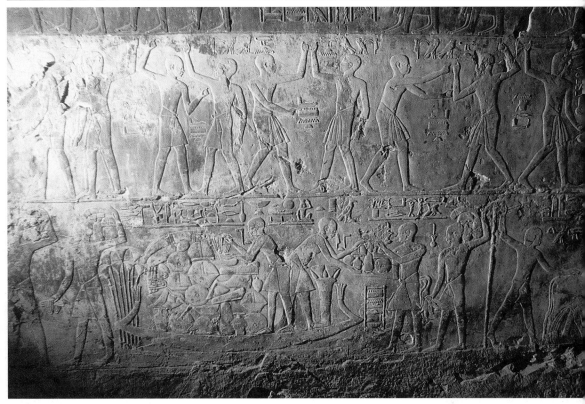

Figure 159

At the very bottom on the far left (see fig. 152) is a long row of nine men: they have a fan, bow-case, throw stick, and shield. The second is not holding anything but has put one hand on his shoulder while his other hand is grasping his forearm. This group is led by Kheruef, wearing a thin, transparent, starched apron. Boats heavy with offerings are approaching from the right (fig. 159). A cow is being slaughtered on a mat in their midst, and offering bearers are coming. Further to the right, cattle and donkeys are being driven in. "Go!" is the inscription above the group of cattle on the left (fig. 160). Donkeys and cattle have the obligation to "circle round the walls four times, on this day of erecting the noble *djed*-pillar of Ptah-Sokar-Osiris," or rather the "*djed*-pillar which is in the *shetit* (Netherworld)."

The first and second columned halls were left unfinished. In the passage to the first one can see only Kheruef with his mother, Ruy, on the left. Behind and before them is a hymn to the rising sun. The text and scene are largely destroyed, however.

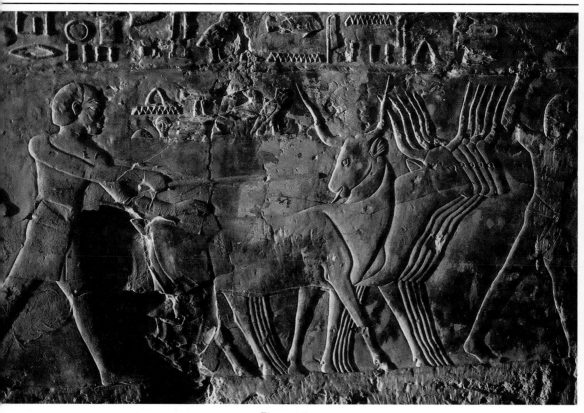

Figure 160

Samut

TT 409

SAMUT "SON OF MUT," nicknamed Kyky, was a scribe and "inspector of cattle in the stalls of Amun." He lived during the reign of Ramesses II. His wife was named Rayay; the names of his parents are unknown. Excavated in 1959, Samut's tomb has a few interesting scenes, but evidence of the hastiness of execution increases as one moves inside. Relief was virtually not attempted, despite the excellent quality of the stone. Although the colors have suffered considerably from the salinity of the stone, they are still easy to appreciate.[1]

The tomb takes us into the world of the Ramesside officials, as opposed to the workers of Deir el-Medineh. The small size of the various pictures prevents them from filling the walls with the aesthetically pleasing divisions of earlier tombs; it is characteristic of the Ramesside period that the unity of scene and wall is broken. At the same time, scenes were extended around corners, as in the funeral procession. Furthermore, a single register can be split into two scenes.[2] This stylistic change hinges upon the increasingly religious (as opposed to cultic) character of the scenes, as the Beyond and the gods play a prominent role. The style thus introduces a new semantic axis, creating a new—vertical—hierarchy, as opposed to the earlier horizontal distribution. It has been emphasized that during Dynasty XVIII the deceased played upon, for instance, the horizontal axiality of the door reveals to indicate entering into and leaving the tomb. A typical example of the Ramesside method will be noted in Samut's tomb where the divine court is placed above and the funeral ceremonies below (see p. 233 and fig. 167).[3]

The plan is conventional, but oriented to the north rather than the west, a situation dictated by the topography (fig. 161). A fictional orientation to the west was thus created. The large courtyard in front of the tomb belongs not to this

0 5 m

Figure 161

tomb alone, but also to that of Bakenamun beside it. A huge mound of rubble suggests that additional tombs will be found to the south (fig. 162). Such repeated use of tombs is also recorded for Ramose and Kheruef. It was, however, hitherto impossible to investigate this question in Samut's tomb.

A stela flanked each side of the entrance. The one on the left shows Kyky and Rayay presenting flowers to Ra-Harakhte and Maat, with an analogous scene on the right with the gods Isis and Horus. A hymn to Amun-Ra-Harakhte is inscribed beside both. Above the entrance is a cavetto cornice bearing traces of paint (fig. 163). On the lower part of the architrave the tomb-owner and his wife are worshipping Osiris and Isis on the left side, and Ra-Harakhte and Maat on the right, as the accompanying texts instruct us. The three vertical columns of text on each side of the passage are stereotypical offering formulae, "a boon which the king gives." On the left Osiris, Horus-the-staff-of-his-father (Harendotes in Greek), and Isis are named and addressed with epithets. The scene is repeated on the right with Ra-Harakhte, Maat, and Thoth. The names and titles of the tomb-owner stand at the end of each column.

The scenes of the deceased on the jambs were done in raised relief. The relief is not only exceptional, but among the best decorations of this tomb. The reveal on the right shows Samut striding into the tomb, his hands raised in adoration. The god being worshipped is not visible, but the text names Osiris, as was to be expected. On the left reveal, Samut is leaving the tomb and worshipping Ra-Harakhte with a hymn:

> Praising Ra-Harakhte when he rises in the eastern horizon of heaven by the (destroyed) who has become Osiris, praised by the great god, the scribe, inspector of cattle in the stalls of Amun, Samut, justified, named Kyky (destroyed), Re, Atum, Horus who traverses the heavens, the great falcon, joyous in festival, circling his father, beautiful of face, with two giant feathers, may you let them see in the netherworld, the daily rising for the *ka*-soul of the scribe who has become Osiris, the inspector of cattle in the stalls of Amun, Kyky, justified.

A harpist appears beneath the scene, singing to Kyky and his wife, the chantress of Amun-Re.

The deceased is clad in a fine pleated garment through which his legs can be seen (fig. 164). He is adorned with a broad necklace and bracelets. The long wig has left his carefully executed ears exposed. On his chin is the short beard of the official. His hands are raised in adoration.

The ceiling in the interior is surprisingly multifaceted, artists having long since abandoned the rigid imitation of the beams and mats of a house.

Figure 162

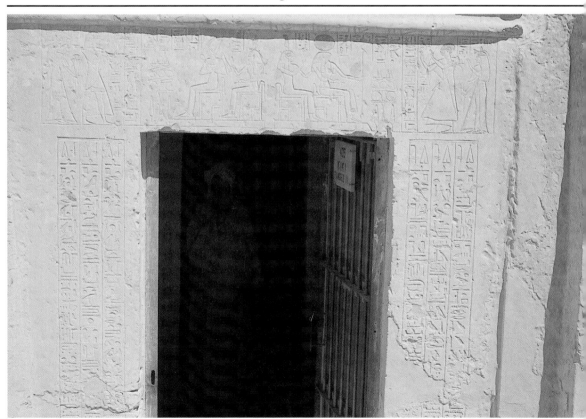

Figure 163

Figure 164

The couple appears high up on the wall to the right of the entry. They are kneeling before Anubis, depicted as a jackal on his shrine, and Hathor, reduced to her symbolic emblem (fig. 165). The couple is shown three times altogether in this upper part, each time before two gates leading into the Netherworld, placed one above the other. Each gate is guarded by demons with spears and knives. The uppermost doors are quite simple, but the lower ones are adorned with a uraeus frieze and thus resemble shrines more than doors. The fifth, fourth, and third gates are mentioned in the texts. The third gate was originally shown in the right part of the wall, which has since been destroyed. This scene draws on Spell 146 of the Book of the Dead, which is a summary version of Spell 145, naming the gates and their guardians. The most detailed version, dating to Dynasty XVIII, is in TT 353, one of the tombs of Hatshepsut's architect, Senenmut. Historically, however, Spells 145 and 146 only become common in the tombs of Ramesside officials (see p. 255).[4]

Below these religious scenes, two rows of colorful cattle are being driven. The tomb-owner was probably the one receiving the herds of Amun; a scribe can be seen behind him. The frieze at the top of the front wall continues across the

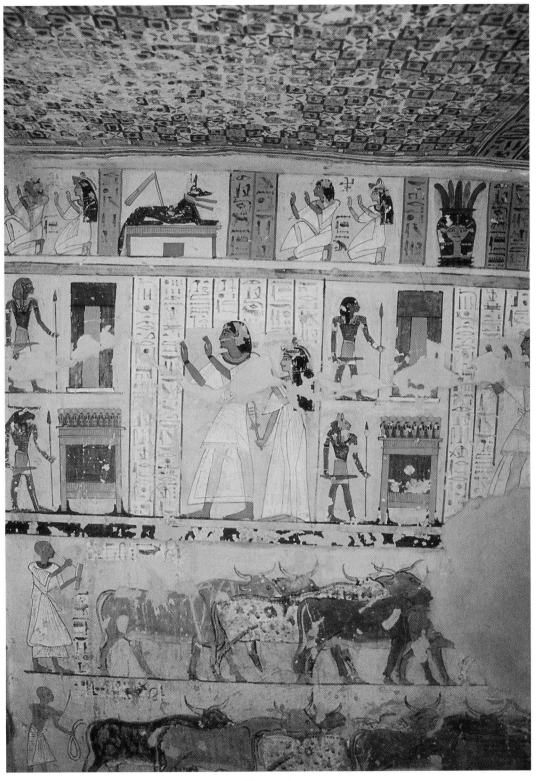

Figure 165

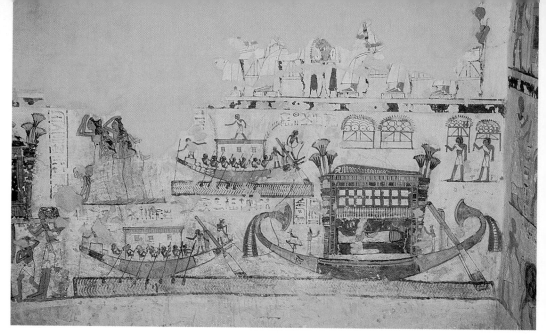

Figure 166

top of the right end. A banquet scene was once visible beneath this, and traces of the guests seated on chairs before tables can still be distinguished (fig. 166). The tomb-owner and his wife can be recognized on the left, where dishes are bring presented to them. This is probably the meal that took place on the occasion of the "Beautiful Festival of the Desert Valley," as the three walls to the right of the entry are all covered with religious scenes.

The funeral procession crosses in the scene below and continues on the next wall as well. The scene would appear to depict the corpse crossing to the west bank. Decorated with tall bouquets, the shrine containing the anthropomorphic sarcophagus is on the cult bark floating on the Nile. Rayay is leaning sadly over the coffin. Isis is at the foot and Nephthys by the head of the coffin; both are bewailing their deceased brother Osiris, or more precisely, Samut, who has become Osiris. The jackal standing at the bow of the boat is probably Wepawat, the "Opener of the Ways," who tends to lead the processions, as his name implies. Ropes attach the cult bark to two other boats, which are towing it. Each of these has a large windowed construction on its deck, and each is decorated with palm branches. One of the crew members is striding atop the upper boat; it must have been quite sturdy. The artistic tension is slightly dispelled by the two sailors who are just about to tie up the ropes. Seven oarsmen on each side of each boat were probably the usual means of propulsion.

Offering bearers are bringing stands with food in the scene above the cult bark. To the left of the boats are the wailing women, tossing dust on their heads to alleviate (or express) their sorrow. "Speech of the women who weep" is written between them and the canopic shrine they are following. The first woman

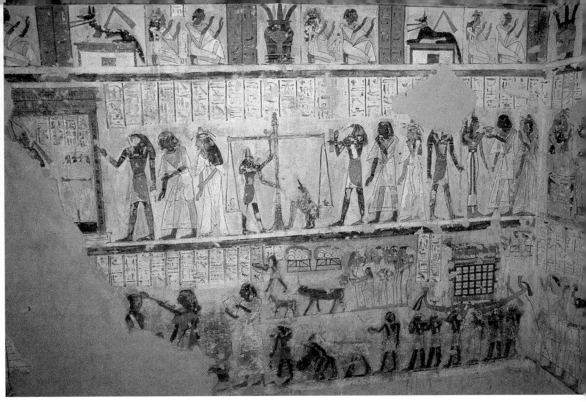

Figure 167

even seems to want to throw herself on the earth, but she may only be stooping to gather dust. The women thus provide the transition to the west bank. The canopic shrine is being carried by three groups of two men in front of the women. Two boys are between them, apparently tossing dust into their hair, like the wailing women. A group of men links the canopic shrine with the sarcophagus that is being transported on the next wall (p. 53). It is remarkable that the transport of the canopic shrine and the bark take up the entire register, while the scenes that precede and follow are allowed only two narrow strips.

Suggesting that she was still alive when he died, the tomb-owner's wife is standing in the midst of a group of men who are bearing the bark with the shrine (fig. 167). The text lists only the names and titles of the tomb-owner. Cattle and the usual offerings are also specified. A lector priest recites while leading the procession. Wailing women and children are spread out in the usual array in this funeral scene.

The scene of the ceremony of the Opening of the Mouth, which follows on the left, is unfortunately quite damaged. A cow following her calf can still be seen. The man just above this calf is hurrying with the haunch, which has just been cut off. This is used in the ritual of the Opening of the Mouth, as can be seen in the tomb of Rekhmire (pp. 169–172). The tongue stretched out of the cow's mouth is intended to express its pain over her calf's discomfort.[5] The text records that the ceremony of the Opening of the Mouth has been accomplished and that the

deceased should turn his face to the south. The recitations of the lector and *sem*-priests follow.

On the far left, the offerings are being brought to the tomb itself, where the rituals are being performed.

One register above, the tomb-owner and his wife can be seen before a goddess, who may be Maat. The god behind her could be Anubis.[6] The former offers them the sign for "mouth," which revives them. These scenes can be plausibly associated with Spells 21 and 22 of the Book of the Dead.[7] It has been suggested that the scene assumes a positive result at the Judgment of the Dead, so that their proven innocence guarantees the dead the corporeal perquisites for continued life.[8] They must still appear in court, however, where each of them has placed an arm across their chest, touching their shoulder with their hand. The ibis-headed Thoth is the court clerk, who also appears as a baboon atop the bar of the balance. Anubis supervises the weighing, and the "devourer of the dead" is ready in case the heart (which is in the right pan of the balance) does not match Maat (truth and justice), seated in the left pan. The deceased couple lived correctly, however, and thus became "justified" dead, as Horus demonstrates. In his role as "guide for the dead," Horus leads them to his father, Osiris, the god of the dead. Accepting the court's judgment, the couple bows reverently before Osiris.[9] Horus says, "Behold, I lead the Osiris Samut to you. He has been examined by the balance and no error has been found. One should return his heart to his body, and his mouth, with which he speaks."[10] The upper part of the wall consists of the frieze already discussed.

The wall on the left of the entry and the end of the tomb have been heavily damaged. Kyky adores the goddess Mut in the second register. That the accompanying text names the Pharaoh Ramesses II is decisive for dating the tomb. The tomb-owner and Rayay can be recognized at the base of the wall, where they are seated. The upper register of this wall is more significant, however, as it has a long text that continues across the corner. It ends just in front of the goddess Mut, seated on a simple throne in a magnificent shrine (fig. 168). The double crown is on her head, and the papyrus scepter in her hand is common among female deities. The widely spread wings are part of her manifestation as a vulture.

The tomb-owner had a special relationship with this goddess, as his name ("Son-of-Mut") indicates. It is thus hardly accidental that he included this long text, which covers three walls:

> There was a man of southern Heliopolis, a true scribe in Thebes,
> whose mother named him Samut, (but was) called Kyky, justified.
> Now his god took notice of him and instructed him in his wisdom.
> He set him upon the way of life, for the sake of protecting his body.
> The god knew him as a child, and noble nourishment was ordered for him.
> Then he took counsel with himself to find a patron for himself,

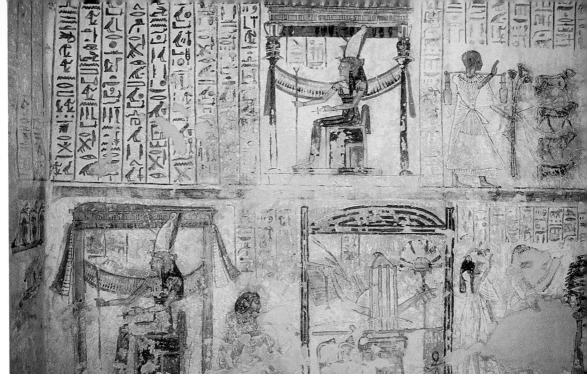

Figure 168

and he found Mut ahead of the gods.

Fate and fortune are with her, as is the duration of life; and breath.

Everything that happens is at her command.

He said:

Now I am giving her my property, all the produce.

I know that she is effective on my behalf, that she is excellent all by herself, that
she frees me from panic.

She is free of evil deeds.

She is come, with the north wind before her, when I call upon her name.

I am a weakling of her town, a pauper and a beggar of her city.

I came into my property only because of her strength, in return for the breath of
life.

Not one of the household shares in them.

They are for the gratification of her *ka*-soul alone.

Oh! how the one who robs the one who waits upon him is under his control!

I say about an official in his prime: "He is strong but he does not take hold."

No, such things are with Sakhmet the Great.

The range of her going cannot be known.

No servant of hers will tend to rage forever and ever.

Oh! Mut, Mistress of the gods, hear my petitions!

A servant performing effectively for his lord is upright. . . .

I have not taken a protector from mankind,

I have not sought protection from a big man

No son of mine have I
who will arrange my burial.
The burial lies in your hand alone.
You are the goddess of birth, who looks after me too,
with an unblemished mummy,
facing departure from life
I have rendered all my property to you,
You have entered into all my things.
So may you work out my preservation
—until I am finished—
from all evil![11]

After a series of additional requests to Mut, and still more praise, follow five verses, each of which begins with "Who makes Mut his protector." The goddess thus acquires all his property, and his family is explicitly excluded. In return, Mut has to look after Kyky.

On a pedestal to the right is a shrine belonging to the god Amun-Re (fig. 169). *Rekhyt*-birds can be recognized on the pedestal. *Rekhyt* is used to designate serfs or the common people, but it originally signified the people of Lower Egypt, once subdued by the king, who now revere him (see pp. 207 and 212). The god's symbolic ram's head with solar disk and uraeus serpent can be seen. Two winged disks are on the side of the shrine. The horizontal dividing lines beneath the winged disks show that two shrines are actually meant. The winged disks usually appear above royal images, as they symbolize divine kingship to some degree.[12] Their wings are thus spread over a king, Ramesses II, who is presenting a figurine of the goddess Maat to Amun-Re. The king hands the god two unguent vessels on the right. The other scene is almost completely destroyed, but the cartouche of Ramesses II is still legible.

In front of this shrine are three tall offering stands, filled with fruits, blossoms, meat, and bread, with tall bouquets among them. To the right is a low offering stand. Samut is approaching from the left, his right hand uplifted in token of reverence, his left drawing three papyrus flowers and four sacrificial cattle on a cord. The yoke on his shoulders has two wine jars (see figs. 168 and 169). This is a scene that does not appear in the other tombs discussed.

In the second register, the goddess Mut is worshipped, much as she was shown beside the hymn (see fig. 168). Samut is kneeling in front of a shrine containing the *henu*-bark of Ptah-Sokar, the god of the dead of the Memphite necropolis (see fig. 169).[13] This bark was moved around the walls of Memphis on the occasion of the great Sokar festival. Clad in festival attire with unguent cones and blossoms on their heads in the adjoining scene, Samut and Rayay worship Osiris and Isis (see figs. 168 and 169). The god is seated in a shrine whose ceiling is hinted at with a uraeus frieze. On Osiris's head is the *atef*-crown, and his insignia—

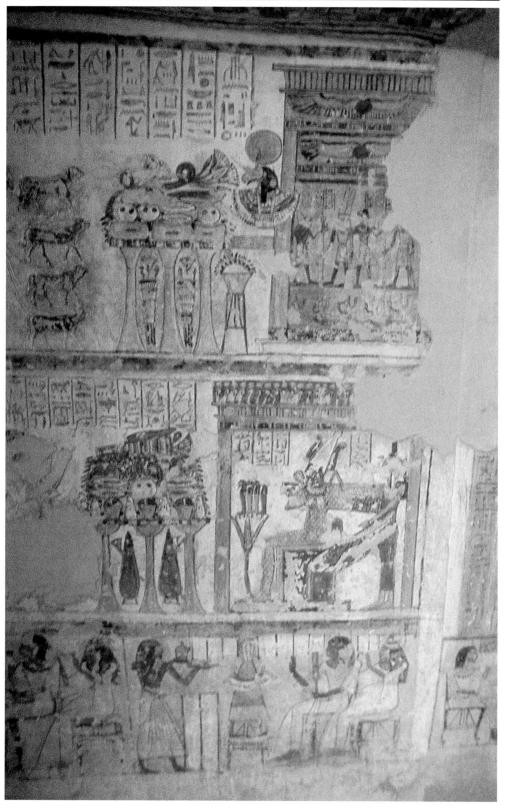

Figure 169

the flail and crook—are in his hands. Isis envelops her brother-husband protectively with her wings, derived from her manifestation as a female kite. In front of them, on a lotus blossom, are the four sons of Horus, the canopics. In front of the shrine are three generously laid offering stands with two unguent vessels entwined in papyrus between their feet. The text only confirms that Osiris is being worshipped, naming the god's titles, along with the names and titles of the tomb-owner and his wife.

Three similar scenes appear at the base of the wall (see fig. 169). A priest brings food and burnt offerings to Kyky and his wife, both in festival attire. The couple receives yet another burnt offering in the next scene. The pyramid-shaped candles are interesting. A purification vessel and a censer are being offered on the far right. Between the priests and the couple is a bouquet in a kind of bucket.

At both sides of the bottom of the passage into the next room, next to the doorposts, the deceased is seated on a chair (see fig. 169). He wears a broad necklace and a white pleated garment; his hands bear the *sekhem*-scepter and a staff. His feet are firmly set on a small reed mat. The texts list only his names and titles. The dirty yellow background of the inscription and the imprecise, superficial execution of the relief are typical of the age.

On the left in the passage, the deceased offers Osiris a bouquet (fig. 170). The god of the dead is in his usual form, standing on a base in the form of a *maat*-hieroglyph. This text is on the same yellow background.

In the scene below, Kyky brings Osiris (who is only mentioned in the text) food offerings. The right side of the passage was similarly decorated but has been seriously damaged. The entire interior chamber was left unfinished. The upper register to the left of the entry shows the erection of a *djed*-pillar, with the worship of a tree goddess below (see pp. 258–259).

To the left is the transport of the mummy into the burial chamber. This was only done in sketches, on what was the real west side, where the burial chamber really was located. Steps lead down to it, but virtually no objects were found there. Six wailing women lead the deceased, who is being borne and led by priests. Two of them are wearing Anubis masks and one a falcon mask.

Samut is standing on the right side, followed by three women in front of Ra-Harakhte and Isis, who are in a shrine (fig. 171). The scene was not finished and the accompanying inscription was omitted.

Likewise incomplete, below this, is the deceased followed again by three women, led by Horus. It can be assumed that the god was supposed to lead them to Osiris. The back wall of the chamber shows a group of statues, with a *djed*-pillar on each side of the niche. In the middle were two men, with a woman seated beside each of them. From right to left, these are Rayay, Kyky, Meri, and Tutuya. It is impossible to say who the latter two were.

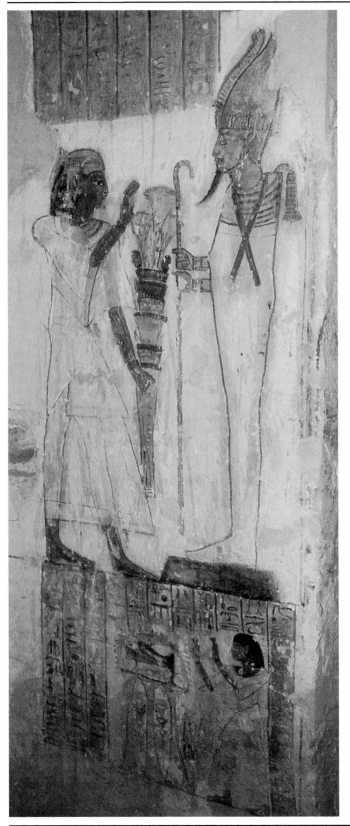

Figure 170

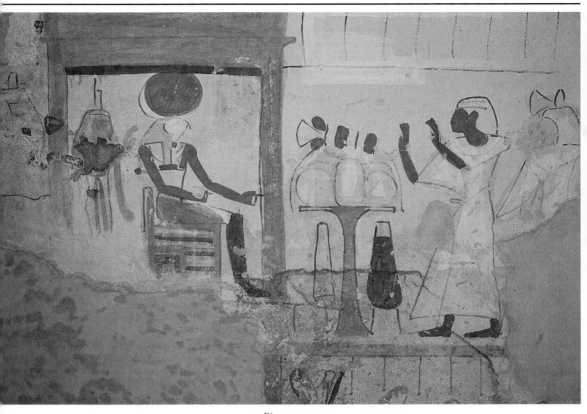

Figure 171

Deir el-Medineh

THE NAME DEIR EL-MEDINEH is the modern Arabic designation for the area around a well-preserved Pharaonic village (fig. 172). The craftsmen who lived there worked in the royal tombs in the Valley of the Kings. Their own private tombs lay beside their village, which they called *pa demi*, "the village."

The village was therefore the home of the "servants in the place of truth," the workers who excavated and decorated the tombs in the New Kingdom royal necropolis, the Valley of the Kings. The village was abandoned at the end of Dynasty XX when the royal necropolis was shifted to the temple at Tanis in the Delta. Most of the tombs at Deir el-Medineh date to Dynasty XIX, but some were cut later, such as the tomb of Inher-kha, which dates to Dynasty XX.

The village and necropolis at Deir el-Medineh are unique in ancient Egypt. The settlement was a kind of ghetto where a professional group lived a secluded existence, completely dependent upon outside supplies. Although they did not have any fields of their own, their quality of life was so high that they had their own servants. We are better informed about life in Deir el-Medineh than anywhere else in ancient Egypt. Written sources document all their concerns, and even the first recorded strike in world history.

Figure 172
The village and cemetery at Deir el-Medineh.

The workers did not strike for shorter hours or higher pay, but merely to have their wages paid on time.[1]

The "gang" of workers was divided into two "sides," a "right" and a "left," each under a foreman. Although the foremen and draftsmen were literate, a scribe stood beside each foreman to take attendance and to record the lists of materials used and work done.[2] Besides the ordinary laborers there were draftsmen, basket carriers, and guardians. The latter protected not only the tomb and the village, but also the precious materials, such as paints and metal tools. Nubian policeman were responsible for overall security.

The craftsmen had to cross the mountain when going to work, and when returning to their families in the village. It was not far, but at night they were afraid of the desert, which concealed scorpions, snakes, and evil demons. During the day, they hated the scorching heat of the sun and dreaded the rocky path home that must have worn out sandals and been equally painful to follow barefoot. On occasion, therefore, they remained in the valley during the working "week."

They did not have holidays in the modern sense of the term, but they had every 10th day off. They also had all the festival days off. And they also took off on any other days they wanted as well. The excuses were quite original, as can be seen from the attendance lists. Explanations range from being "ill" to having been "beaten by the wife," but some are merely listed as having been "lazy."[3]

The workers would have used these days to work on their own tombs. These lay on the slopes adjoining the southern wall of the village. They belonged to the villagers at Deir el-Medineh who never benefited from royal gifts of funerary equipment, although the higher officials frequently did receive these. The tombs were inherited like household possessions.[4] The small hill was nevertheless quickly honeycombed with tombs. This inevitably resulted in unusual plans, as villagers always had to avoid each other's tombs, but this also permitted them to develop an unusual form of theft. They were quite willing to remove corpses from other tombs, to underscore their own claims and to deprive their opponent of evidence. Documents[5] from the village recorded the tale of a workman named Amenemope, who related that the Steward Tuthmosis "assigned the tomb of Amun-(mes) to Hay, my father as Hener, my mother and his daughter . . . since he did not have any male offspring and his tomb (lit., "places") had been abandoned."

An inspection in 1182, under the reign of Ramesses III, investigated

> the shaft in the tomb of the worker Kha-em-nun. They discovered that the shaft where the worker Amenemope was, was also open. . . . The scribe Amun-nakht, of the Office of the Vizier, called me, saying "Open to the north of the pillar in your tomb: I see the opening of your shaft there. . . ." On inspection, they found a smoothed coffin that did not have the name of anyone at all inscribed on it. . . .

(Three weeks later) The worker Amenemope, son of Mery-Re, and the worker Wennenefer, son of Pen-Amun reported to me.

The court composed of the foreman Khonsu, the foreman Inherkha, the Scribe from the Office of the Vizier Amun-nakht, the worker Hesi-su-nebef, the deputy Amen-kha said that the house of Amen-mes was mine, and his tomb. The property of Bak was indeed mine (lit., "his") too, as he threw my Mistress out of the tomb of my father.

The court made him swear, "If I enter this burial chamber again," that he would be struck with a hundred blows and 5 wounds."

This demonstrates that an open tomb shaft was proof of possession, that the dead buried in the tomb had been removed to eliminate the witnesses to the deed, and that names could be completely effaced from funerary equipment as well as from tomb walls, as has been seen earlier. It would appear that this accusation against Kha-em-nun was made by his tomb neighbor Amenemope. The former then got revenge by opening the tomb shaft of the latter and apparently also removing the corpses. The commission then established irregularities in Amenemope's case. As no bodies were found in his tomb, he lost his claim to it and had to appeal to the king to recover it.

How were these hotly disputed tombs organized? It is impossible to see the superstructures at the site today. Lengthy investigations have shown, however, that there were two basic types: the rock tomb and the pyramid tomb.[6]

The appearance of a pyramid tomb (fig. 173) is best exemplified by the model of the tomb of the workman Kha in the Egyptian museum in Turin, Italy. A mud-brick wall enclosed a small rectangular courtyard with flowers, trees, or shrubs, as well as a water basin if there as enough room. The eastern gate was a kind of pylon, and the small mud-brick pyramid stood across from it, in the west, on a small platform or a flat surface hewn from the rock slope. A small stela occasionally stood in a small cult niche in the outer wall of the pyramid, and its top could be a small stone pyramidion with a stela as well.[7]

A steep shaft or vertical stairway to the north usually led to the two or three subterranean chambers. The first chambers were usually roughly hewn, but the walls of the last one, the burial chamber, were usually covered with plaster or clay and painted. The ceiling was also frequently painted. The barrel vaulting was made with particularly thin bricks, frequently bearing finger impressions along their length, intended to improve the bonding. The pyramid tombs could only be placed on a gentle slope.

The other typical tomb was a simple rock-cut tomb (fig. 174). These were usually sunk where the slopes were steeper. They also had small courtyards in the east, but the walls were usually hewn from the rock, which also formed the rear wall, usually cut flat and ornamented with a cavetto cornice. In front of the

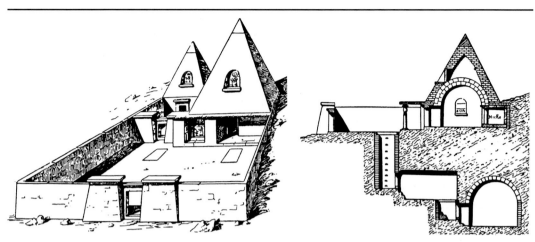

Figure 173
Pyramid tomb at Deir el-Medineh (reconstruction and section adapted from
Georg Steindorff and Walther Wolf, *Thebanisch Gräberwelt*).

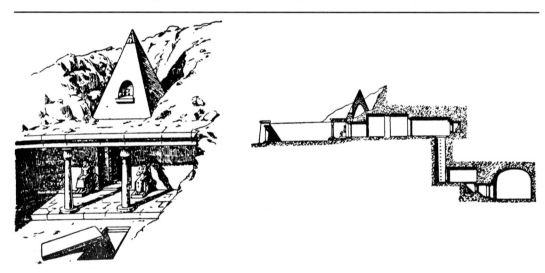

Figure 174
Rock-cut tomb at Deir el-Medineh (reconstruction and section adapted from
Georg Steindorff and Walther Wolf, *Thebanisch Gräberwelt*).

wall may have been a small columned hall with statues and stelae. A small pyramid also adorned the flat roof of the rock chambers.[8] Standing on the rock itself, this pyramid too had a small pyramidion of sandstone or more usually limestone, like that of Ramose in the Turin Museum.[9]

The cult chambers are in the rock, reached through a passage in the columned hall. These are usually rectangular or square rooms. The second one is usually significantly smaller than the other and usually has an image of the tomb-owner on the west wall. The shaft leading to the burial chambers is similar to that of the pyramid tombs, and the entrance is almost invariably from the innermost room.

The burial chamber is almost always painted in the Deir el-Medineh tombs, which was unusual in private tombs (see p. 7). The materials were probably "organized" while working in the Valley of the Kings. That the owners devoted considerable care and effort to this painting was logical, since they were professionals, commanding the requisite skills and knowledge, and frequently revealing more dedication than they displayed in the royal tombs.

The themes and pictures in their tombs differ substantially from those common in private tombs, probably because of their detailed knowledge of the decoration in the royal tombs. The decoration is of unusual significance, closely linked to the Beyond and what happens there. Vignettes and spells from the Book of the Dead play an important role.[10] Many of these illustrate a profound knowledge of the content of the texts they carved in the royal tombs, while obeying the limits of not actually infringing on the royal texts themselves.

The colors are vivid and frequently well preserved. Judgments on the quality of the paintings differ widely. Some rapturous admirers suggest that they are the very best in Thebes; more reserved observers contend that they have been overvalued because they are so well preserved.[11] The difference is probably ultimately to be found in the character of Egyptian art and modern reactions to it. On the one hand is the modern appreciation of skilled craftsmanship; on the other is the critical attitude toward artistic rigidity and lack of imagination. Such judgments are of course those of modern observers, who are naturally incapable of grasping the artistic sensitivity of the ancient Egyptians. The originality does charm the modern visitor, even if the paintings frequently omit those delightful details that distinguish the other "houses of the West."

Deir el-Medineh was a world unto itself where things differed greatly from the cities and villages of the world "outside." The people in this village may have been more quarrelsome because they shared their lives with their neighbors and few others. Whether they were thus more bourgeois and pious is another matter.[12]

Like the officials and their wives in the other private tombs of the Theban necropolis, the workers from Deir el-Medineh are shown in their very best clothing in the scenes of their tombs. Unlike those of the other officials, the scenes

in their tombs do not depict their official life in the necropolis, but rather scenes from the Book of the Dead and the world of religion. The workers and their wives can thus be seen working the fields of the Beyond in fine pleated white garments and adorned with blossom diadems and unguent cones, even sandals and earrings. The sandals frequently seen on their feet also suggest a certain degree of prosperity. The captions give their correct titles, and the men wear the beards of the official.

Furnishings found in intact tombs demonstrate that the tombs belonged to families who used them for generations. These prosperous workers were thus also able to provide their relatives with tomb offerings. The tomb of Sennedjem was thus filled with furniture, tools, and cosmetics as well as the usual tomb equipment; all of it can be seen in the Cairo Museum (see p. 24). What was found in the tomb of Kha can be seen in the Egyptian museum in Turin, Italy, and objects from various tombs can be seen in the Metropolitan Museum in New York.[13]

Sennedjem

THE NAME SENNEDJEM means roughly "the brother is sweet." Sennedjem worked in the Necropolis during the reigns of Sethos I and Ramesses II. His wife was named Iy-neferti ("the beautiful one is coming"), and his father was Kha-bekhenet ("the temple-gate appears"); his mother's name is unknown. The tomb (fig. 175) was found intact in 1886. There were 20 mummies in it, 9 of them in anthropomorphic coffins that belonged to Sennedjem and his wife Iy-neferti, their son Khonsu and his wife Ta-amakhet, as well as Rahotep, Ta-ashen, Ramose, Isis, and a girl named Hathor. Among the finds was a large flake of limestone (an "ostracon") inscribed with the first part of the famous story of Sinuhe. Some of the finds landed in a number of museums, including the Metropolitan Museum of Art in New York, but most of the furnishings were taken to Cairo, where they are on display.[1]

Among those in Cairo is the wooden door of the passage leading into the burial chamber. The outer side shows the couple, along with their daughter Iru-nefer, worshipping Osiris and Maat. Led by Kha-bekhenet, their seven sons revere the falcon-headed god of the dead, Ptah-Sokar-Osiris, and Isis. The inner side shows Sennedjem and Iy-nefterti before a *senet* board game. Because of the door's excellent state of preservation, the light- and dark-colored playing pieces can be distinguished. A table is beside the board game.[2]

The tiny burial chamber is extremely well preserved, and thus the colors are very striking, even if the painting is not of the highest quality.

In the entry passage, the solar cat kills the Apopis serpent (see pp. 282 and 285). On the left-hand reveal are two sitting lions facing the hieroglyph for "horizon": the sun between

Figure 175

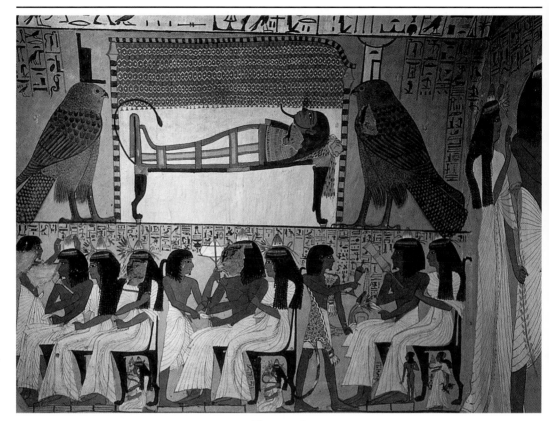

Figure 176

two hills. These lions are elsewhere designated as "yesterday" and "today." On
the ceiling one can recognize the solar disk being received by the outstretched arms
of a goddess.[3] Unfortunately, these three scenes can only be understood by includ-
ing the decoration on the inner side of the wooden door, which was removed.
All of these scenes belong to the content of Spell 17 of the Book of the Dead,
"Beginning of the Uplifting and Enlightenment of going forth and descending
(again) in the Necropolis." It is one of the most important texts of this collec-
tion, which contains the distilled essence of the main points of Egyptian beliefs
about life after death.[4]

 To the left of the entry, in the form of female kites, Nephthys and Isis mourn
the deceased (fig. 176). Usually Nephthys is standing at the head and her sister
Isis at the feet. They can be distinguished as their attributes are on their heads.
Isis has the throne on her head and on Nephthys's head are the *neb*-basket and
a walled enclosure, which can be read as "house," making her "the Mistress of

the House." The Osiris legend relates that the two goddesses mourn their dead brother Osiris. By the New Kingdom, it was popularly believed that every dead Egyptian became an Osiris, which entitled Sennedjem to enjoy the privilege of being mourned by Osiris's two sisters as well. The accompanying text relates that Nephthys wishes that the deceased be granted protection. The already mummified corpse of the deceased is lying on the lion bed.

Ramo, a priest, stands below, facing Kha-bekhenet and two women. The first is Tahenni. The other is Larsu, who must have been either Kha-bekhenet's second wife or a concubine. All three have unguent cones and are dressed for festivities. Both of these women, and all of the other women in the tomb, have diadems with lotus blossoms dropping down their foreheads. Ramo has placed his hands on the man's unguent cone and is thus anointing the person depicted. The girl sniffing a lotus blossom under the chair is not named.

In the next scene, Ramo is also presenting a libation offering and a sail to his relatives, Tjara and his wife Taya, who are embracing each other. The accompanying text explains: "Bringing the breath of life and water for Tjara who has become Osiris, from the hand of your son, Ramo, justified and venerated." This formula meant that Ramo was already deceased. The text adds: "His sister, the mistress of the house, Taya, justified." The sail symbolizes the breath of life guaranteeing eternal existence, which suggests a reference to Spell 38 of the Book of the Dead: "The Spell of living from breath in the Necropolis," reading "I live from air there. . . . I live after my death, like Re, eternally," and "I open my mouth that I taste life. I live from air. I renew life after death, like Re, eternally."[5] As usual, the party goers are all shown clad for a festival, with unguent cones on their heads, and jewelry on their bodies. The little girl kneeling under the chair is Ta-ash-sen, and she is enjoying the fragrance of a lotus blossom. To the right of this couple is another of Sennedjem's sons, Bunakhtef. He is performing the office of *sem*-priest, as can be seen from the leopard skin draped over his shoulders, and the white kilt (see pp. 128–129 and 169–172 for the *sem*-priest). His head is, however, not closely shaven as was customary among priests at the time. He is offering a libation to his parents, who are given cattle, fowl, and unguents as well as good and pure things, as the inscription notes. Two children are standing beside the deceased: the naked boy is Ranekhu, and the girl is Hetepu, grasping a lotus blossom with one hand and a duck with the other.

In the tympanum on the left end are two blue-black Anubis jackals on a shrine, which probably symbolizes the tomb (fig. 177). Flails come forth from their backs, and red ribbons are around their necks. These jackals can be understood as guardians of the gates of the East and the West.[6] Between the pair is a libation vessel on an offering stand, with two lotus blossoms placed on it. The lotus was a symbol of life, and above them was a *nun*-vessel symbolizing the waters indicated by the three wavy water lines above it. At the top was a *shen*-ring. A frieze

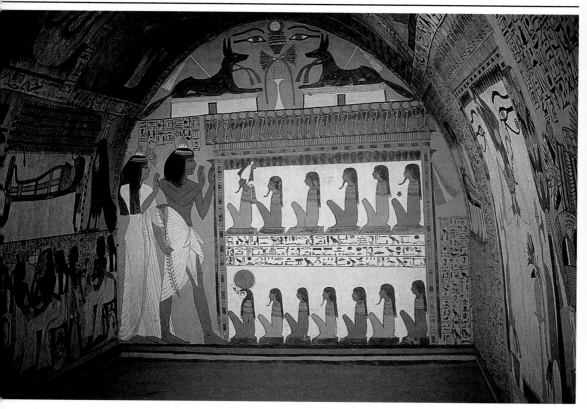

Figure 177

of uraeus serpents with solar disks atop their heads belongs to the shrine with the gods of the Netherworld, literally "the gods of the Dat," being worshipped by Sennedjem and Iy-neferti. The gods are arranged in two rows, led by Osiris above and Ra-Harakhte below. All the gods are seated on the hieroglyph for *maat*—justice and truth. The text between the rows of divinities explains the scene. It is an excerpt from Spell 190 of the Book of the Dead: "A text to render the (deceased) *akh*-spirit excellent in the face of Re, giving him power before Atum, to let him grow before Osiris, to give him strength before Khonty-imentyu, to give him respect before the Ennead. A treatment of the heart of the *akh*-spirit, to let him go abroad, to let him recover his stride, to drive off deafness, and to open his face, together with the god."[7]

The adjoining wall shows the deceased lying on a lion bed (fig. 178). As in the preceding mourning scene, the deceased is already mummified and his face is hidden by the mummy mask. A priest with a jackal's mask is attending to the mummy. The jackal symbolizes Anubis, a god of the dead, and one specifically

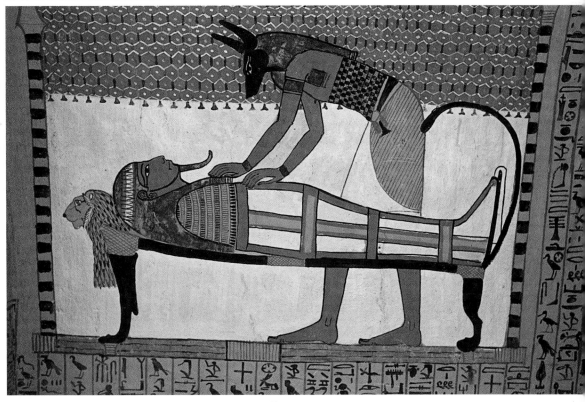

Figure 178

responsible for mummification. As the lord of the hours of vigil, he also protects the dead from the dangers of the Netherworld. The long inscription is that of Spell 1 of the Book of the Dead, but parts of the text were omitted, probably to save space. The detailed heading is: "Beginning of the spells of going forth by day, of uplifting and enlightenment, of going forth from and entering into the Necropolis; to be recited on the day of the burial of the blessed deceased who enters, after he has gone forth."[8]

To the right of this scene is Osiris, standing on a *maat*-hieroglyph in a shrine crowned with a uraeus frieze (fig. 179). The green color of the god hints at fertility. The *atef*-crown is on his head, and his hands grasp his attributes, the crook and flail. *Udjat*-eyes are seen on each side of the crown.

On a stand in front of the god is a libation vessel. Inside the shrine, on each side of the god, is an *imiut*.[9] This is a headless stuffed animal skin affixed to a pole. It was originally a fetish associated with Anubis, and its name means roughly "he who plays the enveloper (embalmer)." An *imiut* appears in connection

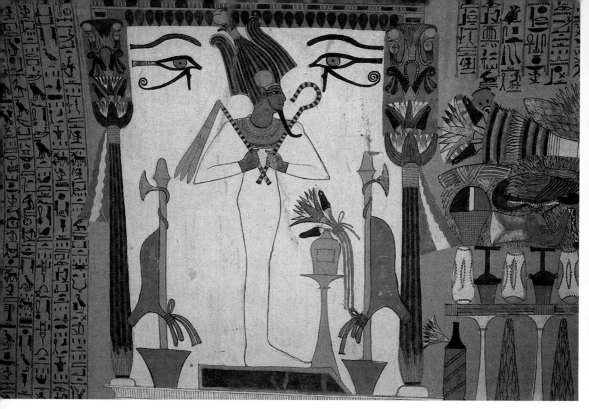

Figure 179

with the renewal of life, but also as the symbol of renewal for the appropriate deity, and thus it appears with Osiris. The deceased tomb-owner kneels in worship before Osiris, on the right, and presents him a generously laid table.

The deceased is being led to Anubis and Osiris, further right (fig. 180). The god and the man can be seen clasping hands. The god's praise is addressed to Osiris Khonty-imentyu, Wenennefer, the lord of *ta-djeser* (the sacred land), and the lord of the *atef*-crown. The text relates that Sennedjem has declared himself free of sin and error and begs that he thus be given life and water in the Beyond.

The entire scene followed the scene of the weighing of the heart or replaced this scene, as in the present tomb (see pp. 101–105).[10] It thus displays the dead being found innocent before Osiris. Anubis addresses Sennedjem: "The gods of the Netherworld (*Dat*) receive you, providing you with a place in the realm of the dead. You are purified with incense, your members joined as you were created by the forbears; you are one of these gods who are in the *Dat*-Beyond."[11]

The wall at the end of the tomb is that for which the tomb is justly famous (fig. 181). At the top are two baboons worshipping the falcon-headed sun god Ra-Harakhte in his bark. The *shemes*-sign in the boat symbolizes the followers of Horus. This *shemes*-sign consists of a harpoon, a knife, and a human leg, bound together with a rolled-up rope. The swallow on the bow of the boat is both a messenger and a companion of the sun god during its morning journey. The swallow is also a symbol of regeneration and can awaken the deceased from the sleep

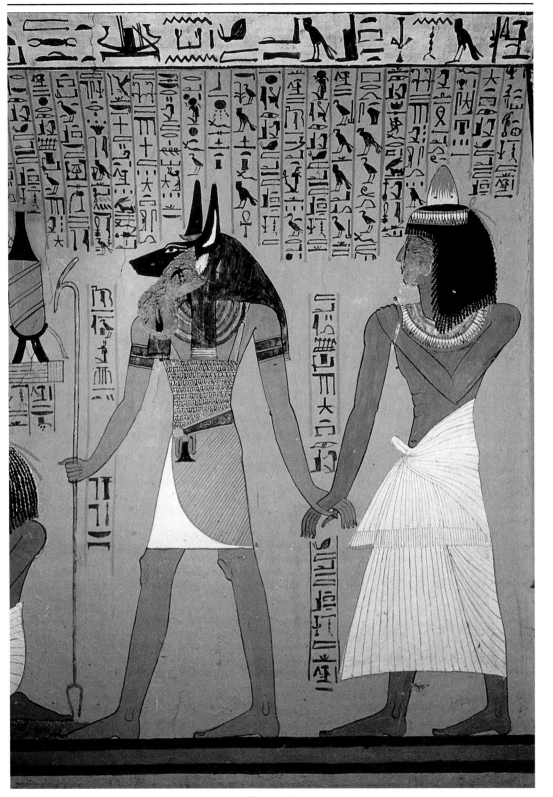

Figure 180

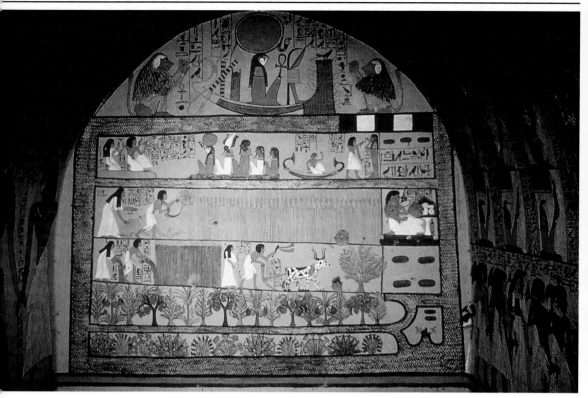

Figure 181

of death.[12] Swallows were particularly appreciated in Deir el-Medineh. The small house behind it represents the sanctuary at Buto, the most important temple in Lower Egypt. In the four registers below are the *iaru*-fields, the reed fields of the blessed dead. It is rare that the scene was executed in such detail, and with such care. The heading of Spell 110 of the Book of the Dead explains the images: "Beginning of the spells of the Offering Fields, the spells of going forth by day, of entering and going forth from the necropolis, uniting in the field of reeds, and to be in the Field of Offerings of the great city of the 'Mistress of Breath,' of being powerful there, being enlightened there, plowing there, and harvesting there; eating there and drinking there; making love there, and doing everything as it is done on earth."[13] Except for the upper right corner, which represents the entrance, these fields are surrounded by flowing water. In the upper register, Sennedjem and Iy-neferti are kneeling in front of Ra-Harakhte, Osiris, Ptah, and two smaller figures, all of whom are seated on the *maat* chisel hieroglyph. The last two figures have not been identified with certainty, but they may be the tomb-

owner and his wife.[14] "His beloved son Rahotep" sails in a bark at right, and further right, "his beloved son Khonsu, justified," opens his father's mouth, as the text explains (see pp. 169–172).[15]

The couple is harvesting in the scene below (see figs. 181 and 182). In the third register, they are pulling flax, plowing, and sowing, with a large sycamore on the far right (figs. 181 and 183). Trees heavy with fruit, including date palms, and bushes and shrubs close the scene at the bottom. Completely separate from these three registers but within the water are three ovals, labeled "fighting place," "offering place," and "greatest." In the scene below, Sennedjem is seated on a mat and enjoys the fragrance of a lotus blossom, with a table of offerings before him. The following ovals are probably "offering place," "light red," "luxuriant green," and the "mistress of the Two Lands." The *djed-tefet*-bark can be seen at the very bottom, on a small mountain of water. The bow and stern end in serpent heads. The two ovals above are the "strong" and the "landing place."[16] All of these designations are explained in the Book of the Dead, Spell 110. This spell draws on the myths of the conflict between Horus and Seth; fields of offerings are described and named, as well as certain places actually directly addressed. In the later part of the spell, the deceased would appear to rule like the sun god Re. A parallel to this spell was already present in the Coffin Texts of the Middle Kingdom.[17]

The wall with the entrance to this room shows Sennedjem and his wife worshipping the ten guardians of the gates (fig. 184). They are all crouching on a *maat*-hieroglyph and holding a knife on their knees. Only the guardian in the middle of the upper row, a hairless child, is holding two knives in front of his chest. The *kheker*-frieze lines the tops of all the scenes, as a formal border. This image can also be traced back to the Book of the Dead, Spells 145 and 146. The first is the detailed version, and the second the abridged one, merely naming the guardians.[18] The text indicates exactly which gate is which, so that one can name them and thus be given leave to pass through. In the upper row, Sennedjem is paying his respects to the guardians of the odd gates, one to nine, and in the lower one, Iy-neferty is doing the same at gates two to ten. The iconography of the guardians is given precisely: in the upper row, from right to left, the first two have the heads of a vulture and crocodile, the third is bare headed, and the final two are human headed and jackal headed. Those of the lower row have only animal heads: a lion, a bull, a serpent, a bird, and a dog.

The long row below shows the relatives of the deceased couple bringing fowl and tall bouquets (see fig. 184). Objects belonging to these people were actually found in the tomb and can be seen in Cairo, Berlin, and New York. Dressed in the latest style, and seated from right to left, are Tutu, Mesu, Kha-bekhenet, and Sahti. Their feet are on a mat, and some of them are holding a lotus blossom to their noses. Tutu's hands are reaching out to an offering stand in front

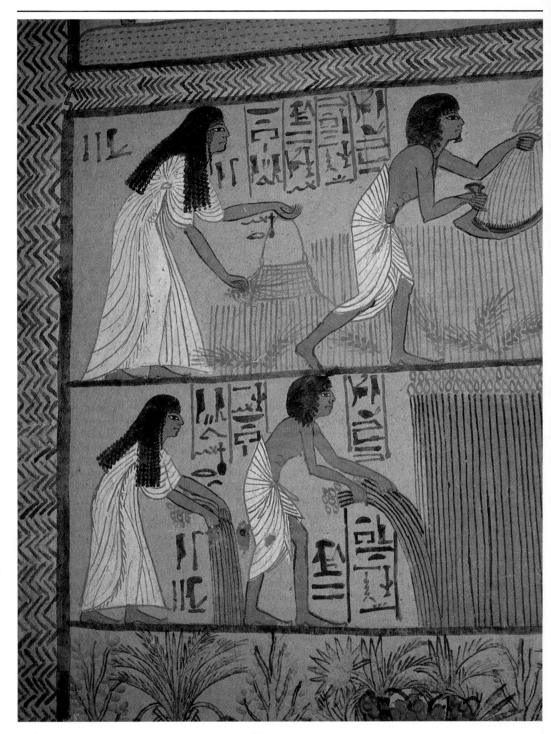

Figure 182

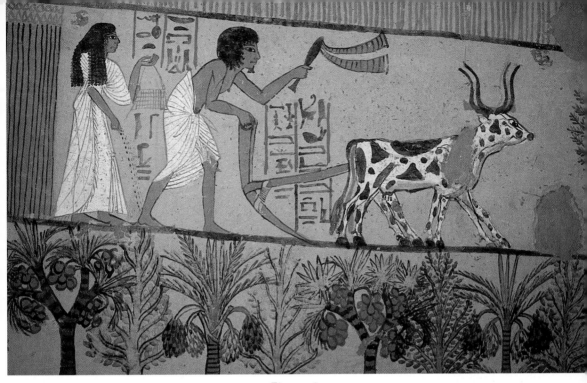

Figure 183

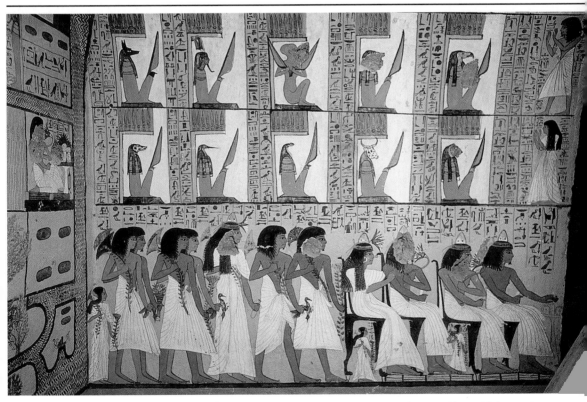

Figure 184

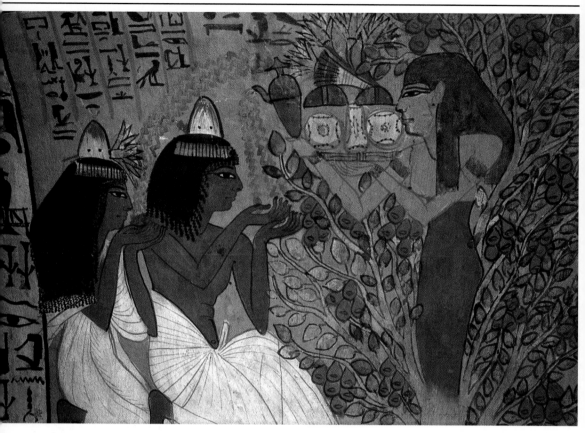

Figure 185

of him. The last two in the row are the son, named after the grandfather, and Sennedjem's daughter-in-law. Kha-bekhenet owned tomb number two at Deir el-Medineh. Standing are Bu-nakhtef, Rahotep, Irt-nefer, Khonsu, Ramose, Anhotep, and Renekhu. The little girl at the end of the line is not named. The children under the chair are Taya and Henet-weret.

The barrel-vaulted ceiling is also painted. The part on the right facing the entrance shows Sennedjem and his wife kneeling in front of the tree goddess, who is offering them water and food (fig. 185). The goddess's torso is purely human, but her legs melt into the tree. The Egyptians worshipped the spirit of the tree, which symbolized both shade and water, as there are no trees where there is no water. In temple decoration, Thoth, the god of wisdom, writes the king's regnal years on the leaves of a tree from the split trunk of which the sun god appears in the morning. In the course of time, the tree goddesses were associated not only

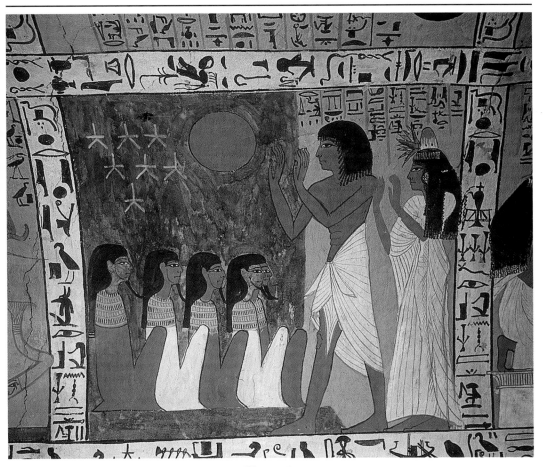

Figure 186

with Hathor, but also with Nut, both of whom are frequently called the "mistress of the sycamore." Spell 59 of the Book of the Dead aids in understanding the scene, which is frequently seen in lists of offerings: "Spell of causing the breathing of air and having command of water in the Necropolis. O, sycamore of Nut, let me be the given water and air in you."[19]

Beside this are Senedjem and Iy-neferti, dressed in festive attire, worshipping five seated divinities with human heads (fig. 186). Above this are seven stars and a full moon, which fits "another spell to recite when the new moon appears at the beginning of the month."[20] The spell deals mainly with expelling clouds from the heavens. Interpretations of the spell suggest, however, that it is also concerned with fending off the menace of a solar eclipse associated with a new moon, in

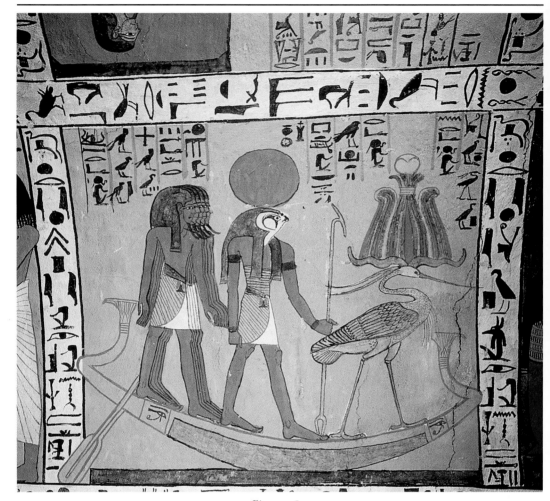

Figure 187

which case the spell really must be understood as referring to the solar disk rather than to the moon.[21]

Beside this is a bark with a crowned phoenix—"the Benu of Re"—in front of the falcon-headed "Ra-Harakhte-Atum, Lord of the Two Lands, the Heliopolitan," and five gods representing the "great Ennead in the Bark of Re" (fig. 187). A spell also belongs to this—Spell 100 of the Book of the Dead, which explains the image: "Book of perfecting an *akh*-spirit (that is, the deceased) and letting him go down into the bark of Re with those who are in his following" (see fig. 209 and p. 278).[22]

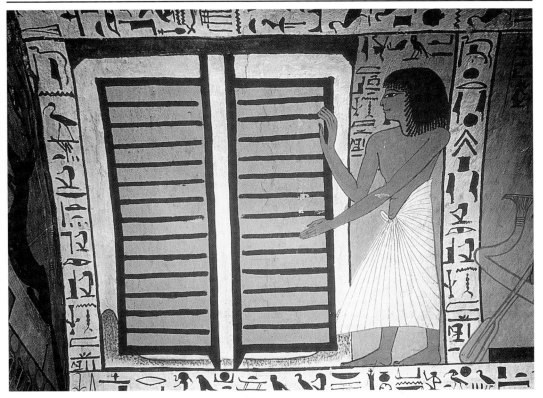

Figure 188

And finally, the deceased stands before heaven's gate, rooted in the earth below—the hieroglyph for "mountain"—and striking heaven above, with the hieroglyph for "sky" (fig. 188). Spell 68 of the Book of the Dead is not written here, although the spell reflects the meaning of the scene: "Spell of going forth by day. Open for me are the two leaves of the door of heaven; opened for me are the two leaves of the door of the earth." The accompanying inscription only notes: "Made by the servant in the place of truth, Sennedjem, justified."[23]

The ceiling of the room on the entrance side (across from the gates of heaven) shows the deceased before gods seated on the *maat*-hieroglyph: the ibis-headed god of wisdom, Thoth, with the god signifying percipience, Sia, and the sun god Atum (fig. 189). The last two are both human headed and Atum is wearing the double crown of Upper and Lower Egypt. Atum is a god of creation, the primeval god of Heliopolis who emerged from the primeval waters, Nun. He embodies the unity of the world from which plurality emerged. He is also the god of the last days, as he will survive the destruction of the world. Atum is at the head of

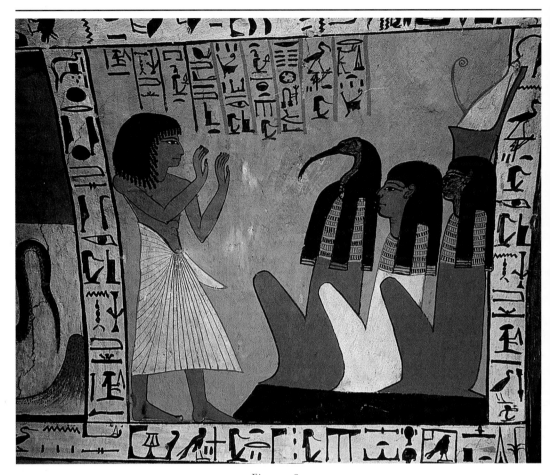

Figure 189

the divine community of Heliopolis, the Heliopolitan Ennead of which Osiris, Isis, Seth, and Nephthys are the last generation.[24] As percipience, Sia is closely associated with Hu, the personification of the word "expression." Both are effective powers essential to the creation and thus closely bound to Atum. In the Book of Gates, one of the royal books of the underworld used in the decoration of the tombs in the Valley of the Kings, Sia and Hu are the only gods accompanying the sun god in his bark on the journey through the Netherworld.[25] Although associated with the creation and Atum, they were not members of his Heliopolitan Ennead. Nor were they members of the Hermopolitan Ogdoad associated with Thoth, who himself actually embodies both gods, although they also accompany him at times. The suitable passage from the Book of the Dead is not inscribed here,[26]

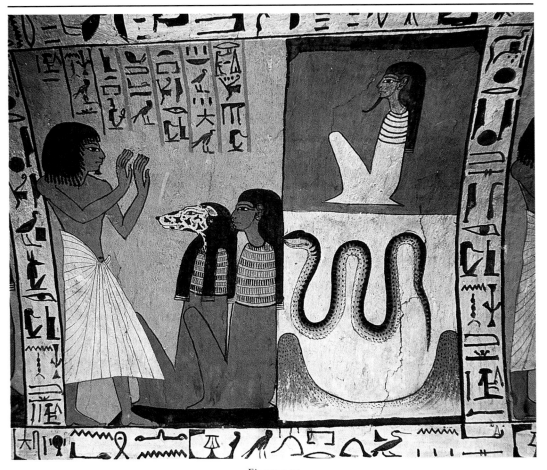

Figure 190

but the accompanying inscription notes: "Praise to Thoth, Lord of Hermopolis, the scribe of truth (*maat*) of the Ennead. For the *ka*-soul of . . . Sennedjem."[27]

In the next scene, the deceased worships another two deities seated on the *maat*-hieroglyph, one canine headed, and the other human headed; beside them are the mountain and sky hieroglyphs, below and above respectively (fig. 190). A long serpent is coiled in the mountain valley, and a purely anthropomorphic deity is seated below the hieroglyph for the sky. The inscription notes laconically: "Praise to all the gods of the Netherworld from . . . Sennedjem."[28] The scene is the vignette from Spell 108 of the Book of the Dead, which explains how the deceased is guided to the sunset by the "Westerners." The evil Apopis serpent "full of the glowing fire" waits menacingly and must be overcome.

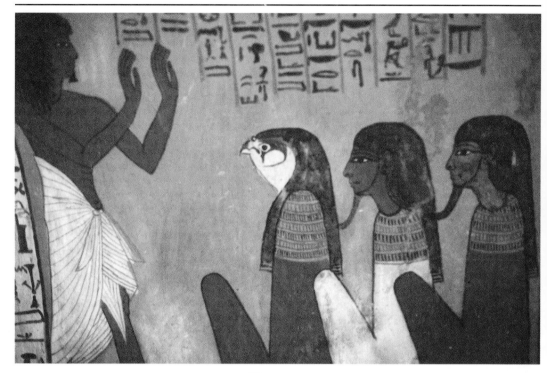

Figure 191

To the left, the deceased stands in adoration before three seated deities: the falcon-headed Horus, Amset, and Hapi (fig. 191 and see p. 53). The scene belongs to Book of the Dead, Spell 112, "to know the powers of Buto."[29] The text describes Horus's relationship to the Delta town Buto. The text is not that of the spell, however, but rather a prayer: "Praise to the Lord of Justice. Praise to your beautiful countenance. May you satisfy your *ka*-soul every day."

The final image is that of a god seated on a calf, before which is a falcon-headed god (fig. 192). A solar disk is on his head, and a snake is coiled around the entire figure: Ra-Harakhte, the sun god. The adjoining text records: "Words to be spoken by Ra-Harakhte-Atum, Lord of the Two Lands, the Heliopolitan."[30] This vignette belongs to Spell 109 of the Book of the Dead.[31] The deceased wishes that he himself may accompany the god in the solar bark, reaching the reed fields of the blessed dead, for "I know the eastern powers: it is Harakhte, it is the solar calf, it is the morning star." The calf in this image is thus the newly born sun. The two trees can therefore be associated with the "two sycamores of turquoise, between which Re goes forth, that he go forth with the rising of the (air god) Shu (heaven) to that gate of the Lord of the East from which Re comes forth."

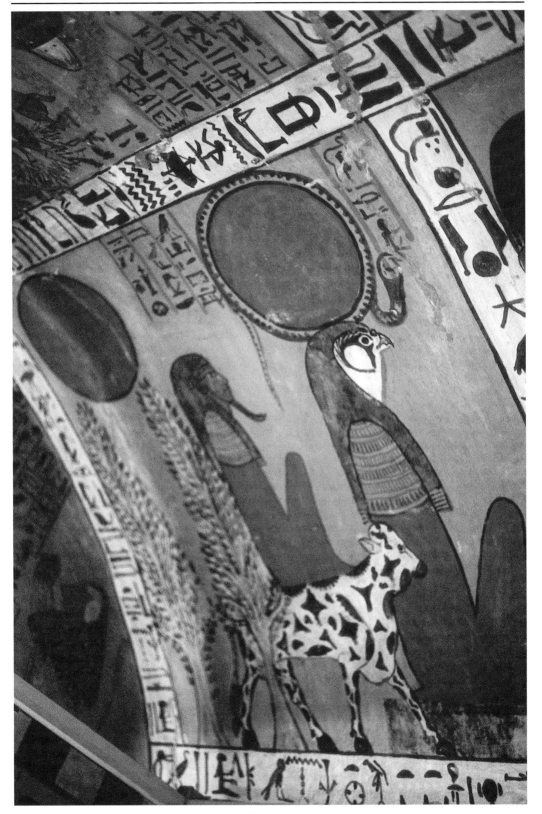

Figure 192

Inher-kha

TT 359

THE NAME INHER-KHA means "Onuris appears," as the Greeks pronounced the name of the god Iny-her as "Onuris." Inher-kha's father was Hay, and his wife was Web. He was a master craftsman and foreman of the workers at Deir el-Medineh during the reigns of Ramesses III and IV of Dynasty XX, and the tomb's decoration is typical of contemporary workmanship and fashion with its yellow background and fine garments.[1]

A comparison of the notes made by the German Egyptologist Lepsius a century and a half ago with the tomb's lamentable state today is an unpleasant reminder of just how much has been destroyed in the intervening years.[2] Only the doorposts remain of the entrance that leads into the first room (fig. 193). The offering formula is recorded four times in blue hieroglyphs inscribed on a yellow background. The paintings of the antechamber are unfortunately badly preserved. The ceiling is decorated with a magnificent carpet pattern combining rosettes with a series of cattle heads with red solar disks between their horns (fig. 194). Cattle heads or "bucrania" had been used in Egypt since the First Dynasty (ca. 3000 B.C.), when mastabas at Saqqara were decorated with bull's heads modeled of mud. As in other cultures, the worship of both bulls and cows was practiced in ancient Egypt, Hathor being the most prominent. Cretan influence is clearly visible from the beginning of the New Kingdom, and the "red solar disks" can thus be recognized as Cretan rosettes, which originally depicted swirls of hair. They therefore should not be interpreted as representing Hathor, although this is commonly maintained in the literature. It is probably advisable to

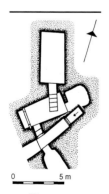

0 5 m

Figure 193

Figure 194

understand them as being apotropaic in character, like many ordinary objects and ritual instruments.[3]

The scene to the right of the entry is largely lost today, but it once showed the tomb-owner with his wife burning incense before two rows of royalty.[4] The upper row consists of three kings and seven queens althogether, the prince Sa-pa-iry being the last. The painter Huy is squatting below, as the last figure in the lower row, holding his palette. This row includes seven kings, a prince, and a queen.

The rulers of the Two Lands are all identical, dressed in white and adorned with the royal headcloth and a uraeus serpent, holding the insignia of their office. They can only be distinguished because of the cartouches, and the same applies to the queens, who are holding *ankh*-signs and queenly fans. All of them have the vulture cap on their heads. The headdress originally belonged to the vulture goddesses, Mut and Nekhbet, the goddess of Upper Egypt. They were eventually also assigned to Wadjyt, the goddess of Lower Egypt from Buto. Over the centuries, the original significance of the vulture skin was lost. It eventually became an attribute of goddesses, and of queens since Dynasty IV.[5]

The upper row is led by Amenophis I and Ahmose, second and first rulers of Dynasty XVIII. Seated at the front of the lower row is a black queen, followed by kings, the first being Men-pehty-Re, Ramesses I (Dynasty XIX), and the second Neb-hepet-Re, Menthuhotep II (Dynasty XI) (fig. 195). The queen's vulture headdress can still be seen, and it is probably Ahmes-Nefertari, the wife of Ahmose and mother of Amenophis I. Her husband drove the Hyksos out of Egypt and

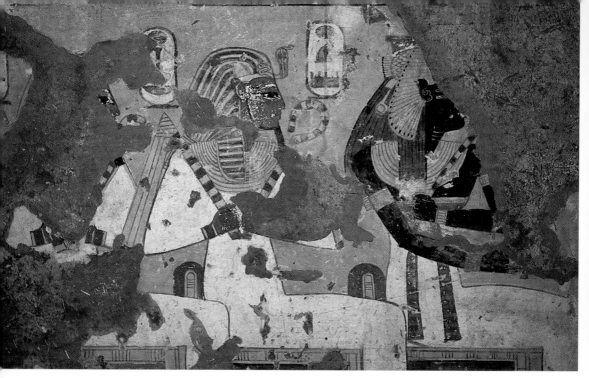

Figure 195

thus united Egypt, founding the New Kingdom. She was worshipped as a founder of Deir el-Medineh, together with her son, the two being regarded as the patron deities of the Theban necropolis (see p. 198). The queen's black skin color is derived from her function, as black is the color of both the fertile earth and of the Netherworld and death.[6] On the upper left is an Anubis-jackal couchant; the lower part of the wall is undecorated.

The left end once had a scene with Isis spreading her wings, but little can be seen today. Kneeling in adoration below was the deceased, followed by his wife, before a Hator cow now badly damaged, with the nine guardians of the gates to the Netherworld at the very bottom. This scene is likewise seriously damaged. At the top of the adjoining wall is the tomb-owner in a papyrus vessel. He is seated on a lion-footed chair. A colorful bead necklace is above his white garment and a white sheet is behind him, like a shawl. The largely destroyed text once said that the deceased was to sail to Abydos on the day of the transport of the coffin, which was to take place on the seventeenth day of the first month of Inundation season, so that the deceased could rest in *u-peqer*, the district where Osiris was supposedly buried.[7] Inher-kha is seated on a lion-footed chair behind the scene.

The next scene shows Inher-kha and his wife in the "*Seh*-hall" playing the *senet*-game.[8] This scene is also heavily damaged, like most of the other scenes. The inscription records a variant of the text concerning the board game. The adjoining portrait of the bareheaded tomb-owner is very well preserved, however. He is dressed in a fine garment with a panther skin thrown over it; his raised hands hold two vessels for burnt offerings with birds lying above them (fig. 196). His

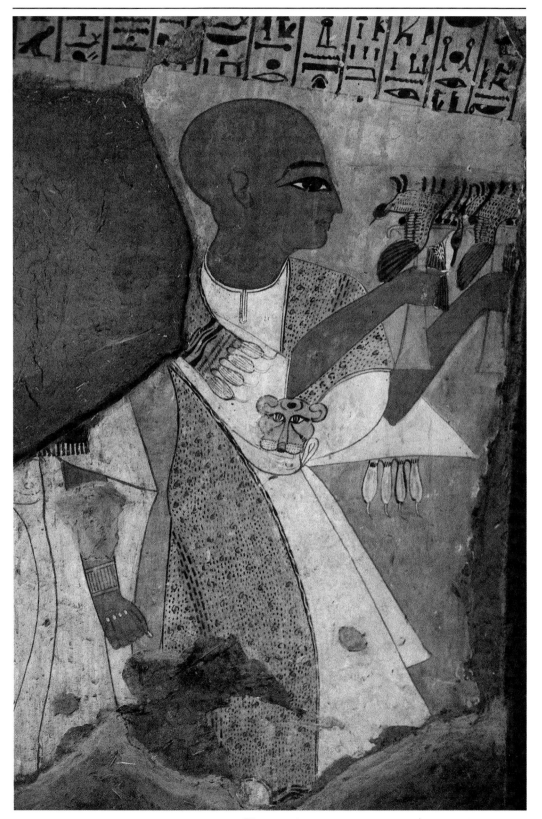

Figure 196

wife was standing behind him but can hardly be seen. This burnt offering was for Osiris, with Isis behind him; both were once visible at the end of the tomb. In the scene below, the texts record that incense is being burnt for the deceased, who are also being presented with offerings and libations.

In the scene to the left, the deceased tomb-owner faces left and grasps the fan with his left hand and an *ankh*-sign with his right. The radiant blue of the *wesekh*-pectoral and of the leaves of the fan in Inher-kha's hand is particularly striking. A wreath of leaves hangs on the arm of the son making the offerings. At the same time, the tomb-owner is receiving what may be an unguent vessel. Inher-kha's daughter is standing behind the offering bearer with a lotus blossom as a symbol of life. The deceased couple are seated on a lion-footed couch and dressed in festive attire; he is wearing sandals.

In the scene to the right, they are seated, facing left, in front of an offering table adorned with a persea tree. Inher-kha is reaching for a fruit, and Web is holding a bird in her extended hand. Three bareheaded priests are approaching them; these are also sons of the deceased couple. The two in the back have censers in their left hands at their sides, while their raised right hands bear libation vessels. A panther skin is draped over the one in front, who is pouring a libation offering from a three-part vessel.

The scene at the extreme right is seriously damaged. The deceased were depicted as in the previously mentioned scenes. A luxuriously well-laid table with onions, haunches of beef, and round loaves stands before them. Their daughter is carrying a basket with grapes, and their son, a censer and a libation vessel.

Only traces of Nephthys's wings remain at the right end of the tomb. Below them were once the images of Osiris and Isis, for whom Inher-kha was once burning incense. The deceased tomb-owner and his son Hor-Min, holding a palette, are on the left side of the passage into the burial chamber. His wife Web and small daughter are on the right.

The wonderful scenes of Amenophis I in his fine pleated garment and royal insignia, along with his black-skinned mother Ahmes-Nefertary in an equally fine pleated dress are in the Egyptological collections in Berlin today.[9] They once flanked the passage on the inside of the burial chamber. Virtually all of the scenes in the three registers on each wall of the burial chamber were drawn from the Book of the Dead, as may be expected from its function.

The tomb-owner has lifted his hands in adoration before a *ba*-bird seated on a pylon in the upper register on the right wall (fig. 197). The human face of the *ba* is beautifully done. Inher-kha wants "to transform himself into a living *ba*-soul, and go in and out and stay wherever he wants."[10] The deceased worships the creator god Ptah, who is holding his customary insignia: the *was*-scepter (power), *ankh* (life), and *djed* (endurance). The god's body is always shown in outline and should not be understood as a mummy. The people of Deir el-Medineh

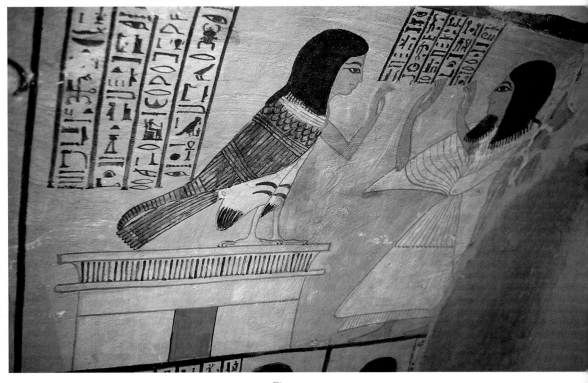

Figure 197

had a special relationship to him, as he is the god of craftsmen. Only the first words of the spell (Book of the Dead, Spell 82) belonging to this vignette are inscribed: "to change into Ptah, to eat bread and drink water."[11]

The long text that follows is that of Spell 42 where the individual members of the body are assigned to specific deities (fig. 198).[12] The shapes then follow at the end of each column, so that where the deceased wishes to "assume the form of a swallow,"[13] there follows a picture of a swallow seated on a hill, which consists of concentric red curves. The final scene of the register shows two lions seated back to back, separated by the hieroglyphic sign for "horizon" with a red solar disk from which an *ankh* is hanging (fig. 199).[14] The vignette is from Spell 17 of the Book of the Dead, but the inscription has bits of a hymn to Re.[15] The pair of lions worshipped by the tomb-owner is designated as "Re." Hathor is striding out of the tomb at the extreme right of the second register.[16] Once, however, she was turning to Queen Ahmes-Nefertari, who has since been removed. She was holding an *ankh* in the one hand still preserved, and the other would probably have grasped a papyrus scepter. Dressed again in his finest festival attire,

Figure 198

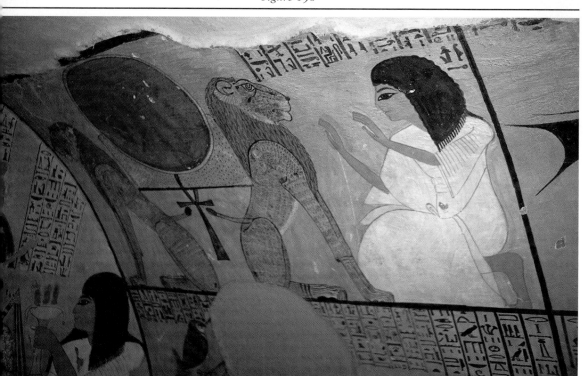

Figure 199

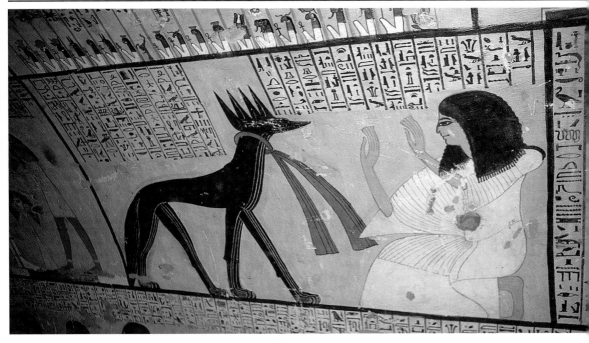

Figure 200

the deceased worships a snake. "Greetings, son of the earth who has come forth from the primeval ocean, the heir of the gods." This text is not that of Spell 87 of the Book of the Dead, which customarily is illustrated with this vignette.[17] As in other cultures, the snake plays a many-faceted role. Occasionally it is worshipped as one of the primeval gods, as here where the snake is a creature that comes forth from the earth and rejuvenates itself. The snake also enjoys an amuletic character. On the other hand, it is an animal imbued with terror that must be countered.[18]

In the next scene, the deceased Inher-kha worships four jackals that can be appreciated as a perfect example of layering (fig. 200). The fashion in which a single collar is clasped around all four necks is quite refined. These four *sab*-jackals tow the bark of the sun god Re through the Netherworld. "Greetings to the four jackals." "They say: 'Reporting the secret chapel, turning about in the *Dat* (Netherworld) at the secret place. You are drawing the honorary Osiris, the craftsmen in the place of truth, Inher-kha, to Khefet-her-neb-ankhet (a mythical place). Receiving the offerings and food like the *bas* of Rosetau. Your *ba*-power is called in the broad hall of the justified and the gods in it.'" The text above the deceased names all of the members of the family along with their titles.

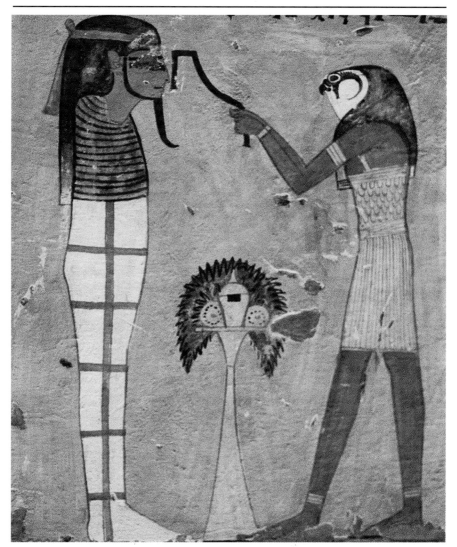

Figure 201

The ceremony of the Opening of the Mouth must also be performed for Inher-kha. A falcon-headed priest uses an adz to open the mouth of the deceased tomb-owner, depicted in mummy form (fig. 201). The priests and the deceased are standing on a reed mat, separated by a stand with offerings. The ritual is explained in Spell 23 of the Book of the Dead, which was abridged and emended to save space: "Spell to open the mouth of the honorary Osiris, Inher-kha, justified. Your mouth is opened. Your mouth has been opened by Ptah with that

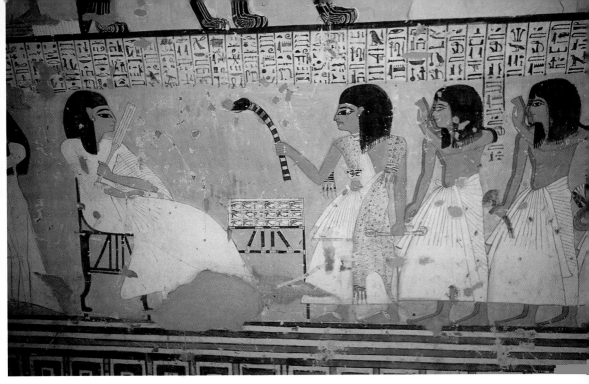

Figure 202

chisel of the ore of heaven. Horus opens your mouth. He opens your eyes for you."[19] Right beside this is the "Spell to satisfy the *ka*-soul of . . . Inher-kha in the Necropolis."[20] The scene is not entirely comprehensible as it is depicted here. The deceased was actually supposed to burn incense and make sacrifices or offer water to his *ka*, which is the beginning of enduring in the Beyond (see p. 2). The text of the spell does, however, state expressly that the deceased already possessed his *ba*-soul. The heading is not that usually associated with this vignette, but rather: "Spell of bringing food from the *iaru*-fields (the Elysian fields of the Egyptians), to move with all the gods who take nourishment there."[21] On the extreme left is the sign for the West: a falcon on a standard with religious symbols, including a feather. Associated with this is: "Spell to begin the path into the beautiful West (the realm of the dead), to become among the gods who are there."[22]

The deceased couple is seated before a laden table at the far right in the lowest register. The chair on which they are seated is delicate and adorned with lion's feet. In the adjoining scene Inher-kha, seated on a chair and holding a *sekhem*-scepter, is approached by a priest in a panther skin and sandals (fig. 202). In one hand, he has a ram-headed bent staff like those used in rituals, and the other holds a censer.[23] He is followed by a total of five couples dressed in long white garments and wearing luxurious wigs. The text names a total of 13 men and 8 women, although only 11 people are shown. Many of them are identified as sons and daughters, which only shows that they all belong to the same generation and not

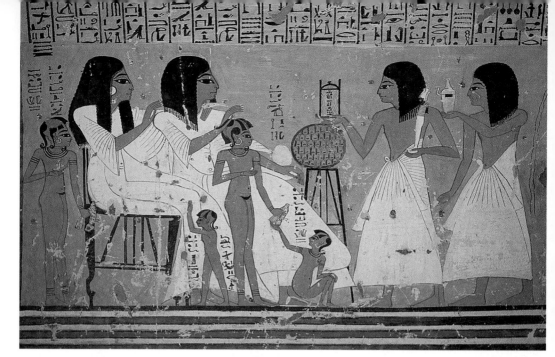

Figure 203

that they are all Inher-kha's natural children, although a relationship to the deceased need not be excluded.[24]

The deceased couple is seated on a lion-footed chair on the left (fig. 203). Both are clad in luxurious pleated garments, and Web is tenderly embracing her husband. They are surrounded by four "children's children" who are all quite small, as indicated by their nudity. From right to left, they are: Henet-wati; Bak-Ptah; Onuris-kha, nicknamed Patya-Re, the only grandson; and Anukis-ta-nehet. All are shown conventionally, that is, as diminutive adults, but naked, and with side locks reminiscent of the *sem*-priest's. The rest of their hair was bound up in three thick braids. The girls are wearing earrings and necklaces. What is missing here, but common among boys, is the index finger pressed to the lips. In their hands, they have birds and chicks—symbols of life. Inher-kha and Web are spreading their arms over the children protectively. Offering bearers are approaching from the right. The first has an Osiris figure and an *ushebti*-box with "Master Craftsman at the Place of Truth" written on it. He is a "*wab*-priest in the beautiful place" (that is, the Valley of the Queens), named Ken. A libation vessel follows, and the next one also has a *hes*-vessel and a censer, with the woman holding a perfume bottle. Between these offering bearers and the deceased is a stand with a vessel filled with figs.[25]

The deceased Inher-kha is striding out of the tomb at the top of the left wall (fig. 204). He must have been facing King Amenophis I, corresponding to the scene on the other side of the room. A staff is in one hand and an amuletic Isis knot in the other. This scene is the vignette of Spell 64 of the Book of the Dead, which was intended to aid in coming out by day, as the picture suggests, but the

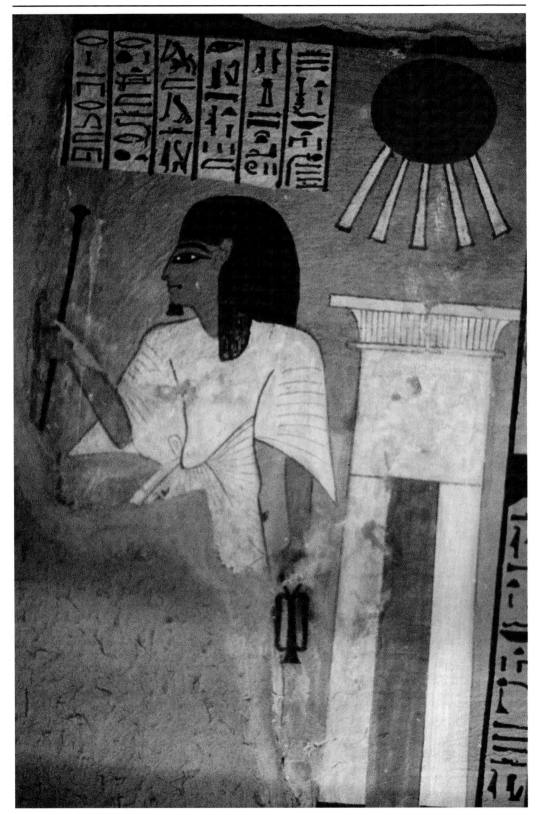

Figure 204

actual text attached, "Spell of going forth by day and not dying again," is a mixture of the headings for several spells, particularly 64 and 44.[26] Holding a flail, and both dressed in tight white garments, the deceased couple is seated under a baldachin, sailing on a boat steered by their son Inher-kha (fig. 205). The heading of the spell that goes with this vignette, "Spell to sail upstream," is not known from the collection in the Book of the Dead. The Egyptian Egyptologist Mohamed Saleh assumes that this unusual heading is due to a copying error in which the scribe mistook the signs for "sailing upstream" for those meaning "fending off," known from Spells 30–33, 36–37, and 39–42.[27] The magnificent scarab on a chain, beneath this scene, belongs to Spell 30B of the Book of the Dead, while the accompanying text is that of Spell 76: "The Spell of transforming into any shape you desire."[28]

The adjoining scene recalls both Spells 30B and 125, where the deceased Inher-kha stands before Osiris, guided by Thoth, the ibis-headed god of wisdom (fig. 206). Spell 125 is the familiar "Declaration of Innocence" in which the deceased justifies himself before Osiris, the judge of the dead (see pp. 103–105).[29] In the next scene, Inher-Kha is led to the lake of fire by an ape-headed god. The text used to be legible and related that the heart of the deceased bore truth and was free of falsehood.[30] Two barks are sailing in the opposite direction in the next scene. A falcon head bearing a solar disk encircled by a serpent can still be discerned in the upper one, which is sailing on the hieroglyph for "heaven." The scene is that of Spell 136B enabling the deceased to sail with the entourage on the solar bark.[31] The lower vessel is floating on water, bearing Isis, Thoth, Khepri, and Hu (fig. 207). The deceased Inher-kha has taken over the rudder himself (Spell 100, see p. 260).

Only the first four stations of the realm of the dead are introduced here. There was not enough room for the other ten, of which the headings alone were inscribed, omitting the descriptions of all the splendors awaiting the enlightened, blessed dead.[32]

Unfortunately, the first scene of the next register is damaged, but it once showed the deceased Inher-kha kneeling in adoration before a lotus blossom.[33] In the next, he is kneeling again, but this time—exceptionally—bareheaded, before the jackal-headed *ba*s ("souls" or "powers") of Nekhen (Hierakonpolis) (fig. 208). These are always shown kneeling in the "*henu*-position," with one hand placed on their breast, and the other raised (see p. 136). There were also similar *ba*s in Heliopolis and Buto in the Delta, the latter being falcon headed. According to one interpretation these *ba*s represent predynastic kings; another suggests that these are ancient groups of gods associated with these places.[34]

The deceased Inher-kha is worshipping the *benu*-bird, the phoenix, in the adjoining scene (fig. 209).[35] A basket with fruit and bread is in front of the bird, which is ornithologically a heron (*Ardea cinera* or *purpura*), with its characteristic

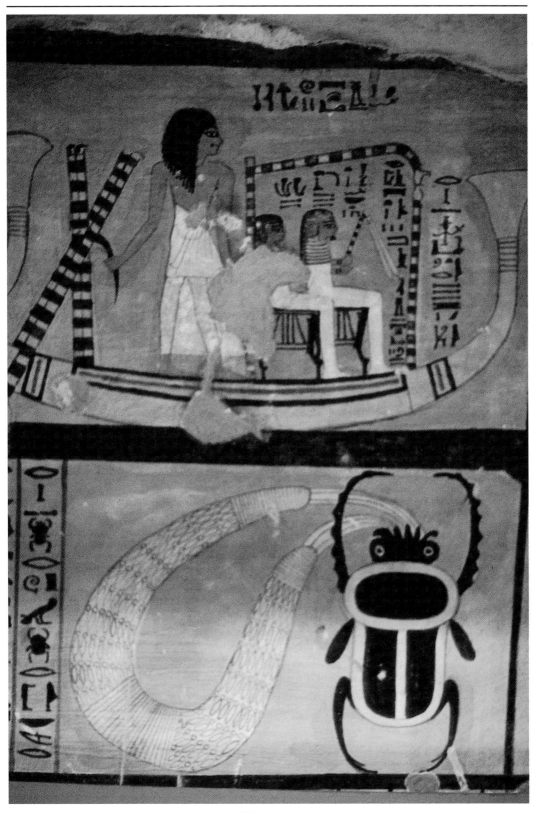

Figure 205

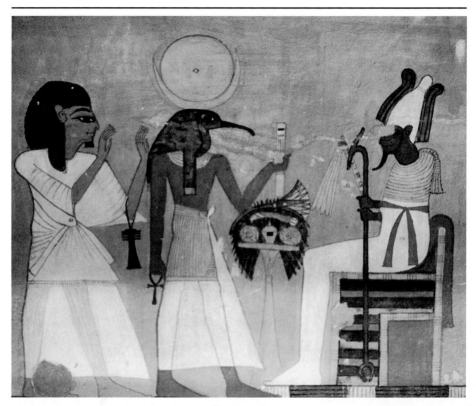

Figure 206

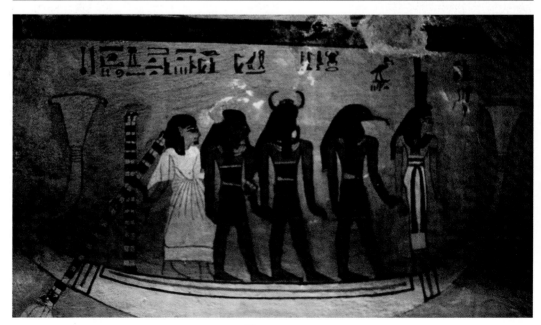

Figure 207

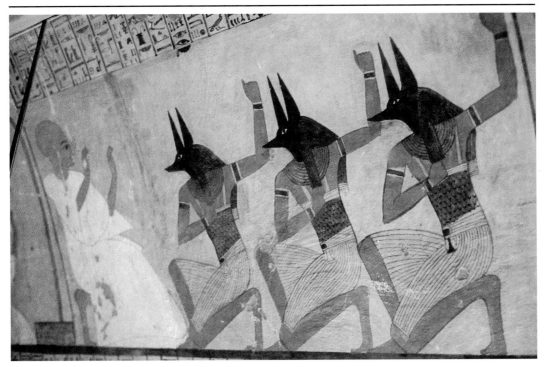

Figure 208

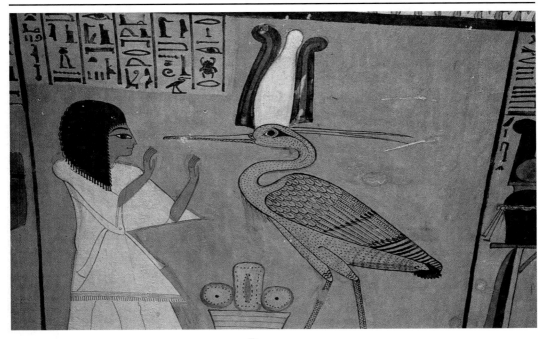

Figure 209

plumage jutting from its head. The *atef*-crown on its head hints at its divinity. The *benu*-bird was viewed as the soul of both Re and Osiris. Being closely identified with both eternity and cyclical return, the bird was integrated into the beliefs surrounding the mystery of death. The adjoining text is that of Book of the Dead, Spell 83: "Spell of becoming a *benu* by the Master Craftsman in the Place of Truth, Inher-kha, justified."[36]

In the next scene, the jackal-headed Anubis has placed a heart at Inher-kha's nose (fig. 210). This is part of the "ritual of the Opening of the Mouth" (see pp. 169–172).[37] The god and the mummy are both standing on a reed mat, with a basket of fruit and bread between them. Behind Anubis is an Osiris fetish, the symbol of *Ta-wer*, "the Great Land," as the Egyptians named the Thinite nome where Abydos was located. Every Egyptian aspired to enjoy a burial in the holy places of Abydos, as reflected in the adjoining text, the heading of Spell 26 of the Book of the Dead: "Spell of returning the heart of the honorary Osiris, master craftsman in the Place of Truth, Inher-kha, in order to follow Sokar in his festival, on the day of circling the walls, to eat bread in the fields of reeds and drink water from their lake." The rest of the text does not belong to this spell and deals instead with rituals in which the deceased wishes to participate. As there was not enough room for a longer text, it is probable that the scribe chose the texts deliberately, keeping to the essentials, and thus renouncing the precise wording of the spell of the Book of the Dead.[38]

On the right, the deceased tomb-owner respectfully greets a "gold falcon, the great god who sets the two lands (Egypt) in a festive mood" (fig. 211). This great falcon has a flail on its back and stands on a small hill.[39] The deceased's face is unshaven, a token of mourning in ancient and modern Egypt. The solar cat, "the great tomcat in Heliopolis," kills the evil Apopis serpent under the persea tree (fig. 212).[40] This scene is similar to the seventh hour of the Amduat, a text found only in royal tombs.[41] Almost at the top, in the second line from the right of the accompanying inscription, the sign symbolizing the Apopis serpent has been pierced with knives, rendering it harmless. (The text is to be read from right to left.) The text does not belong to the Book of the Dead.[42] It reads: "Spell of driving off the enemy, to cut off Apopis's backbone. This god is joyous, together with his team, the gods. I have come to you, my heart full of truth: the *ka* of the Osiris Master Craftsman in the Place of Truth on the West of Thebes, Foreman of Works in the Necropolis (literally, 'Horizon of Eternity') Inher-kha, justified, his sister, the Housewife, the Chantress of Amun of Pa-khenty, Web, justified. His Osiris brother, the draughtsman in the Necropolis, Hor-Min, justified."

The register closes with a net trap attached to a *was*-scepter on the right (see fig. 212).[43] The ability to avoid the trap demanded that its individual parts be known. The foreman of the work, Nakhtemmut, stands below.

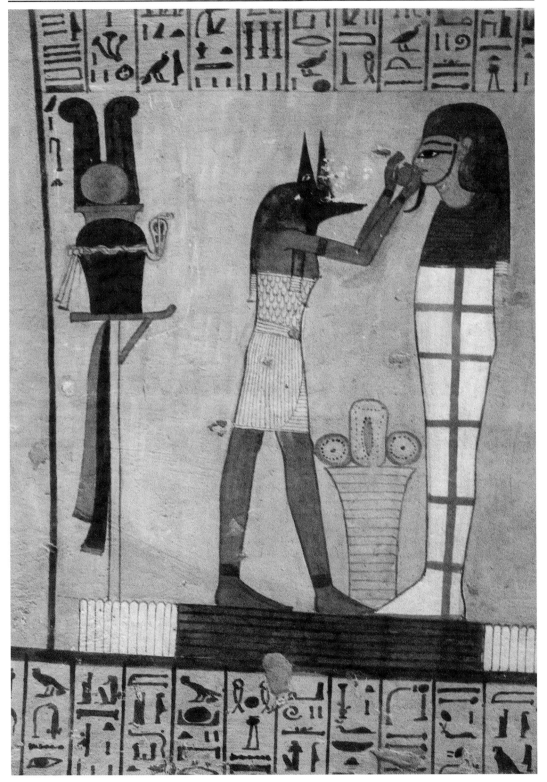

Figure 210

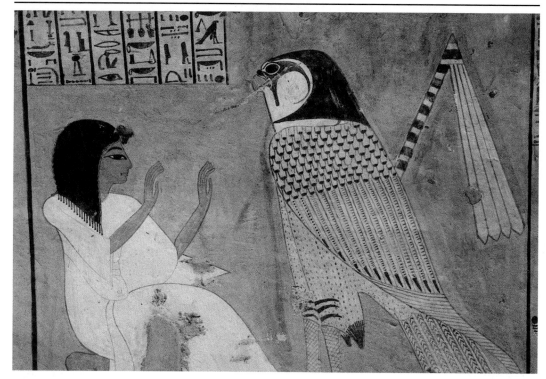

Figure 211

Dressed in fine pleated party clothes, Inher-kha and his wife Web are seated on a lion-footed chair (fig. 213). She embraces her husband in the usual fashion. Two men present them with incense and a libation in a *hes*-vessel. The scene was better preserved when Lepsius saw it more than a century ago, and he read that these two were the couple's sons.

The couple are seated in their festival finery on a lion-footed chair in the next scene as well. Before them is a stand with four burning torches (fig. 214). Exceptionally, the husband has put his arm around his wife's shoulder, and she is tenderly holding his hand. His face is again unshaven, and he is holding a libation vessel in the other hand. They face a row of six bald priests. The last four are approaching in pairs, and different shades of skin color were employed to contrast the pairs. Except for the first of them, whose panther skin thrown over his shoulders identifies him as a *sem*-priest, all of the priests are holding *hes*-libation vessels. The *sem*-priest has a censer with balls of incense clearly visible. The second is also distinguished by a specific costume, but all are relatives of the deceased. The first is his beloved son Qenena, *web*-priest of Ptah in the Valley

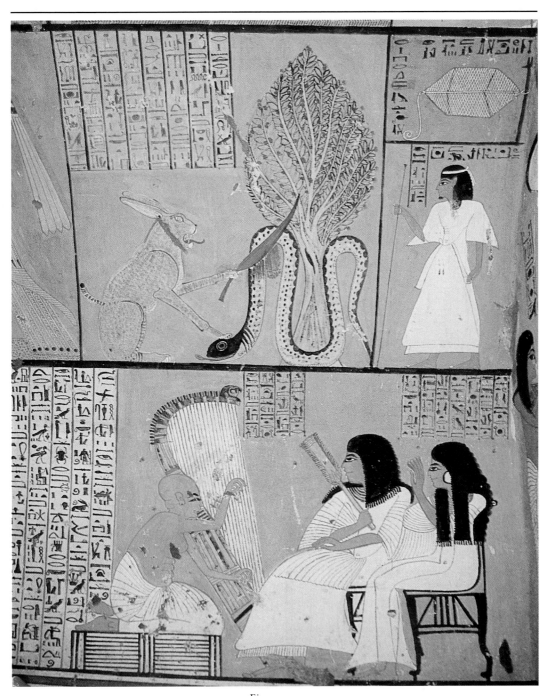

Figure 212

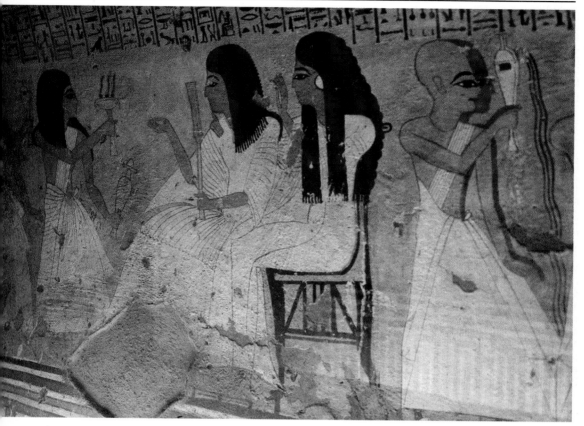

Figure 213

of the Queens. The others are craftsmen or draughtsmen in the royal necropolis. These are his sons Hor-Min, Imenemhab, and Hormes, along with his brothers Hay, Buqen, the *web*-priest Patjau, the engraver Qaha, and Ramose.

On the wall opposite the entrance is the deceased tomb-owner, together with "his son, the draftsman of the Horizon of Eternity (the necropolis), Hor-Min," with Ptah on the left, and with his son Qenena before Osiris. Incense is being burnt or prepared for the gods, who are standing on a mat in the form of the hieroglyph for maat (fig. 215).

Inher-kha and "the Housewife, the Chantress of Amun-Re, the King of the Gods," are listening to a blind harpist seated on a mat (see fig. 212). The departed are dressed in their best festival attire; she has large earrings and he is holding a *sekhem*-scepter, which is a symbol of rank. The musician is playing a large harp with its characteristic sound box, on which 36 red and blue pegs can be counted,

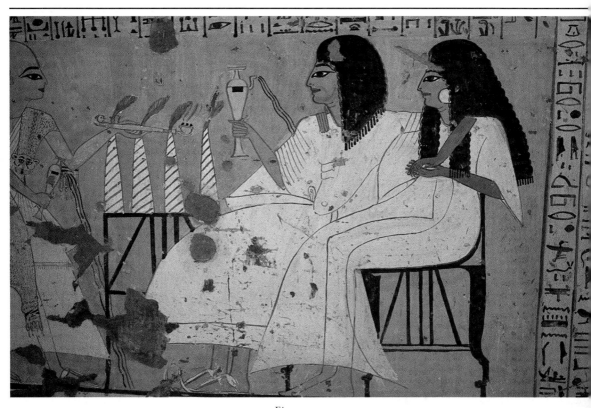

Figure 214

but only 22 strings were drawn. *Djadjat,* the Egyptian word for this instrument, may be of African origin.[44] The "Harper's Song" is a plea for a life of pleasure:[45]

> The musician says to the Osiris, the foreman of the gang in the Place of Truth, Inher-kha, justified. I say:

I am an official
a man in truth, in the fine fate
made by the god himself.
Forms are transformed, from the body,
passing away, since the time of the god.
Youth comes in their places.
The *ba*-powers and *akh*-spirits
which are in the Netherworld,
and the mummies too.
And the same for the builders of mortuary mansions and tombs:
They are the ones who rest in their pyramids.

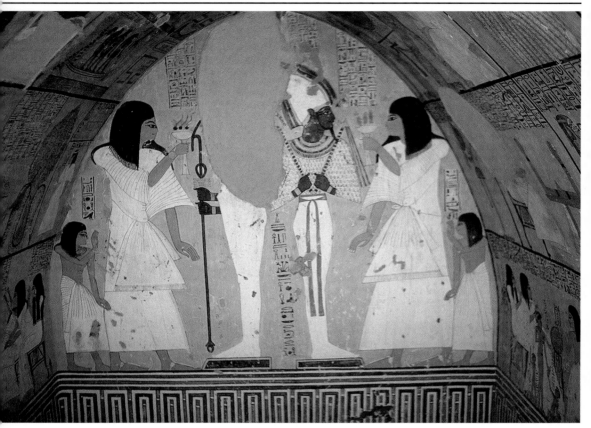

Figure 215

Make for yourself a mansion in the sacred land,
that your name may endure in it.
Your works in the necropolis shall be reckoned,
and excellent shall be your place of the West.

The flood flows downstream
and the northwind upstream.
Every man has his hour.

Spend a happy day,
Osiris, foreman of the gang in the Place of Truth, Inher-kha, justified.
Do not let your heart be weary, at all ever!
Together with your beloved.
Do not vex your heart
during the time of your being.

Spend a happy day indeed!
Put unguent and fine oil at your side,
Hang lotus blossoms and flowers on your breast.
The lady who is in your heart:
She is the one at your side.

Do not anger your heart
On account of anything that happens.
Put song before you.
Do not recall evil or the abominations of the god.

Recall for yourself your joys, you man:
righteous of heart,
witness of truth,
cool, calm and collected,
rested and joyful,
never speaking evil.

Make your heart drunk every day.
Until that day comes,
when you must moor.[46]

Abbreviations

The following abbreviations are used throughout the notes and selected bibliography.

ÄA	Ägyptologische Abhandlungen. Wiesbaden.
ADAIK	Abhandlungen des Deutschen Archäologischen Instituts Kairo. Glückstadt, Hamburg, New York.
ÄF	Ägyptologische Forschungen. Glückstadt, Hamburg, New York.
AH	Aegyptiaca Helvetica. Basel-Geneva.
AHAW	Abhandlungen der Heidelberger Akademie der Wissenschaften, phil. hist. Klasse, Heidelberg.
AMAW	Abhandlungen der Akademie der Wissenschaften und der Literatur in Mainz. Wiesbaden.
ASAE	*Annales du Service des Antiquités de l'Égypte.* Cairo.
ASE	Archaeological Survey of Egypt. London.
ÄUAT	Ägypten und Altes Testament. Wiesbaden.
AV	Archäologische Veröffentlichungen, Deutsches Archäologisches Institut, Abteilung Kairo. Vol. 1–3, Berlin; vol. 4 ff., Mainz.
BAe	Bibliotheca Aegyptiaca. Brussels.
BdE	Bibliothèque d'étude, institut français d'árchéologie orientale. Cairo.
BIE	*Bulletin de l'institut d'Égypte,* bis 1920: *Bulletin de l'institut égyptien.* Cairo.
BIFAO	*Bulletin de l'Institut Français d'árchéologie orientale.* Cairo.
CdÉ	*Chronique d'Égypte.* Brussels.
FIFAO	Fouilles de l'Institut Français d'archéologie orientale du Caire. Cairo.
GM	*Göttinger Miszellen.* Göttingen.
GOF	Göttinger Orientforschungen, IV. Reihe: Ägypten; Wiesbaden.
HÄB	Hildesheimer Ägyptologische Beiträge. Hildesheim.
JEA	*Journal of Egyptian Archaeology.* London.
JESHO	*Journal of the Economic and Social History of the Orient.* Leiden.
JNES	*Journal of Near Eastern Studies.* Chicago.

JSSEA	*Journal of the Society for the Study of Egyptian Antiquities.* Toronto.
KÄT	Kleine Ägyptische Texte. Wiesbaden.
LÄ	*Lexikon der Ägyptologie.* Wiesbaden.
LÄS	Leipziger Ägyptologische Studien. Glückstadt.
LD	Carl Richard Lepsius (ed.). *Denkmaeler aus Ägypten und Äthiopien.* 12 vols. and suppl. Berlin, 1849–58; Lepzig, 1913.
MÄS	Münchner Ägyptologische Studien. Berlin.
MDAIK	*Mitteilungen des Deutschen Archäologischen Instituts, Abteilung Kairo.* Before 1944: *Mitteilungen des Deutschen Archäologischen Instituts für Ägyptische Altertumskunde in Kairo.* Berlin and Wiesbaden; from 1970, Mainz.
MET	Mond Excavations at Thebes. London.
MIFAO	Mémoires publiés par les membres de l'Institut Français d'archéologie orientale du Caire. Cairo.
NAWG	Nachrichten der Akademie der Wissenschaften in Göttingen, Phil.-hist. Kl. Göttingen.
NUMEN	Numen, International Review for the History of Religions. Leiden.
OBO	Orbis biblicus er orientalis. Fribourg.
OIP	Oriental Institute Publications, University of Chicago. Chicago.
OLA	Orientalia Lovaniensia Análecta. Louvain.
P	Papyrus
PÄ	Probleme der Ägyptologie. Leiden.
PKG	Propyläen Kunstgeschichte. Berlin.
PMMA	Publications of the Metropolitan Museum of Art, Egyptian Expedition. New York.
RdÉ	*Revue d'Égyptologie.* Cairo; vol. 7ff., Paris.
RPTMS	Robb de Peyster Tytus Memorial Series, PMMA, New York.
RT	*Recueil de travaux rélatifs à la philologie et à l'àrchéologie égyptiennes et assyriennes.* Paris.
SAGA	Studien zur Archäologie und Geschichte Altägyptens. Heidelberg.
SAK	*Studien zur Altägyptischen Kultur.* Hamburg
SAOC	Studies in Ancient Oriental Civilization, Oriental Institute, University of Chicago. Chicago.
SBAW	Sitzungsberichte der Bayerischen Akademie der Wissenschaften, Phil.-hist. Abt. Munich.
SMPK	Staatliche Museen Preussischer Kulturbesitz
SÖAW	Sitzungsberichte der Österreichischen Akademie der Wissenschaften, phil.-hist. Klasse, Vienna.
TÄB	Tübinger Ägyptologische Beiträge. Bonn.
Urk. IV	Kurt Sethe and Wolfgang Helck. *Urkunden der 18. Dynastie.* Leipzig and Berlin.
Urk. IV. Übers.	Übersetzung von Elke Blumenthal, Ingeborg Müller, Walter F. Reineke, unter Leitung von Adelheid Burkhardt. Berlin, 1984.
VIO	Deutsche Akademie der Wissenschaften zu Berlin, Institut für Orientforschung, Veröffentlichungen. Berlin.
ZÄS	Zeitschrift für Ägyptische Sprache und Altertumskunde. Leipzig and Berlin.

Notes

Abbreviations used in the notes appear in the list of abbreviations that precedes this section.

Theban Tombs of the New Kingdom

1. The Instruction for Merikare, dating to *c.* 2100 B.C.; cf. Wolfgang Helck, *Die Lehre für König Merikare* (Wiesbaden, 1977), pp. 31–33; Miriam Lichtheim, *Ancient Egyptian Literature* (Berkeley, 1975–1980), 1:101; Raymond O. Faulkner, "The Teaching for Merikare," in William Kelly Simpson (ed.), *The Literature of Ancient Egypt* (New Haven, 1972), pp. 183–184.

2. See, e.g., John Baines, "Society, Morality, and Religious Practice," in Byron E. Shafer (ed.), *Religion in Ancient Egypt: Gods, Myths, and Personal Practice* (London, 1991), pp. 123–200; Paul John Frandsen, "Trade and Cult," in Gertie Englund (ed.), *The Religion of the Ancient Egyptians: Cognitive Structures and Popular Expressions* (Uppsala, 1989), pp. 95–108; Jan Assmann, *Zeit und Ewigkeit im Alten Ägypten* (Heidelberg, 1975), pp. 11–17; Wolfhart Westendorf, "Raum und Zeit als Entsprechungen der beiden Ewigkeiten," in Manfred Görg (ed.), *Fontes atque Pontes: Eine Festgabe für Hellmut Brunner* (Wiesbaden, 1983), pp. 422–435.

3. See Wolfhart Westendorf, "Tod," *LÄ* VI: 613–615; Jan Zandee, *Death As an Enemy* (Leiden, 1960); Siegfried Morenz, *Egyptian Religion* (Ithaca, 1973), pp. 183–213.

4. See e.g., the tomb of Inher-kha, pp. 287–289, and Miriam Lichtheim, "The Songs of the Harpers," *JNES* 4 (1945): 178–212.

5. See Alexander Scharff, *Das Grab als Wohnhaus in der Ägyptischen Frühzeit* (Munich, 1947).

6. Georges Posener, "Le début de l'Enseignement de Hardjedef," *RdÉ* 9 (1952): 109–120, esp. 111–113.

7. See Siegfried Schott, *Das schöne Fest vom Wüstentale: Festbräuche einer Totenstadt* (Wiesbaden, 1953).

8. See n. 1.

9. See the tomb of Rekhmire, and Eberhard Otto, *Das ägyptische Mundöffnungsritual* (Wiesbaden, 1960).

10. See Heike Sternberg, "Mumie," *LÄ* IV: 213–216;

11. See Hans Bonnet, *Reallexikon der ägyptischen Religionsgeschichte* (Berlin, 1953). pp. 74–77; Louis V. Zabkar, "Ba," *LÄ* I: 588–590; Louis V. Zabkar, *A Study of the Ba Concept in Ancient Egyptian Texts* (Chicago, 1968); Elske Marie Wolf-Brinkmann, *Versuch einer Deutung des Begriffes 'b3' anhand der Überlieferung der Frühzeit und des Alten Reiches* (Freiburg, 1968). The *shut*-shadow concept is rare outside the royal tombs, which are not discussed in this book; see Beate George, *Zu den altägyptischen Vorstellungen von Schatten als Seele* (Bonn, 1970).

12. [As with all other quotes from the Book of the Dead, translated from the Egyptian of Edouard Naville *Das Aegyptische Todtenbuch der XVIII. Bis XX. Dynastie* (Berlin, 1886). Trans.] See also Erik Hornung, *Das Totenbuch der Ägypter* (Zurich, 1979), p. 172; Raymond O. Faulkner, *Book of the Dead* (London, 1972), p. 82.

13. Bonnet, *Reallexikon*, pp. 357ff, esp. p. 358 (quote from this page); cf. Peter Kaplony, "Ka," *LÄ*, III: 275–282; Liselotte Greven, *Der Ka in Theologie und Königskult der Ägypter des Alten Reiches* (Hamburg, 1956); Ursula Schweitzer, *Das Wesen des Ka im Diesseits und Jenseits der Alten Ägypter* (Hamburg, 1956).

14. See, e.g., Raymond O. Faulkner, "The Maxims of Ptahhotpe," in Simpson, *Literature*, pp. 159–176.

15. See Joachim Quack, *Die Lehren des Ani* (Freiburg, 1994), pp. 107, 307; Lichtheim, *Literature*, 2: 40.

16. Walther Wolf, *Kulturgeschichte des Alten Ägypten* (Stuttgart, 1962), pp. 330–331; Alan H. Gardiner, *Egypt of the Pharaohs* (Oxford, 1961), p. 298; Kenneth Kitchen, *Pharaoh Triumphant* (Warminster, 1982), p. 218.

17. Ali Radwan, *Die Darstellungen des regierenden Königs und seiner Familienangehörigen in den Privatgräbern der 18. Dynastie* (Berlin, 1969), passim.

18. Friederike Kampp, *Die Thebanische Nekropole: Zum Wandel des Grabgedankens von der XVIII. bis zur XX. Dynastie* (Mainz, 1996), p. 3. On the lost tombs, see Lise Manniche, *Lost Tombs* (London, 1988).

19. "Cube" statues are stylized statues of individuals crouching with their knees closely drawn up in front of them. The Egyptians used the effect to obliterate detail and leave the body a mere "cube" with head and feet attached; the inscription is in Kenneth Kitchen, *Ramesside Inscriptions* (Oxford, 1980), III: 297. Similar statues from different epochs can be seen in, e.g., Gay Robins, *The Art of Ancient Egypt* (London, 1997), pp. 106 and 241.

20. Access to the tombs in the entire Theban necropolis varies according to official policy.

21. See Georg Steindorff and Walther Wolf, *Die Thebanische Gräberwelt* (Leipzig, 1936), pp. 44–72. Steindorff and Wolf's important book was used as a basic reference in the German edition of this book, but F. Kampp (*Nekropole*, pp. 4–5) assumed that it was too general. In her study, she "initially intended to find the tombs and describe the courtyards, façades and superstructures as most of these details are not discussed in the publications currently available." Kampp's major new work has therefore been used to bring the U.S. edition of this book up to date, but Steindorff and Wolf's slim volume is far more accessible than Kampp's weighty tomes, and a detailed discussion of all Kampp's various tomb types and superstrucures, etc., would be out of place here as it would only lead to exhaustion and confusion.

22. See Kampp, *Nekropole*, pp. 11–12, 47–48.

23. See pp. 100–111.

24. Kampp, *Nekropole*, pp. 86–87.

25. Kampp, *Nekropole*, pp. 76–77.

26. See Kampp, *Nekropole*, pp. 82–89.

27. Jan Assmann, "Das Grab mit gewundenem Abstieg," *MDAIK* 40 (1984): 277–290; Karl-Joachim Seyfried, "Zweiter Vorbericht über die Arbeiten des Ägyptologischen Instituts der Universität Heidelberg in thebanischen Gräbern der Ramessidenzeit," *MDAIK* 40 (1984): 265–276, esp. 271–273. The fourth hour of the *Amduat* is beautifully preserved along with the rest of the book in the tombs of Tuthmosis III and Amenophis II; see Erik Hornung, *The Valley of the Kings: Horizon of Eternity* (New York, 1990), p. 81.

28. Erik Hornung, *Die Unterweltsbücher der Ägypter,* 3rd ed. (Zurich, 1989), p. 112.

29. See Kampp, *Nekropole,* pp. 59–60.

30. Jan Assmann, "Priorität und Interesse: Das Problem der Ramessidischen Beamtengräber," in Jan Assmann, Günter Burkard, and Vivian Davies (eds.), *Problems and Priorities in Egyptian Archaeology* (London, 1987), p. 39.

31. Kampp, *Nekropole,* pp. 80–81.

32. Petra Barthelmess, *Der Übergang ins Jenseits in den thebanischen Beamtengräbern der Ramessidenzeit* (Heidelberg, 1992), p. 2.

33. See Steindorff and Wolf, *Thebanische Gräberwelt,* p. 45; Mark Lehner, *The Complete Pyramids* (London, 1997), pp. 192–193.

34. Lehner, *Pyramids,* p. 192.

35. Kampp, *Nekropole,* pp. 95–103.

36. See pp. 243–245.

37. There are burial scenes earlier than these, but it is not certain that they show tomb façades. See. Eberhard Dziobek, *Die Gräber des Vezirs User-Amun Theben Nr. 61 und 131* (Mainz, 1994), pp. 59–60; Eberhard Dziobek, "Eine Grabpyramide des frühen NR in Theben," *MDAIK* 45 (1989): 109–132.

38. Agnès Rammant-Peeters, *Les Pyramidions Égyptiennes du Nouvel Empire* (Louvain, 1983); Assmann, "Priorität," p. 38; Dziobek, "Grabpyramide," p. 131.

39. For Thebes, see Kampp, *Nekropole,* pp. 108–109, esp. n. 521; for Saqqara, see, e.g., Geoffrey T. Martin, "The Tomb of Tia and Tia," *JEA* 70 (1984): 5–12; Geoffrey T. Martin, *The Hidden Tombs of Memphis* (London, 1991), pp. 112–114; Dietrich Raue, "Zum memphitischen Privatgrab im neuen Reich," *MDAIK* 51 (1995): 255–268.

40. Rammant-Peeters, *Pyramidions,* pp. 3–100.

41. Kampp, *Nekropole,* pp. 106–109.

42. See Rammant-Peeters, *Pyramidions,* Doc. 14, pl. 10; Kampp, *Nekropole,* p. 107, n. 510.

43. Rammant-Peeters, *Pyramidions,* p. 165.

44. See Arne Eggebrecht, "Grabkegel," *LÄ* II: 857–859; Norman de G. Davies and M. F. Laming Macadam, *A Corpus of Inscribed Egyptian Funerary Cones* (Oxford, 1957).

45. Kampp, *Nekropole,* figs. 67–69.

46. See Kampp, *Nekropole,* pp. 121–122.

47. Jan Assmann, *Ägyptische Hymnen und Gebete* (Zurich, 1975), p. 13; Jan Assmann, "Das Grab mit gewundenem Abstieg," *MDAIK* 40 (1984): 284.

48. Assmann, *Ägyptische Hymnen,* p. 14; Christine Beinlich-Seeber and Abdel Ghaffar Shedid, *Das Grab des Userhat (TT56)* (Mainz, 1987), p. 22.

49. See Christa Müller, "Anruf an Lebende," *LÄ* I: 293–299.

50. Kurt Sethe, *Urkunden der 18. Dynastie* (Leipzig, 1909), 1083–1085.

51. See Michael V. Fox, "The Entertainment Song Genre in Egyptian Literature," in Sarah Israelit-Groll (ed.), *Egyptological Studies* (Jerusalem, 1982), pp. 268–316.

52. Schott, *Das schöne Fest;* Sylvia Wiebach, "Die Begegnung von Lebenden und Toten im Rahmen des Thebanischen Talfestes," *SAK* 13 (1986), pp. 263–291.

53. Schott, *Das schöne Fest,* p. 25.

54. Jaroslav Černý, *The Valley of the Kings* (Cairo, 1973); Hornung, *Valley of the Kings*, pp. 39–48.
55. Steindorff and Wolf, *Thebanische Gräberwelt*, pp. 54–59.
56. See Dieter Arnold, "Grabbau," *LÄ* II: 845–881, esp. 847–851; Walther Wolf, *Die Kunst Ägyptens: Gestalt und Geschichte* (Stuttgart,1957), p. 478; Arpag Mekhitarian, *Egyptian Painting* (Geneva, 1954), pp. 22–35; Ernest Mackay, "The Cutting and Preparation of Tomb-Chapels in the Theban Necropolis," *JEA* 7 (1921): 154–168, esp. 159–163.
57. *Urk.* IV: 57, 9–11; see Wolf, *Kunst*, p. 479.
58. Gary Robins, *Proportion and Style in Ancient Egyptian Art* (Austin 1994), p. 89; the discussion that follows is based on pp. 87–118, 254–255, and 257–258.
59. Robins, *Proportion*, p. 259. The number of examples discussed in Robins and the leap from the grid to the horizontal lines tend to confuse rather than clarify. This makes it difficult to follow.
60. Robins (*Proportion*, p. 182) suggests that a small-scale plan of the scene may have been made on papyrus. The price of papyrus renders this improbable, however. Original drawings from Deir el-Medineh suggest that limestone ostraca were probably used for such plans; after all, limestone flakes were both free and abundant. Although frequently assumed to be expensive, papyrus was probably not particularly so: see Jacobus J. Janssen, *Commodity Prices from the Ramessid Period* (Leiden, 1975), pp. 447–448; see n. 88.
61. See Robins, *Art of Ancient Egypt*, pp. 150 and 192.
62. Robins, *Proportion*, p. 259.
63. Mekhitarian, *Egyptian Painting*, p. 28.
64. See Hornung, *Valley of the Kings*, p. 42.
65. Černý, *Valley of the Kings*, pp. 43–54.
66. Herodotus, *Histories* II: 62.
67. Alfred Lucas, *Ancient Egyptian Materials and Industries* (J. R. Harris, ed.) (London, 1962), pp. 338–366; John R. Harris, *Lexicographical Studies in Ancient Egyptian Minerals* (Berlin, 1961), pp. 141–162. Although these two works document the physical properties of color in ancient Egypt, it is still occasionally stated—against the evidence—that the Egyptians used vegetable colors, or even that the characteristics of the Egyptian colors remain unknown.
68. See, e.g., Birgit Schlick-Nolte, "Fritte," *LÄ* II: 332–333.
69. See Wolfgang Helck, "Gummi," *LÄ* II: 921; Harris, *Lexicographical Studies*, pp. 158–159.
70. TT 20 of Mentuherkhepeshef, see Norman de G. Davies, *Five Theban Tombs* (London, 1913), p. 6, No. 2, pl. 17.
71. Lucas, *Materials*, p. 134.
72. Claude Traunecker,"Farbe," *LÄ* 2: 115–117; Emma Brunner-Traut, "Farben," *LÄ* II: 117–128.
73. Elisabeth Staehelin, "Zu den Farben der Hieroglyphen," *GM* 14 (1974): 49. See also John Baines, "Color Terminology and Color Classification: Ancient Egyptian Color Terminology and Polychromy," *American Anthropologist* 87 (1985): 282–297; Baines is too rigid, but the bibliography is useful.
74. The German Egyptologist Wolf treated the subject of the reliefs and paintings of the New Kingdom in detail; the reader is referred to his masterly treatment. See Wolf, *Kunst*, pp. 278–284. H. Schäfer's entire book (*Von Ägyptischer Kunst*) on the development of Egyptian art through time has been translated as *Principles of Egyptian Art* (Oxford, 1974); Robins, *Art of Ancient Egypt*, pp. 20–24 and 138–142, touches on it briefly.

75. Jan Assmann (*Zeit und Ewigkeit*) attempted to interpret and define the conceptual basis of time in Egyptian thought, which is ultimately reflected in art.

76. Robins, *Proportion*, p. 21.

77. Emma Brunner-Traut, "Aspective," *LÄ* I: 474. See also Brunner-Traut's notes on aspective in Schäfer's *Principles of Egyptian Art*, pp. 421–448; and also Brunner-Traut, *Frühformen des Erkennens, am Beispiel Altägyptens* (Darmstadt 1990), pp. 7–70.

78. Wolf, *Kunst*, p. 263.

79. Wolf, *Kunst*, pp. 265–266.

80. See Dietrich Wildung, *Ägyptische Malerei: Das Grab des Nakht* (Munich, 1980), p. 59; Wolfhart Westendorf, "Das Alte Ägypten," *Enzyklopädie der Weltkunst* (Baden-Baden, 1977), p. 123.

81. Hermann Kees, "Die Befriedung des Raubtiers," *ZÄS* 67 (1931): 56–59.

82. Dietrich Wildung, "Erschlagen der Feinde," *LÄ* II: 14–17.

83. Discussed in detail by Beinlich-Seeber and Shedid, *Userhat*, p. 29, notes 151, 152.

84. See Beinlich-Seeber and Shedid, *Userhat*, p. 28.

85. See Hornung, *Valley of the Kings*.

86. See the tomb furnishings of the craftsman Kha, in the Turin Museum in Italy today. The Metropolitan Museum also has an excellent collection; see William C. Hayes, *The Scepter of Egypt: A Background for the Study of the Egyptian Antiquities in the Metropolitan Museum of Art*, parts 1 and 2 (New York, 1978).

87. See Faulkner, *Book of the Dead*; Hornung, *Totenbuch*; Mohamed Saleh, *Das Totenbuch in den thebanischen Beamtengräbern des Neuen Reiches* (Mainz, 1984).

88. See Janssen, *Commodity Prices*, pp. 245–246; Klaus Baer, "The Low Price of Land in Ancient Egypt," *Journal of the American Research Center in Egypt* 1 (1962): 29.

89. Jan Assmann, *Ägypten, Theologie, und Frömmigkeit einer frühen Hochkultur* (Stuttgart, 1984), p. 114. See Spells 99 (Faulkner, *Book of the Dead*, pp. 90–97; Hornung, *Totenbuch*, p. 189); 125 (Faulkner, *Book of the Dead*, pp. 29–34; Hornung, *Totenbuch*, pp. 233–245); 144 (Faulkner, *Book of the Dead*, pp. 133–135; Hornung, *Totenbuch*, pp. 276–281); 146 (Faulkner, *Book of the Dead*, pp. 135–137); 147 (Hornung, *Totenbuch*, pp. 293–298).

90. Assmann, *Ägypten*, p. 82.

91. Erich Lüddeckens, "Untersuchungen über religiösen Gehalt, Sprache und Form der ägyptischen Totenklagen," *MDAIK* 11 (1943): 134–135. See also Morenz, *Egyptian Religion*, p. 187.

92. Quack, *Die Lehren des Ani* pp. 96–99, 291–292; Lichtheim, *Literature*, II: 138.

93. Philippe Derchain, "La mort ravisseuse," *CdÉ* 33 (1958): 29–32; Hermann Grapow, "Der Tod als Räuber," *ZÄS* 72 (1936): 76–77; Zandee, *Death as an Enemy*.

94. Morenz, *Egyptian Religion*, pp. 186–187, 192–193.

95. The quotes are from the Harper's Song; see Miriam Lichtheim, "The Songs of the Harpers," *JNES* 4 (1945): 178–212, esp. p. 195 and pl. 7; Siegfried Schott, *Altägyptische Liebeslieder* (Zurich, 1950), pp. 132–135.

Nakht

1. Matthias Seidel and Abdel Gaffar Shedid, *The Tomb of Nakht* (Mainz, 1992); Norman de Garis Davies, *The Tomb of Nakht at Thebes* (New York, 1917); Dietrich Wildung, *Ägyptische Malerei: Das Grab des Nacht* (Munich, 1980).

2. Davies, *Nakht,* p. 50. Seidel and Shedid (*Nacht,* p. 28) concurred, arguing that the conservative dress and spare ornamentation matched the long transparent kilts and the generally wedge-shaped narrow belt, all of which justified the date suggested by Davies. This is further supported by the right angles used to depict the thighs of seated women; the puffy pleated kilts common during the later part of the reign of Tuthmosis IV fail to appear in this tomb.

3. Likes Davies's, the argument is therefore stylistic. The heavily laden offering tables, the richly pleated garments, and the massive curled wigs are all supposed to be features typical of the reign of Amenophis III, as are the hues: the deep blue and green tones resemble those in the tomb of Menna (TT 69), tones that also appear in the royal tomb of Amenophis III. The scene is similar to a fragment in the Luxor Museum today, from TT 226, depicting Amenhotep III with his mother, Mutemwia. It has even been suggested that the same painter was responsible for works in the royal tomb of Amenophis III, Nakht (TT 52), Menna (TT 69), and TT 226 (see Arielle P. Kozloff, "Tomb Decoration: Paintings and Relief Sculpture," in Arielle P. Kozloff, Betsy M. Bryan, and Lawrence M. Bermann [eds.], *Egypt's Dazzling Sun: Amenhotep III and His World* [Cleveland 1992], pp. 261–299). It should, however, be evident that selecting the later date is hardly of historical relevance or of relevance to the visitor, as it is only a question of a few years. Of more interest is that the only female musician regularly depicted nude was the lute player—in tombs, on ostraca, and on faience bowls—and this scene is not an exception (as opposed to Kozloff, "Tomb Decoration," p. 271, 298).

4. See Wildung, *Nacht,* p. 16.

5. See Christiane Ziegler, "Sistrum," *LÄ* V: 959–963; Christiane Ziegler, *Catalogue des instruments de musique égyptiens* (Paris, 1979), pp. 31–40; Bonnet, *Reallexikon,* pp. 716–720; Geraldine Pinch, *Votive Offerings to Hathor* (Oxford, 1993), pp. 139–147; Hans Hickmann, *Musikgeschichte in Bildern* (Leipzig, 1975), pp. 46ff.

6. See Elisabeth Staehelin, "Menit," *LÄ* IV: 52–53; Bonnet, *Reallexikon,* pp. 450–451; Pinch, *Votive Offerings to Hathor,* pp. 269–272.

7. Siegfried Schott, *Das schöne Fest vom Wüstentale: Festbräuche einer Totenstadt* (Wiesbaden: 1953), p. 24, fig. 7.

8. *Urk.* IV: 1605, 3–10.

9. See Book of the Dead Spells 81A, 81B, and 82, Raymond O. Faulkner, *Book of the Dead* (London, 1972), p. 79; Emma Brunner-Traut, "Lotos," *LÄ* III: 1091–1095; Hermann Schlögl, *Der Sonnengott auf der Blüte* (Geneva, 1977); and the tomb of Inher-kha, p. 271.

10. *Urk.* IV: 1604, 18–19. Translation by D. Warburton. The gods mentioned are not depicted.

11. A "sack" was roughly 75 liters or 2 bushels; an *aroura* was 2,735 m², or about 2/3 of an acre. In real terms, the difference could range from about 1.2 bushels/acre (135 liters/ha) for a state employee (such as a soldier) to 25 bushels/acre (3000 liters/ha) for the state lands; see Wolfgang Helck, "Getreide," *LÄ* II: 586–589; Wolfgang Helck, "Abgaben und Steuern," *LÄ* I: 3–12; Alan H. Gardiner, "Ramesside Texts Relating to Taxation and Transport of Corn," *JEA* 27 (1941): 19–73; David Warburton, *State and Economy in Ancient Egypt* (Fribourg, 1997).

12. Jan Assmann, "Flachbildkunst des neuen Reiches," in Claude Vandersleyen (ed.), *Das Alte Ägypten* (Berlin, 1975), No. 289a, p. 319.

13. The false door indicates the place where offerings were to be placed. The deceased was supposed to pass through this door and thus live off the offerings of his mortuary estab-

lishment. The false door declined in significance in the course of time, as the offering cult was replaced by a "memory" cult. See Gerhard Haeny, "Scheintür," *LÄ* V: 563–574.

14. See Raymond O. Faulkner, *The Ancient Egyptian Book of the Dead* (London, 1985), p. 69; Wildung, *Nacht*, p. 52; Ingrid Gamer-Wallert, "Baum, Heiliger," *LÄ* I: 655–660; pp. 258–259.

15. Christa Müller, "Salbkegel," *LÄ* V: 366–367.

16. See Curt Sachs, *The Rise of Music in the Ancient World: East and West* (New York, 1943), p. 74; Hans Hickmann, *Musik des Altertums*, Lieferung 1: Ägypten (Leipzig, 1975), p. 138, fig. 94; for the instruments in the following scene, p. 98, fig. 61. See also Lise Manniche, *Music and Musicians in Ancient Egypt* (London, 1991), pp. 45, 97–107; Miriam Lichtheim, "The Songs of the Harpers," *JNES* 4 (1945): 178–212.

17. Walther Wolf, *Die Kunst Ägyptens: Gestalt und Geschichte.* (Stuttgart, 1957), p. 495.

18. *Urk.* IV: 1605, 18–1606, 5.

19. *Urk.* IV: 1605, 13–15.

20. See Davies, *Nakht*, p. 50; see *Dazzling Sun*, p. 236, 206–207. This speaks in favor of a slightly later date for the tomb.

21. See pp. 114–115; these thoughts are carefully discussed in detail by Christine Beinlich-Seeber and Abdel Ghaffar Shedid, *Das Grab des Userhat (TT56)* (Mainz, 1987), p. 30.

22. See Erik Hornung, *Der ägyptische Mythos von der Himmelskuh* (Fribourg, 1982).

23. See Wolfgang Helck, "Schesemu," *LÄ* V: 590–591; Hans Bonnet, *Reallexikon der ägyptischen Religionsgeschichte* (Berlin, 1953), pp. 679–680.

Ramose

1. Norman de Garis Davies, *The Tomb of the Vizier Ramose* (London, 1941); Sylvia Schoske, "Ramose," *LÄ* V: 98–99; Arielle P. Kozloff, "Tomb Decoration: Paintings and Relief Sculpture," in Arielle P. Kozloff, Betsy M. Bryan, and Lawrence M. Bermann (eds.), *Egypt's Dazzling Sun: Amenhotep III and His World* (Cleveland, 1992), pp. 275–280.

2. See Davies, *Ramose*, p. 6, for the earlier work.

3. See Winfried Barta, "Sechem," *LÄ* V: 772–776; Hans Bonnet, *Reallexikon der ägyptischen Religionsgeschichte* (Berlin, 1953), pp. 692–693.

4. Walther Wolf, *Die Kunst Ägyptens: Gestalt und Geschichte* (Stuttgart, 1957), p. 504. These reliefs bear a striking similarity to the statues of Maya and his wife Merit, where the wigs and the clothing are identical, allowing a comparison of relief and statuary. Maya and Merit must be dated to the end of the reign of Tutankhamun and are thus several decades later; Wolf (*Kunst*, p. 504) pointed out that it would have been impossible to improve this style any further. The statues of Maya and Merit come from their tomb at Memphis but are in the Leiden Museum today; see Hans D. Schneider, Geoffrey T. Martin, Barbara Greene Aston, Jacobus van Dijk, Rutger Perizonius, and Eugen Strouhal, "The Tomb of Maya and Meryt," *Journal of Egyptian Archaeology* 77 (1991): 7–21; Hans D. Schneider and Maarten J. Raven, *De Egyptische Oudheid* (Leiden, 1981), pp. 88–89, 91–92.

5. Siegfried Schott, *Das schöne Fest vom Wüstentale: Festbräuche einer Totenstadt* (Wiesbaden: 1953), pp. 25–27, 102.

6. Elisabeth Staehelin, "Tracht," *LÄ* VI: 726–737; Eva Martin-Pardey, "Wesir, Wesirat," *LÄ* VI: 1227–1235, esp. 1229.

7. Christine Beinlich-Seeber and Abdel Ghaffar Shedid, *Das Grab des Userhat (TT 56)* (Mainz, 1987), p. 42 and n. 223.

8. *Urk.* IV: 1778, 6–19.

9. *Urk.* IV: 1784, 18–19.

10. *Urk.* IV: 1784, 12–17. Isheru is the name of the Mut Temple at Karnak; the name originally was used to designate any curving waterway, which was a favorite location for cults of lion goddesses such as Mut; see Eberhard Otto, "Ascheru," *LÄ* I: 460–462.

11. *Urk.* IV: 1784: 3–11. Wenennefer was rendered as Onophoros in Greek; it was an ancient Egyptian designation for Osiris, meaning "the existing good."

12. *Urk.* IV: 1783, 18–1784, 2. [It is extremely interesting that Amenhotep's name was not effaced here by Akhenaten's fanatics, who usually removed "Amun" everywhere; he must have been very important. Trans.]

13. *Urk.* IV: 1785, 19–1786, 10.

14. See Davies, *Ramose,* p. 2, but also Helck, *Urk.* IV: 1786. Both have the same wife—May, Chantress of Amun. The titles in all three cases are virtually the same. The small woman (Davies, *Ramose,* pl. IX) could be his daughter, and therefore Ramose's wife.

15. Hartwig Altenmüller, "Bestattungsritual," *LÄ* I: 745–765; Jürgen Settgast, *Untersuchungen zu altägyptischen Bestattungsdarstellungen* (Glückstadt, 1963); Max Wegner, "Stilentwicklung der thebanischen Beamtengräber," *MDAIK* 4 (1933): 84–89.

16. See Bonnet, *Reallexikon,* p. 365; Karl Martin,"Kanopen II," "Kanopenkasten," *LÄ* III: 316–320; Barbara Lüscher, *Untersuchungen zu den ägyptischen Kanopenkasten: Vom Alten Reich bis zum Ende der Zweiten Zwischenzeit* (Hildesheim, 1990); Aidan Dodson, *The Canopic Equipment of the Kings of Egypt* (London, 1994).

17. Bonnet, *Reallexikon,* p. 26; Arne Eggebrecht, "Amset," *LÄ* I: 226. See the Hermopolitan ogdoad, where each of the four primeval male gods is paired with a grammatically feminine counterpart.

18. Adolf Erman, "Beiträge zur ägyptischen Religion" (Berlin, 1916), p. 1151, A3.

19. Bonnet, *Reallexikon,* p. 315; Matthieu Heerma van Voss, "Horuskinder," *LÄ* III: 52–53.

20. Wolfgang Helck, "Tekenu," *LÄ* VI: 308–309.

21. See Erik Hornung, *Idea into Image: Essays on Ancient Egyptian Thought* (New York, 1992), p. 169.

22. [This, is however, improbable, as Ramose's wife may have been much younger than he was—as she was his niece; and the couple does not appear to have had children. Trans.]

23. Christine Strauss, "Kronen," *LÄ* III: 811–816; Abdel Moneim Abu Bakr, *Untersuchungen über die altägyptischen Kronen* (Glückstadt, 1937); Wegner, "Stilentwicklung," 55–58; Ali Radwan, *Die Darstellungen des regierenden Königs und seiner Familienangehörigen in den Privatgräbern der 18. Dynastie* (Berlin, 1969).

24. *Urk.* IV: 1777, 4–8.

25. Berlin SMPK Inv./No. 1/63. Labib Habachi, "Varia from the Reign of King Akhenaten," *MDAIK* 20 (1965): 85–92.

26. See Bonnet, *Reallexikon,* p. 199.

27. Herman te Velde, "Iunmutef," *LÄ* III: 212–213.

28. Davies, *Ramose,* pl. 21.

29. Davies, *Ramose,* p. 20.

30. Schott, *Das schöne Fest,* pp. 41–44.

31. Davies, *Ramose,* pl. 18.

Userhat

1. Christine Beinlich-Seeber and Abdel Ghaffar Shedid, *Das Grab des Userhat (TT 56)* (Mainz, 1987).

2. *Urk.* IV: 1477.
3. See Wilhelm Spiegelberg, *Rechnungen aus der Zeit Setis I* (Strassburg, 1896); Kenneth A. Kitchen, *Ramesside Inscriptions* (Oxford, 1975ff), Texts I: 243–281, *Translations* I: 207–230, and *Notes and Comments* I: 159–185.
4. See Beinlich-Seeber and Shedid, *Userhat*, pp. 106–113.
5. For the history, see Gardner Wilkinson, *The Manners and Customs of the Ancient Egyptians* (London, 1847); Robert Mond, "Report of Work in the Necropolis of Thebes during the Winter of 1903–1904," *ASAE* 6 (1905): 65–96; Carl Richard Lepsius, *Denkmaeler aus Aegypten und Aethiopien* (Leipzig, 1900), Text III: 283–284.
6. See Beinlich-Seeber and Shedid, *Userhat*, pp. 114–146, for a detailed discussion of the artistic merits of the tomb.
7. See Beinlich-Seeber and Shedid, *Userhat*, pp. 14–16.
8. Renate Germer, "Lattich," *LÄ* III: 938–939; Renate Germer, *Flora des pharaonischen Ägypten* (Mainz, 1985), pp. 185–186.
9. For flowers and bouquets, see Johanna Dittmar, *Blumen und Blumensträusse als Opfergabe im alten Ägypten* (Berlin, 1986).
10. Beinlich-Seeber and Shedid, *Userhat*, p. 43; Siegfried Schott, *Das schöne Fest vom Wüstentale: Festbräuche einer Totenstadt* (Wiesbaden, 1953), pp. 12–23; Renate Germer, "Weihrauch," *LÄ* VI: 1167–1169; Nigel Groom, *Frankincense and Myrrh: A Study of the Arabian Incense Trade* (London, 1981).
11. Max Wegner, "Stilentwicklung der thebanischen Beamtengräber," *MDAIK* 4(1993): 70–71; Beinlich-Seeber and Shedid, *Userhat*, p. 44.
12. Beinlich-Seeber and Shedid, *Userhat*, p. 46.
13. For this scene, see pp. 169–172; for the priests, see, e.g., Wolfgang Helck, "Priester, Priesterorganisation, Priestertitel," *LÄ* IV: 1084–1097; Hans Bonnet, "Priester," "Sempriester," and "Vorlesepriester," *Reallexikon der ägyptischen Religionsgeschichte* (Berlin, 1952), pp. 596–607, 697–687, 860–861.
14. Adolf Erman and Hermann Ranke, *Ägypten und Ägyptisches Leben* (Tübingen, 1923/ Hildesheim, 1977); Barbara Watterson, *Women in Ancient Egypt* (Stroud, Eng. 1991), pp. 44–45, 91; see also Gay Robins, *Women in Ancient Egypt* (Cambridge, Mass., 1993), pp. 88–91; Anne K. Capel and Glenn E. Markoe (eds.), *Mistress of the House, Mistress of Heaven: Women in Ancient Egypt* (Cincinnati, 1996).
15. Beinlich-Seeber and Shedid, *Userhat*, p. 78.
16. See Ali Radwan, *Die Darstellungen des regierenden Königs und seiner Familienangehörigen in den Privatgräbern der 18. Dynastie* (Berlin, 1969), pp. 5–6.
17. The text itself is preserved in several copies, as scribes enjoyed a perceived sense of superiority to soldiers, while evidently feeling compelled to discourage young scribes from turning to the profession of arms. This version is from P. Lansing, published by Sir Alan H. Gardiner, *Late-Egyptian Miscellanies* (Brussels, 1937), pp. 108–109, and translated by Ricardo A. Caminos, *Late-Egyptian Miscellanies* (London, 1954), pp. 401–402. Translation by D. Warburton.
18. Beinlich-Seeber and Shedid, *Userhat*, pp. 108–110, esp. 110.
19. See pp. 33–34 and Eberhard Otto, *Das ägyptische Mundöffnungsritual* (Wiesbaden, 1960).
20. Schott, *Das schöne Fest*, p. 71.
21. Beinlich-Seeber and Shedid, *Userhat*, p. 56. Translation by D. Warburton.
22. Beinlich-Seeber and Shedid, *Userhat*, p. 63.
23. Arpag Mekhitarian, *Egyptian Painting* (Geneva, 1954), p. 57.

Menna

1. The tomb itself has not yet been the subject of an exhaustive monograph, but see Colin Campbell, *Two Theban Princes* (Edinburgh, 1910), pp. 85–106.

2. Part of the logic in this argument is circular, as the proposed slightly later date for the tomb of Menna is itself employed as an argument for lowering the date of the tomb of Nakht (see Arielle P. Kozloff, "Tomb Decoration: Paintings and Relief Sculpture," in Arielle P. Kozloff, Betsy M. Bryan, and Lawrence M. Bermann [eds.], *Egypt's Dazzling Sun: Amenhotep III and His World* [Cleveland 1992], pp. 268–273). Kozloff bases her argument on the slanting, almond-shaped eyes and the tip-tilted noses, also arguing that the image of Osiris at the left end of Menna's tomb can be compared to the representations of gods in the tomb of Amenophis III (see also p. 28). The tombs of Menna and Pa-iri (TT 139) can also be compared, and Pa-iri latter certainly lived under Amenophis III. F. Kampp remarks that the scene of the sistrum-bearing girls cannot really be dated earlier than Amenophis III (see *Die Thebanische Nekropole zum Wandel des Grabgedankens von der XVIII. bis zur XX. Dynastie* [Mainz: 1996], p. 294), but the source for her argument is the same circular logic cited at the beginning of this note (with the exception that Kampp [p. 294] refers to cartouches in TT 78 that are no longer visible [see Annelies and Artur Brack, *Das Grab des Haremhab: Theben Nr. 78* (Mainz, 1980), pl. 56 contra pl. 88] and falsely assigns the article on tomb decoration to Bermann instead of Kozloff).

 The decoration itself is also part of this argument. The scene of the judgment of the dead in Menna's tomb is among the earliest in the Theban necropolis. Only in the tomb of the military official Horemhab (TT 78), who is not the general who later became pharaoh, is there a similarly early version. The inscriptions and titles in that Horemhab's tomb suggest that the decoration in the passage (where the judgment scene was placed) was added during the reign of Amenophis III. This Horemhab served Amenophis II and III, as well as Tuthmosis IV, who reigned between them (see Brask and Brack, *Das Grab des Haremhab*, p. 83.). There is no way of dating the judgment scene within the reign of Amenophis III, as the Bracks' logic for a later date depends on the bold assumption that private tombs were dependent upon royal resources (p. 84). This scene could therefore date to any time in the reign of Amenophis III, but its date within that reign can be taken as certain. On the other hand, Horemhab already enjoyed high status during the reign of Tuthmosis IV, and Amenophis III is not mentioned in the transverse hall, underlining that the passage was the last part of the tomb completed and suggesting that this occurred at the beginning of the reign of Amenophis III.

3. Kampp (*Nekropole*, pp. 292–294) also argues that Menna's tomb is oriented northeast-southwest because both tomb and courtyard may have had—hypothetically—to avoid the existing tomb of Mery-Ptah (TT 68). The High Priest of Amun, Mery-Ptah, can be firmly dated to the reign of Amenophis III, as he is mentioned by name on a statue of Nebnefer dating to Amenophis III year 20. He could have held the office earlier, and thus the tomb could date to early in the reign (see Karl-Joachim Seyfried, *Das Grab des Paenkhemenu (TT 68) und die Anlage TT 227* [Mainz: Theben VI, 1991], p. 116). It is not clear, however, why the arrangement of Menna's tomb and courtyard must be ascribed to the presence of earlier tombs (see Kampp, *Nekropole*, Plan III, G4), and Kampp's tentative remark (*Nekropole*, p. 294, n. 1) suggests that ultimately her interpretation of the orientation is the basis for the dating, which amounts to circular logic once again.

4. Jan Assmann, *Sonnenhymnen in Thebanischen Gräbern* (Mainz, 1983), p. 138. The first lines are damaged, but Jan Assmann has proposed restorations.

5. *Urk.* IV: 1607, 16–1608, 2.
6. Siegfried Schott, *Das schöne Fest vom Wüstentale: Festbräuche einer Totenstadt* (Wiesbaden, 1953), p. 69, fig. 43, and pp. 41–44.
7. See Waltraud Guglielmi, *Reden, Rufe und Lieder auf altägyptischen Darstellungen der Landwirtschaft, Viehzucht, des Fisch- und Vogelfangs vom Mittleren Reich bis zur Spätzeit* (Bonn: 1973).
8. For the Egyptian calendar, see Richard A. Parker, *The Calendars of Ancient Egypt* (Chicago, 1950), and Jürgen von Beckerath, *Chronologie des pharaonischen Ägypten* (Mainz, 1997), pp. 7–9. The Egyptian year had three seasons with 4 months of 30 days each: *Akhet* (Inundation), *Peret* (Winter), *Shemu* (Harvest). These seasons moved around the calendar year because the Egyptian civil calendar lacked the quarter-day required to keep up the solar rhythm, although it did have 5 additional days. To prevent the civil calendar from disturbing the agricultural calendar, the beginning of the agricultural year was determined as coinciding with the beginning of the inundation, when Sirius reappeared above the horizon, roughly on 19 July of each year.
9. Wolfgang Helck, *Zur Verwaltung des Mittleren und Neuen Reichs* (Leiden, 1958), p. 139; Paul C. Smither, "A Tax Assessor's Journal of the Middle Kingdom," *JEA* 27 (1941): 74.
10. This version is from P. Sallier I, published by Sir Alan H. Gardiner, *Late-Egyptian Miscellanies* (Brussels, 1937), p. 83, and translated by Ricardo A. Caminos, *Late-Egyptian Miscellanies* (London, 1954), pp. 315–316.
11. Hermann te Velde, *Seth, God of Confusion* (Leiden, 1976); Hermann te Velde, "Seth," *LÄ* V: 908–911; Hans Bonnet, *Reallexikon der ägyptischen Religionsgeschichte* (Berlin, 1952), pp. 702–715.
12. Helck, *Verwaltung,* pp. 138–139; see the tomb of Rekhmire, *Urk* IV: 1111, 8–13.
13. *Urk.* IV: 1608, 14–1609, 4.
14. Schott, *Das schöne Fest,* pp. 20–27, esp. p. 24.
15. Schott, *Das schöne Fest,* p. 106.
16. See Jan Assmann, *Ma'at: Gerechtigkeit und Unsterblichkeit im Alten Ägypten* (Munich, 1990), pp. 122–159; Jan Assmann, *Maât: l'Égypte pharaonique et l'idée de justice sociale* (Paris, 1989), pp. 74–85; Christine Seeber, *Untersuchungen zur Darstellung des Totengerichts im Alten Ägypten* (Berlin, 1976), pp. 16–18; Christine Seeber, "Jenseitsgericht," *LÄ* III: 249–252.
17. See Mohamed Saleh, *Das Totenbuch in den Thebanischen Beamtengräbern des Neuen Reiches* (Mainz, 1984), p. 63.
18. See Joachim Boessneck, *Die Tierwelt des Alten Ägypten* (Munich, 1988), pp. 49–50, and Patrick F. Houlihan, *The Birds of Ancient Egypt* (Cairo, 1988), for the egret (pp. 16–18), the glossy ibis (pp. 26–27), and the goose (pp. 62–65), which appear in this scene.
19. See Boessneck, *Tierwelt,* p. 50.
20. See Eberhard Otto, *Das ägyptische Mundöffnungsritual* (Wiesbaden, 1960).

Sennefer

1. For the tomb, see Eva and Arne Eggebrecht (eds.), *Ägyptens Aufstieg zur Weltmacht* (Mainz, 1987), pp. 66–99; Philippe Virey, "Le tombeau des vignes à Thebes," *RT* 20 (1898): 212–223; 21 (1899): 127–133, 137–149; 22 (1900): 83–97, and Christiane Desroches Noblecourt, Michel Duc, Eva Eggebrecht, Fathy Hassanein, Marcel Kurz, and Monique Nelson, *Reconstitution du caveau de Sennefer dit "Tombe aux Vignes"* (Paris, 1985); = Christiane Desroches Noblecourt, Michel Duc, Eva Eggebrecht, Fathy Hassanein,

Marcel Kurz, and Monique Nelson, *Sen-nefer: Die Grabkammer des Bürgermeisters von Theben* (Mainz, 1986). For the person of the tomb-owner, see Desroches Noblecourt, *Sen-nefer*, German edition, pp. 15–22; Eggebrecht, *Aufstieg*, pp. 61–65; and Wolfgang Helck, *Zur Verwaltung des Mittleren und Neuen Reichs* (Leiden, 1958), pp. 423–424.

2. For some possibilities, see Eggebrecht, *Aufstieg*, pp. 61–64, and Desroches Noblecourt, *Sen-nefer*, p. 22. [Others have been added by the translator. Trans.]

3. See Eggebrecht, *Aufstieg*, p. 81, and Desroches Noblecourt, *Sen-nefer*, p. 14.

4. *Urk.* IV: 1425, 10–1426, 2.

5. Eggebrecht, *Aufstieg*, p. 72 and fig. 2, as well as pp. 32–35.

6. Karl-Joachim Seyfried, "Zweiter Vorbericht über die Arbeiten des Ägyptologischen Instituts der Universität Heidelberg in thebanischen Gräbern der Ramessidenzeit," *MDAIK* 40 (1984): 268.

7. See Paule Posener-Kriéger, "Wag-Fest," *LÄ* VI: 1135–1139; Christine Meyer, "Wein," *LÄ* VI: 1169–1182.

8. Hans Bonnet, *Reallexikon der Ägyptischen Religionsgeschichte* (Berlin, 1952), pp. 296–297; Alexandre Piankoff, *Le "Coeur" dans les textes Égyptiens depuis l'Ancien jusqu'à la fin du Nouvel Empire* (Paris, 1930); Helmut Brunner, "Das Herz im ägyptischen Glauben," in *Das Herz im Umkreis des Glaubens* (Biberach, 1965) I: 81–106; Helmut Brunner, "Herz," *LÄ* II: 1158–1168.

9. For the *imiut*, see Ursula Köhler, *Das Imiut: Untersuchungen zur Darstellung und Bedeutung eines mit Anubis verbundenen religiösen Symbols.* (Göttingen, 1975). For the cemeteries, see Barry Kemp, "Abydos," *LÄ* I: 28–41, and Christiane M. Coche-Zivie, "Ro-setau," *LÄ* V:303–309.

10. See Brigitte Altenmüller, "Anubis," *LÄ* I: 327–333; Bonnet, *Reallexikon,* pp. 40–45.

11. Eggebrecht, *Aufstieg*, p. 81.

12. See Emma Brunner-Traut, "Lotos," *LÄ* III: 1091–1096

13. See infra, pp. 164–168; Hartwig Altenmüller, "Butisches Begräbnis," *LÄ* I: 887; Hermann Junker, "Der Tanz der *Muw* und das Butische Begräbnis im Alten Reich," *MDAIK* 9 (1940): 1–39; Jürgen Settgast, *Untersuchungen zu altägyptischen Bestattungsdarstellungen* (Glückstadt, 1963), p. 50.

14. Edgar B. Pusch, "Senet," *Lexikon der Ägyptologie* V: 851–856; Edgar B. Pusch, *Das Senet-Brettspiel im alten Ägypten* (Berlin, 1979).

15. Christa Müller, "Spiegel," *LÄ* V:1147–1150.

16. Hartwig Altenmüller, "Abydosfahrt," *LÄ* I: 42–47; Hermann Kees, *Totenglauben und Jenseitsvorstellungen der alten Ägypter, Grundlagen und Entwicklung bis zum Ende des Mittleren Reiches* (Berlin, 1956), pp. 232–235.

17. See Raymond O. Faulkner, *The Ancient Egyptian Book of the Dead* (London, 1985), pp. 145–149; Erik Hornung, *The Valley of the Kings: Horizon of Eternity* (New York, 1990), p. 194; Mohamed Saleh, *Das Totenbuch in den Thebanischen Beamtengräbern des Neuen Reiches* (Mainz, 1984), p. 84.

18. Faulkner, *Book of the Dead*, p. 14.

19. Spell 137A of the Book of the Dead deals extensively with torches; see Faulkner, *Book of the Dead*, pp. 127–130.

20. See Mattieu Heerma van Voss, "Egyptische magische tichels," *Handelingen van het Negenentwintigste Nederlands Filologencongres* (Groningen, 1966), p. 198, and Mattieu Heerma van Voss, "An Egyptian Magical Brick," *Jaarbericht van het Voor
aziatisch-Egyptisch Genootschap "Ex Oriente Lux"* VI/18 (1965): 314–316.

21. Desroches Noblecourt, *Sen-nefer*, p. 67.

22. See Friederike Kampp, *Die Thebanische Nekropole: Zum Wandel des Grabgedankens von der XVIII. bis zur XX. Dynastie* (Mainz, 1996), p. 89.
23. Faulkner, *Book of the Dead*, pp. 145–148. For the *djed*-pillar, see Jacques van der Vliet, "Raising the djed: A rite de marge," in Sylvia Schoske (ed.), *Akten des Vierten Internationalen Ägyptologen Kongresses München 1985* (Hamburg, 1989), III: 405–411.
24. Bettina Schmitz, "Sem(priester)," *LÄ* V: 833–836.
25. *Urk.* IV: 1425, 3–6.
26. Bonnet, *Reallexikon*, pp. 698–699; Ursula Rössler-Köhler, "Sepa," *LÄ* V: 859–863; Hermann Kees, "Anubis 'Herr von Sepa' und der 18. oberägyptische Gau," *ZÄS* 58 (1923): 79–101, esp. 82–90.
27. Lászlo Kákosy, "Ischedbaum" *LÄ* III: 182–184; Bonnet, *Reallexikon*, pp. 83–85.
28. Bonnet, *Reallexikon*, pp. 854–856; Carol Andrews, *Amulets of Ancient Egypt* (London, 1994), pp. 43–44; Claudia Müller-Winkler, "Udjatauge," *Lexikon der Ägyptologie* VI: 824–826.
29. Renate Germer, *Flora des pharaonischen Ägypten* (Mainz, 1985), pp. 169–171.

Rekhmire

1. Norman de Garis Davies, *The Tomb of Rekh-mi-Re' at Thebes*, 2 vols. (New York, 1943).
2. Wolfgang Helck, *Zur Verwaltung des Mittleren und Neuen Reichs* (Leiden, 1958), pp. 294–295.
3. Helck, *Verwaltung*, pp. 294–295.
4. Davies, *Rekh-mi-Re'*, 1:4ff.
5. *Urk.* IV: 1072,10–1082, 13 (excerpts, translation following A. H. Gardiner in Davies, *Rekh-mi-Re'*, I: 79–82). See also T.G.H. James, *Pharaoh's People* (London, 1984).
6. *Urk.* IV: 1087, 6–1091, 5 (excerpts, translation following A. H. Gardiner in Davies, *Rekh-mi-Re'*, I: 86–87).
7. *Urk.* IV: 1105, 2–10. For an exhaustive discussion and translation of the complete text, see G.P.F. van den Boorn, *The Duties of the Vizier: Civil Administration in the Early New Kingdom* (London, 1988).
8. *Urk.* IV: 1112, 9–1113,7.
9. *Urk.* IV: 1119, 16–1120,5.
10. *Urk.* IV: 1129, 3.
11. For the animals, see Joachim Boessneck, *Die Tierwelt des Alten Ägypten* (Munich, 1988), p. 52.
12. Egyptologists usually agree that the term *wadj-wer*, "Great Green," can designate large bodies of water, such as the Red Sea and Lake Moëris; in this case it evidently means Mediterranean. For a different opinion, see Alessandra Nibbi, *The Sea Peoples: A Reexamination of the Egyptian Sources* (Oxford, 1972).
13. See, e.g., Hans-Günther Buchholz and Vassos Karageorghis, *Altägäis und Altkypros* (Tübingen, 1971), nos. 920, 960–964, 1088, 1238–1241, 1629.
14. The conclusions correspond to those summarized by Wolfgang Helck (*Die Beziehungen Ägyptens und Vorderasiens zur Ägäis bis ins 7. Jahrhundert v. Chr.* [Darmstadt, 1979], pp. 51–52), the dates being those of the currently recognized chronology assigning Tuthmosis III's accession to the throne to the year 1479 B.C. (see Jürgen von Beckerath, *Chronologie des pharaonischen Ägypten* [Mainz, 1997], pp. 108–111). Jean Vercoutter (*L'Égypte et le Monde Égéen préhellénique* [Cairo, 1951], pp. 211–223, 243–256, 397–414) took a more conservative and balanced approach to the sources, concluding that the change

of the kilts signified the first appearance of the Myceneans, but not necessarily their conquest of Crete. The people of Crete were textually identified during the reign of Tuthmosis III's successor but depicted in various ways, and thus the significance of the matter is uncertain (see Vercoutter, *L'Égypte*, pp. 223–229).

15. See *Urk.* IV: 1233, 16; Wolfgang Decker, *Die physische Leistung Pharaos* (Cologne, 1971), p. 53; Boessneck, *Tierwelt*, p. 53.

16. For Late Bronze Age trading vessels, see Geoge Bass, *Cape Gelidonya: A Bronze Age Shipwreck* (Philadelphia, 1967); George Bass, "Oldest Known Shipwreck," *National Geographic Magazine* 172 (December 1987): 692–733; George F. Bass, Cemal Pulak, Dominique Collon, and James Weinstein, "The Bronze Age Shipwreck at Ulu Burun," *American Journal of Archaeology* 93 (1989): 1–29.

17. User has two tombs in the Theban necropolis, one with very unusual royal decoration; see Eberhard Dziobek, *Die Gräber des Viziers User-Amun Theben Nr. 61 und 131* (Mainz, 1994).

18. See Boessneck, *Tierwelt*, pp. 35f.

19. See Hartwig Altenmüller, "Jagd," "Jagddarstellungen," "Jagdmethoden," *LÄ* III: 221–231.

20. *Urk.* IV: 1143: 8–14.

21. *Urk.* IV: 1140, 15–17.

22. TT 279, of Pabes. Apiculture was practiced by Dynasty V; see Elmar Edel, *Zu den Inschriften auf den Jahreszeitenreliefs der "Weltkammer" aus dem Sonnenheiligtum des Niuserre* (Göttingen, 1963), fig. 11 and pp. 177–179.

23. Wolfgang Helck, *Die Lehre des Dw³-htjj* (Wiesbaden, 1970), I: 39–45; see William Kelly Simpson, "The Satire on the Trades: The Instruction of Dua-Khety," in William Kelly Simpson (ed.), *The Literature of Ancient Egypt* (New Haven, 1973), p. 331.

24. Hermann Junker, *Weta und das Lederkunsthandwerk im Alten Reich* (Vienna, 1957), pp. 13–15.

25. T.G.H. James, *Pharaoh's People* (London, 1984) pp. 196–208.

26. *Urk.* IV: 1149, 8–11.

27. *Urk.* IV: 1149, 17–1150, 4.

28. See Bernd Scheel, "Studien zum Metallhandwerk im Alten Ägypten III," *SAK* 14 (1987): 247–264, esp. p. 260, n. 48, where the anvil and anvil block are not clearly distinguished.

29. See Bernd Scheel, "Studien zum Metallhandwerk im Alten Ägypten I," *SAK* 12 (1985): 117–177, esp. p. 135.

30. Diane Lee Caroll, "Löten," *LÄ* III: 1079–1080.

31. *Urk.* IV: 1150, 11–14

32. See Scheel, "Studien III," p. 259, and Hans Jüngst, "Zur Interpretation einiger Metallarbeiterszenen auf Wandbildern altägyptischer Gräber," *GM* 59 (1982): 15–27.

33. *Urk.* IV: 1153, 10–11.

34. For details, see Jürgen Settgast, *Untersuchungen zu den altägyptischen Bestattungsdarstellungen* (Glückstadt, 1963), and Hartwig Altenmüller, *Die Texte zum Begräbnisritual in den Pyramiden des Alten Reiches* (Wiesbaden, 1972).

35. Settgast, *Bestattungsdarstellungen*, p. 12.

36. Hermann Junker, "Der Tanz der *Mww* und das Butische Begräbnis im Alten Reich," *MDAIK* 9 (1940): 1–39, and Hartwig Altenmüller, "Zur Frage der *Mww*," *SAK* 2 (1975): 1–37.

37. Eberhard Otto, *Das ägyptische Mundöffnungsritual* (Wiesbaden, 1960).

38. Otto, *Mundöffnungsritual*, p. 26.

39. See Otto, *Mundöffnungsritual*, p. 10; Eberhard Otto, "Cheriheb," *LÄ* I: 940–943; Bettina Schmitz, "Sem(priester)," *LÄ* V: 833–836.

40. Otto (*Mundöffnungsritual*, pp. 16–26) discusses the tools at length.
41. *Urk.* IV: 1158, 15–16.
42. Beatrix Geßler-Löhr, "Die Totenfeier im Garten," in Jan Assmann (ed.), *Das Grab des Amenemope (TT 41)* (Mainz, 1991), pp. 162–183; Beatrix Geßler-Löhr, *Die heiligen Seen ägyptischer Tempel* (Hildesheim, 1983), pp. 106–107.
43. Geßler-Löhr ("Totenfeier") discusses the differences between the Theban and Memphite versions.
44. *Urk.* IV: 1162: 6–12.
45. *Urk.* IV: 1162, 15–1163, 5.
46. Siegfried Schott, *Das schöne Fest vom Wüstentale: Festbräuche einer Totenstadt* (Wiesbaden, 1953), p. 73.
47. *Urk.* IV: 1163, 11.
48. *Urk.* IV: 1163, 13–16.
49. Schott, *Das schöne Fest,* pp. 74–80.
50. *Urk.* IV: 1164, 5–6.
51. *Urk.* IV: 1164, 8–11.
52. *Urk.* IV: 1164, 13–14.
53. The rectangular drum actually looks like a washboard but is frequently mistaken for a lyre; for this and the harp, see Hans Hickmann, *Musikgeschichte in Bildern* (Leipzig, 1975), I, fasc. 2, p. 70.
54. *Urk.* IV: 1159, 10–1160, 14.
55. Helck, *Verwaltung,* pp. 293–296.

Neferhotep

1. Norman de Garis Davies, *The Tomb of Nefer-Hotep at Thebes,* 2 vols. (New York, 1933).
2. Jan Assmann, "Priorität und Interesse: Das Problem der Ramessidischen Beamtengräber," in Jan Assmann, Günter Burkard, and Vivian Davies (eds.), *Problems and Priorities in Egyptian Archaeology* (London, 1987), p. 39.
3. Restored version of Davies, *Nefer-Hotep,* pl. 36; Jan Assmann, *Ägyptische Hymnen und Gebete* (Zurich, 1975), pp. 177–178; Jan Assmann, *Sonnenhymnen in Thebanischen Gräbern* (Mainz, 1983), pp. 86–87.
4. See Ali Radwan, *Die Darstellungen des regierenden Königs und seiner Familienangehörigen in den Privatgräbern der 18. Dynastie* (Berlin, 1969), pp. 32, 86.
5. Barry Kemp (*Ancient Egypt: Anatomy of a Civilization* [London, 1989], p. 288) locates the "Window of Appearances" at the "King's House" in Amarna, i.e., in a palace and not a temple. Dieter Arnold ("Erscheinungsfenster," *LÄ* II: 14) and Rainer Stadelmann ("Tempelpalast und Erscheinungsfenster in den Thebanischen Totentempeln," *MDAIK* 29 [1973]: 221–242) assign it to the royal mortuary temples on the Theban west bank. Stadelmann's conclusion is partially based on the erroneous assumption that a certain statue must be assigned to the first courtyard of the Ramesseum (*MDAIK* 29: 228), although a statue of the same name is known from Piramesse, the residential city in the Delta (see P. Anastasi II, 1,6 = Alan Gardiner, *Late-Egyptian Miscellanies* [Brussels, 1937], p. 12; Ricardo Caminos, *Late-Egyptian Miscellanies* [Oxford, 1954], pp. 37, 39), which would provide a secular—and not a sacred—palace background for the "Window of Appearances," despite Stadelmann's claim to have demonstrated the opposite (*MDAIK* 29: 229).
6. The obelisks are a problem. On the one hand, it could be suggested that had the craftsmen shown the obelisks of Tuthmosis, this would have made it impossible to show the

open door, as the obelisks would have been immediately within. On the other hand, however, the absence of Hatshepsut's obelisks is striking; they could have been omitted because the activity prevented the obelisks from being shown, which would in turn imply that the decisive action must be shifted to between the III and IV pylons, which would suggest that the obelisk depicted was Tuthmosis III's, which was shifted slightly to the east to make room for the open door.

7. The Egyptian authorities prepared long and detailed lists of servants and slaves. William Hayes has edited a list of runaway slaves from the Middle Kingdom (*A Papyrus of the Late Middle Kingdom in the Brooklyn Museum* [New York, 1972]).

8. For the pair, see Erik Hornung, "Amenophis I," *LÄ* I: 201–203; Michel Gitton, "Ahmose Nofretere," *LÄ* I: 102–109; Franz-Jürgen Schmitz, *Amenophis I* (1978); Michel Gitton, *L'épouse du dieu Ahmes Néfertary: Documents sur sa vie et son culte posthume* (Besançon, 1975).

9. Konstantin Emil Sander-Hansen, *Das Gottesweib des Amun* (Copenhagen, 1940), pp. 13, 18–21.

10. See N. B. Millet, "A Representation of the Deir el-Bahri Hathor Shrines." *Bulletin of the Egyptological Seminar* 10 (1989/90): 95–100.

Kheruef

1. Mohamed Saleh, "Cheriuf," *LÄ* I: 943–944; Ahmed Fakhry, "A Note on the Tomb of Kheruef at Thebes," *ASAE* 42 (1943): 449–508; Epigraphic Survey and Department of Antiquities, *The Tomb of Kheruef: Theban Tomb 192* (Chicago, 1980).

2. Some scholars have alleged that Amenophis III and Akhenaten had a period of coregency, but this idea has been increasingly discarded in recent years, so that it may be assumed that Kheruef survived Amenophis III.

3. Hellmut Brunner, "Ein Bruchstück aus dem Grabe des Cheriuf," *ZÄS* 81 (1956): 59–60.

4. Karl Martin, "Sedfest," *LÄ* V: 782–790; Erik Hornung and Elisabeth Staehelin, *Studien zum Sedfest* (Geneva, 1974).

5. Jan Assmann, *Ägyptische Hymnen und Gebete* (Zurich, 1975), pp. 162–163; Jan Assmann, *Sonnenhymnen in Thebanischen Gräbern* (Mainz, 1983), pp. 248; Epigraphic Survey, *Kheruef*, pl. 7. Nun was the primeval ocean, and Naunet his female counterpart; together they are a quarter of the Heliopolitan Ogdoad.

6. Epigraphic Survey, *Kheruef*, pp. 35–37, pls. 14–15.

7. Walther Wolf, *Die Kunst Ägyptens: Gestalt und Geschichte* (Stuttgart, 1957), p. 502; Cyril Aldred, *Akhenaton—Pharaoh of Egypt* (London, 1968); Erik Hornung, *Echnaton: Die Religion des Lichts* (Zurich, 1995); Hermann Schlögl, *Amenophis IV, Echnaton* (Hamburg, 1986).

8. Hornung and Staehelin, *Sedfest*, pp. 73–79.

9. See Peter Kaplony, "Kiebitz(e)," *LÄ* III: 417–422.

10. See Wolfgang Helck, "Maat," *LÄ* III: 1110–1119; Jan Assmann, Ma'at: *Gerechtigkeit und Unsterblichkeit im alten Ägypten* (Munich, 1990), pp. 200–212.

11. Adapted from Edward Wente in Epigraphic Survey, *Kheruef*, pp. 45–46.

12. These are wrongly identified as Egyptian royal princesses in Kurt Lange and Max Hirmer, *Egypt: Architecture, Sculpture, Painting in Three Thousand Years* (London, 1968⁴), pls. 166–167 and p. 447.

13. Adapted from Edward Wente in Epigraphic Survey, *Kheruef*, p. 46.

14. Adapted from Edward Wente in Epigraphic Survey, *Kheruef*, p. 48.

15. See Fakhry, "Kheruef," *ASAE* 42: 500; Christine Seeber, "Maske," *LÄ* III: 1196–1199.

16. Dominique Valbelle, *Les Neuf Arcs: L'Égyptien et les étrangers de la préhistoire à la conquête d'Alexandre* (Paris, 1990); Dietrich Wildung, "Neunbogen," *LÄ* IV: 472–473; Jean Vercoutter, "Les Haou-Nebout," *BIFAO* 46 (1947): 125–158, and *BIFAO* 48 (1949): 107–209

17. See Raphael Giveon, "Skarabäus," *LÄ* V: 968–981; Hans Bonnet, "Skarabäus," *Reallexikon*, pp. 720–722; Othmar Keel, *Corpus der Stempelsiegel-Amulette aus Palästina/Israel: Von den Anfängen bis zur Perserzeit: Einleitung* (Fribourg, 1995).

18. Bonnet, "Dedpfeiler," *Reallexikon*, pp. 149–153; Hartwig Altenmüller, "Djed-Pfeiler," *LÄ* I: 1100–1105; C. J. Bleeker, *Egyptian Festivals: Enactments of Religious Renewal* (Leiden, 1967), pp. 116–117.

Samut

1. Muhammed Abdul-Qader, "Two Theban Tombs: Kyky and Bak-en-Amun," *ASAE* 59 (1966): 161–184. Maged Negm, *The Tomb of Simut Called Kyky. Theban Tomb 409 at Qurnah* (Warminster 1997).

2. Jan Assmann, "Priorität und Interesse: Das Problem der Ramessidischen Beamtengräber," in Jan Assmann, Günter Burkard, and Vivian Davies (eds.), *Problems and Priorities in Egyptian Archaeology* (London, 1987), p. 35. Assmann terms this *Bilderstreifenstil*, "picture-strip style" which can almost be translated as "cartoon style"; he considers it to be a developed form of the tableaux used in the Amarna tombs.

3. Assmann, "Priorität," p. 36.

4. Mohamed Saleh, *Das Totenbuch in den Thebanischen Beamtengräbern des Neuen Reiches* (Mainz, 1984), 76–81; Spell 146, Raymond Faulkner, *The Ancient Egyptian Book of the Dead* (London, 1985), pp. 135–139.

5. Petra Barthelmess (*Der Übergang ins Jenseits in den thebanischen Beamtengräbern der Ramessidenzeit* [Heidelberg, 1992], pp. 91–92) discusses the significance of this act. Using earlier sources, she seeks to understand the use of a cultically pure calf's haunch in lieu of the usual haunch of beef as an indication of the former's greater capacity to secure vitality. The cow's pain would thus be related not to her offspring, but to an expression of sympathy with the wailing women attempting to reawaken the deceased.

6. Christine Seeber, *Untersuchungen zur Darstellung des Totengerichts im Alten Ägypten* (Berlin, 1976), pp. 157 and 97 n. 366

7. Seeber, *Totengericht*, pp. 93–98, esp. 96, and see Spells 21 and 22, Faulkner, *Book of the Dead*, p. 51.

8. Seeber, *Totengericht*, p. 97.

9. Seeber, *Totengericht*, p. 99.

10. Seeber, *Totengericht*, p. 160.

11. Adapted from John Wilson, "The Theban Tomb (No. 409) of Si-Mut, called Kiki," *JNES* 29 (1970): 190, following restorations by Jan Assmann, *Ägyptische Hymnen und Gebete* (Zurich, 1975), pp. 374–376.

12. Dietrich Wildung, "Flügelsonne," *LÄ* II: 277–279.

13. Edward Brovarski, "Sokar," *LÄ* V: 1055–1074; Hans Bonnet, *Reallexikon der ägyptischen Religionsgeschichte* (Berlin, 1952), pp. 723–727.

Deir el-Medineh

1. For a survey of life in the village and the workers themselves, including their religious beliefs and social structure, see Leonard Lesko (ed.), *Pharaoh's Workers: The Villagers*

of *Deir el-Medina* (Ithaca, 1994), but also Jaroslav Černý, *A Community of Workmen at Thebes in the Ramesside Period* (Cairo, 1973); Dominique Valbelle, *"Les Ouvriers de la Tombe," Deir el-Médineh à l'époque Ramesside* (Cairo, 1985); Jacobus J. Janssen, *Commodity Prices from the Ramessid Period* (Leiden, 1975); a popular account was published by John Romer (*Ancient Lives* [London, 1984]).

2. See Černý, *Community,* pp. 191–230; Jacobus J. Janssen, "Absence from Work by the Necropolis Workmen of Thebes," *SAK* 8 (1989): 127–152.

3. Janssen, "Absence from Work," pp. 135–150; see also Jaroslav Černý and Alan Gardiner, *Hieratic Ostraca* (Oxford, 1957), pls. 83, 84.

4. Aside from the documents cited in the next note, see Jac. J. Janssen and P. W. Pestman, "Burial and Inheritance in the Community of the Necropolis Workmen at Thebes," *JESHO* 11 (1968): 137–170; and Jaroslav Černý, "The Will of Naunakhte and the Related Documents," *JEA* 31 (1945): 29–53.

5. The ancient Egyptian text is preserved in the collections of three modern European museums: P. BM 5624, P. Berlin 10496, and O. Florence 2621; see Schafik Allam, *Hieratische Ostraka und Papyri aus der Ramessidenzeit* (Tübingen, 1973), pp. 43–45, 148–149, and 277–280; pls. 81 and 83; Wolfgang Helck, *Materialien zur Wirtschaftsgeschichte des Neuen Reiches: 5 Fascicles* (Mainz, 1961–1969), pp. 347–349; Aylward Blackman, "Oracles in Ancient Egypt," *JEA* 12 (1926): 167–181.

6. See Georg Steindorff and Walther Wolf, *Die Thebanische Gräberwelt* (Leipzig, 1936), pp. 55–59; Bernard Bruyère, *Fouilles de l'institut français d'archéologie orientale du Caire (Années 1922–1923), I: 1* (Cairo, 1924).

7. Mario Tosi, "La Capella di Maia," *Quaaderno del Museo Egizzio di Torio* 4 (1970), without page number.

8. Agnes Rammant-Peeters, *Les Pyramidions Égyptiens du Nouvel Empire* (Louvain, 1983).

9. Tosi, "Capella."

10. Mohamed Saleh, *Das Totenbuch in den Thebanischen Beamtengräbern des Neuen Reiches* (Mainz, 1984).

11. The former is the attitude of Emma Brunner-Traut (*Die Alten Ägypter* [Stuttgart, 1974], p. 204), the second that of Hans-Wolfgang Müller ("Relief und Malerei," in Jean Leclant [ed.], *Ägypten: Das Grossreich* [Munich, 1980], p. 141).

12. Janssen (*Commodity Prices,* pp. 533–538) has pointed out that they were quite middle class; Gerhard Fecht (*Literarische Zeugnisse zur "Persönlichen Frömmigkeit in Ägypten"* [Heidelberg, 1965]), that their letters betray a change in personal attitudes toward the gods and the divine.

13. See Ernesto Schiaparelli, *La Tomba intatta dell'architetto Cha nella necropoli di Tebe* (Turin, 1927).

Sennedjem

1. For the tomb and its discovery, see Bernard Bruyère, *La Tombe No. 1 de Sen-nedjem à Deir el Médineh* (Cairo, 1959); Gaston Maspero, "Rapport sur les fouilles et travaux exécutés en Égypte dans l'hiver de 1885–1886," *BIE* 7 (1886): 201–208; Abdel Gaffar Shedid, *Das Grab des Sennedjem: Ein Künstlergrab der 19. Dynastie in Deir el Medineh* (Mainz, 1994). For the contents of the tomb, see Mohammed Saleh and Hourig Sourouzian, *The Egyptian Museum Cairo: Official Catalogue* (Mainz, 1987), Nos. 215–219—the door is JdÉ 27303; William C. Hayes, *The Scepter of Egypt: A Background for the Study of the Egyptian Antiquities in the Metropolitan Museum of Art. Part II:*

The Hyksos Period and the New Kingdom (New York, 1978), 425–426, and p. 428 with fig. 274.

2. See Edgar Pusch, *Das Senet-Brettspiel im Alten Ägypten* (Berlin, 1979), pp. 103–105.

3. Raymond Faulkner (*The Ancient Egyptian Book of the Dead* [London, 1985], p. 44) and Erik Hornung (*Das Totenbuch der Ägypter* [Zurich, 1979], pp. 58, 422) agree that Spell 16 of the Book of the Dead did not really exist, as the vignette did not have an accompanying text and actually belonged to a solar hymn. Hornung has discussed the solar context at length in his comments (p. 422). Shedid, *Sennedjem*, pls. 56–67, shows a reconstruction of the interior and exterior of the entrance. While the door itself is in Cairo, parts are in the Anthropological Museum of the University of California at Los Angeles and in the magazines at Deir el-Medineh itself.

4. Faulkner, *Book of the Dead*, pp. 44–50; Mohamed Saleh, *Das Totenbuch in den Thebanischen Beamtengräbern des Neuen Reiches* (Mainz, 1984), pp. 19–22.

5. See Faulkner, *Book of the Dead*, pp. 58–60, for Spells 38A and 38B. Busiris was the main Lower Egyptian center for the worship of Osiris in the middle of the Delta.

6. [The Egyptians identified jackals as the guardians of the necropolis because the jackals would have torn apart any mummies that happened to have been exposed on the surface, and identifying them thus as guardians "magically" transformed their role from evil to good. Trans.]

7. See Saleh, *Totenbuch*, p. 90; Hornung, *Totenbuch*, pp. 405–406.

8. Saleh, *Totenbuch*, pp. 9–12, Faulkner, *Book of the Dead*, pp. 34–35,

9. Ursula Köhler, *Das Imiut, Untersuchungen zur Darstellung und Bedeutung eines mit Anubis verbundenen religiösen Symbols* (Göttingen, 1975).

10. Christine Seeber, *Untersuchungen zur Darstellung des Totengerichts im Alten Ägypten* (Berlin, 1976), pp. 58–62.

11. Seeber, *Totengericht*, p. 158; Bruyère, *Sen-nedjem*, p. 63.

12. Rolf Wassermann, "Schwalbe," *LÄ* V: 754–755.

13. See Faulkner, *Book of the Dead*, pp. 103–108 and 110–111; Saleh, *Totenbuch*, pp. 58–61; Hornung, *Totenbuch*, pp. 217, discusses the issue.

14. Saleh, *Totenbuch*, p. 60.

15. Eberhard Otto, *Das ägyptische Mundöffnungsritual* (Wiesbaden, 1960), II: 153–154.

16. See Faulkner, *Book of the Dead*, pp. 103–108; Saleh, *Totenbuch*, pp. 58–61.

17. For Coffin Texts Spells 464–468, see Hornung, *Totenbuch*, pp. 482–484; Raymond Faulkner, *The Ancient Egyptian Coffin Texts* (Warminster, 1977), II: 90–101.

18. See Faulkner, *Book of the Dead*, pp. 135–137; Saleh, *Totenbuch*, pp. 76–81; Hornung, *Totenbuch*, comments on Spell 145, pp. 503–504.

19. See Faulkner, *Book of the Dead*, p. 68; Saleh, *Totenbuch*, pp. 28–32.

20. See Faulkner, *Book of the Dead*, p. 123; Saleh, *Totenbuch*, pp. 72–74.

21. See Hornung, *Totenbuch*, pp. 262, 497. Hornung's comments suggest that it is possible that this concerns an eclipse of the solar disk by a new moon, rather than the moon itself.

22. László Kákosy, "Phönix," *LÄ* IV: 1030–1039; Faulkner, *Book of the Dead*, p. 98; Saleh, *Totenbuch*, p. 54.

23. See Faulkner, *Book of the Dead*, pp. 70–71; Saleh, *Totenbuch*, pp. 36–37.

24. Hans Bonnet, *Reallexikon der ägyptischen Religionsgeschichte* (Berlin, 1953), pp. 71–74; László Kákosy, "Atum," *LÄ* I: 550–552; Sigfried Morenz, *Egyptian Religion* (Ithaca, 1973), pp. 23–27, 162–163; Siegfried Morenz, *Ägyptische Religion* (Stuttgart, 1960), pp. 173–177; Hermann Kees, *Der Götterglaube im Alten Ägypten* (Leipzig, 1956), pp. 214–219.

25. Bonnet, *Reallexikon,* p. 715; Hartwig Altenmüller, "Hu I.-III.," *LA* III: 65–68; Morenz, *Egyptian Religion,* p. 165, and *Ägyptische Religion,* pp. 173–174.
26. Hornung, *Totenbuch,* pp. 225–226, 487.
27. Saleh, *Totenbuch,* p. 62.
28. Faulkner, *Book of the Dead,* pp. 101–102; Saleh, *Totenbuch,* p. 57.
29. Faulkner, *Book of the Dead,* pp. 108–109; Saleh, *Totenbuch,* p. 61.
30. Saleh, *Totenbuch,* pp. 57–58.
31. Faulkner, *Book of the Dead,* p. 102.

Inher-kha

1. Bernard Bruyère, *Rapport sur les fouilles de Deir el Medineh* (Cairo, 1933).
2. Carl Richard Lepsius, *Denkmäler aus Aegypten und Aethiopien: Text,* Eduard Naville, (ed.), (Leipzig, 1897–1913), III: 292, No. 108.
3. Wolfgang Helck, "Bukranion," *LÄ* I: 882–883.
4. *LD* III: 22 shows the entire scene as originally preserved.
5. Hans Bonnet, *Reallexikon der ägyptischen Religionsgeschichte* (Berlin, 1953), p. 211; Emma Brunner-Traut, "Geierhaube," *LÄ* II: 515.
6. Konstantin Emil Sander-Hansen, *Das Gottesweib des Amun* (Copenhagen, 1940), p. 18, n. 6.
7. Mohamed Saleh, *Das Totenbuch in den Thebanischen Beamtengräbern des Neuen Reiches* (Mainz, 1984), p. 93.
8. Edgar B. Pusch, *Das Senet-Brettspiel im Alten Ägypten* (Berlin, 1979), pp. 124–125. See p. 124.
9. *LD* III: 296, Berlin Inv-Nos. 2060 and 2061. [Shortly before these lines were translated, the Egyptological collection in the former East Berlin Bode Museum (where the pair was on display) was closed, and it will not be reopened there. Some of the objects will be temporarily on display in Charlottenburg until the Berlin Museum collections are reunited on the Museum Island. Trans.]
10. Saleh, *Totenbuch,* p. 48; Raymond Faulkner, *The Ancient Egyptian Book of the Dead* (London, 1985), pp. 82–83.
11. Spell 82; Saleh, *Totenbuch,* p. 45; Faulkner, *Book of the Dead,* p. 80.
12. Spell 42; Saleh, *Totenbuch,* p. 27; Faulkner, *Book of the Dead,* p. 62.
13. Spell 86; Saleh, *Totenbuch,* p. 49; Faulkner, *Book of the Dead,* p. 83.
14. Spell 17; see pp. 247–248; Saleh, *Totenbuch,* pp. 14–22; Faulkner, *Book of the Dead,* pp. 44–50; Ursula Rössler-Köhler, *Kapitel 17 des Ägyptischen Totenbuches* (Göttingen, 1979).
15. Saleh, *Totenbuch,* p. 18.
16. *LD* III: 300, referring to "Hathor."
17. Saleh, *Totenbuch,* p. 49.
18. Bonnet, *Reallexikon,* pp. 681–684; Lothar Störk, "Schlange," *LÄ* V: 644–652.
19. Saleh, *Totenbuch,* p. 24.
20. Spell 105; Saleh, *Totenbuch,* pp. 55–56; Faulkner, *Book of the Dead,* p. 101.
21. Saleh, *Totenbuch,* p. 55; Faulkner, *Book of the Dead,* p. 101.
22. Saleh, *Totenbuch,* p. 93.
23. Eberhard Otto, *Das ägyptische Mundöffnungsritual* (Wiesbaden, 1960), II: 19.
24. Bruyère, *Rapport* (1933), p. 56.
25. Bruyère, *Rapport* (1933), p. 57 ("sycamore figs").

26. Saleh, *Totenbuch*, p. 36. [A misprint in Saleh's book gives 34 and 44. Trans.]
27. Saleh, *Totenbuch*, p. 91.
28. Spells 76 and 30B: Saleh, *Totenbuch*, p. 40; Faulkner, *Book of the Dead*, pp. 53, 56–57, 73.
29. Saleh, Totenbuch, pp. 63–71.
30. Eduard Naville (ed.), with Ludwig Borchardt and Kurt Sethe, *Denkmaeler aus Aegypten und Aethiopien* (Carl R. Lepsius, ed.), Textband III: Theben (Berlin, 1900), p. 299; at that time the lake of fire and the text were clearly visible.
31. Spell 136B, Saleh, *Totenbuch*, p. 74; Faulkner, *Book of the Dead*, pp. 126–127.
32. Spell 149, Saleh, *Totenbuch*, p. 83; Faulkner, *Book of the Dead*, pp. 137–145.
33. The vignette belongs to Spells 81A and 81B "being transformed into a lotus blossom"; see Saleh, *Totenbuch*, pp. 45; Faulkner, *Book of the Dead*, p. 79.
34. Erik Hornung, *Conceptions of God in Ancient Egypt: The One and the Many* (Ithaca, 1982), pp. 69–74; see Elske Marie Wolf-Brinkmann, *Versuch einer Deutung des Begriffes "b3" anhand der Überlieferung der Frühzeit und des Alten Reiches* (Freiburg, 1968), p. 64.
35. László Kákosy, "Phönix," *LÄ* IV: 1030–1039; Bonnet, *Reallexikon*, pp. 594–596.
36. Saleh, *Totenbuch*, p. 46.
37. See Otto, *Mundöffnungsritual*.
38. Saleh, *Totenbuch*, p. 25.
39. Spell 77; Saleh, *Totenbuch*, p. 40.
40. Eberhard Otto, "Die Ätiologie des grossen Katers von Heliopolis," *ZÄS* 81 (1956): 65–66; Bonnet, *Reallexikon*, p. 371.
41. In the *Amduat* in particular, which is vividly painted on the walls of the tombs of Tuthmosis III and his son Amenophis II in the Valley of the Kings; see Erik Hornung, *Die Unterweltsbücher der Ägypter*, 3rd ed. (Zurich, 1989), pp. 128–139.
42. Saleh, *Totenbuch*, p. 19.
43. Spells 153A and 153B: Dino Bidoli, *Die Sprüche der Fangnetze in den altägyptischen Sargtexten* (Mainz, 1976); Saleh, *Totenbuch*, p. 85; Faulkner, *Book of the Dead*, pp. 149–152.
44. Hans Hickmann, *Ägypten* (Leipzig, 1975), p. 128, fig. 96.
45. For reflections on the meaning of the songs, see Jan Assmann, "Fest des Augenblicks—Verheissung der Dauer: Die Kontroverse der ägyptischen Harfnerlieder," in Jan Assmann, Erika Feucht, and Reinhard Grieshammer (eds.), *Fragen an die altägyptische Literatur: Studien zum Gedenken an Eberhard Otto* (Wiesbaden 1977), pp. 55–84.
46. Bruyère, *Rapport 1930*, pl. 23; see Miriam Lichtheim, "Songs of the Harpers," *JNES* 4 (1945): 201.

Selected Bibliography

Abbreviations used in the bibliography appear in the list of abbreviations that precedes the notes.

Abdul-Qader, Muhammed. "Two Theban Tombs: Kyky and Bak-en-Amun," *ASAE* 59 (1966): 161–184.

Abu Bakr, Abdel Moneim. *Untersuchungen über die altägyptischen Kronen*. Glückstadt, 1937.

Allam, Schafik. *Hieratische Ostraka und Papyri aus der Ramessidenzeit*. Tübingen, 1973.

Altenmüller, Hartwig. *Die Texte zum Begräbnisritual in den Pyramiden des Alten Reiches*. Wiesbaden: ÄA 24, 1972.

Altenmüller, Hartwig. "Zur Frage der *Mww*," *SAK* 2 (1975): 1–37.

Assmann, Jan. *Ägyptische Hymnen und Gebete*. Zurich, 1975.

——. "Flachbildkunst des neuen Reiches." in Claude Vandersleyen (ed.), *Das Alte Ägypten*. Berlin: PKG 15, 1975.

——. *Zeit und Ewigkeit im Alten Ägypten*. Heidelberg: AHAW, 1975.

——. "Fest des Augenblicks—Verheissung der Dauer: Die Kontroverse der ägyptischen Harfnerlieder." In Jan Assmann, Erika Feucht, and Reinhard Grieshammer (eds.), *Fragen an die altägyptische Literatur: Studien zum Gedenken an Eberhard Otto*. Wiesbaden, 1977.

——. *Ägypten, Theologie, und Frömmigkeit einer frühen Hochkultur*. Stuttgart, 1984.

——. "Das Grab mit gewundenem Abstieg." *MDAIK* 40 (1984): 277–290.

——. "Priorität und Interesse: Das Problem der Ramessidischen Beamtengräber." In Jan Assmann, Günter Burkard, and Vivian Davies (eds.), *Problems and Priorities in Egyptian Archaeology*. London, 1987.

——. *Sonnenhymnen in Thebanischen Gräbern*. Mainz: Theben 1, 1987.

——. *Maât: l'Égypte pharaonique et l'idée de justice sociale*. Paris, 1989.

——. "Der schöne Tag—Sinnlichkeit und Vergänglichkeit im altägyptischen Fest." In Walter Haug and Rainer Warning (eds.), *Das Fest, Poetik und Hermeneutik* XIV. Munich, 1989.

——. *Ma'at: Gerechtigkeit und Unsterblichkeit im Alten Ägypten*. Munich, 1990.

Baer, Klaus. "The Low Price of Land in Ancient Egypt." *Journal of the American Research Center in Egypt* 1 (1962): 25–45.

Baines, John. "Color Terminology and Color Classification: Ancient Egyptian Color Terminology and Polychromy." *American Anthropologist* 87 (1985): 282–297.

——. "Society, Morality, and Religious Practice." In Byron E. Shafer (ed.), *Religion in Ancient Egypt: Gods, Myths, and Personal Practice*. London, 1991.

Barthelmess, Petra. *Der Übergang ins Jenseits in den thebanischen Beamtengräbern der Ramessidenzeit*. Heidelberg: SAGA 2, 1992.

Beckerath, Jürgen von. *Chronologie des pharaonischen Ägypten*. Mainz: MÄS 46, 1997.

Beinlich-Seeber, Christine, and Abdel Ghaffar Shedid. *Das Grab des Userhat (TT56)*. Mainz: AV 50, 1987.

Bidoli, Dino. *Die Sprüche der Fangnetze in den altägyptischen Sargtexten*. ADAIK 9. Glückstadt: 1976.

Bleeker, C. J. *Egyptian Festivals: Enactments of Religious Renewal*. Leiden, 1967.

Boessneck, Joachim. *Die Tierwelt des Alten Ägypten*. Munich, 1988.

Bonnet, Hans. *Reallexikon der ägyptischen Religionsgeschichte*. Berlin, 1952.

Brack, Artur, and Annelies Brack. *Das Grab des Haremhab: Theben Nr. 78*. Mainz: AV 3, 1980.

Brunner, Hellmut. "Ein Bruchstück aus dem Grabe des Cheriuf." *ZÄS* 81 (1956): 59.

——. *Altägyptische Erziehung*. Wiesbaden, 1957.

——. "Das Herz im ägyptischen Glauben," In *Das Herz im Umkreis des Glaubens*. Biberach, 1965.

Brunner, Hellmut. *Altägyptische Weisheit*. Zürich, 1988.

Brunner-Traut, Emma. "Aspective." In Heinrich Schäfer (Emma Brunner-Traut [ed.], J. Baines [trans.]), *Principles of Egyptian Art*. Oxford, 1976.

——. *Die alten Ägypter*. Stuttgart, 1981.

——. *Frühformen des Erkennens, am Beispiel Altägyptens*. Darmstadt, 1990.

Bruyère, Bernard. *Rapport sur les fouilles de Deir el Medineh, 1922–23*. Cairo: FIFAO I,1, 1924.

——. *Rapport sur les fouilles de Deir el Medineh*. Cairo: FIFAO VIII, 3, 1933.

——. *La Tombe No. 1 de Sen-nedjem à Deir el Medineh*. Cairo: MIFAO 88 and 89, 1959.

Buchholz, Hans-Günther, and Vassos Karageorghis. *Altägäis und Altkypros*. Tübingen, 1971.

Caminos, Ricardo (trans.). *Late-Egyptian Miscellanies*. London, 1954.

Campbell, Colin. *Two Theban Princes*. Edinburgh, 1910.

Capel, Anne K., and Glenn E. Markoe (eds.). *Mistress of the House, Mistress of Heaven: Women in Ancient Egypt*. Cincinnati, 1996.

Černý, Jaroslav. *A Community of Workmen at Thebes in the Ramesside Period*. Cairo: BdÉ 50, 1973.

——. *The Valley of the Kings*, Cairo: BdÉ 51, 1973.

Černý, Jaroslav, and Alan H. Gardiner. *Hieratic Ostraca*. Vol. I. Oxford, 1957.

Davies, Nina de Garis. "Some Representations of Tombs from the Theban Necropolis." *JEA* 24 (1938): 27–40.

Davies, Norman de Garis. *Five Theban Tombs*. London: ASE 21, 1913.

——. *The Tomb of Nakht at Thebes*. New York: PMMA–RPTMS 1, 1917.

——. *The Tomb of Nefer—Hotep at Thebes*. 2 vols. New York: PMMA 9, 1933.

——. *The Tomb of the Vizier Ramose*. New York: MET I, 1941.

——. *The Tomb of Rekh-mi-Re' at Thebes*. 2 vols. New York: PMMA 11, 1943.

Davies, Norman de Garis, and Laming M. F. Macadam. *A Corpus of Inscribed Egyptian Funerary Cones*. Oxford, 1957.

Derchain, Philippe. "La mort ravisseuse." *CdÉ* 33 (1958): 29–32.

Desroches Noblecourt, Christiane, Michel Duc, Eva Eggebrecht, Fathy Hassanein, Marcel Kurz, and Monique Nelson, *Reconstitution du caveau de Sennefer dit "Tombe aux Vignes."* Paris, 1985.

Desroches Noblecourt, Christiane, Michel Duc, Eva Eggebrecht, Fathy Hassanein, Marcel Kurz, and Monique Nelson, *Sen-nefer: Die Grabkammer des Bürgermeisters von Theben.* Mainz, 1986.

Dittmar, Johanna. *Blumen und Blumensträusse als Opfergabe im alten Ägypten.* Berlin: MÄS 43, 1986.

Dodson, Aidan. *The Canopic Equipment of the Kings of Egypt.* London, 1994.

Dziobek, Eberhard. "Eine Grabpyramide des frühen NR in Theben." *MDAIK* 45 (1989): 109–132.

Edel, Elmar. *Zu den Inschriften auf den Jahreszeitenreliefs der "Weltenkammer" aus dem Sonnenheiligtum des Niuserre. II. Teil.* Göttingen: NAWG No. 5, 1963.

Epigraphic Survey and Department of Antiquities. *The Tomb of Kheruef: Theban Tomb 192.* Chicago: OIP 102, 1980.

Erman, Adolf. "Beiträge zur ägyptischen Religion." Berlin: 1916.

Erman, Adolf, and Hermann Ranke. *ägypten und Ägyptisches Leben.* Tübingen, 1923; Hildesheim, 1977. Cf. p. 267.

Fakhry, Ahmed. "A Note on the Tomb of Kheruef at Thebes." *ASAE* 42 (1943): 449–508.

Faulkner, Raymond. *The Ancient Egyptian Coffin Texts.* 3 vols. Warminster, 1973–1978.

——. *The Ancient Egyptian Book of the Dead.* C. Andrews (ed.), R. O. Faulkner (trans.). London, 1985.

Faulkner, Raymond O. "The Teaching for Merikare." In William Kelly Simpson (ed.), *The Literature of Ancient Egypt.* New Haven, 1972.

Fecht, Gerhard. *Literarische Zeugnisse zur "Persönlichen Frömmigkeit in Ägypten."* Heidelberg: AHAW 1965, 1.

Foster, John L. "Thought Couplets and Clause Sequences in a Literary Text: The Maxims of Ptah-Hotep," *JSSEA* 5 (1977).

Fox, Michael V. "The Entertainment Song Genre in Egyptian Literature." In Sarah Israelit-Groll (ed.), *Egyptological Studies* (Jerusalem 1982): 268–312.

Frandsen, Paul John. "Trade and Cult." In Gertie Englund (ed.), *The Religion of the Ancient Egyptians: Cognitive Structures and Popular Expressions.* Uppsala: Boreas 20, 1989.

Gardiner, Alan H. "The Autobiography of Rekhmere," *ZÄS* 60 (1925): 62–76.

——. *Late-Egyptian Miscellanies.* Brussels: BAe 7, 1937.

——. *Egypt of the Pharaohs.* Oxford, 1961.

George, Beate. *Zu den altägyptischen Vorstellungen vom Schatten als Seele.* Bonn, 1970.

Germer, Renate. *Flora des pharaonischen Ägypten.* Mainz, 1985.

Geßler-Löhr, Beatrix. *Die heiligen Seen ägyptischer Tempel.* Hildesheim: HÄB 21, 1983.

——. "Die Totenfeier im Garten." In Jan Assmann (ed.), *Das Grab des Amenemope (TT 41).* Mainz: Theben III, 1991.

Gitton, Michel. *L'épouse du dieu Ahmes Néfertary: Documents sur sa vie et son culte posthume.* Besançon: Annales littéraires de l'Université de Besançon, 172, 1981.

Grapow, Hermann. "Der Tod als Räuber." *ZÄS* 72 (1936): 76–77.

Greven, Liselotte. *Der Ka in Theologie und Königskult der Ägypter des Alten Reiches.* Hamburg: ÄF 17, 1952.

Groom, Nigel. *Frankincense and Myrrh: A Study of the Arabian Incense Trade.* London, 1981.

Guglielmi, Waltraud. *Reden, Rufe und Lieder auf altägyptischen Darstellungen der Landwirtschaft, Viehzucht, des Fisch- und Vogelfangs vom Mittleren Reich bis zur Spätzeit.* Bonn: TÄB 1, 1973.

Gundlach, Rolf. "Das Grab des Sennefer." In Eva and Arne Eggebrecht (eds.), *Ägyptens Aufstieg zur Weltmacht,* pp. 56–83. Hildesheim, 1987.

Habachi, Labib. "Varia from the Reign of King Akhenaten," *MDAIK* 20 (1965): 70–97.

Harris, John R. *Lexicographical Studies in Ancient Egyptian Minerals*. Berlin: VIO 54, 1961.

Hayes, William C. *A Papyrus of the Late Middle Kingdom in the Brooklyn Museum: Edited with Translation and Commentary*. New York, 1972.

——. *The Scepter of Egypt: A Background for the Study of the Egyptian Antiquities in the Metropolitan Museum of Art. Part 1: From the Earliest Times to the End of the Middle Kingdom*. New York, 1978. *Part 2: The Hyksos Period and the New Kingdom*. New York: 1978.

Helck, Wolfgang. *Untersuchungen zu den Beamtentiteln des ägytischen Alten Reiches*. Hamburg: ÄF 18, 1954.

——. *Urkunden der 18. Dynastie: Übersetzung*. Berlin, 1955–1961.

——. *Zur Verwaltung des Mittleren und Neuen Reichs*. Leiden: PÄ 3, 1958.

——. *Materialien zur Wirtschaftsgeschichte des Neuen Reiches: 5 Fascicles*. Wiesbaden: AMAW, 1961–1970.

——. "Soziale Stellung und Grabanlage." *JESHO* 5 (1962): 225–243.

——. *Die Lehre des DwA-xtjj*. Wiesbaden: KÄT, 1970.

——. *Die Lehre für König Merikare*. Wiesbaden: KÄT, 1977.

——. *Die Beziehungen Ägyptens und Vorderasiens zur Ägäis bis ins 7. Jahrhundert v. Chr.* Darmstadt, 1979.

Hermann, Alfred. *Die Stelen der Thebanischen Felsgräber der 18. Dynastie*. Hamburg: ÄF 11, 1940.

Herzog, Rolf. *Punt*. Glückstadt: ADAIK 6, 1969.

Hickmann, Hans. *Ägypten*. Leipzig: Musikgeschichte in Bildern II; Musik des Altertums, fasc. 1, 1975.

Hornung, Erik. *Das Amduat oder die Schrift des verborgenen Raumes*. 3 vols. Wiesbaden: ÄA 7, 12, 13, 1963–1967.

——. *Das Totenbuch der Ägypter*. Zürich, 1979.

——. *Der ägyptische Mythos von der Himmelskuh*. Fribourg: OBO 46, 1982.

——. *Conceptions of God in Ancient Egypt: The One and the Many*. J. Baines (trans.). Ithaca, 1982.

——. *Altägyptische Unterweltsbücher*. Zurich, 1984.

——. *Die Unterweltsbücher der Ägypter*, 3rd ed. Zurich, 1989.

——. *The Valley of the Kings: Horizon of Eternity*. D. Warburton (trans.). New York, 1990.

——. *Idea into Image: Essays on Ancient Egyptian Thought*. E. Bredeck (trans.). New York, 1992.

——. *Echnaton: Die Religion des Lichtes*. Zurich, 1995.

Hornung, Erik, and & Elisabeth Staehelin. *Studien zum Sedfest*. Geneva: AH 1, 1974.

Houlihan, Patrick F. *The Birds of Ancient Egypt*. Cairo, 1988.

——. *The Animal World of the Pharaohs*. London, 1996.

James, T.G.H. *Pharaoh's People*. London, 1984.

Janssen, Jacobus J. *Commodity Prices from the Ramessid Period*. Leiden, 1975.

——. "Absence from Work by the Necropolis Workmen of Thebes." *SAK* 8 (1989): 127–152.

Janssen, Jacobus J., and P. W. Pestman. "Burial and Inheritance in the Community of the Necropolis Workmen at Thebes." *JESHO* 11 (1968): 137–170.

Jüngst, Hans. "Zur Interpretation einiger Metallarbeiterszenen auf Wandbildern altägyptischer Gräber," *GM* 59 (1982): 15–27.

Junker, Hermann. "Der Tanz der *Muu* und das Butische Begräbnis im Alten Reich." *MDAIK* 9 (1940): 1–39.

——. *Weta und das Lederkunsthandwerk im Alten Reich*. Vienna: SÖAW, 1957.

Kampp, Friederike. *Die Thebanische Nekropole: Zum Wandel des Grabgedankens von der XVIII. bis zur XX. Dynastie.* Mainz: Theben 13, 1996.

Kees, Hermann. "Anubis 'Herr von Sepa' und der 18. oberägyptischen Gau." *ZÄS* 58 (1923): 79–101.

——. "Die Befriedung des Raubtiers." *ZÄS* 67 (1931): 56–59.

——. *Der Götterglaube im Alten Ägypten.* Leipzig, 1956.

——. *Totenglauben und Jenseitsvorstellungen der alten Ägypter, Grundlagen und Entwicklung bis zum Ende des Mittleren Reiches.* Leipzig, 1956.

Kemp, Barry J. *Ancient Egypt: Anatomy of a Civilization.* London, 1989.

Köhler, Ursula. *Das Imiut: Untersuchungen zur Darstellung und Bedeutung eines mit Anubis verbundenen religiösen Symbols.* 2 vols. Göttingen: GOF IV, 4, 1975.

Kozloff, Arielle P. "Tomb Decoration: Paintings and Relief Sculpture." In Arielle P. Kozloff, Betsy M. Bryan, and Lawrence M. Bermann (eds.), *Egypt's Dazzling Sun: Amenhotep III and His World.* Cleveland, 1992.

Kozloff, Arielle P., Betsy M. Bryan, and Lawrence M. Bermann (eds.). *Egypt's Dazzling Sun: Amenhotep III and His World.* Cleveland, 1992.

Krah, Karen. *Die Harfe im pharaonischen Ägypten: ihre Entwicklung und Funktion.* Göttingen: Orbis Musicarum 7, 1990.

Lange, Kurt, and Max Hirmer. *Egypt: Architecture, Sculpture, Painting in Three Thousand Years.* R. H. Boothroyd, J. Filson, and B. Taylor (trans). London, 1968.

Lehner, Mark. *The Complete Pyramids.* London, 1997.

Lepsius, Carl Richard. *Denkmaeler aus Aegypten und Aethiopien.* 12 vols. and suppl. Berlin, 1849–58; Leipzig, 1913.

——. *Denkmœler aus Aegypten und Aethiopien: Text.* Eduard Naville (ed.). 5 vols. Leipzig, 1897–1913.

Lesko, Leonard H. (ed.). *Pharaoh's Workers: The Villagers of Deir el Medina.* Ithaca, 1994.

Lichtheim, Miriam. *Ancient Egyptian Literature.* 3 vols. Berkeley, 1975–1980.

——. "The Songs of the Harpers." *JNES* 4 (1945): 178–212.

Lucas, Alfred. *Ancient Egyptian Materials and Industries.* J. R. Harris (ed.). London, 1962.

Lüddeckens, Erich. "Untersuchungen über religiösen Gehalt, Sprache und Form der ägyptischen Totenklage." *MDAIK* 11 (1943).

Lüscher, Barbara. *Untersuchungen zu den ägyptischen Kanopenkasten: Vom Alten Reich bis zum Ende der Zweiten Zwischenzeit.* Hildesheim: Hildesheimer Ägyptologische Beiträge 31, 1990.

MacKay, Ernest. "The Cutting and Preparation of Tomb-Chapels in the Theban Necropolis." *JEA* 7 (1921): 159–168.

Manniche, Lise. *Music and Musicians in Ancient Egypt.* London, 1991.

Martin, Geoffrey T. "The Tomb of Tia and Tia." *JEA* 70 (1984): 5–12.

Maspero, Gaston. "Rapport sur les fouilles et travaux exécutés en Égypte dans l'hiver de 1885–1886." *BIE* 7 (1886): 201–208.

Mekhitarian, Arpag. *Egyptian Painting.* Geneva, 1954.

Mond, Robert. "Report of Work in the Necropolis of Thebes during the Winter of 1903–1904." *ASAE* 6 (1905): 65–96.

Morenz, Siegfried. *Ägyptische Religion.* Stuttgart, 1977.

——. *Egyptian Religion.* A. E. Keep (trans.). Ithaca, 1973.

Müller, Hans Wolfgang. "Relief und Malerei." In Jean Leclant (ed.), *Ägypten: Das Grossreich.* Munich, 1980).

Müller, W. Max. *Die Liebespoesie der Alten Ägypter.* Leipzig, 1899.

Naville, Edouard. *Das Aegyptische Todtenbuch der XVIII. Bis XX. Dynastie.* 3 vols. Berlin, 1886.

Negm, Maged. *The Tomb of Simut, Called Kyky: Theban Tomb 409 at Qurnah.* Warminster, 1997.

Otto, Eberhard. "Die Ätiologie des grossen Katers von Heliopolis." *ZÄS* 81 (1956): 65–66.

——. *Das ägyptische Mundöffnungsritual.* Wiesbaden: ÄA 3, 1960.

——. *Ägypten, der Weg des Pharaonenreiches.* Stuttgart, 1979.

Parker, Richard A. *The Calendars of Ancient Egypt.* Chicago: SAOC 26,1950.

Piankoff, Alexandre. *Le "Coeur" dans les textes Égyptiens depuis l'Ancien jusqu'à la fin du Nouvel Empire.* Paris, 1930.

Posener, Georges. "Le début de l'enseignement de Hardjedef." *RdÉ* 9 (1952): 109–120.

Pusch, Edgar B. *Das Senet-Brettspiel im alten Ägypten.* Berlin: MÄS 38, 1979.

Quack, Joachim. *Studien zur Lehre für Merikare.* Wiesbaden: Göttinger Orientforschungen IV: 23, 1992.

——. *Die Lehren des Ani.* Freiburg, 1994.

Radwan, Ali. *Die Darstellungen des regierenden Königs und seiner Familienangehörigen in den Privatgräbern der 18. Dynastie.* Berlin: MÄS 21, 1969.

Rammant-Peeters, Agnes. *Les pyramidions égyptiens du nouvel empire.* Louvain: OLA 11, 1983.

Ramses le Grand. Paris: Galeries Nationales du Grand Palais. 1976.

Ranke, Hermann. *Die Altägyptischen Personennamen.* 3 vols. Glückstadt, 1935, 1952, and 1977.

Robins, Gay. *Women in Ancient Egypt.* Cambridge, Mass., 1993.

——. *Proportion and Style in Ancient Egyptian Art.* Austin, 1994.

——. *The Art of Ancient Egypt.* London, 1997.

Romer, John. *Ancient Lives.* London, 1984.

Rössler-Köhler, Ursula. *Kapitel 17 des Ägyptischen Totenbuches.* Göttingen: GOF IV, 10, 1979.

Saleh, Mohamed. *Das Totenbuch in den Thebanischen Beamtengräbern des Neuen Reiches.* Mainz: AV 46, 1984.

Saleh, Mohamed, and Hourig Sourouzian. *The Egyptian Museum Cairo: Official Catalogue.* Peter Der Manuelian and Helen Jacquet-Gordon (trans.). Mainz, 1987.

Sander-Hansen, Konstantin Emil. *Das Gottesweib des Amun.* Copenhagen, 1940.

Schäfer, Heinrich. *Principles of Egyptian Art.* E. Brunner-Traut (ed.), J. Baines (ed. and trans.). Oxford, 1974.

Scharff, Alexander. *Das Grab als Wohnhaus in der ägyptischen Frühzeit.* Munich: SBAW 6, 1947.

Scheel, Bernd. "Studien zum Metallhandwerk im Alten Ägypten." *SAK* 12 (1985): 117–177; 13 (1986): 181–205; 14 (1987): 247–264.

Schiaparelli, Ernesto. *Relazione sui lavori della Missione Archaeologica Italiana in Egitto, anni 1903–1920.* I. Turin, 1923.

——. *La Tomba intatta dell'architetto Cha nella necropoli di Tebe.* Turin, 1927.

Schlögl, Hermann A. *Der Sonnengott auf der Blüte.* Geneva: AH 5, 1977.

——. *Amenophis IV, Echnaton.* Hamburg, 1986.

Schlögl, Hermann A., and Michel Sguaitamatti. *Arbeiter des Jenseits.* Zurich: Zürcher Archäologische Hefte 2, 1984.

Schmitz, Franz-Jürgen. *Amenophis I: Versuch einer Darstellung der Regierungszeit eines äyptischen Herrschers der frühen 18. Dynastie.* Hildesheim: HÄB 6, 1978.

Schneider, Hans D. *Shabtis: An Introduction to the History of Ancient Egyptian Funerary Statuettes with a Catalogue of the Collection of Shabtis in the National Museum of Antiquities at Leiden.* 3 parts. Leiden, 1977.

Schneider, Hans D., and Maarten J. Raven. *De Egyptische Oudheid.* 's Gravenhage, 1981.

Schott, Siegfried. *Altägyptische Liebeslieder.* Zurich, 1950.

——. *Das schöne Fest vom Wüstentale: Festbräuche einer Totenstadt.* Wiesbaden: AMAW 11, 1953.

Schweitzer, Ursula. *Das Wesen des Ka im Diesseits und Jenseits der Alten Ägypter.* Hamburg: ÄF 19, 1956.

Seeber, Christine. *Untersuchungen zur Darstellung des Totengerichts im Alten Ägypten.* Berlin: MÄS 35, 1976.

Seidel, Matthias, and Abdel Gaffar Shedid. *The Tomb of Nakht.* Mainz, 1992.

Sennefer: Die Grabkammer des Bürgermeisters von Theben. Katalog der Ausstellung im Römisch-Germanischen Museums der Stadt Köln. Mainz, 1986.

Settgast, Jürgen. *Untersuchungen zu altägyptischen Bestattungsdarstellungen.* Glückstadt: ADAIK 3, 1963.

Seyfried, Karl-Joachim. "Zweiter Vorbericht über die Arbeiten des Ägyptologischen Instituts der Universität Heidelberg in thebanischen Gräbern der Ramessidenzeit." *MDAIK* 40 (1984): 265–276.

Shedid, Abdel Gaffar. *Das Grab des Sennedjem; Ein Künstlergrab der 19. Dynastie in Deir el Medineh.* Mainz, 1994.

Simpson William Kelly (ed.). *The Literature of Ancient Egypt.* New Haven, 1972.

Smither, Paul C. "A Tax Assessor's Journal of the Middle Kingdom," JEA 27 (1941): 74–76.

Stadelmann, Rainer. *Die altägyptischen Pyramiden.* Mainz, 1997.

Staehelin, Elisabeth. "Zu den Farben der Hieroglyphen," GM 14 (1974): 49–53.

Steindorff, Georg, and Walther Wolf. *Die Thebanische Gräberwelt.* Leipzig: LÄS 4, 1936.

Te Velde, Hermann. *Seth, God of Confusion.* Leiden, 1976.

Tosi, Mario. "La Capella di Maia." *Quaderno del Museo Egizio di Tonio* 4 (1970).

Valbelle, Dominique. *"Les ouvriers de la tombe," Deir el-Médineh à l'époque Ramesside.* Cairo: BdÉ 96, 1985.

Vandersleyen, Claude. *Das Alte Ägypten.* Berlin: PKG 15, 1975.

Vercoutter, Jean. "Les Haou-Nebout." *BIFAO* 46 (1947): 125–158; 48 (1949): 107–209.

Virey, Philippe. "Le tombeau des vignes à Thebes," *RT* 20 (1898): 212–223; 21 (1899): 127–133, 137–149; 22 (1900): 83–97.

Volten, Aksel. *Studien zum Weisheitsbuch des Anii.* Copenhagen, 1937.

Watterson, Barbara. *Women in Ancient Egypt.* Stroud, Eng., 1991.

Wegner, Max. "Stilentwicklung der thebanischen Beamtengräber." *MDAIK* 4 (1933): 38–164.

Westendorf, Wolfhart. "Das Alte Ägypten." In *Enzyklopädie der Weltkunst.* Baden-Baden, 1977.

——. "Raum und Zeit als Entsprechungen der beiden Ewigkeiten." In Manfred Görg (ed.), *Fontes atque Pontes: Eine Festgabe für Hellmut Brunner.* Wiesbaden: ÄUAT 5, 1983.

Wiebach, Silvia. "Die Begegnung von Lebenden und Toten im Rahmen des Thebanischen Talfestes." *SAK* 13 (1986): 263–291.

Wildung, Dietrich. *Ägyptische Malerei: Das Grab des Nacht.* Munich, 1980.

Wilson, John, A. "The Theban Tomb (No 409) of Si-Mut, called Kiki." *JNES* 29 (1970): 187–192.

Wolf, Walther. *Die Kunst Ägyptens: Gestalt und Geschichte.* Stuttgart, 1957.

——. *Kulturgeschichte des Alten Ägypten.* Stuttgart, 1962.

Wolf-Brinkmann, Elske Marie. *Versuch einer Deutung des Begriffes "b³" anhand der Überlieferung der Frühzeit und des Alten Reiches.* Freiburg, 1968.

Zaba, Zbynek. *Les maximes de Ptahhotep.* Prague, 1956.

Zabkar, Louis V. *A Study of the Ba Concept in Ancient Egyptian Texts.* Chicago: SAOC 34, 1968.

Zandee, Jan. *Death As an Enemy.* W. F. Klasens (trans.). Studies in the History of Religions 5. Leiden, 1960.

Index